DIDEROT ON ART: I

DIDEROT ON ART

VOLUME I

The Salon of 1765
and
Notes on Painting

Edited and Translated by
JOHN GOODMAN

Introduction by
THOMAS CROW

Yale University Press · New Haven and London 1995

Set in Bembo by Best-set Typesetter Ltd., Hong Kong
Printed and bound in Great Britain by Bath Press, Avon

Library of Congress Cataloging-in-Publication Data

Diderot, Denis 1713–1784.
[Selections. English. 1995]
Diderot on art/translation and notes by John Goodman:
introduction by Thomas Crow.
p. cm
Translated from the French.
Includes bibliographical references and index.
Contents: v. 1. The salon of 1765 and Notes on painting —
v. 2. Salon of 1767.
ISBN 0–300–06248–6 (v. 1: alk. paper). —ISBN 0–300–06251–6
(v. 1: pbk.: alk. paper). — ISBN 0–300–06249–4 (v. 2: alk. paper).
— ISBN 0–300–06252–4 (v. 2: pbk.: alk, paper)
1. Art, French—Exhibitions. 2. Art, Modern—17th–18th centuries—
France—Exhibitions. 3. Salon (Exhibition: Paris, France)
4. Aesthetics—Early works to 1800. 5. Painting—Early works to
1800. I. Goodman, John, 1952 Sept. 19- II. Title.
N6846.D4613 1995 759.4'09'033—dc20 95–10638 CIP

A catalogue record for this book is available from the British Library.

In Memoriam
John Boswell (1947–1994)

CONTENTS

PHOTOGRAPHIC ACKNOWLEDGEMENTS

Photo © RMN: 7, 8, 14, 17, 22, 23, 34, 35, 36, 49, 50; Photothèque des Musées de la Ville de Paris, © DACS 1995: 24, 25; Sotheby's: 29; Cliché Bernard Ray: 32; Photo Jean Bernard: 33; Photo Emmanuel Michot / Jan-Claude Loty (© Ville de Paris S.O.A.E.): 46.

DIDEROT'S *SALONS*
Public Art and the Mind of the Private Critic

Thomas Crow

AFTER A wait of two centuries, an English-speaking audience can finally have direct access to the writing of Denis Diderot on the art and public exhibitions of his time. Commentaries on his writing, peppered with arresting quotations, have proliferated in recent years, but the available editions of the texts themselves have been cumbersome, expensive, and accessible only to those readers confident of their French. Probably no body of criticism in the visual arts is so often invoked and at the same time so little known in its original form.

A good measure of this prestige stems from the fact that Diderot, uniquely among eighteenth-century critics, enjoys enduring fame in the intellectual and literary history of the period: indeed his name, along with those of Voltaire and Rousseau, can be taken to define it. When he began to write about art, he was nearing the end of the exhausting long-term project of the *Encyclopédie*. Orchestrating the labors of a small army of gifted, volatile contributors, writing a large sheaf of articles himself, and fighting the censors all the way, he had sought to provide a newly enlightened age with a systematic map of secular knowledge. The range of the enterprise extended from the practical crafts (which occasioned the brilliant volumes of illustrative engravings) to the most abstract speculative philosophy. It was to be a charter of knowledge for a future emancipated from the hold of dogma and superstition; in the short term it was to be a primary instrument in breaking their grip.

In 1749, Diderot's first independent efforts as a freethinking philosopher resulted in his being imprisoned in the fortress of Vincennes, arrested by officers in reach of seditious writings "contrary to religion, the state or morals." With the *Encyclopédie* bringing him trouble enough from hostile authorities and carping rivals, his most incendiary writings henceforth remained in private

manuscript while he was alive. The writings on art he produced between 1759 and 1781 were likewise hidden from public view during his lifetime, though the reason was less official surveillance over him than it was the threat of scandal that then surrounded all topical writing on art.

When Diderot took up art criticism it was on the heels of the first generation of professional writers who made it their business to offer descriptions and judgments of contemporary painting and sculpture. The demand for such commentary was a product of the similarly novel institution of regular, free, public exhibitions of the latest art. These were the "Salons" of the Louvre, staged annually or biennially from 1737 onwards by the Royal Academy of Painting and Sculpture (they acquired their name from the box-like *salon carré* in which they were hung). Over some six weeks in late summer, large audiences—encompassing the nobility, the solid middle classes, the artisans of the city, and many fascinated foreign visitors—crowded in to see the show. Several hundred paintings were stacked frame-to-frame high up the gallery walls, from small landscapes and still lifes at eye-level to massive classical and religious narratives adjacent to the ceiling. Wealthy spectators routinely carried binoculars to spy out distant details: it was a feast of gleaming, colorful imagery in a time when compelling visual spectacle on this scale was rare in secular life.

It was also a rare occasion in the cultural life of the Old Regime for such a heterogeneous audience to assemble in an unregulated space—this despite the fact that the Academy itself was anything but democratic or open in its organization and procedures. That body had been formed during the reign of Louis XIV to monopolize the best artistic talent in the realm and place it firmly under state control. In return its members were recognized as practicing a liberal art and raised in status over the painters and sculptors who remained within the traditional guild: no other artists could receive royal commissions or legally open a school. In accord with the larger structures of a ranked society, the Academy adopted its own strict hierarchy: officers and professors were promoted only from those artists qualified as "painters of history," that is, adepts in the classical canon and the composition of large-scale narrative canvases.

But the exclusive values of the corporation had to be balanced against obligations to contribute to displays of royal magnificence. As the great building projects of Versailles were curtailed and with them the demand for their decorative embellishment, the public duties of the Royal Academicians were increasingly discharged in the public exhibitions opened on the name day of each successive Louis (25 August). The original intention was doubtless to impress

a grateful and passive populace with the richness and splendour surrounding the monarch, much as royal entries and festivals had always done. But the audience soon discovered other uses for the exhibition, its members finding themselves free to discuss and debate and to observe the responses of others in the broad light of day. The new critics began to record in print the currents of opinion which flowed through the crowd, and the nickname of the exhibition gave a name to the pamphlets and newspaper items they produced. The first unofficial commentary to greet the permanent establishment of the Salons in 1737 aimed chiefly to entertain, but a new mode entered with the first writer to acquire an individual reputation as a Salon critic, La Font de Saint-Yenne, who preceded Diderot's first efforts by a decade.

The pamphlets of this otherwise obscure writer set the tone for the entire first wave of Salon writing. And the fact that La Font's preoccupations were only incidentally aesthetic established the terms within and against which Diderot's writing should be read. The motives of the former were largely political in origin. He justified his controversial enterprise by borrowing the contemporary language of complaint against abuses of royal power; his was the eighteenth-century patriot's rhetoric of virtuous resistance to "despotism." It was the duty of artists, he declared, to provide images of the heroes of antiquity—Brutus, Socrates, Scipio—who had provided undying models of courage and selfless devotion to country.

That writing on the Salon should have been deemed an important vehicle for intervention in politics is a sign of the growing cultural investment in the public exhibition, and La Font's campaign inaugurated the forum for topical public discussion of the visual arts. His political mission proved, however, to be limited in scope and effectiveness by the relative failure of his aesthetic imagination. Beyond suggesting that his preferred subject matter be treated in a clear and dignified manner founded on the seventeenth-century example of Nicolas Poussin, he offered little further direction in the area of stylistic choices. He was much clearer about what he did not want, chiefly the playful and scintillating confections of Rococo decorators, designed for a corrupt and uncivic marketplace; only in relation to these cautionary examples does he speak clearly about formal invention.

This lack of a comprehensive blueprint for patriotic reform in the visual arts is one reason why his prescriptive, disciplinary criticism was easily resisted by the Royal Academicians, the artists predictably resenting a self-appointed outsider telling them their business. They recruited their own supportive critics, who exploited the weak points in La Font's arguments and overwhelmed him with ridicule.

But against the intentions of their sponsors, it was these writers who sharpened the tenor of public *debate* over the conduct of the arts. La Font's aesthetic shortcomings were filled in by others; Salon reviews were more avidly read and anticipated; readers in the provinces and abroad who could not attend the exhibitions used them to keep up with Parisian developments. The artists found the showcase of their talents attracting ever greater interest, but as individuals they faced perilous scrutiny as often as flattering applause.

One of the strongest complaints about dissenting critics was that their negative judgments would damage the reputations of artists among the body of readers who could not see the works and form opinions of their own. Princely and titled collectors across Europe had agents in the French capital deputized to acquire the best new work. Dealer networks served others, and French artists were being recruited for commissions abroad. Then as now, critical opinion was a factor in economic equations. And that factor, as much as local political considerations, moved the authorities to an effective suppression of unregulated Salon writing by the end of the 1750s.

The average reader was then left with only a few tame, affirmative reviews of subsequent exhibitions, a situation which would persist until a general liberalization took place in the early 1770s. But there were some who would not be denied. These were a group of pan-European subscribers to the *Correspondance littéraire*, a manuscript newsletter issued every two weeks in Paris by a German expatriate and free-lance man of letters, Melchior Grimm. Such sheets, termed *nouvelles à la main*, flourished in the city as an ad hoc alternative to print journalism, a means of conveying uninhibited gossip and opinion beneath the scrutiny of the state censors. Grimm's was distinguished by its cosmopolitanism, exclusivity, and unusual discretion in its distribution. The secret subscription list never numbered more than fifteen; it included at various times the monarchs of Russia, Poland, and Sweden, along with members of some dozen ruling houses in Germany. Individual copies passed through diplomatic channels, and a strict understanding forbade copying or passing them on (Goethe relates that he felt it a great privilege once even to be allowed to look at an issue for a few hours).[1]

Just at the moment when the supply of published Salon criticism was drying up in Paris, Grimm proposed that Diderot should begin reporting on the exhibitions. He started in a small way in 1759. For each of the next four, his output in words grew dramatically; his text of 1765 is three times longer than the one that immediately preceded it, which was in turn eight times longer than his first. The

1 *Goethes Briefe*, ed. K. R. Mandelkow (Hamburg: Christian Wegner Verlag, 1962), I, p. 300.

Salon of 1767 on its own is the size of a normal annual volume of the *Correspondance,* and comes close to matching the number of pages produced by all the critics of any Salon in the previous decade. 1765 and 1767 form the pinnacle of the enterprise, which understandably declined in extent and energy thereafter. And all of this phenomenal outpouring was received happily by Grimm and by those paying his bills. Thanks to Diderot's diligence and enthusiasm, they were able to summon up an effective equivalent to the whole body of commentary that had once surrounded each exhibition.

This Diderot strove to provide, and in a more profound sense than sheer volume of output. The task he set himself was to reproduce the variety of voices and concerns that went into making the new public sphere for art: as he declares in beginning the review of 1765, "I collected the verdicts of old men and the thoughts of children, the judgments of men of letters, the opinions of sophisticates, and the views of the people; and if it sometimes happens that I wound artists, very often it is with the weapons they themselves have sharpened for me." Consistent with this ambition, the motif of conversation is explicitly sustained throughout. No one approach is reserved for any one kind of painting; therefore no one level of discussion ever pretends to adequacy. His writing thereby becomes a flexible instrument of a kind unknown in his own time and rarely if ever encountered since. During the drought years of the 1760s, a few potentates found themselves in a position to order up, for their private edification, a one-man substitute for the fascinating but inaccessible chorus of voices that constituted the Salon public.

This was the thrust of a triumphal letter Diderot wrote to his mistress, Sophie Volland, on finishing his text for 1765.

It is without doubt the best thing I have done in all my literary career, from whatever angle one chooses to look at it, whether diversity of tone, variety of subjects, or abundance of ideas which have never, I imagine, passed through any head but my own. It is a mine of wit, sometimes light, sometimes strong; in places it is the purest of conversation such as we carry on by the fireside; in others it carries all the eloquence and depth you can imagine. I find myself at times pulled this way and that by distinctly opposite feelings. There are moments when I would like to see this labor of mine fall from the sky, printed in full, down into the middle of the capital.[2]

2 The text of the letter is reproduced with commentary in Marie-Catherine Sahut and Nathalie Volle, *Diderot et l'art de Boucher à David: les Salons, 1759–81* (Paris, Réunion des Musées Nationaux, 1984), pp. 67–9. This volume is the best general introduction to the texts and to their institutional and artistic context.

Contractual obligations precluded that last eventuality; Grimm's subscribers would have their exclusivity at all costs. To Volland he offered the supplementary excuse that his frankness would do gratuitous harm to the reputations of too many artists, many of whom Diderot saw on a regular basis. There is an element of disingenuousness in Diderot's expressions of solicitude, in that he was reaching directly, with no mediation by contrary voices, the most prestigious of possible patrons, who had whole state treasuries at their disposal. Certainly one of the voices woven through the Salons is that of the scout or purchasing agent. Here and there one finds him suggesting that a certain work might represent a canny acquisition. He pointedly observes in 1765 that the triumph of the preceding Salon by Jean-Baptiste Greuze, the *Filial Piety*, had languished for two years in the studio without finding a buyer—but was now on its way to a subscriber in the person of Catherine the Great. Perhaps the most obvious structural effect of this function is to be seen in the lengthy, patient enumeration of motifs in small, portable, genre paintings and landscapes by artists like Jean-Baptiste Le Prince and Hubert Robert. While possessing a concisely evocative force of their own, these entries add up to a sales catalogue for buyers on the look-out for favorite themes and details.

As the extent and ambition of Diderot's commentaries increased, they followed ever more closely the form of a catalogue, this being the official pamphlet (the *livret*) sold at the exhibition. This publication (sales of which which gave the Academy an important source of revenue) provided a description of each work and arranged the entries according to the strict hierarchy of academic rank: all the submissions by the Rectors would be listed first, Professors, Councillors, ordinary Academicians, and provisional members following, all in order of seniority. Thus his readers could follow his texts from the *livret* and surely did so, the latter providing, for example, the dimensions of works, a crucial item of information for collectors and their decorators. In the case of the grand historical canvases hung high above the crowd, the official catalogue also provided what were often prolix narratives to explain the subject matter and actions depicted. Diderot was then at liberty to play his freewheeling and opinionated acounts off of these dull and self-important recitations. And through the ironic modesty entailed in accepting the official order of things, his uninhibited capacity for invective, to which the grandest names were as subject as the least, achieved its most startling effect.

For the orchestrator of (and martyr to) the *Encyclopédie*, the arbitrary order of rank bore an analogy to the equally arbitrary order of the alphabet. This produced the positive connotation of objective totality in Diderot's texts, one which he would have welcomed.

The encyclopedic project, which linked abstract philosophy to the matter-of-fact expertise of the skilled trades, was conceived as an emancipatory form of *publicity*; the Salon exhibitions were the quintessentially public displays of high erudition mixed with fascinating material technique and sensual seduction. The analogy can be taken one step further in that the universal ideal of the *Encyclopédie* entailed that its actual reception would be constrained and distorted by the threat of censorship and prohibitive costs. Diderot's *Salons* were also contractually barred from the actual public sphere and increasingly took on a form and scope which the illicit (not to mention the approved) print trade in Paris could never have supported.

The paradox of combining a maximal public ambition with the most extreme exclusivity and privacy is fundamental to these, the two greatest of the *Salons*. The first report he produced at Grimm's request, that of 1759, follows the conventions established by the Parisian pamphleteers before him. It is subjective in its ordering, giving priority to those works which had a particular effect on the critic and leaving aside everything else. It was written more or less on the spot, delivered in time for Grimm to have the manuscript copied and dispatched within a month of the exhibition closing. As the commentaries expanded to book-length dimensions, that sort of immediacy and timeliness became impossible for even a writer of Diderot's legendary energy and *alla prima* perfection. In 1765 he procrastinated, at least by his previous standards, finally completing the whole of the text in a furious fifteen days of writing, isolated in the country, in the latter part of October. The *Salon* of 1767 left all considerations of topicality far behind: beginning in September, he did not complete his work until the end of the following year.

Thus the effort to encompass the entirety of the public phenomenon that was the Salon exhibition required a progressive removal from the event and customary forms of participation in it. The latter were of course essential preliminaries. During its run Diderot would go to the Louvre on a daily basis, generally arriving in the morning so as to avoid the worst of the crowds; he would make copious notes and quiz artist acquaintances like Falconet, Chardin, and Vernet. The actual and invented dialogues with Grimm which appear in the *Salons* had a precedent in visits to the exhibition they made in one another's company; other writers like the Abbé Galiani were sometimes present to sharpen the discussion. In 1765 Diderot made the acquaintance of his future disciple, Jacques-André Naigeon, a former art student who could be deputed to gather useful inside information from the studios; the young painter Philibert La Rue also offered his help. But as he wrote this initial engagement was left further and further behind, and in their final form his meditations were barred from re-entering the normal

dialogue of French intellectual life. As they were removed from active discussion and contestation around the works of art, the inevitable partiality of the participant could be overcome and the sort of privacy achieved that was the paradoxical condition for recreating the fullness of the public sphere of art.

The state which Diderot achieved in these Salons is something like the one described by the artist Allan Kaprow as the goal of the practitioner addressing his own work:

> when an artist writes about his art, he should write in the profoundest sense only for himself. He should amuse himself, cajole, invent roles for himself, saddle his image with great tasks, address with studied relish his towering ambitions, above all, take himself as unseriously as possible. It is just at that moment when his words become most perfectly soliloquized that they take on something of the air of authenticity.[3]

Writing for a dozen crowned heads was the closest a critic in need of a paying job was ever likely to come to this sublime privacy of writing. Beyond the prosaic responsibilities of reporting on prospective purchases, Diderot plainly enjoys the privilege of addressing Grimm's subscribers at whatever length and with all the frankness he desires. No levelling Jacobin before his time, he takes seriously the idea that the enlightened prince is the one individual in the polity above the petty divisions, jealousies, and resentments which blinker ordinary private individuals. The singular private vision of the monarch is the only one that can take in the body of the public. The crucial trick of the *Salons* is that vision can only come from Diderot: his readers, for all their power, cannot see the things he describes for them. His words assume an authority like those of the ancient writers whose ecphrastic descriptions provide the only record of the lost masterpieces of Greek art and thus hold all modernity in thrall.

But that vision is, to an important degree, denied him at the same time. As his thought expands, its capture on paper must go on in the absence of the works of art which brought it about. Once the Salon was closed, there was no returning to direct experience; everything from that point on had to be reconstructed in memory and only there. Without photographs to stand in for vision, no descriptive notes could be extensive enough to take the place of full, imaginative synthesis in the mind's eye. When he sets about writing in a way that cannot be supplemented by illustration, he is writing for

3 Allan Kaprow, "The Demiurge," *The Anthologist* (Spring 1959), p. 4. I am grateful to Robert Haywood, author of an important forthcoming study of Kaprow, for bringing this rare text to my attention.

himself as much as for his clients and grasps in a profound way—
more than any modern illustrated book can do—how it is that one
knows art.

In the age of photographic reproduction, it is easy to forget how
much the experience of visual art for the modern viewer still
remains one of memory. Though Diderot writes for readers in a
position to possess and enjoy the constant presence of great works,
he places them in the same position as the ordinary middle-class
consumer of culture. Grimm's subscribers may have their splendid
private collections, but the scene of knowledge is now elsewhere, in
an essentially public display which exceeds the capacities of any
individual: "Even if all the works of Europe's painters and sculptors
could be brought together," he tells them, "our Salon could not be
equalled. Paris is the only city in the world where such a spectacle
can be enjoyed every two years." The qualitative uniqueness of the
public exhibition goes hand in hand with its limited duration. One's
maximum exposure to any single painting or sculpture could be
easily reckoned in minutes; one was forced to apprehend objects of
immense complexity and internal development in the time required,
say, to read no more than a short chapter of a novel—and the novel,
unlike the work of art, would always be there awaiting one's return.
The full understanding of the visual work could only come retro-
actively, when it had adequate time to unfold, and therefore that
understanding always had to happen in memory and in awareness of
the loss of its object. Diderot announces to the old order the coming
of the modern condition of viewing, which remains our own.

In this sense Diderot's writing can be taken as more truthful to
the present than the greater part of the criticism being written today,
which proposes ever more exotic descriptions of fugitive mental
events in the presence of the object (the content of "the gaze") and
erases the long life of memory. The disappearance of the physical
presence of the work of art was the defining condition of its
modernity, long before photographic reproducibility became an
issue. It was the condition of the democratization of access to the
originals and the full accession of art to the discursive realm of
philosophical reflection. This is the fundamental theme of the great
set pieces of the two *Salons*. In 1765 he professes to have been
unable to approach Fragonard's *Corésus and Callirhoé* because of the
crowds, so instead he pretends to report a dream of the illusory
moving pictures to which the inhabitants of Plato's cave are
condemned, one moment of which happens to correspond precisely
to the painting in question. In 1767 his entry on the landscapist
Vernet takes the form of an even longer report on actual excursions
he claims to have taken through captivating terrain surrounding a
country retreat. Deprived of the object, language veers between its

generic extremes: from abstract speculation on the falsity of experi-
ence to ecstatic celebration of the senses. Perhaps just as revealing as
these elaborate conceits is the single stunning moment in 1765
when, recalling two landscapes by the late Deshays that he had
neglected to mention in his earlier entry on the artist, he dismisses
the thought with the words, "both of them are as crude and
harsh . . . as these last words."

In that sudden reversal is the critic's rare comprehension that he
is not above even the worst of his objects of criticism, that the
conditions which engender mediocrity implicate him, give him his
reason for writing and must therefore overtake even his own acts of
judgment. If there is a firm principle to be derived from Diderot's
criticism, it is the certainty that such reversals will befall even the
most confident and closely held beliefs about the purposes of art. So
it is with the dominant set of ideas in the *Salons* (decidedly
uncongenial to present-day tastes) which manifest his firm belief in
the academic rationalization of the classical tradition, *le grand goût*.
That conviction leads him to pronounce in 1765 with no irony
whatsoever that 'there are only three great and original painters:
Raphael, Domenichino, and Poussin." But everywhere in the text is
the simultaneous recognition that there is something inhuman in
any such aesthetic of rigor and renunciation, indeed, that there is
something inhuman in greatness itself—the history painter would be
nothing without towering passions, and such passions grow from
towering crimes. This is precisely the line of argument advanced by
the character after whom Diderot's famous dialogue of the same
period is named, *Rameau's Nephew* (another soliloquy never
published in his lifetime). Having a genius for an uncle proved
doubly oppressive for this figure, in that the great man's character is
as heartless as his musical prowess is beyond reach. Diderot's own
surrogate in the text, the voice of philosophical high-mindedness
and self-denial, appears weak in confronting the unbridled
sensualism and amorality argued by the nephew, whom he allows
to make the case that to be human requires settling for baser
consolations.

The walls of the Salon could at times reinforce Diderot's confi-
dence that the philosophical attitude promised its own amply
compensating state of happiness. The beauty of a landscape sends
him into a rapturous state of disinterested self-sufficiency, knowing
"the pleasure of belonging to myself, the pleasure of knowing myself
to be as good as I am, the pleasure of examining and taking delight
in myself, and the still sweeter pleasure of forgetting myself." So his
alter ego rhapsodizes in one of the fictional promenades through the
paintings of Vernet. This state of purely mental delight, he reports,
was broken only by the sound of a washerwoman at a nearby

stream. But the interruption is no accident and the reported sound
a thin alibi. The woman is in the picture, seen rather than heard.
The disturbance to his state of mind comes from no external source,
but rather from internal erotic longing prompted by the vision of
Vernet's little figure and the involuntary thought of a licentious
interlude: "If only she'd come here," he finds himself musing, "if
she'd appear before me, if I could see her large eyes once more, if
she'd place her hand softly on my forehead, if she'd smile at me . . ."
And at that point, the self-parody in the preceding passage stands
out in relief.

This is the constant character of the *Salons*: no sooner is a position
of viewing and judgment established than its limits are revealed in
the light of some incompatible alternative. The battle between the
interlocutors of *Rameau's Nephew* is always underway within himself,
as it was observable on every side in the competing responses
coming from within the crowds in the Louvre. But the effect is as
far as possible from nihilistic self-cancellation. The writing of these
texts came directly after he had finished his twenty years of labor on
the *Encyclopédie*; in August 1765 he had written an impassioned letter
to its subscribers defending the improving mission of the project
against its many enemies. He was not about to set aside the sacrifice
of so much of his life and creative energy to the advancement of
systematic and transparent knowledge as an instrument of human
emancipation. But he had acquired over that time all too much
understanding of the manifold resistance to this aspiration, of which
he was not himself free. Assessing his fascination with religious
painting, the instrument of credulousness and superstition, this
ex-Abbé recalls in the *Salon* of 1765 that he can never witness a
religious procession without tears coming to his eyes (how foolish
are religious iconoclasts, he muses, how they unwittingly further the
cause of secular rationality). Returning to the exhibition in the eye
of memory, glimpsing a momentary freedom from the abstract
regime of language, allowed him see his most cherished convic-
tions from the limits of their effectiveness—and thereby realistically
to define them through their endemic conflict with the contrary
demands of life. The result is an extraordinary model of non-
hierarchical thinking, and for this reason the *Salons* always anticipate
and outdistance their present-day commentators, who invariably
have a hierarchy of interpretative priorities in mind. The best intro-
duction to Diderot the critic of art is to transpose to the realm of
ideas his own praise of Vernet in 1765: "While he's the most prolific
of all our painters, he makes me work the least. It's impossible to
describe his compositions, they must be seen."

TRANSLATOR'S PREFACE

An excellent author who falls into the hands of a bad translator, like Homer into the hands of Bitaubé, is lost. A mediocre author lucky enough to meet up with a good translator, like Lucan with Marmontel, has everything to gain. It's just the same with painters and engravers, especially if the former is not a good colorist. Engraving kills the painter whose color is everything, just as translation kills the author who is all style.

<div style="text-align: right">Diderot, Salon of 1765</div>

AS MUCH AS anyone, Denis Diderot (1713–84) is responsible for having defined and implemented the momentous critical project we have come to know as the French Enlightenment. He was a moving force behind the first edition of the *Encyclopédie* (1751–80), its flagship enterprise, which was not only a massive compendium of useful information, as its title still suggests, but also a mighty consciousness-raising machine intended to instill in its readers sceptical habits of thought that have since become second nature to educated westerners. His best-known works of fiction—*The Nun, Jacques the Fatalist*, and *Rameau's Nephew* (much admired by Goethe, who translated it)—are brilliant entertainments that shift style and tone with dizzying facility; for this reason they have become touchstones for later authors wary of normative modes of writing. Moving to a broader frame of reference, Diderot was among a handful of important eighteenth-century authors (including Voltaire and J.-J. Rousseau) who legitimized the role of the modern writer-intellectual as a pestering, gadfly-like creature, a figure that still carries considerable cultural authority today. And the quicksilver volatility of his highly personal idiom—encompassing by turns savage wit and anecdotal ingratiation, psychological penetration and

astute social critique, nice irony and expansive sentimentality—gave
Enlightenment scepticism what is arguably its most remarkable and
captivating voice.

Thus it is with some trepidation that I preface my brief comments
with the passage cited above, for the author whose work you are
about to read—rendered into English by myself—is anything but
mediocre or minor. While it would be ludicrous to claim he was
"all style," the idiosyncratic gait of his French prose—its charm
and acerbity, its conversational grace and punch—was more than
incidental to his achievement, and it presents considerable challenges
to anyone setting out to translate it. Diderot was renowned conver-
sationalist, and in his art criticism he sought to capture something of
the colloquial rhythms of his impromptu utterances in Parisian
society. He was remarkably successful in achieving this goal.
Encountering these texts in their original language, we feel like
privileged guests at a gathering dominated by an extraordinary talker
capable of holding his listeners in thrall as much through sheer
human generosity as through force of mind. We are seduced into
imagining ourselves as part of a social gathering in which convivi-
ality and sensuality blend almost imperceptibly with theoretical
speculation and political commentary, and off-color anecdotes are
taken just as seriously—or as lightly—as extended pronouncements
on the nature and limits of representation. Who among us would
not be tempted to enter such a rich, commodious world?

These extended texts were shaped by the order in which works
were listed in the Salon catalogue, for Diderot kept to this sequence
in discussing them. Even so, he gave considerable thought to the
effects produced by the pacing of his observations—especially in the
Salon of 1767, which was revised over a period of sixteen months.
The reader is likely to emerge from an encounter with these texts
feeling challenged and exhilarated, and much of their considerable
energy is the result of an idiosyncratic but carefully calculated
rhetorical mix: as already noted, in these pages the high-toned is
cunningly juxtaposed with the colloquial. Likewise, grammatical
conventions are sometimes exploited but may just as easily be
violated for effect; telegraphic phrases and free-floating predicates
abound. As a translator I have tried to follow a middle course,
rendering such gestures and contrasts faithfully when possible but
never hesitating to substitute idiomatic equivalents when these
seemed consistent with the author's intentions. I have made free use
of contractions: they have proved invaluable in capturing the inti-
macy of Diderot's writing, which in the original is capable of
disarming even the most resistant reader.

Diderot has never been a truly popular author, even in France,
but academic esteem for his writing has grown considerably since

World War II. His protean intellectual style and his penchant for dialogic ambiguity struck a nerve in many sophisticated postwar readers, so it is surprising that, alone among his important achievements, his art criticism has never been rendered into English. On the occasion of this edition's publication, perhaps it will be useful to consider some of the possible reasons for this delay.

It might be surmised that textual problems presented serious obstacles, but this is not the case. The Naigeon edition of 1798 is quite good; a small number of short passages are absent (three in the *Salon of 1767*, none in the *Salon of 1765*), but this text is satisfactory in all salient respects. A perfectly acceptable English-language edition could have been produced using Naigeon at any point.

Other possible reasons one might cite for the delay are the limited contemporary interest in most of the works discussed and a widespread unfamiliarity with the aesthetic and political value systems informing them. While the public continues to hold Chardin and Fragonard in high esteem, and Diderot certainly has interesting things to say about both of them, they take up relatively little space here, even allowing for the extended set-piece on the *Corésus and Callirhoé*. Greuze and Joseph Vernet, two painters whose resistance to conventional categorization excited Diderot's imagination—he states that their ambitious genre and landscape paintings, respectively, should be ranked in quality and interest above most contemporary history painting—have long been regarded as offering little to sustain the interest of modern viewers. The same might be said of the blatantly artificial and mercenary Boucher, a particular *bête noir* of Diderot's, with his formulaic pastorals, parsley trees, and powdered female bottoms. The list of painters and sculptors with limited appeal to modern art lovers could be expanded to include the balance of those on view in the Salons.

Similar claims could be advanced regarding Baudelaire's art criticism, the next benchmark of art-critical writing in the French tradition: Delacroix and Ingres aside, the artists he discusses are today little-known figures. Even so, these texts have been available in English for several decades.[1] But by the 1840s and 1850s, when Baudelaire was writing his criticism, the French "system of the arts"

1 Baudelaire's *Le Peintre de la vie moderne* was first rendered into English in 1930 by P. G. Konody (as *The Painter of Victorian Life*); another translation by Norman Cameron followed in 1950. The balance of his important art criticism became accessible in versions by Jonathan Mayne five years later, in a volume entitled *The Mirror of Art*, which was the first illustrated edition of these works. The Mayne translations have been republished many times since (they are now available under the title *The Painter of Modern Life and Other Essays*), and in 1981 they were joined by *Selected Writings on Art and Artists*, with English-language renderings by P. E. Charvet.

had changed considerably, moving much closer to the one within which Manet and the Impressionists would be operating a few years later. The cultural connections between Baudelaire's *modernité* and the social and cultural circumstances shaping late nineteenth-century Parisian artistic practice were comprehensible to many readers—less difficult for them to grasp, in any event, than those in the Paris of the 1760s, when a strictly hierarchical categorization of the genres still held sway, the notion of the visual artist as cultural critic was largely unfamiliar, and the market for art works was much smaller than it would subsequently become. Furthermore, Baudelaire had an artist-hero of considerable appeal in the person of Delacroix, whose complex relation to tradition made him an ideal catalyst for reflection on the nature of modern life and culture. Diderot made fitful attempts at presenting Greuze as such a hero in the 1760s; but, given twentieth-century antipathy to his work, this has been something of a deterrent for modern readers. Perhaps even more to the point, Baudelaire himself came to function very early on in the West as the paradigmatic poet of alienated subjectivity, making his ruminations on the proper role of the artist in society readily assimilable, whereas Diderot has been securely installed within the literary Pantheon for only a few decades.

But interest in Diderot continues to grow, and increasingly it is not restricted to his literary and philosophical output. He too is becoming something of a hero for those who believe in the activist intellectual, certainly more so than Baudelaire. Both of them were committed to constructive social criticism, but they went about implementing this project in very different ways. Baudelaire's was an intensely personal voice, as is perhaps fitting for a poet; so was Diderot's, but his life was more imbricated in the social and intellectual networks of his day, and as a result his work gained in range. It is true that Baudelaire took part in the revolution of 1848, but with its betrayal under Napoleon III he grew wary of the overtly political. Diderot, while never literally on the barricades, in a manner of speaking spent his whole life there. He too grew cautious in the wake of his imprisonment in 1748, but he then went right ahead with the *Encyclopédie*, never allowing bitterness or spleen to become installed in his imagination. Indeed, he found a kind of liberation in the realization that he could write pretty much whatever he liked, so long as its circulation was restricted—as was the case with the *Salons*. He knew that he had access to those in power, and not only through the pages of the *Correspondance littéraire*. He chose to exploit that access selectively, strategically, for his was a critical intelligence imbued with a healthy sense of realism. While he pursued certain truly anomalous projects in secrecy (*Rameau's Nephew*, for example), he was not above working his connections, directly or indirectly.

Surely I am not alone in finding that, as a model of productive
critical practice, Diderot has more to offer us at the end of the
twentieth century than the romantic isolationism of Baudelaire,
however trenchant his attacks against middle-class complacency.

The same shift in the intellectual climate that has ushered Diderot
onto center stage has made the appearance of these texts in English
viable, even necessary. Increasingly, we are coming to see the
eighteenth century as the breeding ground of the modernist
aesthetic as well as of the social conditions shaping contemporary
politics. Cultural and political historians have been working over-
time to convince us of this, and their labor has not been wasted. We
have come to understand that, while the hierarchy of genres still
carried considerable authority in 1760s France, the seeds of its
demise had already been sown. The advent of what Jürgen
Habermas has taught us to call the public sphere—a journalistic
space in which critical voices claiming to speak for the "public"
could address the important issues of the day—marked a watershed
moment in the emergence of the world in which we live. In
a process neither brief nor linear but ultimately implacable, an
evolving egalitarian mindset was undermining the viability of seven-
teenth-century notions of social hierarchy and decorum. We have
begun to examine the visual productions of the period with eyes
made newly perceptive by these scholarly lenses, and we are being
rewarded with a more acute understanding of their genuine interest
and complexity.[2]

This brings me to another possible deterrent to translation: the
obscurity of Diderot's many topical references. Even Jean Seznec
and Jean Adhémar, whose erudition was formidable, left many of
these unglossed; but recent scholarship on Diderot and eighteenth-
century Paris has made it possible to annotate these texts more
fully, making them that much more accessible. The Hermann
Oeuvres complètes (see below) sets a high standard in this regard. I
have used the information contained in the copious notes of this
edition, in some cases expanding upon it with findings from my
own research. But annotations have been kept brief; while often
sorely tempted to comment at length, in the end I opted for
concision.

2 To cite the most notable recent art-historical titles to appear in English: Michael
 Fried, *Absorption and Theatricality: Painting and Beholder in the Age of Diderot*, Berkeley,
 1980; Norman Bryson, *Word and Image: French Painting of the Ancien Régime*,
 Cambridge, 1981; Thomas Crow, *Painting and Public Life in Eighteenth-Century Paris*,
 New Haven and London, 1985 Mary Sheriff, *Fragonard: Art and Eroticism*, Chicago,
 1990; Barbara Maria Stafford, *Artful Science: Enlightenment Entertainment and the Eclipse
 of Visual Education*, Cambridge, Mass. and London, 1994.

There are two texts in this volume, the *Salon of 1765* and the *Notes on Painting* (*Essais sur la peinture*), the latter, a wide-ranging primer of visual aesthetics, was conceived by Diderot as an appendix to the *Salon* proper. The two works have not always been published between the same covers, but they belong together. There are two invaluable critical editions of these texts. The one by Seznec and Adhémar in their four-volume set of the complete *Salons* (Oxford, 1957–65) was the first in which an attempt was made to collate the various surviving manuscripts; and it was also the first illustrated edition, enabling the reader to compare Diderot's descriptions with the original works when these survive in some form. In matters of textual criticism and annotation, however, this edition has now been superseded by that in the superb *Oeuvres complètes* now being published by Hermann, which also includes illustrations of obscure paintings not previously reproduced. I have consulted both in the course of my work, but for reasons of copyright, the text used for this translation is that in volume XIII of the set of Diderot's works overseen by Naigeon, published in 1798 and frequently reprinted thereafter (see summary bibliography). Naigeon's versions of these works were based on manuscripts provided by Diderot on the eve of his departure for Russia in 1773. As already noted, they are quite good. Several manuscript copies of the *Salon of 1765* and the *Notes on Painting* survive (none of them autograph), but the divergences between them are relatively insignificant: most are so minor as to disappear in translation. In one case, however, I have departed from the Naigeon text. The entry on Roslin's portrait of the La Rochefoucault family was rendered from the version that appeared in the *Correspondance littéraire*; it probably reflects some reworking by Grimm, but in any case I find it superior to the one published by Naigeon.

Like many of his contemporaries, Diderot spent long hours studying the Greek and Latin classics; he was completely at ease with them and frequently incorporated passages from his favorite authors in his critical writing, usually quoting from memory. In the interest of remaining faithful to this multilingual texture, Latin citations and the occasional Italian phrase have been left in the original, with translations and references provided in the accompanying notes.

The spelling of names has been changed to conform with modern usage. Exhibition numbers from the *Salon* catalogue have been retained. The dimensions provided by the same source have been omitted, as these are notoriously inaccurate, but I have sometimes added the indication "large painting," a phrase used by Diderot on occasion, to orient the reader as to scale.

A word about my handling of *tableau*, the preferred term in eighteenth-century French for "painting." When it appears in title

headings I have rendered it as "painting," and the phrase *peinture d'histoire* has been translated as "history painting." However, in most other instances in which clarity did not dictate otherwise I have rendered it as "picture." This word has a relaxed, conversational ring that is altogether consistent with the colloquial tone of Diderot's text, and this alone made it an attractive choice. But another consideration was decisive in shaping my decision: the pronounced theatrical associations of the French word, which are important and tend to disappear in English. "Picture" has a more general range of application than "painting," and this makes it preferable as a substitute. The fact that it also figures in the English phrase "stage picture" clinched the matter for me.

In closing I would like to express my gratitude to five individuals: Thomas Crow, for his generous suggestion that I was the right person to undertake this project; John Nicoll of Yale University Press, for his judicious advice; Sandra Raphael, for her fine editing; Sheila Lee, also of Yale University Press, for her help in obtaining photographs; and Ralph Hexter, for his expert assistance with the Latin.

<div style="text-align: right">

John Goodman
November 1994

</div>

The Salon of 1765

THE SALON OF 1765

To my dear friend Grimm.[1]

Non fumum ex fulgore, sed ex fumo dare lucem Cogitat.
<div align="right">Horace[2]</div>

IF I POSSESS a few considered ideas about painting and sculpture, it's to you, my friend, that I owe them. I'd have followed the lead of the crowd of idlers at the Salon, like them I'd have cast no more than a superficial, distracted glance at the productions of our artists; in a word, I'd have thrown precious works onto the fire or praised mediocre ones to the skies, approving or dismissing them without seeking out reasons for my infatuation or disdain. It's the task you set me that fixed my eyes on the canvas and made me circle around the marble. I gave my impressions time to coalesce and settle in. I opened my soul to the effects, I allowed them to penetrate through me. I collected the verdicts of old men and the thoughts of children, the judgments of men of letters, the opinions of sophisticates, and the views of the people; and if it sometimes happens that I wound artists, very often it's with weapons they themselves have sharpened for me. I've questioned them and come to understand fine draftsmanship and truth to nature; I've grasped the magic of light and shadow, become familiar with color, and developed a feeling for

1 Friedrich Melchior, known as Baron Grimm (1723–1807). A close friend of Diderot's and editor of the *Correspondance littéraire*, for which the *Salons* were written. See introduction.
2 "His intention is not to give smoke from the flame, but light from out the smoke": Horace, *Ars Poetica* vv. 143–4.

flesh. On my own I've reflected on what I've seen and heard, and artistic terms such as *unity*, *variety*, *contrast*, *symmetry*, *disposition*, *composition*, *character*, and *expression*, so comfortable on my lips but so indistinct in my mind, have taken on clear, fixed meanings.

Oh, my friend, how these arts whose object is the imitation of nature, whether by means of eloquence and poetry in discourse, sound in music, paint and brush in painting, chalk in drawing, chisel and clay in sculpture, burin, stone, and metal in printmaking, bow-drill in precious stone carving, stylus, hammer, and punch in chasing, are tedious, laborious, and difficult arts!

Remember that Chardin once said to us in the Salon:

> Messieurs, Messieurs, go easy. Find the worst painting that's here, and bear in mind that two thousand wretches have broken their brushes between their teeth in despair of ever producing anything as good. Parrocel, whom you call a dauber, and who is one in comparison with Vernet, this Parrocel is an exceptional man relative to the crowd that abandoned the career they began to pursue at the same time as he. Lemoyne said it took thirty years to learn how to retain the qualities of one's original sketch, and Lemoyne was no fool.[3] If you'll listen to me, you might learn to be a bit more indulgent.

Chardin seemed to doubt there was any education that took longer or was more laborious than that of painters, not excluding those of doctors, lawyers, and professors at the Sorbonne.

> The chalk holder is placed in our hands, [he said], at the age of seven or eight years. We begin to draw eyes, mouths, noses, and ears after patterns, then feet and hands. After having crouched over our portfolios for a long time, we're placed in front of the *Hercules* or the *Torso*, and you've never seen such tears as those shed over the *Satyr*, the *Gladiator*, the *Medici Venus*, and the *Antinous*. You can be sure that these masterpieces by Greek artists would no longer excite the jealousy of the masters if they were placed at the mercy of the students' grudges. Then, after having spent entire days and even nights, by lamplight, in front of an immobile, inanimate nature, we're presented with living nature, and suddenly the work of all the preceding years seems reduced to nothing; it's as though one were taking up the chalk for the first time. The eye must be taught to look at nature; and many are those who've never seen it and never will! It's the bane of our existence. After having spent five or six years in front of the

3 François Lemoyne (1688–1737). His most famous work is the ceiling of the Hercules Salon in the palace of Versailles.

model, we turn to the resources of our own genius, if we have any. Talent doesn't reveal itself in a moment; judgments about one's limitations can't be reached on the basis of first efforts. How many such efforts there are, successful and unsuccessful! Valuable years slip away before the day arrives when distaste, lassitude, and boredom set in. The student is nineteen or twenty when, the palette having fallen from his hands, he finds himself without profession, without resources, and without moral character: for to be young and have unadorned nature ceaselessly before one's eyes, and yet exercise restraint, is impossible. What to do? What to make of oneself? One must either take up one of the subsidiary crafts that lead to financial misery or die of hunger. The first course is adopted, and while twenty or so come here every two years to expose themselves to the wild beasts, the others, unknown and perhaps less unfortunate, wear breastplates in guardrooms, or carry rifles over their shoulders in regiments, or dress themselves in theatrical attire and take to the boards. What I've just told you is the life story of Bellecour, Lekain, and Brizart,[4] bad actors out of despair at being bad painters.

Chardin told us, if you recall, that one of his colleagues whose son was the drummer in a regiment answered queries about him by saying he'd abandoned painting for music. Then, adopting a serious tone again, he added:

Many fathers of these incapable, sidetracked children don't take the matter so lightly. What you see here is the fruit of the small number who've struggled more or less successfully. Those who've never felt art's difficulty will never produce anything of value; those who, like my son, feel it too early on, produce nothing at all; and rest assured that most of the high posts in our society would remain empty if one gained access to them only after trials as severe as those to which we must submit.

But Monsieur Chardin, I say to him, you mustn't hold it against us if

Mediocribus esse poetis
Non homines, non di, non concessere columnae;[5]

4 Jean Claude Gilles Colson, known as Bellecour (1725–78); Jean-Baptiste Britard, known as Brizard (1721–91); Henri-Louis Cain or Kain, known as Lekain (1729–78). Contemporary actors; the first two performed in Diderot's *Père de famille* in 1761.

5 "As for poets who are only mediocre, neither men nor the gods pardon them, nor even the columns of the place they recite their verses": Horace, *Ars Poetica*, vv. 372–3.

for this man who incites the irritation of gods, men, and columns against the mediocre imitation of nature was not unaware of the difficulty of his craft.

"Well then," he answered me,

> it's better to think he warned the young student of the perils he ran than to make of him an apologist for gods, men, and columns. It's as if he said to him: My friend, take care, you mistake your judge; he knows nothing, but is no less cruel for that . . . Farewell, messieurs, go easy, go easy . . .

I'm rather afraid Chardin was soliciting alms from statues. Taste is deaf to all pleas. What Malherbe said of death, I'd apply to criticism; everything must bow to its law,

> And the guard keeping watch at the gates of the Louvre
> Cannot protect our kings from it.[6]

I'll describe the paintings for you, and my descriptions will be such that, with a bit of imagination and taste, you'll be able to envision them spatially, disposing the objects within them more or less as we see them on the canvas; and to facilitate judgment about the grounds of my criticism or praise, I'll close the Salon with some reflections on painting, sculpture, printmaking, and architecture. You'll read me like an ancient author who transmits an ordinary passage instead of a finely wrought line.

I can almost hear you declaiming sadly: All is lost: my friend is arranging, ordering, and leveling everything. One doesn't borrow crutches from Abbé Morellet[7] except when one lacks genius oneself . . .

It's true that my head is weary. The burden I've carried for twenty years[8] has so bowed me down that I'm desperate to stand up straight. However that may be, remember my epigraph, "Non fumum ex fulgore, sed ex fumo dare lucem."[9] Let me smoke for a moment, and then we'll see.

Before getting down to business I must warn you, my friend, not to assume that all the paintings I discuss briefly are simply bad. The productions of Boizot, Nonotte, Francisque, Antoine, Lebel, Amand, Parrocel, Adam, Descamps, Deshays the younger, and

6 "Et la garde qui veille aux barrières du Louvre / N'en défend pas nos rois": François de Malherbe (1555–1628), *Consolation à Monsieur du Périer, gentilhomme d'Aix-en-Provence, sur la mort de sa fille,* vv. 79–80.

7 André Morellet, Abbé (1727–1819). French writer and translator a member of the circle that met regularly at the homes of Madame Geoffrin and Baron d'Holbach.

8 Diderot is referring to the *Encyclopédie.*

9 See above, note 2.

others are positively detestable, infamous. I except only Amand's middling *Mercury and Argus*, painted in Rome, and one or two heads by Deshays the younger, sketched for him by his rascal of a brother to improve his fortunes at the Academy.

When I point out flaws in a composition, assume, if it's bad, that it would remain bad even if its faults were corrected; and if it's good, that it would be perfect if these faults were corrected.

This year we lost two great painters and two accomplished sculptors: Carle Van Loo and Deshays the elder, Bouchardon and Slodtz. On the other hand, death has delivered us from the cruelest of amateurs, the comte de Caylus.[10]

This year we were less richly supplied with large paintings than two years ago, but as compensation we had more small compositions, and there's also consolation in the fact that some of our artists displayed gifts that might rise to all challenges. And who knows what Lagrenée will make of himself? Either I'm much mistaken, or the French school, the only one that remains vital, is still far from waning. Even if all the works of Europe's painters and sculptors could be brought together, our Salon would not be equalled. Paris is the only city in the world where such a spectacle can be enjoyed every two years.

PAINTING

THE LATE CARLE VAN LOO[11]

Carle Van Loo alone left twelve pictures: *Augustus Closing the Doors of the Temple of Janus*, [*The Three Graces*,] a *Susanna*, seven oil sketches for the *Life of Saint Gregory*, [a *Vestal Virgin*,] a *Study of an Angel's Head*, and an *Allegorical Painting*.

10 Anne-Claude-Philippe de Tubières, comte de Caylus (1692–1766). Antiquarian, connoisseur, teacher, poet, and author of pornographic literature. In the 1750s he published three books intended to facilitate artists' access to classical subject matter. Diderot found him a tiresome pedant.
11 Charles-André Van Loo, known as Carle Van Loo (1705–65). Student of his elder brother Jean-Baptiste Van Loo, Benedetto Luti, and the sculptor Pierre II Legros. Received as a full Royal Academician on July 30, 1735.

Monsieur Evergreen Holly, you resemble the leaves of your emblem that prick on all sides.[12] Eight days ago the article on Van Loo was too short, today it is too long. Leave it, if you please, as it is.

1. *Augustus Closing the Doors of The Temple of Janus* (Pl. 1)
Large painting
Commissioned for the gallery at Choisy

To the viewer's right, the temple of Janus oriented so the doors are visible. Beyond these doors, against the temple façade, the statue of Janus on its pedestal. This side of it, a tripod with its cover on the ground. A priest dressed in white, his two hands grasping a large iron ring, closes the doors, whose upper, middle, and lower segments are traversed by wide iron bands. Beside this priest, further back, two other priests dressed like the first. In front of the priest closing the doors, a child carrying an urn and observing the ceremony. In the center foreground of the scene is Augustus, alone, erect, in military attire, silent, an olive branch in his hand. At Augustus' feet, on the same level of depth, a child, one knee to the ground, a basket on his other knee, holding flowers. Behind the emperor, a young priest of whom little more than his head is visible. To the left, some distance away, a mixed crowd of people and soldiers. On the same side, at the edge of the canvas and in the foreground, a senator seen from behind and holding a roll of paper. This is what Van Loo sees fit to call a public festival.

It seems to me that the temple, not being here a pure accessory, a simple background decoration, should have been given emphasis rather than depicted as such a paltry, impoverished structure. The iron bands traversing the doors are wide and make a fine effect. As for the Janus, he almost looks like two bad Egyptian figures joined together. Why flatten the saint of the day against the wall? The priest pulling the doors pulls them marvelously, his action, drapery, and characterization are all beautiful. I say the same of

12 This is an allusion to Grimm, for whom Diderot had invented a personal emblem picturing a sprig of holly with the French phrase "Au Houx, toujours vert" ("To Evergreen Holly, always green") above and, below, the Latin legend *Semper frondescit*. The latter phrase translates into French as "il fait toujours des feuilles", or in English, "he/it is always making leaves." There is a bilingual pun here: *feuilles* means both leaves (as in a plant's leaves) and sheets or pages (as in sheets of manuscript). Thus Diderot's emblem playfully evokes Grimm's journalistic fecundity as editor of the *Correspondance littéraire*.

his neighbors; their heads are beautiful, painted in an idiom that's grand, simple, and true, their handling is virile and strong. If another artist would be capable of doing as well, I'd like to know who he is. The little urn-bearer is heavy-handed and perhaps superfluous. The other child throwing flowers is charming, well conceived, and could hardly have been better posed; he tosses his flowers with grace, perhaps too much grace, he brings to mind Aurora shaking them from the tips of her fingers. As for your Augustus, Monsieur Van Loo, he's miserable. Wasn't there a single student in your studio who dared tell you he was stiff, ignoble, and short, that he was made up like an actress, that this red drapery in which you've decked him out offended the eyes and threw the painting out of kilter? This is an emperor? With the long palm he carries flush against his left shoulder, he's a member of the confraternity of Jerusalem returning from the [Palm Sunday] procession.[13] And this priest I see behind him, what am I to make of his little casket and his foolish, embarrassed air? Or of this senator encumbered by his robe and his paper, his back turned to me, mere figural padding, the amplitude of whose lower drapery makes his upper portion seem thin and insubstantial? And what's the significance of the whole? Where's the interest? Where's the subject?

To close the temple of Janus is to announce a general peace throughout the Empire, an occasion for rejoicing, for celebration, and in examining this canvas I can't find the slightest indication of joy. It's cold, it's insipid; everything is gloomy silence, dreadful sadness; it's the burial of a vestal virgin.

If it were up to me to execute this subject, I'd have made the temple more prominent. My Janus would have been imposing and handsome. I'd have placed a tripod at the temple door, with young children crowned with flowers burning incense. There, a grand priest venerable in expression, drapery, and character would have been visible; behind this priest I'd have grouped others. In all periods priests have been the jealous observers of sovereigns: they'd have tried to determine what they might hope for or fear from the new master, I'd have had them fix their attentive gazes on him. Augustus accompanied by Agrippa and Maecenas would have commanded that the temple be closed, he'd have gestured accordingly. The priests, their hands grasping the rings, would have been poised to obey. I'd have assembled a tumultuous crowd of people that the soldiers would have barely been able to control. Above all, I'd have wanted my scene to be well lit; nothing augments gaiety so

13 The reference is to a contemporary religious confraternity.

much as a beautiful day. The procession from Saint Sulpice never would have departed in such sombre, cloudy weather.[14]

And yet if, after the artist's death, a fire had consumed this composition, sparing only the group of priests and a few scattered heads, all of us would have acknowledged the impression these precious remains made on us by crying out: What a shame!

2. *The Three Graces* (Pl. 3)
Large painting

Since these figures hold on to each other the painter thought they were grouped. The eldest of the three sisters is in the center, her right arm resting against the lower back of the one on her right and her left arm intertwined with the right arm of the one on her right. She faces us directly. The setting, such as it is, is a landscape. We see a cloud that descends from the sky, passes behind the figures, and spreads itself over the ground. The head and back of the Grace to the left are seen in two-thirds view, her left arm resting on the shoulder of the central one and her right hand holding a vial; she's the youngest. The second one, her back in two-thirds view and her head in profile, holds a rose in her left hand; in her right she grasps a branch of myrtle that had been given to the eldest.[15] The site is strewn with a few flowers.

It's difficult to imagine a colder composition, Graces more insipid, less aerial, less attractive. They have neither life, nor action, nor character. What are they doing? I'm ready to die if they have the slightest idea. They display themselves. This is not the way the poet saw them. It was in spring, he evoked beautiful moonlight; fresh greenery covered the mountains; streams murmured, one heard and saw the play of the silvery waters; the beams of the night star undulated on their surface. The spot was solitary and tranquil. It was on the soft grass of a meadow, near a forest, that they sang and danced. I can see and hear them. How sweet is their song! How beautiful they are! How firm is their flesh! The tender moonlight further softens the whiteness of their skin. How easy and buoyant are their movements! It's old Pan who plays the flute. The two

14 The Corpus Christi procession held every spring, in which the host was paraded through the city streets, which were specially decorated for the ocassion.

15 In Diderot's description he has transposed the right and left hands of the Grace on the right. Such errors often creep into his descriptions, which is not surprising when we consider that he worked largely from memory, writing at his desk and, to a considerable extent, after the Salon had closed. In this translation all such mistakes have been left as they are in Diderot's text.

young fauns at his side have adorned their pointed ears; their ardent eyes peruse the most secret charms of the young dancers: what they see doesn't prevent their regretting what the changing movements of the dance conceal from them. The wood nymphs approach, the water nymphs lift their heads among the reeds; soon they will join in the games of the obliging sisters.

Junctaeque nymphis Gratiae decentes
Alterno terram quatiunt pede . . .[16]

But let's return to those by Van Loo, who aren't equal to the ones I leave behind. The central one is stiff; one would say she'd been posed by Marcel.[17] Her head's too big, she has difficulty holding it up. And these little scraps of drapery flush against the buttocks of one and the upper thighs of another, who put them there? Nothing other than the bad taste of the artist and the bad morals of the people. They don't understand that it's a woman who's undressed and not a woman who's nude that's indecent. An indecent woman has a little cap on her head, her stockings around her ankles, and her slippers on her feet. This reminds me of the way Madame Hocquet made the *Venus Pudica* into the most disreputable figure imaginable. One day she fancied the goddess hid herself very badly with her lower hand, and lo and behold she placed some plaster drapery between this hand and the corresponding portion of the statue, which suddenly took on the air of a woman drying herself. Do you think, my friend, that Apelles would have imagined placing strips of drapery as wide as your hand over the bodies of the three Graces? Alas! Since their appearance in the nude out of the head of the old poet, since the time of Apelles, if any painter has seen them, I swear to you it isn't Van Loo.

Those by Van Loo are tall and lanky, above all in their upper portions. This cloud descending on the right and spreading at their feet belies common sense. The handling is too firm, too vigorous for such soft, pliant creatures; and then there's an odd, fantastic green cast all around them that darkens and obscures them. Without effect, without interest; painted and drawn without freshness, from habit. This composition is far inferior to the one he showed in the preceding Salon and cut into pieces. No doubt the Graces, being sisters, should resemble one another, but must they all have the same head?

Even so, the worst of these three figures is superior to the affectations, mannerisms, and red bottoms of Boucher. At least

16 "The comely graces linked with nymphs tread the earth with tripping feet": Horace, *Odes* I, iv, vv. 6–7.
17 Marcel was a celebrated teacher of dancing and deportment.

they're flesh, and even beautiful flesh, with a severe aspect that's less displeasing than debauchery and bad morals. If there's mannerism here, it sins in the direction of grandeur.

3. *The Chaste Susanna* (Pl. 2)

One sees Susanna seated in the center of the canvas; she's just emerged from her bath. Placed between the two old men, she leans towards the one to the left, surrendering to the gaze of the one on the right her beautiful arms, her beautiful shoulders, her lower back, one of her buttocks, all of her head, three-quarters of her charms. Her head twists upward; her eyes turn towards the heavens, appealing for aid; her left arm secures the cloth covering her upper thighs; her right hand moves outward, pushing away the left arm of the old man on that side. What a beautiful figure! The pose has grandeur; her perplexity, her pain are strongly expressed; she's conceived in the grand manner; this is real flesh, these are beautiful colors, and there are many truths of nature spread over the neck and throat, on the knees; her legs, her thighs, all her undulating limbs could hardly have been better disposed; there's a grace that doesn't preclude nobility, a variety that's free of artificial contrast. The part of the figure in shadow is most beautifully handled. The white material over her thighs reflects admirably onto the flesh, its bright mass doesn't destroy the effect: a magic that's difficult to achieve and that demonstrates both the painter's skill and the vigor of his color.

The old man to the left is seen in profile. His left leg is bent, and he seems to press his right knee against Susanna's thigh. His left hand pulls at the cloth covering her thighs, and his right hand invites Susanna to yield. This old man somewhat resembles Henry IV. Such a facial characterization is well chosen, but it should have been joined to more movement, more action, more desire, more expression. This is a cold, heavy-handed figure that offers only a large, stiff, uniform garment without folds, beneath which nothing is discernible: it's a sack from which a head and two arms protrude. Certainly drapery should be handled amply, but not like this.

The other old man is standing and almost faces us directly. With his left hand he has pulled away all the material that hid Susanna from his view; he still holds this material to one side. His right hand and arm extend in front of the woman in a menacing gesture; likewise his facial expression. This one is even colder than the other: cover up the rest of the canvas, and this figure will strike you as a Pharisee putting some difficult question to Jesus Christ.

Greater warmth, greater violence, greater passion in the old men would have considerably increased the interest of this beautiful, innocent woman, completely at the mercy of two old villains; consequently, she herself would have expressed greater terror and intensity, for everything is interrelated. Passions on the canvas complement or clash with one another like colors. The whole manifests a harmony of feeling as surely as it does one of colors. If the old men had been presented as more insistent, the painter would have sensed that the woman should seem more frightened, and soon the intensity of her heavenward gaze would have increased.

One sees to the right a structure made of greyish stone; apparently it's a reservoir, a bathing place; in the foreground is a pool from which spouts a paltry little jet of water, in very poor taste, breaking the silence. If the old men had manifested the most intense determination imaginable and Susanna a corresponding terror, the noise of a flow of water forcefully launched into the air might have seemed an appropriate accessory.

Even with these flaws, Van Loo's composition is a beautiful thing. There's scarcely any earlier painter who hasn't been struck by this subject and attempted to paint it, and I'd wager that Van Loo's would hold its own among all these works. Some suggest the Susanna is overly academic. Do they mean that her pose is a bit studied, that as a result her movements are a bit too harmonious for such a violent situation? Or rather that sometimes the model is so well posed that this study posture can be successfully applied to the canvas, even though retaining traces of its origin? If the action of the old men were more violent, the Susanna could have taken on a truer, more natural cast. But I'm content with her just as she is, and if I were unfortunate enough to live in a palace, I might well try to get this work into my gallery to represent the artist's production.

An Italian painter composed this subject with great ingenuity. He put both the old men to one side. The Susanna holds up all her clothing to this side, blocking the old men's view but making herself completely visible to the eyes of the spectator. This composition takes considerable liberties, but no one is offended by it; the underlying intention saves the day, and the spectator is never in doubt about the subject.

Since I've seen this *Susanna* by Van Loo I'm no longer interested in the one owned by Baron Holbach,[18] and it's by Bourdon.

18 Paul–Henri Dietrich, known as the Baron d'Holbach (1723–89). French *philosophe* and author; a close friend of Diderot. He is perhaps best known for his materialist *Système de la nature* (1770).

4. *The Suppliant Arts* (Pl. 4)
Allegorical painting
Property of M. de Marigny

The afflicted Arts implore Destiny to spare Madame de Pompadour,[19] who was in fact their protectress. She was fond of Carle Van Loo; she was Cochin's benefactress.[20] The cameo-maker Guay[21] kept a bow-drill in her rooms. Happy the nation in which she restrained herself from distracting the sovereign with amusements and commissioned paintings and statues! In the lower right of the canvas one sees Painting, Sculpture, Architecture, Music, each of these fine arts identifiable by her clothing, her head, and her attributes, almost all of them kneeling with their arms lifted towards the upper left, where the painter has placed Destiny and the three Fates. Destiny leans on the World; the Book of Mortality is to his left, while on his right is the urn from which he draws in determining individuals' luck. One of the Fates holds the distaff, another is spinning, the third is about to cut the thread of life so dear to the Arts, but Destiny stays her hand.

This is a very precious work; it couldn't be more highly finished; beautiful postures, beautiful characterizations, beautiful drapery, beautiful passions, handsome color, and a composition that couldn't be bettered. Painting should stand out among the other arts, and she does so here: the most violent alarm registers on her face, she lurches forward, her mouth falls open, she cries out. The Fates are ravishingly conceived; their action and postures are totally natural. Neither the accuracy of the draftsmanship, nor the overall arrangement, nor the truth of the whole leave anything to be desired. The handling is spirited and fresh throughout. Difficult judges maintain the unmodulated color of the figures diminishes the overall harmony. The only objection I'd add, if I dared, is that the group of Destiny and the Fates, instead of receding, seems to advance forward; the laws of recession are not observed. They also claim the area below the Fates is a bit overworked. That could be. What struck me about these figures is the excellent taste with which they're drawn. Perhaps Vernet would insist that the clouds on which

19 Jeanne-Antoinette Lenormand d'Etiolles, Marquise de Pompadour (1721–64). In 1745 she became the official mistress of Louis XV; the king's ardor cooled a few years later, but she remained on intimate terms with him as friend, companion, and confidante until her death. She was very actively involved in artistic affairs.

20 Charles-Nicolas Cochin; notes on artists who exhibited work in the 1765 Salon, as did Cochin, are to be found below, where Diderot discusses their submissions.

21 Jacques Guay (ca. 1715–87). He taught Madame de Pompadour the rudiments of precious-stones carving.

they're seated should be more aerial; but who can make skies and clouds to suit Vernet, aside from Nature or God? A sombre reddish glow emerges from beneath the clothing and feet of the Fate with the scissors, which evokes a scene accompanied by the sound of thunder and the cries of the disconsolate Arts. At the left of the painting, below the Fates, one sees a crowd of stricken, devastated, prostrate figures; it's Engraving with her students.

This is beautiful, very beautiful, and everywhere the color tonalities could not be more expertly blended and more suave. It's the work an artist would choose to take away from the Salon if he had his pick, but we'd prefer another, you and I, because the subject is cold and because there's nothing in it that speaks directly to the soul. Cochin, I consent to your taking Van Loo's allegory, but leave Greuze's *Girl Crying* for me. While you remain transfixed by the artist's skill, the ingenious effects of his art, I'll speak to my little afflicted girl, I'll console her, I'll kiss her hands, I'll dry her tears, and when I've left her I'll devise a few sweet verses about the death of her bird.

Van Loo's Suppliants obtained nothing favorable to France or the Arts from Destiny; Madame de Pompadour died at the moment in which it was believed she'd escaped harm. And what now remains of this woman who used up our men and our monies, left us devoid of honor and energy, and unsettled the entire European political system? The treaty of Versailles which will last a while, the *Cupid* by Bouchardon which will be forever admired, a few engraved stones by Guay which will astonish antiquarians of the future, a handsome little painting by Van Loo which will sometimes be looked at; and a fistfull of ashes.

5. *Oil Sketches for the Chapel of Saint Gregory in the Invalides*

If Carle had left only these oil sketches they'd exalt him to the highest rank among painters. But why did he call them sketches? They're highly colored, they're paintings, and beautiful paintings that have something more due to a hand that was failing as it executed them, compounding their admirable qualities with a quality that's profoundly touching.

There are seven of them. The saint sells his goods and distributes the earnings to the poor. He succeeds in stopping the plague with his prayers. He converts a woman heretic. He refuses the papacy. He receives the homage of his priests. He dictates his homilies to a secretary. He ascends into heaven.

The first. One sees the saint to the left, on the stairs of a peristyle; an assistant is behind him. On the ground, in the foreground, is a

poor mother grouped with her two children. How touching she is, this mother! How well this little girl begs the saint's charity! Look at the avidity with which the little boy consumes his bit of bread, and the interest with which these figures observe the more central portion of the subject! A crowd of other beggars is scattered around the balustrade, turning towards the back; it's a mass in shadow against a well lit ground. A light penetrating through an arcade illuminates the scene, establishing the sweetest of harmonies. This is the way to paint mendicity, to make it interesting without making it hideous, to find a permissible compromise between overly opulent and tattered clothing; this is the sort of beauty appropriate to men, women, and children who've suffered from hunger and lacked the wherewithal to satisfy the most basic of life's needs. It's difficult to keep to such a fine line. A beautiful thing, my friend! Beautiful in its characterization, expression, and composition.

The second. The barefoot saint walks through the streets imploring the heavens to stop the plague. He is followed and preceded by his priests. A group of acolytes dressed in white makes a luminous focal point in the center. The procession moves from left to right towards a house of worship; the saint and his assistant call a halt to the advancing clergy. The saint turns his eyes heavenward. He's dressed in a deacon's robes; a sweet clarity emanating from his head sets him apart, as do, even more, his simplicity, his nobility, and his piety. But how beautiful are all these young acolytes! How these burning torches instil terror! How a single incident proves sufficient for genius to represent the desolation of an entire city! All he needs is a young girl who, supporting a dying old man, exhorts him not to lose hope. The saint's gesture has attracted the attention of this group. What defiance in this dying man! What confidence in this young girl! A beautiful thing, my friend! A beautiful thing! A stormy sky through which light begins to break seems to announce the scourge's imminent end.

In the third, the saint, dressed in white, stops one of his ears and waves away the envoy of the clergy come to offer him the papal tiara. It's clear the saint, retired beneath a vault, had been praying when the envoy arrived, for he's bent over and his hand still touches the masonry on which he leaned in standing up. How simple this is! How well he refuses! How completely he's penetrated by his own inadequacy! This is not the hypocritical "nolo episcopari"[22] of our little priests. The advance of age has been indicated without compromising the likeness. A beautiful thing, my friend! And the

22 "I don't want to be Bishop."

effect of this bright cloud in the background and this dark precinct in the foreground, who could resist it?

In the fourth he's shown to us wearing the papal tiara, the pontifical staff in his hand, seated on the throne of Saint Peter dressed in religious vestments. He extends his arm, blessing the prostrate clergy. The scene unfolded just like this, I'm sure of it. The good saint must have had this venerable, sweet character, the priests must have prostrated themselves just like this. This assisting cardinal was to his left; these other prelates were to his right. He was underneath a baldachin; the baldachin's shadow covered him and his darkened figure stood out against this greyish architecture. The postures of these figures registered no greater contrast than was appropriate to their actions. Look at this scene, and tell me if there's a single element in it that rings false. The facial characterizations derive from ordinary, everyday life, I've seen them a hundred times in our churches. They make up a crowd, but one without confusion. The expressions and backs are all convincing. Here's the head appropriate for the common father of the faithful. And this corpulent assistant, so well fed, visible in the foreground below the throne, what do you make of him? Doesn't he remind you of our old, handsome, good friend Cardinal Polignac? Not at all; the latter would have been an ideal subject for a bust or portrait in our own day; but cruder, Gothic times demand greater simplicity and less nobility. Shall I tell you a truth? These regular, noble, imposing faces are as harmful in a historical composition as a large, handsome tree that's quite straight, quite rounded—whose trunk rises relentlessly, whose bark is free of cracks, crevasses, and chinks, and whose identical branches extend in every direction, so as to form a perfectly regular crown—would be in a landscape painting. They're too monotonous, too symmetrical. Circle around this tree, it presents nothing new, one's seen everything there is to see from a single point of view. From every side it's the very image of happiness and prosperity; there's not a trace of idiosyncrasy in either this handsome face or this handsome tree. How attentive is the cardinal in this sketch! How focused his gaze! How handsome his body! How beautiful his posture! How simple and natural it is! He didn't take this down at the Academy. And then the interest and the action cohere; all points of the canvas say the same thing, though in different ways. A beautiful thing, my friend! A beautiful thing!

But have you heard the story that someone wanted to buy these sketches, that the ministry offered a hundred louis?—For each one? —No, my friend, for the whole set, yes, all of them, in other words the price of a single one, which is about half what it cost the artist to make his preliminary studies. Even their most ordinary

portions are magnificent. His heirs bought them at the estate sale for six or seven thousand livres. Some day they'll be considered the equals of Poussin's *Family of Lycomedes* and Pigalle's *Mercury*.

It's surprising that, despite all the efforts made here to snuff out the sciences, the arts, and philosophy, this never happens. Which confirms the view that even if sacks of gold were to be emptied at the feet of a genius nothing would come of it, because it's not gold he wants as compensation; it's his vanity he wants to satisfy, not his avarice. Reduce him to sleeping in a garret on a pile of straw, allow him only water to drink and bread to eat, you'll irritate him, but you won't snuff him out. Nowhere on earth will he receive the tribute of esteem more rapidly, more lavishly than here. The ministry will tread him down, but the nation will praise him to the skies. Genius works in a constant state of rage and hunger.

In the fifth, Saint Gregory celebrates Mass. The pontifical throne is to the right in the preceding one, in this one the altar is to the left. One sees the radiant, luminous bread of the Eucharist in the saint's hands. The heretical woman, kneeling on the altar steps, observes the miracle with surprise. Below this woman the painter has placed priests and assistants. The same praise as in the earlier ones, the same exclamations. Composition rich without confusion.

The sixth is, in my view, the most beautiful one. Yet there are only two figures, the saint dictating his homilies and his secretary writing them down. The saint is seated, his elbow resting on the table; he wears surplice and stole, the biretta on his head. And what a beautiful head it is! One scarcely knows whether to focus one's eyes on it or on the posture of the secretary, so simple, true, and natural; one moves from one to the other of these figures, and always with the same pleasure. The naturalness, truth, solitude, and silence of this study, the soft, tender light illuminating it in a way that's perfectly appropriate to the scene, the action, and the figures, that, my friend, is what makes this composition sublime, things that Boucher will never understand. This sketch is surprising. But tell me where this lout of a Van Loo found this, for he was a lout, he was incapable of thinking, speaking, writing, or reading. Beware those people whose pockets overflow with intelligence and who scatter it about on the slightest pretext. They don't have the demon; they're not sad, sombre, melancholy, and taciturn; they're never awkward or stupid. The finch, the lark, the linnet, and the canary chatter and babble all day long; when the sun sets they poke their heads under their wings and go right to sleep. But this is when the genius takes up his lamp and lights it, when the solitary bird, wild, untameable, his plumage dull and brown, opens his throat, begins his song, making the wood resound, melodiously piercing the silence and gloom of the night.

In the seventh, one sees the saint with his hands clasped together and his eyes turned towards the heavens, into which he is lifted by a host of angels; there are at least seven or eight of them, grouped in the boldest, most truthful way. A brilliant glory pierces the dome to reveal the eternal abode; the angels and the saint cohere into a single mass, but a mass in which everything is rendered distinguishable by variety and accidental effects of light and color. One sees the saint and his cortège advance and rise vertically. This is not the least successful of the sketches. The others are a bit drab, as is only proper for sketches; this one is highly colored.

The time spent by Van Loo in the studio of the sculptor Legros[23] wasn't wasted on the painter, above all when he found himself charged with executing aerial works such as this, in which truth can be captured only with difficulty, by sheer imaginative force, and in which the brush proves resistant to depicting even the clearest and most carefully conceived of ideal images. Carle made a model for this machine,[24] studying its lighting, foreshortening, and overall effect suspended in the air. On discovering a point of view he preferred, he stopped and reoriented his composition so as to make it livelier, more vigorous and picturesque.

Ah, Monsieur Doyen, what a challenge these sketches have set you![25] I have an appointment with you at the next Salon. Despite everything you've done since your Diomedes, your Bacchantes, and your Virginia to belie the good opinion I had of your gifts; though I know you pride yourself on your wit, the worst of all qualities in a great artist; that you frequent fashionable, brilliant company and cut a rather brilliant figure yourself, I still hold you in esteem, but nonetheless I think you'd do well to thank anyone who burned Van Loo's sketches, though I know such thanks would never be forthcoming because you're presumptious and vain, another troubling symptom.

23 Pierre II Legros (1666–1719), with whom Carle Van Loo studied during his Roman sojourn (ca. 1712–13).

24 The word *machine* was used by French contemporaries to describe large and/or ambitious history paintings; the usage was coined to evoke the complexity of their pictorial mechanics.

25 Gabriel-François Doyen (1726–1806). Student of Carle Van Loo. Granted provisional membership in the Royal Academy on August 5, 1758; received as a full academician August 23, 1759. In the wake of Carle Van Loo's death, he was charged with executing the Saint Gregory cycle in the Invalides. The other three paintings evoked by Diderot are *The Death of Virginia* (1759 Salon), *A Festival in the Garden of the Gods* (1759 Salon) and *Venus Wounded by Diomedes* (1761 Salon). Doyen did not exhibit in the 1765 Salon.

6. *A Vestal Virgin*

Why is it that these figures of vestal virgins almost always give
pleasure? Because they're premised on youth, grace, modesty, inno-
cence, and dignity; because, in addition to these qualities deriving
from antique models, we associate them with accessory ideas of
temples, altars, meditation, retreat, and the sacred; because their
loose white mantles, with their ample folds, which leave nothing
visible but hands and heads, are in excellent taste; because these
mantles or veils falling over their faces, hiding portions of them, are
original and picturesque; because vestal virgins are beings that are
simultaneously historical, poetic, and moral.

This one is fitted out with a veil; she carries a basket of flowers.
She faces us directly; she has all the charms following from her
circumstances. To right and left, two ringlets of black hair slip from
beneath her veil: these parallel locks are unfortunate: they make her
neck seem too small, especially from a certain distance.

7. *Study of an Angel's Head*

It's vigorously painted, this head. It looks heavenward; but one is
tempted to find its forehead too short for its volume and for the
considerable extent of the lower face. Close up, let's be frank, it
seems a bit limp and graceless. It remains to be seen whether, if
intended for a cupola one or two hundred feet in the air, a judg-
ment made from four feet away will hold up.

That's all that Carle Van Loo left behind for us. He was born on
February 15, 1705 in Nice, in Provence. The following year Marshal
Berwick laid siege to that city. The child was taken into a cellar. A
bomb fell on the house, went right through the ceilings, consumed
the cradle, but the infant was no longer there, he'd been taken away
by his young brother. Benedetto Luti[24] instructed Jean and Carle
Van Loo in the first principles of art. The latter became acquainted
with the sculptor Legros and became interested in sculpture. Legros
died in 1719, and Carle abandoned the chisel for the brush. His taste
manifested itself very early in his fiery temperament. His brother
Jean, more tranquil, ceaselessly preached to him about prudence and
rigor. They worked together, but Carle left Jean to become a set
designer at the opera. If he took a dislike to this wretched genre, it
was to take up little portrait drawings, a genre more wretched still.
These were the errors of a young man madly in love with pleasure
for whom the quickest ways to obtain money were the best. In

26 Benedetto Luti (1666–1724).

1727 he travelled to Rome with Louis and François Van Loo, his nephews. In Rome he won the prize for drawing. He was admitted to the pension.[27] His gifts were recognized. Foreigners sought out his work; for England he painted an oriental woman at her toilette with a bracelet on her ankle, a singular touch that made the work famous. From Rome he proceeded to Turin. He decorated churches, he embellished palaces, and the compositions of the finest masters didn't eclipse his own. He appeared in Paris with the daughter of the musician Somis, whom he'd married. He coveted admission into the Academy, and obtained it. He rapidly became adjunct professor, professor, recipient of the ribbon of Saint Michel, first painter to the king, director of the school. This is how talent should be encouraged. Among his cabinet pictures, a *Resurrection*, his *Allegory of the Fates*, his *Spanish Conversation*, and an *Instrumental Concert* are especially admired. Of his public paintings, his *San Carlo Borromeo Administering Communion to the Plague-Stricken* and his *Saint Augustine Preaching* are held to be particularly distinguished. Carle drew easily, rapidly, and in an imposing idiom. His handling was free; his coloring vigorous and skillful; much technique, little of the ideal. He was rarely pleased with his works, and often those he destroyed were his best. He didn't know how to read or write. He was born a painter as one is born an apostle. He didn't turn up his nose at the advice of his students, whose sincerity he sometimes rewarded with a slap or a kick, but a moment later both the artist's liberty and the flaw in the work were repaired. He died July 15, 1765, from a brain hemorrhage, so it's said, and I'll not contest this as long as it's conceded that the limp *Three Graces* he exhibited at the previous Salon accelerated his end. If he'd survived this first version, the last one he painted would have done the trick. His death is a real loss for Doyen and Lagrenée.

MICHEL VAN LOO[28]

The most remarkable of his portraits at the Salon was the one of Carle, his uncle. It was hung on the wall with the best light. Above

27 That is, he won the *grand prix* and was sent to the French Academy in Rome.

28 Louis-Michel Van Loo (1707–71), nephew of Carle Van Loo. Student of his father Jean-Baptiste Van Loo. Received as a full Royal Academician on April 25, 1733. He spent fifteen years in Spain, where he was named first painter to the king in 1744. He returned to Paris in 1752, where until his death he pursued a prolific career as a portraitist.

it one saw the *Susanna*, the *Augustus*, and the *Three Graces*; to either
side of it, oil sketches; below it, angels that seemed to carry not only
Saint Gregory to heaven but the painter as well. Lower still, a short
distance away, the *Vestal Virgin* and the *Suppliant Arts*. This was a
mausoleum that Chardin had devised to honor his colleague. Carle,
in dressing gown and studio cap, his body in profile, his head facing
us directly, emerged from the midst of his own works. It's said to be
an astonishing likeness; his widow can't look at it without shedding
tears. The touch is vigorous; it's painted grandly, though it's a bit
too red. In general Michel's male portraits are amply handled and
well drawn; his women, however, are something else again. He's
heavy-handed, he's without tonal finesse, he aims at Drouais' chalki-
ness. Michel is a bit cold; Drouais is completely false. When one
examines all these dreary faces lining the walls of the Salon, one
cries out: La Tour, La Tour, "ubi es?"[29]

BOUCHER[30]

I don't know what to say about this man. Degradation of taste,
color, composition, character, expression, and drawing have kept
pace with moral depravity. What can we expect this artist to throw
onto the canvas? What he has in his imagination. And what can be
in the imagination of a man who spends his life with prostitutes of
the basest kind? The grace of his shepherdesses is the grace of
Madame Favart in *Rose and Colas*;[31] that of his goddesses is borrowed
from La Deschamps.[32] I defy you to find a single blade of grass in

29 "Where art thou?" Diderot here invokes Maurice-Quentin de La Tour (1704–88),
 the great contemporary master of the highly finished pastel portrait, who did not
 exhibit at the 1765 Salon. The Drouais in question is François-Hubert Drouais
 (1727–75), whose submissions to the Salon are discussed below.
30 François Boucher (1703–70). Student of François Lemoyne. Granted provisional
 membership in the Royal Academy on November 24, 1731; received as a full
 academician on January 30, 1734. He bacame fashionable soon after his return from
 Italy (1731), his fluent handling and erotic imagery being perfectly attuned to the
 tastes of a certain prosperous clientele (he became Madame de Pompadour's favorite
 painter and was named first painter to the king in 1765).
31 Marie Benoîte Duronceray, known as Madame Favart (1727–72), was a con-
 temporary actress. *Rose et Colas*, a one-act comedy by Sedaine with music by
 Monsigny, was first performed in March of 1764.
32 Deschamps was the pseudonym adopted by Anne-Marie Pagès, an actress and
 celebrated courtesan of the day.

any of his landscapes. And then there's such a confusion of objects piled one on top of the other, so poorly disposed, so motley, that we're dealing not so much with the pictures of a rational being as with the dreams of a madman. It's of him that it was written:

velut aegri somnia, vanae
fingentur species, ut nec pes, nec caput[33]

I'd say this man has no conception of true grace; I'd say he's never encountered truth; I'd say the ideas of delicacy, forthrightness, innocence, and simplicity have become almost foreign to him; I'd say he's never for a single instant seen nature, at least not the one made to interest my soul, yours, that of a well-born child, that of a sensitive woman; I'd say he's without taste. Of the infinite number of proofs I could provide to support this, a single one will suffice: in all the multitude of male and female figures he's painted, I defy anyone to find four that would be suitable for treatment in relief, much less as free-standing sculpture. There are too many little pinched faces, too much mannerism and affectation for an austere art. He can show me all the clouds he likes, I'll always see in them the rouge, the beauty spots, the powder puffs, and all the little vials of the make-up table. Do you think he's ever had anything in his head as straightforward and charming as this image from Petrarch,

E'l riso, e'l canto, e'l parlar dolce, humano?[34]

Those subtle, refined analogies that summon objects onto the canvas and bind them together by means of imperceptible threads, my God, he hasn't the vaguest notion of them. He's the most mortal enemy of silence known to me. He makes the prettiest marionettes in the world; he'll end up an illuminator. Well, my friend, it's at precisely the moment Boucher has ceased to be an artist that he's appointed first painter to the king. Don't get it into your head that he's to his genre as Crébillon the younger[35] is to his; their morals are largely the same, but the writer is far more gifted than the painter. The only advantage the latter has over the former is an inexhaustible fecundity, an incredible facility, especially in the accessories of his pastorals. When he does children he groups them well, but they're

33 "Only idle fancies, without motivation, like the dreams of a sick person; in which neither feet, nor head [may be assigned to a single shape]": Horace, Ars Poetica, vv. 7–8.

34 "And the laughter, and the song, and the sweet discourse of humankind: Petrarch, Canzoniere, sonnet CCXLIX."

35 Claude Prosper Jolyot de Crébillon (1707–77). French writer specializing in salacious fiction set in the beau monde; author of Les Égarements du coeur et de l'esprit (1736–8) and Le Sofa (1742).

best left to frolic on their clouds. In the whole of this numberless family you won't find a single one capable of the real activities of life, of studying his lesson, of reading, writing, or scutching hemp; they're fictive, ideal creatures, little bastards of Bacchus and Silenus. Such children are perfectly suited to sculptural treatment around antique vases; they're chubby, fleshy, plump. They'd give the artist an ideal occasion to show us whether he can sculpt marble. In a word, take all this man's paintings, and you'll have difficulty finding a single one before which one couldn't say, like Fontenelle[36] to the sonata: Sonata, what do you want from me? Painting, what do you want from me? There was a time when he couldn't stop making Virgins. And what were these Virgins? Precious little flirts. And his angels? Wanton little satyrs. And then in his landscapes there's a drabness of color and uniformity of tone such that, from two feet away, his canvas can be mistaken for a strip of lawn or bed of parsley cut into a rectangle. But he's no fool, he's a false good painter, like there are false wits. He doesn't command the wisdom of art, only its *concetti*.

8. *Jupiter Transformed into Diana to Surprise Callisto*
Oval painting

Jupiter transformed is in the center. He's in profile; he leans over Callisto's knees. With one hand, his right, he tries gently to push aside her clothing; with his left he caresses her chin: here are two hands with plenty to do! Callisto is painted facing us; she weakly resists the hand trying to undress her. Below this figure the painter has spread out drapery, a quiver. Trees fill out the background. To the left is a group of children playing in the air; above this group, the eagle of Jupiter.

Do the figures of mythology have hands and feet different from ours? Ah! Lagrenée, what would you have me think of this, when I see you right beside it, and am struck by your firm color, by the beauty of your flesh and by the truths of nature that emanate from every point of your composition? Feet, hands, arms, shoulders, a throat, a neck, if you must have them as you've kissed them on occasion, Lagrenée will provide them for you; Boucher, no. Having reached fifty, my friend, scarcely any painter works from the model, they work by rote, and this goes for Boucher. Hackneyed figures turned this way and that. Hasn't he already shown us this Callisto, and this Jupiter, and this tiger's skin covering him a hundred times?

36 Bernard Le Bovier de Fontenelle (1657–1757). French author, poet, and playwright.

9. *Angelica and Medoro*
Oval painting

The two main figures are placed at the viewer's right. Angelica reclines casually on the ground and is seen from the back, except for a small portion of her face that's visible and that makes her seem in a bad mood. On the same side but further back stands Medoro, facing us, his body hunched over, his hand moving towards the trunk of a tree on which he's apparently about to carve the two verses by Quinault, set to music so well by Lully, verses that provide an occasion for Roland to display all his goodness of soul and for me to weep as others laugh:

> Angelica engages her heart,
> Medoro is its conqueror.[37]

Cupids are busy ringing the tree with garlands. Medoro is half covered with a tiger skin, and his left hand holds a hunting spear. Beneath Angelica imagine drapery, a cushion, a cushion, my friend! which is as appropriate here as the carpet of La Fontaine's Niçaise;[38] a quiver and flowers; on the ground, a large cupid stretched out on his back and two others playing in the air, in the vicinity of the tree to which Medoro confides his happiness; and then at left some landscape and trees.

It has pleased the painter to call this *Angelica and Medoro*, but that's the only pleasing thing about it. I defy anyone to show me anything in the scene that designates these characters. And my God! One need only have let the poet lead the way. How much more beautiful, grand, picturesque, and appropriate is the setting he provided for his adventure! It's a rustic lair, a remote spot, the abode of shadow and silence. It's there that, far from all distraction, a lover can be made happy, not in full daylight in the middle of the countryside, on a cushion. It's on the moss of a rock that Medoro inscribes his name and Angelica's.

This defies common sense; a little bedroom composition. And then neither feet, nor hands, nor truth, nor color, and always the same parsley trees. Look or rather don't look at the Medoro, especially his legs; they're the work of a little boy without taste or instruction. The Angelica is a little strumpet. What an ugly word! Very well, but I call it as he paints it. Drawing curvaceous, limp, and

37 "Angélique engage son coeur, / Médor en est vainqueur": from the opera *Roland Furieux* (1685), by P. Quinault and J.-B. Lully.

38 Jean de La Fontaine (1621–95). French poet; author of *Contes et Nouvelles* (1665) and *Fables* (1668; 1678; 1694). "Niçaise" is a reference to the eponymous heroine of one of the tales in the first of these collections.

flesh slack. This man takes up the brush only to show me breasts and buttocks. I'm happy enough to see them, but I don't like it when they're so brazenly touted.

10. *Two Pastorals*

So, my friend, you still haven't understood? In the center of the canvas a shepherdess, Catinon,[39] in a little hat leading a donkey; only the head and back of the animal are visible. On the donkey's back, clothing, baggage, a cauldron. The woman holds the animal's halter in her left hand, in the other she carries a basket of flowers. Her eyes are fixed on a shepherd seated to the right. This great snatcher of blackbirds is on the ground, a cage is on his knees, on the cage are some small birds. Behind this shepherd, further back, stands a little peasant boy who holds out grass to the little birds. Below the shepherd, his dog. Above the little peasant boy, still further back, a structure of stone, plaster, and joists, a kind of sheepfold plunked down there one knows not how. Around the donkey some sheep. Towards the left, behind the sheepfold, a rustic barricade, a stream, a few trees, some landscape. At the bottom, in the foreground, to the far left, a goat and more sheep; and all of this gratuitously pell-mell. It's the best lesson one could give a young student in the art of destroying an effect by dint of objects and despite hard work.

I tell you nothing of color and character, nor of other details; it's just like the preceding. My friend, isn't there any oversight mechanism in this Academy? Lacking a commissioner of paintings who'd reject this entry, wouldn't it be permissible to propel it with kicks the length of the Salon and onto the stairs, into the courtyard, until the shepherd, the shepherdess, the sheepfold, the donkey, the birds, the cage, the trees, the child, the whole pastoral was in the street? Alas, no! It has to remain in place; but indignant good taste will treat it no less brutally, though justly, for that.

11. *Another Pastoral* (Pl. 5)
Same format and same value as the preceding

Do you think, my friend, that my brutal taste will be more indulgent for this one? Not at all. I hear it declaiming inside me: Out of the Salon, out of the Salon. I try to insist on Chardin's lesson: Go

39 Mademoiselle Foulquier, an actress renowned for her performance in *Supplément de la Soirée des Boulevards*, an *opéra comique* by Charles Favart.

easy, go easy . . . but it becomes more irritated and cries out still louder: Out of the Salon.

This is an image of delirium. In the right foreground, again the shepherdess Catinon or Favart reclining and asleep, with a serious inflammation in her left eye; why go to sleep in so damp a spot? A little cat in her lap. Behind this woman, beginning at the edge of the canvas and receding at successive levels of depth, turnips and cabbages and leeks, and a clay pot and a syringa in this pot, and a large block of stone, and on this large block of stone a large vase with garlands of flowers, and trees and greenery and landscape. Facing the sleeping woman, a standing shepherd who contemplates her; he's separated from her by a little rustic barricade. In one hand he carries a basket of flowers, in the other he holds a rose. There, my friend, tell me what a kitten is doing in the lap of a peasant girl who's not sleeping at the door of her cottage? And this rose in the peasant's hand, isn't it unbelievably banal? And why doesn't this booby bend over, why doesn't he kiss, or prepare to kiss, this mouth that's presented to him? Why doesn't he approach her gently? But you think this is all it has pleased the painter to throw down on his canvas? Isn't there another landscape beyond? Doesn't one see smoke rising behind the trees, apparently from a neighboring cottage?

A wretched little picture in the collection of Philippe d'Orléans in which one sees the two prettiest, most innocent little children possible provoking with their fingers a sparrow in front of them repays attention, accords greater pleasure than all this; it's because one sees from the little girl's expression that she's playing maliciously with the bird.

Same confusion of objects and same falseness of color as in the preceding. What an abuse of painterly facility!

12. *Four Pastorals* (Pl. 6)
Two are in an oval format

I am just, I am good, and I like nothing better than bestowing praise. These four works make up a charming little poem. Let it be recorded that once in his life the painter knew a moment of reason. A shepherd ties a letter to the neck of a pigeon; the pigeon flies away. A shepherdess receives the letter, she reads it to one of her friends; it's an invitation to a rendezvous. She appears there, as does the shepherd.

To the viewer's left, the shepherd is seated on a bit of rock. He has the pigeon on his knees, he's tying on the letter. His crook and his dog are behind him; at his feet is a basket of flowers intended,

perhaps, for his shepherdess. Further left, a few outcroppings of
rock. To the right, greenery, a stream, sheep. Everything is simple
and sensible; all that's missing is color.

2. One sees the courier pigeon, the ornithological Mercury,
arriving at the left; it advances at full speed. The standing shepherd-
ess, her hand pressed against a tree in front of her, sees it through
the foliage and stares fixedly at it; she's the very picture of
impatience and desire. Her posture, her action are simple, natural,
interesting, elegant; and the dog that sees the bird arriving, that
rises on its hind feet on a little promontory, that points its head
towards the messenger, that barks joyfully and seems to wag its
tail, is wittily conceived: the animal's action signals an amorous
exchange that's been going on for some time. To the right, behind
the shepherdess, one sees her distaff on the ground, a basket of
flowers, a little hat and a shawl; at her feet a sheep. Even simpler
and better composed; all that's missing is color. The subject is so
clearly conveyed that the painter's inclusion of these details cannot
obscure it.

3. To the right one sees two young girls, one in the foreground
reading the letter, her companion immediately behind her. The first
turns her back, which is unfortunate, for her face could easily have
conveyed her action; it's her companion who should have been so
disposed. The disclosure is made in a solitary, isolated spot, at the
foot of a rustic stone building from which flows a fountain, above
which is a small Cupid in relief. To the left, goats and sheep.

This is less interesting than the preceding one, and it's the artist's
fault. This should have been the spot of the rendezvous; it's the
fountain of love. The color still rings false.

4. The rendezvous. In the center, towards the viewer's right, the
shepherdess seated on the ground, a sheep beside her, a lamb on her
knees. Her shepherd gently embraces her and looks at her lovingly.
Above the shepherd, his dog tied up; very good. To the left a basket
of flowers. To the right, a shattered, broken tree; also very good. In
the background, cottage, shed, a bit of a house. The letter should
have been read here, and the rendezvous placed at the fountain of
love.

However that may be, the whole is refined, delicate clearly
thought through; these are four little eclogues in the spirit of
Fontenelle. Perhaps the manners of Theocritus or those of Daphnis
and Chloe, simpler, more naive, would have held greater interest
for me. My shepherd and shepherdess would have done everything
that these do, but they wouldn't have been able to anticipate the
outcome, whereas these know exactly what will happen in
advance, which I find irritating, given that it's not handled with
candor.

13. *Another Pastoral*

This is a standing shepherdess who holds a crown in one hand and carries a basket of flowers in the other; she has stopped in front of a shepherd seated on the ground, his dog at his feet. What does this mean? Nothing. Behind, at the far left, some leafy trees towards the tops of which, one can't quite make out how, is a fountain, a round hole from which water is flowing. Apparently these trees hide a rock, but why obscure it? I'm easily placated; without the four preceding works, I'd easily have been capable of saying of this one: Out of the Salon; but in the end I'll let it pass.

14. *Another Pastoral*
Oval painting

Will I never be done with these cursed pastorals? This one's a girl who ties a letter around a pigeon's neck; she's seated, we see her in profile. The pigeon is on her knees, it's made for the part, it cooperates, as can be seen from its suspended wing. The bird, the hands of the shepherdess and her lap are encumbered with an entire rosebush. Tell me, I beg you, if it isn't a jealous rival out to ruin this little composition who's put this shrub here? One must be one's own worst enemy to sabotage one's own work like this.

The catalogue also mentions a *Landscape with a Water Mill*. I looked for it but never found it; I doubt you've missed much.

HALLÉ[40]

15. *The Emperor Trajan, Departing on a Military Expedition in a Great Hurry, Dismounts from his Horse to Hear a Poor Woman's Complaints*
Large painting intended for Choisy

Trajan occupies the center foreground of the picture. He looks, he listens to a kneeling woman, some distance away from him between

40 Noël Hallé (1711–81). Student of his father Claude-Guy Hallé and his brother-in-law Jean Restout. Granted provisional membership in the Royal Academy on June 30, 1746; received as a full academician on May 31, 1748.

two children. Beside the emperor, further back, a soldier restrains his rearing horse by its bridle; this horse isn't at all like the one required by Father Canaye and of which he said: "Qualem me decet esse mansuetum."[41] Behind the suppliant is another standing woman. Towards the right, in the background, the suggestion of a few soldiers.

Monsieur Hallé, your Trajan imitated from the antique is flat, without nobility, without expression, without character; he seems to say to this woman: Good woman, I see you're weary; I'd lend you my horse, but he's as temperamental as the devil . . . This horse is in effect the only remarkable figure in the scene; it's a poetic, gloomy, greyish horse such as a child might see in the clouds: the spots on its breast look just like a dappled sky. Trajan's legs are made of wood, as stiff as if a lining of steel or tin-plate were underneath the material. As a cape, he's been given a heavy garment of poorly dyed crimson wool. The woman, whose facial expression should set the pathetic tone for the scene, whose ample blue garment attracts the eye very well, is seen only from the back; I've identified her as a woman, but she might be a young man; on this point I must rely on her hair and the catalogue, for there's nothing about her that specifies her sex. And yet a woman bears no closer resemblance to a man from the back than from the front; there's a different hair style, different shoulders, a different lower back, different thighs, different legs, different feet; and this large yellow carpet I see hanging from her belt like an apron, that folds under her knees and that I then find behind her, she'd apparently brought it along to avoid soiling her beautiful blue robe; but this voluminous piece of material could never figure as part of her clothing if she were standing up. And then nothing's finished in either the hands, or the arms, or the coiffure, it's suffering from the *plica polonica*.[42] The material covering her forearm seems like furrowed St-Leu stone. Trajan's side of the composition is without color; the sky, overly bright, makes the group seem as if in shadow and effectively wipes it out. But it's the arm and hand of this emperor that must be seen to be believed, the arm for its stiffness, the hand and thumb for their faulty draftsmanship. History painters regard these small details as mere trifles, they go after the grand effect; this rigorous imitation of nature, making them stop at each step of the way, would extinguish their fire, would snuff out their genius: Isn't this true, Monsieur Hallé? Such was not the view of Paolo Veronese, he took care with his flesh, his feet, his hands; but the futility of this has now been

41 Roughly, "I need a tame one." The Abbé Étienne de Canaye (1694–1782). A friend of Diderot and d'Alembert.

42 A contemporary name for an illness common in Poland, now unidentifiable.

recognized, and it's no longer customary to paint them, although it's still customary to have them. Do you know what this infant in the foreground rather closely resembles? A bunch of big gnarls; it's just that on his legs, undulating like snakes, they're a little more swollen than on his arms. This pot, this copper domestic vessel on which the other child leans, is such a peculiar color I had to be told what it was. The officers accompanying the emperor are every bit as ignoble as he is. These little bits of figures scattered about, do you really think they suggest the presence of an army? This picture's composition is completely lacking in consistency, it's nothing, absolutely nothing, neither in its color, which resembles the quintessence of dried grass, nor its expression, nor its characterizations, nor its drawing; it's a big enamel plaque, quite dreary and quite cold.

"But this subject was impossible." You're wrong, Monsieur Hallé, and I'm going to tell you how someone else would have handled it. He'd have placed Trajan in the center of the canvas. The main officers of his army would have surrounded him; each of their faces would have registered the impression made by the suppliant's speech. Look at how Poussin's *Esther* presents herself before Ahasuerus. What prevented you from having your woman, overwhelmed by her distress, similarly grouped with and sustained by female companions? You want her alone and on her knees? I consent to this; but my God, show me more than her back: backs aren't very expressive, whatever Madame Geoffrin[43] may say. Have her face convey the full extent of her pain; make her beautiful, with a nobility corresponding to that of her situation; make her gestures strong and moving. You clearly didn't know what to do with her two children; study the *Family of Darius*[44] (Pl. 8) and you'll learn how subordinate figures can be made to enhance the interest of the main ones. Why didn't you indicate the presence of an army with a crowd of heads pressed together beside the emperor? Then a few of these figures sliced by the edge of the canvas would have been sufficient to make me imagine the rest. And why, on the woman's side, are there no spectators, no witnesses to the scene? Was there no one, no relation, no friend, no neighbor, neither man, woman, nor child, curious about the outcome of her mission? Such, it seems to me, would have been the way to enrich your composition, which as it stands is sterile, insipid, and stripped down.

43 Madame Geoffrin was a well-known Parisian art lover and collector; she was notorious for meddling in the pictorial specifics of paintings being executed by her artist friends. She once commissioned a painting in which she was shown from the back.

44 *The Family of Darius before Alexander* (also known as *The Tent of Darius*: 1660–1, Versailles) by Charles Le Brun, one of the most celebrated paintings of the French seventeenth century.

16. *The Race of Hippomenes and Atalanta* (Pl. 7)
Very large painting

This composition is grand and quite beautiful; Monsieur Hallé, I congratulate you, my goodness, neither I nor anyone else expected this. Here's a picture, you've actually produced a real picture. Imagine a grand and spacious landscape, fresh as a spring morning; knolls decked out in new greenery, at different levels of depth, giving the scene both breadth and extent; at the foot of these knolls a plain; part of this plain separated from the rest by a long wooden railing. It's the area in front of this railing that is the site of the race. To the extreme right of this area picture fresh, verdant trees, their branches and shadows intermingling to form a natural bower. Raise up a platform beneath these trees, on this platform place the fathers, mothers, sisters, and judges of the dispute, shield them from the humidity of the trees or from the day's heat with a large canopy hanging from the branches of the trees. Picture in front of this platform, within the area of the race, a statue of Love on its pedestal; this marks the finish line. A large tree serendipitously placed at the other end of the space marks the competitors' starting point. Beyond the barrier scatter spectators of all ages, all sexes, variously concerned about the outcome, and you'll have Monsieur Hallé's composition before your eyes.

Only Hippomenes and Atalanta are in front of the railing. The race is quite advanced. Atalanta hastens to pick up a golden apple. Hippomenes still holds another one that he's preparing to drop: a few steps more and he'll have reached the finish.

Certainly there's considerable variety of posture and expression, among the judges as well as the spectators. Among the spectators placed beneath the tent one singles out a seated old man whose joy leaves no doubt that he's Hippomenes' father. The heads spread out along the far side of the railing are agreeably characterized. I admire this picture, very much. When I'm told it's a tapestry cartoon, I can see no more faults in it. Hippomenes is as nimble as can be, he runs with infinite grace; he rises up on the ball of his foot, one arm thrown forward, the other stretched out behind him; his waist, his posture, and all his person are elegant; joy and the certainty of triumph are in his eyes. Perhaps this race could be a bit more natural, perhaps it's closer to a dance at the opera than to a battle; perhaps when it's a question of winning or losing a person one loves, one runs differently, with hair flying behind, body straining forward, hurling towards the end of the race; perhaps one doesn't rise up on the ball of one's foot, think about the position of one's limbs, show off handsome arms and legs, drop an apple from one's fingertips as if spreading flowers. But perhaps such criticism, which

would be compelling if the race were just beginning, can be disputed, given that it's about to end. Atalanta is still far from the finish, Hippomenes has all but reached it, victory is within his grasp, he's no longer running full out, he shows off, he struts proudly, he basks in his success. It's like our dancers after executing some violent sequence of steps, they take pleasure in casually executing a few more near the wings; it's as if they were saying to the spectators: "I'm not tired. You think I'm already exhausted, but not so; if I must begin again, I'm up to it." This kind of ostentation is very natural, and I have no problem attributing it to Hallé's Hippomenes. In any case that's the way I understand him, and suddenly he and I are reconciled. It will be more difficult for me to make peace with his Atalanta. I find her long, dry, nervous arm disagreeable; she resembles a young man more than a woman. I can't tell whether this figure is running or resting; she looks at the spectators spread out along the railing, she bends down, and if she'd intended to distract their gaze with her own, and furtively pick up the apple beneath her hand, she'd have behaved just like this.

> verum ubi plura nitent in carmine, non ego paucis
> offendar maculis . . .[45]

17. *The Education of The Rich*
Poor oil sketch

This is miserable. One sometimes sees feet and hands carelessly rendered, heads roughly sketched in, everything sacrificed to an overall impression or effect; here nothing is fully rendered, absolutely nothing, and there's no effect: this is at the very limit of license in such sketches. In the left foreground, a child sitting on the floor amuses himself looking at maps. His mother relaxes on a sofa. This pot-bellied man standing behind her, is he the father? I think so. This young man with his elbows on the table, what's he doing? I have no idea. What's this priest up to? I don't know that either. What's the meaning of this servant leaving the room? A globe here, a dog there. Spare me this, Monsieur Hallé. One would say you'd scribbled this canvas from a bowl of pistachio ice cream. If chance led a maker of marbled paper to produce this composition, I'd be surprised, but only because of the odds against it.

45 "So long as a poem is full of beauties, I won't take offence at a few blemishes": Horace, *Ars Poetica* vv. 351–2.

17. *The Education of The Poor*
Poor oil sketch

To the right, one sees an open door in which there's some sort of poor wretch; perhaps he's the master of the house. Inside the hovel, a seated woman teaches a child to read, it's her mother, I think. In the background, a servant carries another up a wooden stairway to an upper room. Further left, in the foreground, an older girl facing us makes lace; behind her, her younger sister, who's not exactly delicate, observes her work. At the feet of the first one, a little cat. Greuze would have used a dog, because all children have them so they can order them around. The left side is occupied by a carpenter's work table. On the near side of this table, the son of the house prepares to push forward a joining-plane. From another side, further back, his standing brother shows him an instruction sheet. The whole thing slackly drawn and draped, as banally colored as one can imagine. Any student submitting such a daub to the grand prize competition would go neither into the pension nor to Rome.[46] Such subjects as this should be left to those who know how to handle and imagine them properly. Chardin, who hung the Salon this year, juxtaposed these two miserable sketches with another by Greuze that puts them cruelly to shame. It's a classic instance of a *malo vicino*.[47]

VIEN[48]

18. *Marcus Aurelius Ordering the Distribution of Bread and Medicine to the People in a Time of Famine and Plague* (Pl. 9)
Large painting for the gallery at Choisy

This work will not be easy to describe, but let's see what we can do.

46 After 1748, when this school was established, winners of the competition were admitted to the École des Élèves Protégés, where they boarded and studied for three years, prior to being sent to Rome for a sojourn of several years more at the French Academy there. See Courajod, 1874, as well as Diderot's discussion in "The Two Academies" at the end of the *Salon of 1767*.

47 "Annoying neighbor."

48 Joseph-Marie Vien (1716–1809). Student of Natoire. Granted provisional membership in the Royal Academy on October 30, 1751; received as a full academician on March 30, 1754. He was the teacher of J.-L. David, for whose neoclassical innovations he is generally held to have prepared the way.

Imagine on a platform, at the top of several steps, a balustrade, from which, at right, two soldiers distribute bread to the people below. One of these soldiers holds a basket full of it; another further back, of whom no more than his head and arms are visible, brings another basket. Among the recipients in the foreground, a young child eating, his mother seen from the back with her arms raised, an elderly man obscured by this woman, save for his head and hands. Marcus Aurelius is passing by; he's accompanied by senators and guards, the senators beside him in the foreground, the guards behind and further back. He pauses to look at a woman who's kneeling, near death, and who extends her arm to him; this woman is on the first steps of the platform, her body falls backwards, she's surrounded and supported by her father, mother, and young brother. Further left, on the steps, a dead woman, on this woman her child, his head turned towards the emperor. At the extreme left a group of men, women, and children stretching out their arms to a soldier beside the emperor distributing medicine to them. Beyond this group, at the edge of the canvas, an elderly man and a woman waiting their turn. Now let's take a closer look at this composition.

First, this child who's eating doesn't eat ravenously like a child suffering from hunger; he's plump and well fed. His mother, who turns her back to me, receives the bread as if she were pushing it away; her hands are not positioned to receive it. The expression of this young girl dying, surrounded by her relations, is cold; one can't say what she wants, what she's asking for. Her father and mother, to judge from their facial expressions and clothing, are peasants, but neither the drapery nor the expression of their daughter indicates that she shares their circumstances. This tall, slender young brother resembles the infant Jesus preaching in the temple. Why give these senators the heads of apostles? For these are certainly apostles' heads; having them speak at the same time as this woman addressing the emperor defies common sense. The two distributors of bread are good. The posture of Marcus Aurelius isn't disagreeable, it's simple and natural, but his face lacks expression; he manifests no pain, no empathy, consistent with the apathy of his sect.[49] What can I tell you about this colossal woman spread out on the steps of the platform? Is she asleep? Is she dead? I've no idea. As for the infant, is this the action of a child beside his mother's corpse? And then he's so soft one would mistake him for a beautiful pelt stuffed with cotton; there are no bones inside. I've looked hard for some horrible traces of famine and the plague, some terrible incidents characteristic of these scourges, and there aren't any; in effect, it seems like a depiction of generosity, of ordinary distribution. This composition

49 That is, Stoicism.

lacks warmth and verve, there's no poetry, no imagination; it's not worth a single line by Lucretius.

The group of citizens occupying the left of the canvas is the only acceptable passage. It has color, expression, character, and is skillfully disposed; but this isn't enough to prevent me from crying out: What a painting for the educated viewer, for the sensitive man, for the elevated soul, for the discerning eye! Everything is harsh, dry, and flat; so many bits of cardboard cut out and pasted over one another. There's neither air nor atmosphere suggestive of space, of depth beyond the heads; these images seem glued to the sky. Although these soldiers are well posed they're poorly characterized, they lack ferocity, they're as compassionate as monks. This structure suggestive of a temple or palace is too dark. The sole merit of this work is that overall it's well drawn. The feet of the colossal woman are very beautiful, they're real flesh, I recognize nature in them. The young girl in the foreground between her father and mother is passable, but you might find her head a bit small.

There is, however, something to be said in justification of Hallé, Vien, and Van Loo, namely that their talents were considerably disadvantaged by the awkwardness of the intended destination. Only an idiot would commission, for a long narrow room, a massacre of the innocents, the Israelites dying of thirst in the desert, the temple of Janus closed by Augustus, Marcus Aurelius aiding the people afflicted by plague and famine, and other such subjects requiring considerable variety of incident. The height of a canvas determines the scale of its main figures, and when two or three large figures cover it completely, a painting more closely resembles a study, a fragment, than a real composition.

Other works are listed under number 19, but they weren't exhibited.

LAGRENÉE[50]

Magnae spes altera Romae.[51]

This is a real painter. The advances he's made in his art are surprising. He has drawing, color, flesh, expression, the most beautiful

50 Louis-Jean-François Lagrenée, the elder (1724–1805). Student of Carle Van Loo. Granted provisional membership in the Royal Academy on September 28, 1754; received as a full academician on May 31, 1755.

51 "[Near him Ascanius,] the second great hope of Rome": Virgil, *Aeneid*, XII, v. 168.

draperies, the most beautifully characterized heads, everything except verve. What a great painter, if only he'd acquire some temperament! His compositions are simple, his actions truthful, his color beautiful and solid; he always works after nature. There are paintings by him in which the severest eye fails to discern the slightest fault. His small virgins are worthy of Guido Reni. The more one looks at his *Justice and Clemency*, his *Goodness and Generosity*, the more satisfying they seem. I remember having once advised him to abandon the brush; but who is it that wouldn't have forbidden Racine to become a poet on the basis of his first verses? Lagrenée explains the progress he's made very simply; he says he uses the money he's earned making poor works to make good ones.

20. *Saint Ambrose Presenting God with the Letter from Theodosius after that Emperor's Victory over the Enemies of Religion*

The altar is to the left. The saint is kneeling on the altar steps. Behind him stand priests carrying his cross, mitre, and crosier.

The subject is cold and the painter is too. Everything he knows has left its mark on this composition; it's solid work. His draperies are amply disposed, their folds firmly brushed. But what I most admire here are the young acolytes, whose heads are beautiful. Even the chair in the right corner is remarkable for its form and the truthful imitation of its gilding. If I'd been at Lagrenée's side when he was sizing up his painting, I'd have advised him to visit Monsieur Watelet, to take a good look at Rubens' *Saint Bruno*, and to rework the head of his Saint Ambrose until it had a similarly striking character. This is the main defect of this work; perhaps its color could also be a bit more vigorous. Lagrenée still doesn't understand large machines, but there's hope for him yet. Even as it stands, this Saint Ambrose would have made Deshays uneasy, and those failing to note its merits don't deserve to see anything better.

21. *Apotheosis of Saint Louis*
Large painting

The kneeling saint is transported to heaven by a single angel. This is the entire composition.

Simplicity is all very well, but it obliges one to attain the sublime, in both conception and execution; in such cases the painter aligns himself with the sculptor. There are no accessories to distract one's attention. The saint is heavy-handed; the considerable richness of his

drapery is insufficient to disguise the poverty of his characterization. A painter once said to a student who'd decked out his Venus with jewelry: "Unable to make her beautiful, you've made her rich." I'd say the same of Lagrenée. This saint totally lacks the rapture, the ecstatic joy of the beatified. As for the angel, he's completely airborne, his head is worthy of Domenichino; but his drapery obscures a bit too much of his lower body. Even if the magic of aerial suspension were present, and it isn't, this painting could be pronounced a failure.

22. *Diana and Endymion*

In the left foreground the sleeping Endymion, his head thrown back, his body lifted slightly on a rise in the ground, his right arm at rest on his dog, who's relaxing nearby. In the right background Diana, whose obligations wrest her away from her beloved. She looks at him as she departs, she takes her leave reluctantly. Between her and Endymion, a Cupid who'd like nothing better than to make her forget her duties, as he's done since the world's beginning.

This work is very beautiful and very well painted. Endymion's pose convincingly evokes sleep; his legs a bit spindly, perhaps, but everything else correctly drawn. I'd prefer him to have finer features; he has a slipper chin that I find annoying and which makes him seem ignoble and brutish. His stomach is agreeably executed, his knees full of surprising detail, and this whole area of flesh of an astonishing verisimilitude. The hand resting on his dog doesn't seem like a hand by Lagrenée, for no one knows how to make hands as well as he. The Diana is slender and buoyant, but her blue drapery brings her too far forward and should have been eliminated or changed. Also, behind the shepherd's head there's a thick, brown cloud that could have been rendered more vaporously; but something was needed to enhance the coloring of the figure, and at least this thick brown cloud isn't detrimental to it. Some claim his posture resembles a dead man's more than that of a man asleep. I cannot agree with this criticism, though I recall very clearly a Christ by Falconet whose arm hangs down in the same way.

23. *Justice and Clemency*
Oval painting, overdoor for the gallery at Choisy

At left, Justice seated on the ground, seen in profile, her left arm resting on the shoulder of Clemency, looking at her sympathetically, and slackly holding her sword in her right hand. To the right, Clemency kneeling in front of her and leaning onto her lap. Behind

Clemency, a small child riding on the back of a roaring lion, lording it over him. Around Justice her scales and other attributes.

Oh, what a beautiful picture! Praiseworthy for its color, its characterizations, its postures, its draperies, and all its details. Feet, hands, everything of the highest finish. What a figure is this Clemency! Where did he get this head? It's the expression of goodness itself; her characterization, her posture, her drapery, her expression, her back, her shoulders, everything is quite fine. I've heard it suggested that the Justice could be a bit more dignified. You've seen her; don't you think she should be left as she is? If I dared whisper some advice to the painter, I'd suggest that he eliminate this bit of drapery spread out behind her that compromises her effectiveness and replace it with whatever he likes; that he change this blue skirt in which his Clemency is decked out; that he rework this child who's reddish and lacking in tonal finesse; that he suppress half the folds in the rumpled drapery on which it reclines, and that he touch up the lion's mane, making it more vigorous. But even as it is, if this work were to be labeled "Guido Reni" and taken to Italy, only its freshness would give the game away.

24. *Goodness and Generosity* (Pl. 10)

It's above all in small cabinet pictures that this artist excels. This one is the pendant of the preceding and need concede nothing to it in the way of perfection. Goodness is seated, I think; she faces us. She squeezes her left breast with her right hand, splashing milk over the face of the child in front of her. Generosity, on the ground, leans against Goodness and scatters pieces of gold with her right hand, while her left hand rests on a large conch shell from which tumble all the symbols of wealth. One must see for oneself the placement of this figure, the effect of her two arms, the way her head recedes into the canvas while everything else advances forward, the way each part sits well in its proper level of depth, the way the arm distributing gold is set off from the body and seems to emerge from the canvas; all the bold, picturesque qualities embodied in the figure as a whole. The shell is most beautifully formed and preciously executed. This work is exemplary in its discriminating use of rich drapery and ordinary drapery. The blue material covering Goodness' knees is amply handled, it's true, but a bit hard, dry, and stiff; that covering the same portions of Generosity, just as amply handled, is soft and pliant as well. Goodness' drapery is arranged modestly; that of Generosity is more richly disposed, which is as it should be. The child beside this last figure is bad: the arm he extends is stiff, he lacks natural details and is reddish in tone. Even so, the work is enchanting and extremely effective; the heads couldn't be more beautifully

characterized, and then what feet, what hands, what flesh, what life. Steal these two pendants from the king, for it's good to steal from kings, and you'll certainly have the finest works in the Salon.

25. *The Sacrifice of Jephtha*

This picture is rather handsomely organized. In the center of the canvas, a burning altar; beside the altar, Jephtha leaning over his daughter, his arm lifted and ready to sink the knife into her breast; his daughter spread out at his feet, throat exposed, back turned towards her father, eyes raised heavenwards. The father doesn't look at his daughter, nor the daughter at her father. In front of the victim a kneeling young man holds a recepticle, ready to collect the blood that's about to flow. To the right, behind Jephtha, two soldiers; to the left, in the background beyond the altar, three elderly men.

A beautiful subject, but one requiring a less controlled, more enthusiastic poet than Lagrenée. —But the Jephtha is rather express- ive. —True, but does he look like a father about to slit his daugh- ter's throat? Don't you think that, having placed on his daughter's chest the hand that will guide the blow, ready to stab with the dagger he holds in his left hand, it would have been truer and more striking for him to close his eyes, grit his teeth, tense his facial muscles, and lift his head towards the heavens? These two soldiers, limp and uninvolved in the scene, serve no purpose whatever, and in the midst of these cold, mute assistants that make Jephtha seem like an assassin, this young man aiding his master without lifting an eyebrow, without pity, without compassion, without rebelling, is unbearably horrific and false. The daughter is better but still rather weak, more plaster than flesh. In a word, ask the indulgent admirers of this work if it inspires anything of the terror, the shudders, the pain evoked by the story alone. The moment chosen by the painter, while the most terrible in its proximity to danger, is perhaps neither the most pathetic nor the most suitable for visual depiction. Perhaps I'd have been more strongly affected if I'd been shown a young girl crowned with flowers and garlands, supported by her companions, her knees giving way, advancing towards the altar where she's to die by her father's hand; perhaps the father would have struck me as more pitiful anticipating his daughter's slaughter than he seems with his arm raised, slaughtering her. Some say this work is well com- posed; but what good is a composition with seven figures in which four are superfluous? Some say it is well drawn, namely that the heads sit well on their shoulders, that none of the feet are too large and none of the hands too small; but such qualities are less important than a main action capable of making me forget such faults, should

they be present. Some say it is well colored. Ah, on this point I invoke his Justice and Clemency, and all his small compositions, which are, it seems to me, much more vigorously handled.

26. *Four Paintings of the Virgin* (Pl. 11)

All four are charming. If you were to seize the first of them that happened to fall into your hands, you could be sure of having a little painting that you'd look at every day with pleasure. The heads of the Virgins are noble and beautiful. The children have an innocence appropriate to their ages. The gestures ring true, the draperies are amply arranged, the accessories carefully worked and highly finished; everything is painted with the greatest vigor and skill. How highly valued these little compositions will be when the artist is no more!

In this one, the Virgin leads the infant Jesus to the little Saint John; the latter prostrates himself in adoration. The infant Jesus places his little arms under Saint John's elbows, urging him to rise. The Saint Anne is even lower, kneeling. In another one the Holy Virgin holds the nude infant Jesus in her arms, presenting him to Saint Joseph; the Virgin looks at Joseph and Joseph at the child. In yet another, the nude infant Jesus is on his mother's knees, he holds a cross with a spear-point on its lower end, which he aims at the head of a serpent threatening to bite the feet of the Virgin, who's seated on the terrestrial globe. To the right and left are small groups of angels hovering in the air. In the last on the Virgin, in profile, one knee on a cushion, helps the infant Jesus sit down on Saint John's lamb; Saint John restrains the lamb's head and holds a cross; the little Jesus grasps an apple in one hand and a ribbon tied around the lamb's neck in the other.

Carmontelle[52] regards these works as so many pastiches, and he's wrong, unless we agree that no more Virgins, nor Saint Johns, nor Josephs, nor Saint Annes, nor Elizabeths, nor Christs, nor apostles, nor any church paintings should be made; for the characterization of all these personages is well established. If his criticism is to be credited, we'd no longer see Juno, or Jupiter, or Mars, or Venus, or the Graces, or ancient mythologies, or modern mythologies treated on canvas; we'd be reduced to historical subjects and public or domestic scenes drawn from life, and perhaps this wouldn't be such a bad thing. I'm not embarrassed to say that Greuze's *Village Bride* interests me more than any *Judgment of Paris*.

52 Louis Carrogis de Carmontelle (1717–1806). French painter, engraver, architect, playwright, actor, director, and wit. He is best known for his portraits of eminent Parisian figures.

But let's return to our Virgins. It seemed to me that in one of these compositions the Saint Anne appeared less aged in her lower face than in her forehead and hands; when one's forehead is furrowed with wrinkles and the joints of one's hands are gnarled, one's neck is covered with slack, flabby pockets of skin. In another I observed an old armchair, as well as a portion of a blanket and a striped pillow, of astonishing truth. If you should ever come across this work, take note of the Virgin's head. How beautiful and finely wrought it is! How beautifully coiffed! What grace, and how effective the narrow ribbons that circle her head and dress her hair! Note the characterization of the infant Jesus, his coloring and his flesh; but don't dwell on the Saint John, he's stiff, awkward and lacking in natural finesse. How is it that one of these children is so fine and the other so bad? I could explain this, but I don't dare; it would play right into Carmontelle's hands.

27. *The Return of Abraham to the Land of Canaan*

It's absolutely necessary to identify this subject underneath the painting, for a landscape with mountains could be Canaan, or it could be somewhere else; a man making his way towards these mountains, followed by a man and a woman, could be Abraham and Sarah with their servants, or some other master with his wife and manservant. In the past Sarah was often depicted riding a donkey, and this custom has not been entirely abandoned; cattle, sheep, and shepherds have always been included.

This work, whatever the subject, is admirable for its vigorous coloring, the beauty of the site, and the truth of the travellers and the animals. Is this a Berchem? No. Is it a Loutherbourg?[53] Not that either.

28. *Roman Charity* (Pl. 12)
Small painting

To the left, the old man is seated on the ground; he seems uneasy. The woman standing on the right, leaning towards the old man, her bosom bared, seems more uneasy still. Both of them stare fixedly at a barred window of the prison, from which they can be observed and through which we see a soldier who watches them. The woman presents her breast to the old man, who dares not accept it; his hand and his left arm signal his dismay.

53 On Loutherbourg, see below, pp. 116 ff.

The woman is beautiful, her face is expressive, her drapery as convincing as one could hope. The old man is handsome, even too handsome, he's too ruddy, as hardy looking as if he had two cows at his disposal. He doesn't seem to have suffered for an instant, and if this young woman doesn't watch out he'll end up getting her pregnant. Those willing to indulge the artist's lack of common sense, his ignoring the sudden, terrible effect of imprisonment and condemnation to die from hunger, will be enchanted by this work. The details, especially in the figure of the old man, are admirable: fine head, beautiful beard, beautiful white hair, beautiful characterization, beautiful legs, beautiful feet, and such arms! Such flesh! But this is not the picture I have in my imagination.

I absolutely reject the notion of having this unfortunate old man and this benevolent woman suspicious of being observed; this suspicion impedes the action and destroys the subject. I'd have the old man in chains and the chain, fixed to the dungeon wall, binding his hands behind his back. Immediately upon his nurse's appearance and baring of her breast, I'd have his avid mouth move towards it and seize it; I'd like to see his hunger reflected in his gestures, and his body betray some effects of his suffering: not allowing the woman time to move towards him, but hurling himself towards her, his chain stretching his arms out behind him. I wouldn't want it to be a young woman, I'd require a woman of at least thirty, of an imposing, austere, and seemly character; with an expression conveying tenderness and compassion. Luxurious drapery would be ridiculous here; she should be coiffed rather carelessly, her long, loose hair falling out from beneath her head-scarf, which should be broadly handled; she shouldn't have beautiful, rounded breasts but hardy, large ones that are full of milk; she should be impressive and robust. The old man, despite his suffering, shouldn't be hideous, if I've construed nature correctly; we should see in his muscles, in his entire body a constitution that's vigorous, athletic. In a word, I'd require that the entire scene be depicted in the grandest style, and that such a compassionate humanitarian act not be turned into something trivial.

29. The Magdalen

She faces us. Her eyes gaze heavenward, tears run down her cheeks, but it's not only her eyes, it's her mouth and all her facial features that are crying. Her arms are crossed over her chest; her long hair meanders down to obscure her breast; only her arms and a portion of her shoulders are nude. As in her pain she presses her arms against her chest and her hands against her arms, the ends of her fingers depress her flesh slightly. The expression of her repentance is tender

and utterly truthful. It's impossible to imagine more beautiful hands, more beautiful arms and shoulders. The slight depressions in the flesh made by her fingertips are rendered with infinite delicacy. This painting is a little diamond, but not a flawless one. The painter has surrounded her head with a damnable luminous glory that destroys the whole effect; and then, to speak the truth, I'm less than thrilled by the drapery.

Behind the penitent saint who, as Panurge[54] says, is well worth a sin or two, there's a bit of rock and on this rock a jar of perfume, the saint's attribute. If the woman who annointed the thirty-three-year-old Christ's feet and dried them with her hair was as beautiful as this one and Christ failed to experience any desire of the flesh, he was no man, and this phenomenon could be used to refute all the arguments of the Socinians.[55]

30. *Saint Peter Repenting of His Sin*

He faces us. His hands are joined and his gaze is directed heavenward. A composition that's skillful but cold; beautiful flesh, but little expression; lacking in temperament; heavy-handed drapery; hands too small; not even a spark of verve; an unremarkable thing. Why not make the saint a little less tidy? Why don't we see his chest or neck? Why not have him lift his clasped hands? That would have made them more expressive, and the drapery over his arms would have fallen away, exposing them to view. Heads like this cry out for exaggeration, for poetry, and unfortunately Lagrenée can't provide them. Will he acquire this ability? I hope so, so that he'll be in no way deficient.

DESHAYS[56]

This painter is no longer among us. He had fire, imagination, and verve; he knew how to present a tragic scene so as to incorporate

54 A character in the work of François Rabelais (ca. 1494–1553): book IV, chap. 7.
55 The Socinians, or followers of Socin (1525–62), refuted the notion of Christ's divinity.
56 Jean-Baptiste-Henri Deshays (1729–65). Student of Colin de Vermont and Jean Restout. Granted provisional membership in the Royal Academy on September 30, 1758; received as a full academician on May 26, 1759. His early death was much lamented.

incidents evoking shudders, and how to emphasize despicable characters by arranging their unforced juxtaposition with innocent, sweet ones; here was a real poet. A born libertine, he died a victim of pleasure. His last productions are weak, betraying the wretched state of his health when he was working on them.

31. *The Conversion of Saint Paul* (Pl. 15)

If ever there was a great subject for picture, it's the conversion of Saint Paul. I'd say to a painter: Do you think you've got what it takes to conceive of such a grand scene, the knowledge to arrange it so it will astonish? Do you know how to make fire fall from the heavens, to instill sheer terror in men and horses? And the magic of light and shadow, have you mastered it? Then take up your brushes and depict Saul's adventure on the road to Damascas for me.

In Deshays' picture one sees Saul thrown down in the foreground; his feet extend into the background, his head is lower than the rest of his body; he supports himself with one of his hands, his other arm is raised, seemingly to protect his head, and his gaze is fixed on the spot from which the danger emanates.

This figure is beautiful, well drawn, quite bold; it's still the work of Deshays, while the rest is not. One expects the terrifying effect of the light to be one of the main elements in such a composition, and the painter gave no thought to this. He's scattered frightened soldiers to the left, another group of them is visible to the right surrounding a fallen horse, but these groups are cold and mediocre, they're neither engaging nor interesting. It's the horse's enormous buttocks that capture and hold the spectator's attention. If one measures this enormous animal by comparing his size to that of the soldier seizing hold of it, it's larger than the one in the Place Vendôme.[57] The color is dingy and heavy-handed throughout and, in all honesty, this is but a fragment of a composition.

32. *Saint Jerome Writing about Death*

To the right, an angel flying swiftly, sounding a trumpet and passing by. To the left, the saint seated on a bit of rock, observing the

57 A reference to the equestrian statue of Louis XIV by François Girardon (1628–1715), destroyed in 1792.

passing angel and listening to his fanfare. On the ground around him, a skull and a few old books.

Deshays was quite ill when he made this painting; there's no fire, no genius. For his Saul and his Saint Jerome he adopted the old-fashioned, dingy, smoky idiom of a century and a half ago.[58] By its standards the Saint Jerome is well painted and well drawn, but the composition is awkward and dull. The angel is energetic and his head beautiful, I admit, but his wings are ruffled, rent, upside down, each of a different color, and one would take him for one of Milton's angels roughed up by the devil. And then what does this angel mean? What's the significance of this saint looking at and listening to him? He's the materialization of one man's imagination. What a miserable, impoverished idea! If the angel sounded a fanfare and passed on, that would be fine; but instead of reinforcing his physical existence by having the saint stare fixedly at him, I'd insist that his face, arms, posture, and expression reflect the terror felt by those confronting the misery of man's final end, by those who look it in the face and are overwhelmed; and this is what Deshays would have done in different circumstances, because the Saint Jerome for which I'm asking was in his head.

33. *Achilles, about to be Submerged in the Scamander and the Simois Rivers, Is Assisted by Juno and Vulcan* (Pl. 16)

In the center of the painting, Vulcan suspended in the air, each hand holding a torch whose flames he shakes into the waters of the Simois and the Scamander; he stands upright and faces us directly. Juno is behind him. The two rivers, one leaning on his urn, reclining and facing us, the other standing and seen from the back, seem to be frightened. Nymphs at their banks, fleeing. The river waters agitated in their beds. Achilles struggling in the waves, pursuing a Trojan he's about to strike with his sword. On the sand, still dry, we see helmets and shields.

The subject requires an immense canvas and this is a small painting. Vulcan seems a young man, with nothing of the vigorous, formidable god of the ironworks, of flaming caverns, of the Cyclops' leader, of the forger made to wield tongs and anvil, to live in furnaces, to pound and hammer flashing masses of iron. This is not

58 Diderot is referring to the dark, dramatically lit style known as Caravaggism (after Michelangelo Merisi da Caravaggio, d. 1610), which swept Europe in the first half of the seventeenth century.

the way the ancient poet saw him. The rivers are awkward, dry, and meagre. The idea is full of passion, but its execution is stiff; no air between objects, no humidity, no harmony, no connections and transitions; everything is crude and flattened into the foreground. One of Van Loo's young daughters, five years old, was asked what it was. "Why nanny, it's fireworks," she responded, and this was a good answer. To realize this work properly, the talents of three or four great masters would have had to be combined. It calls for terrifying, dreadful beings hanging unsupported in the air; agitated waters throwing up mist; tangible atmosphere; frightening nymphs and river gods; riverbeds glutted with helmets, shields, bodies, and quivers; Achilles submerged in the churning waters, etc.

34. *Jupiter and Antiope*

To the left, Antiope, nude, reclining on the ground, asleep, her head thrown back and her body slightly lifted. To the right, Jupiter transformed into a faun; he approaches stealthily; beside him, further back, a little cupid who seems to say: Hush! Behind Jupiter, a hovering eagle, its claws grasping thunderbolts, its beak protracted, observing the scene with interest.

The Antiope is bad. Jupiter has renounced his divine form for a block of plaster; her head isn't even executed: it has neither mouth nor eyes, it's a cloud. The faun, with his long face and endless chin, and his foolish expression, seems like an idiot; he's a faun, he's in the presence of a nude woman, and there's no lust in his mouth, his eyes, his nostrils, in the pores of his skin, and I'm not tempted to cry out: "Antiope, wake up; if you sleep a moment longer . . ." This is because she's not beautiful and I'm not interested in her. The background is too assertive. The satyr is drawn as if to satisfy divine prescriptions, without a single natural detail. And then oh Lagrenée, where are your feet, your hands, and your flesh?

35. *Study*

It's a woman seated before a table. We see her in profile. She's meditating, she's about to write. Her table is illuminated by a round window. Around her are papers, books, a globe, a lamp. Her head isn't beautiful, but her hair is carefully dressed. Her clothing falls marvelously from her shoulders, and this negligence is skillfully

handled. This painting might give satisfaction, if you couldn't remember Feti's *Melancholia*.

36. *Two Sketches*, one representing *The Count of Comminge at La Trappe*, the other, *Artemisia at her Husband's Tomb*

My faith, here the entire genius of the man is present once more. These two sketches are excellent. The first is full of truth, interest, and pathos. The father superior of La Trappe is standing; at his feet, Adelaide dying, reclining in the ashes; near to her, the count bending over and kissing her hands; to the right beside the Abbé, groups of astonished monks; around the count, more groups of astonished monks; further left, in the background, two amazed monks observing the scene. Add a tomb somewhere; look at the characterizations and actions of these monks, and then you'll say: What truth, here's the real story of of the Count of Comminge: the Marquise of Tençin[59] just wrote the novel, it's Deshays who really made it.

37. *Artemisia at The Tomb of Mausolus*

Ludentis speciem dabit, et torquebitur . . .[60]

This entire composition is sad, mournful, sepulchral. It inspires terror, admiration, pain, and respect. The night here is dark; a ray of light would increase its horror and even its darkness without destroying its effect, its silence. In the hands of a man of genius, light is capable of the most various effects. Imposing, soft, graduated, generalized and diffused, each object shares in it equally or in relation to its placement and distance from the light source; it can spread and intensify the joy, or it can be reduced to pure technical prowess demonstrating the artist's mastery while neither adding to nor detracting from the final impression. If focused on a single area, on the face of someone near death, it increases the fear, it makes the surrounding darkness palpable. Here it comes from the left, weak,

59 Claudine-Alexandrine Guérin, marquise de Tencin (1682–1749). French novelist and hostess of a celebrated Parisian salon. She was also the mother of the encyclopedist d'Alembert. Her most famous work was *Mémoires du Comte de Comminge* (1735), which had just been successfully dramatized by François du Bacalard d'Arnauld (*Les Amarts malheureux*, 1764).

60 "He will offer the appearance of one at play, yet be tortured [like a dancer who plays now a satyr, now a cyclops]": Horace, *Epistles*, Book II, 2, v. 124.

attenuated, skimming the surface of only the most prominent ob-
jects; the right is lit solely by an oil lamp hanging from the top of
the monument and by the glow of a brazier on which incense is
burning. All artificial light sources of whatever kind, fires, lamps,
torches, candelabra, sombre and reddish, all of them associated with
the ideas of night, death, ghosts, magicians, sepulchres, cemeteries,
caverns, temples, tombs, secret scenes, factions, plots, crimes, ex-
ecutions, burials, assassinations, bring fear and sadness; they're uncer-
tain, wavering, their constant flickering over faces auguring the
instability of the gentler passions and intensifying the expression of
the baneful ones.

Mausolus' tomb occupies the right side. At the foot of the tomb,
in the foreground, a woman burns incense in an open pan. Behind
this woman, further back, one sees a few watchmen. From the peak
of the tomb, at the far right, falls a large piece of cloth. Very far
back, a bit above, the painter placed a weeping woman; he sus-
pended a lamp above her head and the mausoleum. The light it
generates from above places the underside of every object in
shadow.

Artemisia, in front of the monument, kneels on a cushion; her
upper body is bent forward. She grasps with both hands the urn
containing the cherished cinders; her sorrowful head is pitched
to one side of this urn. A funerary vase is at her feet, and be-
hind her, in the background, rises a column belonging to the
monument.

Two mourning companions have followed her to the tomb.
They're behind her: one is standing, the other crouches between her
and Artemisia. Both convey despair, above all the latter one, whose
head is lifted towards the heavens. Imagine this distraught head lit by
the lamp placed at the top of the monument. On the ground beside
these women there's a cushion, and behind them, in the back-
ground, watchmen and soldiers.

But to feel the full effect, the lugubrious atmosphere of this
composition, it's necessary to see how these figures are draped,
the negligence, volume, and disorder that prevail; this is almost
impossible to describe. I've never been able so fully to grasp how
this element, generally held to be of relatively little importance,
could be a source of energy and requires taste, poetry, and even
genius.

The Artemisia is dressed in way that's impossible to conceive; this
great swathe of drapery covering her head, falling forward in wide
folds and arranged along the side of her head, turned towards the
background, exposing and throwing into relief the portion of her
head exposed to the viewer, is in the grandest style and produces the
most beautiful effect. How imposing, touching, sad, and noble is

this woman! How beautiful she is! How graceful, for her entire body is discernible beneath her drapery! What character this picturesque drapery gives her head and arms! How well posed she is! How tenderly she embraces all that remains of the one so dear to her!

Beautiful, very beautiful composition, a fine poem. Affliction, sadness, pain hurl themselves at the soul from every side. When I compare this sketch with the tomb scenes of our theatre, with their stagey Artemisias and their powdered, frizzed confidantes in hoop skirts, large white handkerchiefs in hand, I swear on my soul that I'll never again sit still for these insipid displays of gloom, and I'll keep my word.

Deshays composed this sketch in the final moments of his life; death's grip had chilled his hand and made the charcoal difficult to control, but the eternal, divine kernel retained all its energy. Archimedes wanted a sphere inscribed within a cylinder engraved on his tombstone. This sketch should be engraved on Deshays'. But in this connection, my friend, did you know that M. Pierre[61] has kindly offered to complete the one of *Count Comminge*? When Apelles died, no one dared finish the Venus he'd begun. As you can see, we have artists more confident of their abilites. How beautiful when our own conscience testifies to our gifts! Joking aside, Pierre did an honorable thing: he made an offer to the minister to paint the chapel in the Invalides after Van Loo's sketches. I'd forgotten about this gesture, which was not self-aggrandizing.

I saw Deshay's birth as well as his death. I've seen everything he produced in the way of large compositions, his *Saint Andrew* adoring his cross, the same saint led to his martyrdom, his insolent and sublime *Saint Victor* defying the proconsul and overturning the idols; Deshays had deduced the special character that a fanatical military man, accustomed to risking his life for other men, should display when acting for the glory of his God. I've seen his dying *Saint Benedict* receiving final communion; his *Temptation of Joseph*, in which he dared depict Joseph as a man, not a stupid brute; his *Marriage of The Virgin*, beautifully set in a temple though custom dictated that it be set in a room. Deshays' imagination was bold, vast. He was a fabricator of large machines who, though sick and dying, is still present in his *Saint Jerome* reflecting on his final end, his

61 Jean-Baptiste-Marie Pierre (1714–89). Student of Natoire and J.-F. de Troy. Granted provisional membership in the Royal Academy on April 8, 1741; received as a full academician on March 31, 1742. In 1770 he was named to succeed Boucher as first painter to the king.

Saul thrown down on the Damascus road, and his *Achilles* battling
with the waters of the Simois and the Scamander, works whose
conception and execution both give off heat. His style is imposing,
lofty, noble. He'd fully mastered spatial organization in depth and
knew how to make his figures arresting and his compositions effec-
tive. His draftsmanship was firm, assured, strongly articulated, a bit
foursquare. He knew how to sacrifice details to overall effect. In his
works one encounters large areas of shadow and repose that provide
relief for the eyes and intensify the brighter passages. Without
delicacy, without preciosity, his color is solid, vigorous, and well
judged. Some criticize his men for being jaundiced, with touches of
a red that's almost pure, and his women for a certain artifical
freshness. His *Joseph* clearly demonstrates that grace and sensuality
weren't foreign to him, though his grace and sensuality retain
elements of austerity and nobility. The drawings he left behind
give us an exalted idea of his gifts: his taste, his velvety way
with charcoal, and his passion make us forgive the mistakes and
exaggerated forms. There's talk of head studies drawn by him of
such skill and feeling that they wouldn't seem out of place among
those left behind by the greatest masters. Great things were expected
of Deshays and his death has been much lamented. Van Loo's
technique was superior, but he was not comparable to Deshays in
the realms of imagination and genius. His father, a bad painter
in Rouen, his birthplace, first placed the chalk in his hand. He
studied in succession with Colin de Vermont, Restout, Boucher,
and Van Loo; under Boucher he risked losing everything he'd
learned from the others, skill and grandeur in compositional
organization, the intelligent deployment of light and shadow, the
effective use of large masses and their imposing quality. Pleasure was
a major distraction in his youth, but he won the Academy's grand
prize and departed for Rome. The silence and sadness of this
declining city were not to his taste and he grew bored there. Unable
to return to Paris to seek out the distractions required by an agitated
nature such as his, he gave himself over to the study of artistic
masterpieces and to his awakening genius. He returned to Paris. He
married Boucher's eldest daughter. The marriage did not lead to any
change in his dubious morals; he died at the age of thirty-five,
a victim of his ill-considered predilections. When I compare the
limited time we devote to work with the surprising progress we
make, I think that a man of ordinary abilities but possessed of a
sturdy, robust temperament, who kept at his books from five in
the morning to nine in the evening, studying literature like another
works metal, would know at forty-five everything it's possible to
know.

BACHELIER[62]

39. *Roman Charity in Prison* (Pl. 13)

Monsieur Bachelier, it is written: "Nil facies invita Minerva."[63] All women are difficult to rape, but Minerva is the most difficult of all. The austere, strict goddess said to you, when you beat poor Abel to death with the jawbone of an ass, when you seized upon our Savior, who was most unhappy to find himself in your hands instead of the Jews', and on a hundred other occasions: "You'll never produce anything worthwhile, I can't be raped." You're wasting your time. Why don't you go back to your flowers and animals? Look how Minerva smiles on you then, how your flowers blossom on the canvas, how your horses caper and kick, how your dogs bark, bite, and rend with their teeth. If you're not careful Minerva will abandon you altogether: you don't know how to paint historical pictures, and when you set out to paint flowers and animals and summon Minerva, the goddess, vexed by a child who insists on having everything his own way, won't come, and your flowers will become pale, wan, withered, faded, your animals devoid of action and truth, as cold and limp as your human figures; I'm even afraid my prophecy is halfway realized. You pursue singular, bizarre effects, something that always signals conceptual sterility and lack of genius. In this *Roman Charity* you wanted to achieve a *tour de force* by illuminating your canvas from above; even if you'd managed to make all artists bow down in admiration, this would not have prevented a man of taste, comparing you with Rembrandt this once, from examining the placement of your figures, your draftsmanship, characterization, passions, expression, heads, flesh, color, and drapery, from shaking his head and saying to you: "Nil facies."

Bachelier's *Roman Charity* has only two figures: a woman who's descended into the depths of a dungeon to nourish an old man

62 Jean-Jacques Bachelier (1724–1806). Granted provisional membership in the Royal Academy on August 29, 1750; received as a full academician on September 2, 1752, as an animal and flower painter; received as a full academician a second time on September 24, 1763, as a history painter. In 1765 he founded the École Gratuit de Dessin, intended to provide training for young craft artists to whom the Royal Academy school was inaccessible. The next Salon (1767) would be his last; weary of critical abuse, he subsequently abstained from exhibiting at the Louvre exhibitions.

63 "You'll achieve nothing against Minerva's will": a corrupt reminiscence of Horace, *Ars Poetica*, v. 385 (the original Latin is: "Tu nihil invita dices faciesve Minerva").

condemned to die of starvation with milk from her breasts. The woman is seated; she faces us; she leans over the old man, who's spread out at her feet, his head resting on her knees, and gives him suck, though one can't quite make out how, so awkward is her posture. This scene is lit by a single ray of light falling through a hole in the upper masonry.

This light casts the woman's head into partial or deep shadow. The artist must have tormented himself to the point of despair over this head, for it's rotund and dark, qualities that, in combination with her long, aquiline nose, give her the bizarre features of a child born of a Mexican mother and a European father, in which the characteristic traits of these two nations blend together.

You wanted your old man to be thin, dried out and fleshless, near death, and you've made him so hideous he inspires fear; the crude handling of the head, with its protruding bones, narrow forehead, and prickly beard, drains humanity from his face; his neck, arms, and legs counter this effect somewhat, but in the end he resembles a monster, a hyena, anything but a man, and the woman who asked Duclos,[64] secretary of the Academy, what kind of beast this is was fully justified. As for color and drawing, if this were a depiction of a large gingerbread it would be a masterpiece; but in fact it's a big piece of chamois leather artistically hung over a skeleton and stuffed with padding here and there. As for your woman, her arm is badly drawn, the foreshortening is botched; her hands are wretched, the one supporting her head can't be made out at all; and the knee on which your nasty human beast rests his head, where does it come from? To whom does it belong? You can't even imitate iron, for the chain binding this man certainly isn't made of it.

The only thing you've been able to do well, without knowing it, is to avoid making your old man and your woman nervous about being observed; such fear denatures the subject, drains it of interest and pathos, so that it's no longer an act of charity. Which isn't to say one shouldn't open a barred window onto the dungeon, and even place a soldier or a spy at this window; but if the painter has any genius, the soldier will be perceived by neither the old man nor the woman giving him suck; only the spectator will be able to see him and the astonishment, admiration, joy, and tenderness registering on his face; and to include a brief word of consolation, I'm less shocked by your hideous old man than I am by the

64 Charles-Pinot Duclos (1704–72). French novelist and historian, author of *Histoire de Louis XI* (1745–6) and *Mémoires pour servir à l'histoire des moeurs du XVIIIe siècle* (1751).

Tithonus-like[65] elder of M. Lagrenée, because I find something
hideous less offensive than something trivial; at least your idea was
forceful. Your woman isn't the woman with broad cheeks, long
austere face, and large ample breasts that I'd want her to be, but then
neither is she a young girl with pretensions to elegance who likes to
show off her beautiful bosom.

But I repeat yet again, a taste for the extraordinary is typical of
mediocrity. When one despairs of making something that's beauti-
ful, natural, and simple, one attempts something that's bizarre. Trust
me, go back to jasmine, jonquils, tuberoses, and grapes, and beware
of heeding my advice only too late. This Rembrandt was a painter
of unique gifts, this Rembrandt sacrificed everything to the magic of
light and shadow; leave him alone, for he was possessed of the rarest
mastery, and nothing less will make us indulge the darkness, smoki-
ness, harshness, and other such faults entailed by his approach. And
then this Rembrandt was a great draftsman, such a touch he had!
Such expression, such characterization! Do you have all that? Do
you think you ever will?

40. *A Sleeping Child*

He reclines on his back; his gown has ridden up as far as his chin,
exposing a belly so enormous, so taut one fears it's about to burst.
One leg is bare, the other shod, the bare leg's footwear is at his side;
the other leg is raised up, resting on something that's round and
unsubstantial; I'm told this is a part of his clothing. A garland of
grapes winds between his thighs and around him; a basket full of
them is behind his head.

Bad painting; "an insignificant thing," as the English would say.
This child is a little piglet who's consumed so many grapes he can't
get any more down and is about to pop. At least that's what the
painter wanted to make, but instead he's depicted a drowned child
with a belly swollen by prolonged exposure to water. Note his
livid color: he's not asleep, he's dead. His parents should be
advised; his little brothers should be chastised, so the same accident
doesn't befall them; and this one should be buried and never spoken
of again.

65 Diderot's term is *titonisé*, a neologism; he intends a reference to Tithonus, beloved
of Aurora, who asked Zeus to grant him immortality but neglected to also request
that he be blessed with eternal youth. As a result he grew perpetually more feeble
and wretched until Aurora, tired of nursing him, locked him in her bedroom,
where he turned into a cicada.

41. *Painting of Fruit in a Basket Lit by a Candle*

To the right, on a table, one sees a basket of fruit; a large bouquet of flowers has been secured to the upper portion of its handle. Beside the basket is a lighted candle in its holder; around the candlestick, some pears and grapes.

Certainly a beautiful lighting effect. A pungent painting; a difficult project successfully realized; a work vigorous in both its color and its handling; it's the truth. But it must be admitted that great care has been taken to drain these flowers of their brilliance, to strip them of their velvety surfaces, and to deprive this fruit of its freshness, of the thin, damp haze covering it: for such is the effect of artificial light. If so inclined, I could find justification for the selection of these particulars. They're part of a meal the artist offered a few friends assembled around his table one evening; the friends having departed, the painter spent the balance of the night painting what remained of the dessert in what light there was. This large bouquet of flowers was fixed to the basket handle after the fact, whimsically; if it had been there from the beginning, no one would have known how to carry the basket. The bluish light of the candle blending with the yellowish green of the pears has given them a crude, muted, saturated green cast that makes them seem unappetizing. A beautiful thing, but rather bizarre.

42. *Two Paintings Representing Flowers in their Vases*

These vases positively overflow with flowers, they're in poor taste, and the flowers are arranged in them without elegance. Some fruit is scattered around them.

Well, Monsieur Bachelier, what did I tell you? Minerva has withheld her favors, and who knows when she'll make them available to you again? The color in these paintings is cold and weak; your flowers no longer have the same beauty, and everything seems dull and flat against the background of sky.

43. *Paintings Executed with New Pastels Made with Oil*

In one of these paintings there's a woman whose elbow rests on a table on which are quill pens, ink, and paper. She hands a sealed letter to a standing slave. The slave, who has temperament, a bad temperament, has understood, and not as the painter intended; she seems disinclined to do her mistress' bidding. The mistress seems a bit sullen, and the slave very much so.

Monsieur Bachelier, pursue your secret no further, and go thank Monsieur Chardin for having hidden your painting so well that I'm the only one who saw it.

It seems to me that when one picks up the brush, one must have an idea that's strong, ingenious, delicate, or savory, and have in mind some effect, some sort of impression. Giving over a letter for delivery is an action so commonplace that it absolutely must be heightened, either by some particular circumstance or by superior execution. Very few artists have ideas, but none save a very small number can manage to dispense with them. Yes, without doubt it's permissible for Chardin to show a kitchen with a servant bent over a tub washing dishes, but note how truthful are this servant's movements, how her fortitude is visible in her upper face, and how the folds of her skirt reveal everything that's beneath them; note the astonishing truth of all the household utensils, the color and harmony of the whole small composition. There's no middle ground: either interesting ideas, an original subject, or astonishing technique. The best would be to unite them, combining a piquant idea with delectable execution. Without his sublime technique, Chardin's ideal would be an impoverished one. Remember this well, Monsieur Bachelier.

CHALLE[66]

44. *Hector Rebuking Paris for his Cowardice*

Paris and Menelaus encounter one another in the fray, they end up in hand-to-hand combat; they're unevenly matched. Paris was about to perish and Menelaus to be avenged when Venus carried him off, bringing him to Helen's side. A sacrifice is being offered to the goddess for having saved Paris; some women burn incense on an altar, others busy themselves playing music which ceases when they perceive Hector. To determine whether Challe's Hector is that of Homer, let's see how the speech of the ancient poet's character agrees with that of our painter. Here is how Hector speaks to Paris in the *Iliad*.

66 Charles-Michel-Ange Challe or Challes (1718–78). Student of Boucher and Lemoyne. Granted provisional membership in the Royal Academy on October 30, 1751; received as a full academician on January 25, 1772.

"Miserable wretch, with only your beauty to recommend you, worthless and vile seducer of women, if only it had pleased the gods for you never to have been born or to die in the cradle! And wouldn't this have been a hundred times better than seeing yourself dishonored? Can't you make out even here the insulting laughter and galling jokes of the Greeks? They'd judged you by appearances, they'd believed you to be formidable, a man of courage, and you're nothing of the kind. What an admirable project, crossing the sea to corrupt foreigners, and initiating your travel companions into the same debauchery! How fitting for a coward like yourself to run off with a brave man's wife! As a consequence of your perfidy, your father is overwhelmed with sorrows, a thousand misfortunes are befalling your family, an entire people, and you've covered yourself with shame. What did you expect of this Menelaus whom you so vilely offended? You must have known what kind of man he was; you must have grasped the power of your beauty, of which you're so vain, and of your mastery of the flute, and of the charms bestowed on you by the goddess protecting you, and of your long hair once it had been dragged in the dust. I can't understand the Greeks' patience; if they weren't as faint-hearted as children, they'd long since have crushed you with stones, and you'd have received a just reward for the misfortunes you've brought down on their heads."

What force! What truth! So spoke the Hector of the venerable Homer. Add or excise a word from this speech, if you dare. —And our painting? —I hear you; but could I possibly pass before the statue of my god without paying it homage? Homer having received his due, I'll turn my attention to Monsieur Challe; but how am I to portray the confusion prevailing among these objects, the sham lavishness of this palace, the impoverished opulence of the composition as a whole?

The canvas presents us with a room in Priam's palace; it's as rich as can be, though not in the best taste. A spacious vestibule of multicolored marble opens into the background, slightly to the right. Hector is alone in the middle of the canvas; his face is turned towards Paris and Helen; he speaks or listens, I'm not sure which. Behind him, to the left, two women who seem surprised; is it because of his presence or his speech? I've no idea. Between Hector and these women, a large group of other women sitting on the floor, holding various instruments in their hands; they've ceased playing with Hector's arrival. Further forward, Helen and Paris, Paris casually reclining and Helen seated by his side. Behind Paris, three women busy themselves making his head as charming as possible. The musicians have had the decency to let their instruments fall silent, but these women continue to work on Paris'

toilette. Behind Helen and Paris, more women staring at Hector. —
Are you almost finished? you ask. —Just a moment, please, there's
more. Higher up, to the far left, Venus and her son, apparently on
an altar. At the edge of the canvas, in the foreground, a few young
girls. Have you followed all that? Can you picture it in your head?
Then you've grasped the left side of the painting. Now for the right
side. I spoke of a beautiful vestibule opening into the background.
At the side of this vestibule imagine a niche; place a figure in this
niche, any figure you like; install a round altar there; light an incense
burner on this altar; have a standing woman throw incense into it;
place at her feet another kneeling woman holding a pigeon, doubt-
less about to be sacrificed; place the pigeon's cage beside her.
Around these women and their attendants scatter tapestries and
various pieces of material. Seat a woman on the floor and imagine
balls of wool nearby; she seems to mock Hector and his recrimina-
tions; she looks at Helen and seems to either envy her or approve
of her comments, if it's she who's speaking. Continue around this
altar and you'll find three women, two of whom also seem to envy
the fate and approve the reasoning of their mistress; as for the third,
her function is, as they say in painter's lingo, to "stop a hole"
[boucher un trou] . . . Ah! my friend, now I can breathe easier, and
you as well. I must have a truly obliging imagination, if it managed
to take in all that. And you're hoping perhaps that I'm going to
provide a detailed critique of this world? Oh no; you want me to
finish, and that would be endless. But rest assured that this descrip-
tion is precise, save a few minor details; a regular tour de force, if you
will.

 Let's begin with Hector:

> Eheu, quantum mutatis ab illo
> Hectore, qui redit exuvias indutus Achillis[67]

What a difference between this Hector and the poet's! He's stiff,
he's cold, he's completely unaware of the discourse he's supposed to
be delivering. Where is anger? Where is indignation? Where is
contempt? They remain in the poet, my friend. Homer's speech
would have inspired a posture, a truthful action very different from
Challe's. His Hector is well posed in the best academic manner,
extending one of his arms towards the altar to contrast with his
torso; he's a lousy provincial actor, and then his color could hardly
be worse or more clashing.

67 "Alas! How changed he was! How different from the Hector returning from battle
 after donning Achilles' spoils": Virgil, Aeneid, Book II, vv. 274–5. Diderot has
 slightly scrambled the original text, which reads: "ei mihi, qualis erat! quantum
 mutatis ab illo."

And this Paris, he's not been altered any less. Is this the man on whom Venus bestowed beauty, who was possessed of charm and grace and whose tresses snared all hearts?

Helen is pale, wan, fatigued, sucked dry, with the air of a well-used, unhealthy strumpet. I'd rather die than put my trust in this woman; she has livid green spots. When Priam summoned her, and she presented herself to the Trojan elders, instead of crying out with one voice, as in the poet's account: "Ah! How beautiful she is! Look at her, she so resembles the immortals she inspires veneration as they do." Instead of this cry of admiration, if they'd seen Challe's personage they'd have exclaimed: "That's all? Send her back right now, get her out of here; it won't be long before she seeks vengeance in the name of our enemies." Then, turning towards Priam, they'd have added in a lower voice: "You'd do well to consult Keyser of Pergamum[68] about your young libertine's health."

Paris' weapons are so close to her she almost seems to sit on them. The women around her have the same coloring and seem equally suspect to me.

And then neither hands nor feet are finished; and such ignoble heads! The whole could serve students as a negative example of irresolution and disharmony. No unity of focus, one doesn't know where to turn; some of the figures look at Hector, some at Helen, and myself at neither. At your service, Monsieur Challe.[69]

You already know what I think of the background, the decor, and the architecture.

As if the faults in this composition weren't obvious enough, imagine that this mischievous Chardin has hung on the same wall, and at the same height, two works by Vernet and five by himself that are so many masterpieces of truth, color, and harmony. Monsieur Chardin, one shouldn't do such things to a colleague; you didn't need such a foil to make your own pictures look better.

Challe's painting is about six meters wide by four high; it is, in faith, one of the largest idiocies ever perpetrated with the brush. But this poor Challe is no longer young; tell me what we might do with him, for I couldn't bear it if he were to continue to paint. I know very well that you defenders of the fable of the bees[70] will tell me this enriches the canvas merchant and the pigment merchant, etc.

68 A contemporary doctor who claimed to have developed pills for the treatment of venereal disease.

69 "Serviteur à Monsieur Challe": a phrase used in issuing a challenge to a duel.

70 Diderot is referring to *The Fable of the Bees* by Bernard Mandeville, the first French edition of which appeared in 1740. This much-discussed work argued that "private vices make public benefits," that the production of luxury goods, far from having a pernicious effect, was beneficial to a nation's economy.

May sophists go to the devil, these people can't tell right from wrong; they'll get what's coming to them from Providence.

CHARDIN[71]

You come just in time, Chardin, to refresh my eyes after your colleague Challe mortally wounded them. Here you are again, great magician, with your silent arrangements! How eloquently they speak to the artist! How much they have to tell about the imitation of nature, the science of color and harmony! How freely the air circulates around your objects! The light of the sun is no better at preserving the individual qualities of the things it illuminates. You pay scarcely any heed to the notions of complementary and clashing colors.

If it's true, as the philosophers claim, that nothing is real save our sensations, that the emptiness of space and the solidity of bodies have virtually nothing to do with our experience, let these philosophers explain to me what difference there is, four feet away from your paintings, between the Creator and yourself.

Chardin is so true, so harmonious, that even though one sees only inanimate nature on his canvases, vases, cups, bowls, bottles, bread, wine, water, grapes, fruit, pâté, he holds his own against and perhaps even draws you away from the two beautiful Vernets he didn't hesitate to put beside his own work. My friend, it's like the universe, in which the presence of a man, a horse, or an animal doesn't destroy the effect of a bit of rock, a tree, a stream; without doubt the stream, the tree, the bit of rock hold less interest for us than the man, the woman, the horse, the animal, but they are equally true.

I must, my friend, communicate to you an idea that's just come to me and that I might not be able to recall at a different moment. It's that the category of painting we call genre is best suited to old men or to those born old; it requires only study and patience, no verve, little genius, scarcely any poetry, much technique and truth, and that's all. You yourself know that the time we devote to what's conventionally known as the search for truth, philosophy, is precisely when our hair turns grey, when we'd find it very difficult to

71 Jean-Baptiste-Siméon Chardin (1699–1779). Student of P.-J. Cazes and N.-N. Coypel; granted provisional membership and received as a full academician on the same day, September 25, 1728.

write a flirtatious letter. Regarding, my friend, these grey hairs, this morning I saw that my entire head was silvered over, and I cried out like Sophocles when Socrates asked him how his love life was going: "A domino agresti et furioso profugi,"[72] I'm free of that savage, merciless master.

I'm all the more willing to digress with you like this because I'm only going to say one thing about Chardin, and here it is: Select a spot, arrange the objects on it just as I describe them, and you can be sure you'll have seen his paintings.

He painted *Attributes of the Sciences, Attributes of the Arts* and of *Music, Refreshments, Fruit,* and *Animals.* It's all but impossible to choose between them, they're all of like perfection. I'll sketch them for you as rapidly as I can.

45. *Attributes of the Sciences*

One sees, on a table covered by a reddish carpet, proceeding, I think, from right to left, some upended books, a microscope, a small bell, a globe half obscured by a green taffeta curtain, a thermometer, a concave mirror on its stand, a pair of glasses with its case, some rolled-up maps, the end of a telescope.

It's nature itself, so truthful are the shapes and colors; the objects separate from one another, move forward, recede as if they were real; nothing could be more harmonious, and there's no confusion, despite their great number and the small space.

46. *Attributes of the Arts*

Here there are books lying flat, an antique vase, drawings, hammers, chisels, rulers, compasses, a marble statue, brushes, palettes, and other such objects. They're arranged on a kind of balustrade. The statue is from the Grenelle Fountain, Bouchardon's masterpiece.[73]

Same truth, same color, same harmony.

47. *Attributes of Music* (Pl. 17)

Across a table covered with a reddish carpet, the painter has placed an array of various objects distributed as naturally, as picturesquely as

72 Cicero, *Cato the Elder or Dialogue on Old Age,* XIV, 47; Diderot's rendering follows.
73 The Fountain of the Four Seasons on the rue de Grenelle in Paris, executed by Edmé Bouchardon between 1739 and 1745.

possible; there's a stand with music, in front of this stand an adjust-
able candle-holder; behind, there's a trumpet and a hunting horn,
the bell of the trumpet visible above the music stand; there are
hautboys, a lute, scattered sheets of music, the neck of a violin with
its bow, and upended books. If a malevolent animal such as a snake
were painted this truthfully, it would really frighten.

48. *Refreshments*

Imagine a squared construction of greyish stone, a kind of window
with ledge and cornice. Arrange there with all the nobility and
elegance you can muster a garland of large grapes extending the
length of the cornice and hanging down on either side. Inside the
window-jamb place a glass full of wine, a bottle, a broken loaf of
bread, other carafes cooling in a faience bucket, a clay jug, radishes,
fresh eggs, a saltcellar, two full, steaming coffee cups, and you'll see
Chardin's painting. This wide stone construction, along with the
garland of grapes decorating it, is of the greatest beauty; it could
serve as the model for a temple to Bacchus.

48. *Pendant to the Preceding Painting*

The same stone construction, around it a garland of plump white
muscat grapes; within, peaches, plums, carafes of lemonade in a tin
bucket painted green, a lemon peeled and cut in half, a basket full
of wheat cakes with a fine handkerchief hanging out of it, a carafe
of barley water and a glass half filled with it. How many objects!
What diversity of shapes and colors! And yet what harmony! What
serenity! The softness of the handkerchief is astonishing.

48. *Third Painting of Refreshments Intended for a Place Between the Two Others*

If it's true that no connoisseur can dispense with owning at least one
Chardin, this is the one to go after. The artist is getting old; he's
sometimes done as well, but never better. Hang a duck by one leg.
On a buffet underneath, imagine biscuits both whole and broken,
a corked jar full of olives, a painted and covered china tureen, a
lemon, a napkin that's been unfolded and carelessly flung down, a
pâté on a rounded wooden board, and a glass half filled with wine.
Here one sees there are scarcely any objects in nature that are
unrewarding and that it's only a question of rendering them prop-
erly. The biscuits are yellow, the jar is green, the handkerchief

white, the wine red, and the juxtaposition of this yellow, this green, this white, this red refreshes the eyes with a harmony that couldn't be bettered; and don't think this harmony is the result of a weak, bland, over-finished style; not at all, the handling throughout is of the greatest vigor. It's true that these objects don't change before the artist's eyes, that as he's seen them one day, so they remain the next. This is not the case with animate nature; invariability is an attribute only of stone.

49. A Basket of Grapes

That's all there is to the painting. Scatter around the basket a few individual grapes, a macaroon, a pear, and two or three lady-apples. You'll agree that some individual grapes, a macaroon, some lady-apples don't promise much in the way of shapes and colors; but just look at Chardin's painting.

49. A Basket of Plums (Pl. 18)

Place on a stone bench a wicker basket full of plums, for which a paltry string serves as handle, and scatter around it some walnuts, two or three cherries, and some small bunches of grapes.

 This man is the finest colorist in the Salon and perhaps one of the finest in all of painting. I can't forgive Webb[74] his impertinence in having written a treatise on art without mentioning a single Frenchman. Nor can I forgive Hogarth[75] for having said the French school lacked even a mediocre colorist. You lied, Monsieur Hogarth, out of either ignorance or stupidity. I'm well aware that your nation has the habit of dismissing impartial authors who dare praise us; but is it really necessary for you so basely to flatter your fellow citizens at the expense of truth? Paint, paint better if you can; learn to draw, and stop writing. We and the English have two very different styles: ours improves upon English work, theirs is inferior to ours. Hogarth was still alive two years ago, he spent time in France, and Chardin has been a great colorist for thirty years.

74 The Irishman Daniel Webb, author of *An Inquiry into the Beauties of Painting; and into the Merits of the Most Celebrated Painters, Ancient and Modern* (1760).

75 William Hogarth (1687–1764). English painter, author of *The Analysis of Beauty* (1753). In this treatise Hogarth expounds his theory of art, in which "the serpentine line" plays a primordial role. This book, and this specific concept, had a considerable influence on Diderot. The discussion of the Farnese Hercules in his "Servandoni" entry below is heavily indebted to Hogarth's text.

Chardin's handling is unusual. It resembles the summary style
[*manière heurtée*] in the way one can't make things out from close up,
while as one moves away the object coalesces and finally resembles
nature; and sometimes it affords as much pleasure from close up as
from a distance. This man is as superior to Greuze as the sky is high,
but in this respect alone. He has no style; no, I'm mistaken, he does
have one that's his alone; but because it's his own style, it should
ring false in certain circumstances, and it never does. Try, my friend,
to explain that to yourself. Can you think of a literary style suited to
anything and everything? The genre of Chardin's painting is the
least demanding one, but no living painter, not even Vernet, is as
perfectly accomplished in the one he's chosen.

I've just remembered two *Landscapes* by the late Deshays I didn't
tell you about; that's because they don't amount to anything,
because both of them are as crude and harsh . . . as these last words.

SERVANDONI[76]

This Servandoni is a man who wouldn't be satisfied even with all
the gold of Peru; he's Rabelais' Panurge, who had 15,000 ways of
collecting money and 30,000 ways of spending it. A great theatrical
machinist, a great architect, a good painter, a sublime decorator,
each of these talents has brought him immense sums, yet he has
nothing and never will. The king, the nation, the public have given
up on the project to save him from misery; he is loved as much for
his current debts as for those he'll contract in the future.

50. *Two Overdoors*

One represents some ruins and a trophy of arms, the effect of its
light is beautiful, it's well colored; but I prefer the one in which we
see some rocks and a tomb with a waterfall, although one might
inscribe above both of them those words summing up one of art's
mysteries, "Parvus videri, sentiri magnus," though he's painted them
small, one experiences these objects as being large.

76 Jean-Nicolas or Jean Jérôme or Giovanni Nicolo Servandoni or Servandony (1695–
 1766). Painter, architect, and theatrical designer. Received a full royal academician
 on May 26, 1731, as a painter of architecture.

If the *Farnese Hercules* (Pl. 20) is a colossal figure only because all its details, its head, neck, arms, back, chest, torso, thighs, legs, and feet, its muscular articulation and its veins are exaggerated in proportion to its size, then tell me why it is that this figure remains a Hercules even when reduced to natural dimensions, to a height of fifteen inches? It's inexplicable, unless some of the shapes in these enormous productions retain their exaggerated form and others don't. But then which are the parts of these figures that retain their exaggeration while the others are proportionally reduced? I'll try to tell you. Permit me to interrupt briefly the monotony of these descriptions and the boredom induced by these parasitical terms, *stroke, impasto, true, natural, well colored, well lit, vigorously executed, cold, dry, soft,* that you've heard so often without understanding them, with an amusing digression.

Who is the Hercules of fable? He's a strong, vigorous man armed with a club who busies himself on important roadways, in forests, in the mountains fighting brigands and crushing monsters; these are the givens. What parts of such a man should be subjected to permanent exaggeration? His head? No; it's not the head one uses to fight, to crush; the head would retain its natural proportions, though brought into conformity with the colossal scale. His feet? No; all the feet need do is provide adequate support for the figure, and they'll do this if simply brought into conformity with its height. His neck? Yes, without doubt; this is the origin of the muscles and the nerves, and the neck should be exaggerated somewhat more than mere adjustment to the colossal scale would require. I'd say the same of the shoulders and chest, and all their muscles, above all the muscles. It's the arms that carry the club and strike with it; that's where a killer of men, a crusher of beasts must be formidable. His thighs should also exceed the ordinary in a way consistent with his mode of life, for he's destined to scale rocks, penetrate forests, and prowl the principal roadways. Glycon's Hercules succeeds in creating such effects. Examine it carefully, and you'll discern a systematic exaggeration of certain parts in accordance with the man's lot that, with a skill, a taste, a discernment nothing less than sublime, slowly and imperceptibly gives way to ordinary natural proportions at the two extremities and in all other areas unaffected by his circumstances. Suppose for a moment that you've reduced this Hercules of eight or nine feet to a smaller scale, to a Hercules of five and a half feet, it will still be a Hercules, because even after having reduced most parts to an ordinary, commonplace scale certain others will retain their exaggeration; you'll see him as small, but you'll sense his grandeur. The more closely an ordinary, commonplace portion is juxtaposed with one that's exaggerated, the weaker it will seem; the greater the distance between exaggerated and non-exaggerated parts, the less

apparent the disproportion will be. Once again, such is the character
of Glycon's Hercules, where the passage from one natural scale to
another is most apparent not in the transition from thighs to feet,
but in the one from head to neck.

Now, beside this Hercules imagine a Mercury, for example.
Reduce this figure to the same dimensions as the other, have the
Mercury take on some of Hercules' exaggerated features and the
Hercules assume something of the characteristics deriving from
Mercury's less strenuous mode of life, and you'll have the propor-
tions of the *Antinous* (Pl. 21). And who is Antinous? A man without
a social function, a sluggard who's never accomplished anything,
whose circumstances haven't altered his proportions at all. Hercules
is the extreme of the working man, Antinous is the extreme of the
lazy man. His proportions are the ones he was born with. He can
serve as a basic, common model, he's the figure with which you'd
choose to work in showing the effects of specific circumstances,
whether it be a matter of exaggerating some parts to indicate
strength or shrinking them to indicate weakness; and it's your
knowledge, more or less thorough, more or less precise, of his cir-
cumstances that will determine where the exaggeration or shrinkage
is to occur. The difficulty isn't in arriving at these choices, Glycon's
sublimity doesn't lie there; the crucial thing is that the transitions
from the diminished or exaggerated parts to the unaltered ones be
imperceptible, such that, whether in a large or a small format, I
always recognize your soldier, if that's what you set out to make of
the *Antinous*, or your street-porter, if that's what you were after.

But if it's a question of the god of light, of the victor over the
serpent Python, if the circumstances betoken strength, grace, gran-
deur, and speed, then you'll leave the proportions of the upper body
as they are. I say proportions and not character, for these are very
different things; and if the changes are restricted to the legs and
thighs, which are made to resemble more closely those of the
Antinous, then you'll have the *Apollo Belvedere*, strong in the upper
body but fleet of foot.

This is the way an experienced horse-trader arrives at his notion
of an ideal military mount. It falls somewhere between the hardiest
of workhorses and the fastest of racehorses; and you can be sure that
two men well versed in this inferior profession will have the same
image in their heads, minor differences apart, one that's similarly
based on exaggerations worked on ordinary, everyday nature.
There, my friend, a little sampling of the metaphysics of drawing,
and there's neither science nor art that doesn't have its own, to
which genius instinctively submits, all unknowingly. Instinctively! A
splendid subject for further metaphysical ruminations! Those will be
for another section, you won't be left in the lurch. There are things

to be said about drawing that are even more subtle, and I'll get to those as well.[77]

51. *Two Small Paintings of Antique Ruins* (Pl. 19)

This is noble and grand, and if you apply the principles I've just established to these architectural remains, you'll be struck by their nobility and grandeur even on a small scale. Here the objects depicted evoke a retinue of associated moral ideas about the persistence of human nature and the power of peoples. What huge masses! They seemed destined to last an eternity, but they're destroyed, they're disappearing, soon they'll vanish completely; the time when countless human multitudes lived, loved, hated, made plans, and sowed trouble around these monuments is long since passed; Caesar, Demosthenes, Cicero, Cato were of their number. In their place are snakes, Arabs, Tartars, priests, ferocious wild animals, brambles, and thorn-bushes; where once the raucous crowd reigned, silence and solitude now prevail. The ruins are more beautiful in the light of the setting sun than in the morning; morning is the moment of the world's awakening noise and tumult; evening is the moment in which it falls silent and becomes calm . . .

So, it would seem I've raised the difficult question of analogies between ideas and feelings, analogies that secretly guide the artist in choosing his accessories. But let's leave it at that, I have to move on.[78]

MILLET FRANCISQUE[79]

52. *Landscape with Saint Genevieve Receiving the Benediction of Saint Germain*

Gloomy color, heavy-handed touch; a landscape drop for the theatre or for a puppet show on the boulevards, with a gaudily dressed

77 Diderot keeps this promise in the first section of his *Notes on Painting*, included in this volume, and in the opening pages of the *Salon of 1767*.

78 Diderot treats these ideas at considerable length in his discussion of Hubert Robert in the *Salon of 1767*.

79 Joseph-Francisque Millet (1697–1777). Granted provisional membership in the Royal Academy on July 24, 1733; received as a full academician on November 27, 1734.

peasant couple and a Bishop of Avranches; everything resembles a
scene from comic opera.

More Landscapes
Two Heads in Pastel

To the Notre Dame bridge.[80]

NONOTTE[81]

I can't imagine how this one got into the Academy. I must take a
look at his reception piece.

BOIZOT[82]

56. The Graces Binding Cupid

The scene is set in the open air and features a wriggling cupid and
Graces that are heavier, stouter, more chubby-cheeked than the
ones I see behind the fish and fruit stands on my way home along
the rue des Boucheries.

57. Mars and Cupid Arguing about the Power of
their Weapons (Subject from Anacreon)

How agreeable to see how Monsieur Boizot has flat-footedly par-
odied in paint the most elegant and delicate of Greek poets; I
haven't the courage to describe this thing. Read Anacreon, and if
you have a copy of his bust, burn Boizot's painting in front of it,
pleading that he never again be permitted to produce anything so
limp based upon so charming an author.

80 The Notre Dame bridge over the Seine, lined with shops, was known for its dealers
 in cheap paintings by hack artists.
81 Donat or Donatien Nonotte or Nonnotte (1708–85). Student of Lemoyne. Re-
 ceived as a full royal academician on August 26, 1741.
82 Antoine Boizot (1702–82). Received as a full royal academician on May 25, 1737.

LEBEL[83]

58. *Several Landscape Paintings*

I'd very much like to know how it is that Chardin, Vernet, and Loutherbourg don't make all these artists abandon their brushes. But then Homer, Horace, and Virgil wrote, and I dare to write in their wake. So, Monsieur Lebel, go right ahead and paint.

In one there's a gorge through some mountains, those to the right high and in shadow, those to the left low and in the light, with a few travellers crossing them. In another one there's another gorge through the mountains; those to the right high and in shadow, those to the left low and in the light, with a torrential stream roaring through the gap.

Figures bad, nature false, not the slightest spark of talent. Monsieur Lebel doesn't understand that a landscapist is a portrait painter whose sole merit consists of his ability to capture a likeness.

PERRONEAU[84]

Among his portraits there was one of a woman worth looking at; well drawn, better than usual for him; it seemed alive, and the shawl was really convincing.

VERNET[85]

View of the port of Dieppe. The four times of day. Two views of the environs around Nogent-sur-Seine. A shipwreck; another shipwreck. A marine at sunset. Seven small landscapes; two more marines. A storm, and several additional paintings listed under the

83 Antoine Lebel (1705–93). Received as a full royal academician on August 27, 1746.

84 Jean-Baptiste Perroneau (1715–83). Student of Natoire and Laurent Cars. Granted provisional membership on August 27, 1746; received as a full academician on July 28, 1753.

85 Claude-Joseph Vernet (1714–89). Granted provisional membership on August 6, 1746; received as a full academician on August 23, 1753.

same number. Twenty-five pictures, my friend, twenty-five pic-
tures! His speed is like the Creator's, his truth is like that of Nature.
A painter wouldn't have been wasting his time devoting two years
to almost any of these compositions, and Vernet produced them all
in that time. What incredible lighting effects! What beautiful skies!
What water! What compositional intelligence! What prodigious
variety in these scenes! Here, a child who's survived a shipwreck is
carried on his father's shoulders; there, a dead woman stretched out
on the shore, with her distraught husband. The sea roars, the wind
whistles, the thunder cracks, the pale, sombre glow of lightning
pierces through the clouds, momentarily revealing the scene. One
hears the noise of a ship's hull being breached, its masts tipped over,
its sails ripped. The crew is terrified; some on the bridge lift their
arms towards the heavens, others throw themselves into the water,
the waves smash them against the neighboring rocks where their
blood intermingles with the whitening foam; I see some of them
floating, I see others about to be swallowed up, I see still others
straining to reach the very shore against which they'll be dashed to
pieces. The same variety of character, action, and expression prevails
among the spectators: some of them shudder and turn away, others
offer help, others still are immobilized by what they're seeing; some
have lit a fire at the foot of a boulder; they busy themselves trying
to revive a dying woman, and I find myself hoping they'll succeed.
Direct your gaze at another sea, and you'll see serenity and the full
complement of its charms: tranquil, smooth, smiling waters stretch-
ing into the distance, their transparency diminishing and their sur-
face gloss increasing all imperceptibly as the eye moves out from the
shore to the point at which the horizon meets the sky; the ships are
immobile, sailors and passengers alike indulge in whatever diversions
might outwit their impatience. If it's morning, what hazy vapors
rise! How they refresh and revivify the objects of nature! If it's
evening, how profoundly the mountain peaks sleep! How nuanced
are the colors of the sky! How wonderfully the clouds move and
advance, casting the hues with which they're colored into the water!
Go into the countryside, direct your gaze towards the sky, note
carefully the phenomena of that single instant, and you'll swear a
patch of the great luminous canvas lit by the sun has been cut
away and transferred to the artist's easel; or close your hand, make
a tube of it through which you can see only a small segment of the
large canvas, and you'll swear it's a picture by Vernet that's been
taken from his easel and moved into the heavens. While of all our
painters he's the most prolific, he's the one that makes me work
the least. It's impossible to describe his compositions; they must be
seen. His nights are as affecting as his days are beautiful; his ports
are as beautiful as his original compositions are pungent. Equally

marvellous, whether his brush is captive to natural givens, or his muse, liberated from its shackles, is left to its own devices; incomprehensible, whether he uses the day star or that of night, natural or artifical light, to illuminate his paintings; always harmonious, vigorous, and controlled, like those great poets, those rare men in whom judgment and verve are so perfectly balanced they're never exaggerated or cold; his utilitarian structures, his buildings, his attire, his actions, his men, his animals all ring true. He's astonishing from close up and even more astonishing from a distance. Chardin and Vernet, my friend, are two great magicians. One would say of the latter that he begins by creating the topography, and that he has men, women, and children in reserve whom he uses to populate his canvas as one populates a colony; then he adds weather, sky, season, good or bad fortune to suit his taste; he's Lucian's Jupiter, who, tired of hearing human beings complain, rises from the table and says: "Hail in Thrace" and instantaneously one sees trees stripped, harvests smashed, huts destroyed and blown away; "Plague in Asia" and one sees the doors of houses closed, streets deserted, and men in flight; "Here, a volcano" and the earth trembles underfoot, buildings collapse, animals take fright, and city dwellers head for the countryside; "There, a war" and entire nations take up arms and slit one another's throats; "In this region a poor harvest" and the old laborer perishes from hunger at his doorstep. Jupiter calls that governing the world, and he's wrong; Vernet calls that making paintings, and he's right.

66. *View of the Port of Dieppe* (Pl. 22)

Immense and imposing composition. Sky lightly overcast, silvery. Handsome mass of buildings. Lively, picturesque view: a multitude of figures busy fishing, preparing and selling the catch, working, mending the nets, and other such tasks; gestures truthful and unforced; figures lively and vigorous of touch; however, as I must be totally candid, neither as lively nor as vigorous as usual.

67. *The Four Times of Day*

Lighting effects that couldn't be more beautifully controlled. Examining these works, I can't get over the special talents, the specific strengths distinguishing them from one another; what results from this? In the end, you begin to think this artist has every talent, that he's capable of anything.

68. *Two Views of Nogent-sur-Seine*

Excellent lesson for Leprince, whose compositions have been placed next to Vernet's; he won't lose what he has, and he'll learn what he lacks. There's much intelligence, levity, and simplicity in Leprince's figures, but there's also weakness, dryness, lack of effect. The other artist's surface handling is of a piece, he's always assured, and smothers his neighbor. His distant prospects are hazy, his skies airy; the same can't be said of Leprince. But the latter doesn't lack merit; at a certain distance from Vernet he gains in strength and grows more beautiful; the other one eclipses and obliterates him. This cruel juxtaposition is another of Chardin's pranks.

69. *Two Pendants, One a Shipwreck, the Other a Landscape*

The landscape is charming, but the shipwreck is something else again; the figures are particularly arresting. The wind is terrible, the men are finding it difficult to remain standing. Look at the drowned woman who's just been pulled from the water, and remain untouched by her husband's pain if you can.

70. *Another Shipwreck by Moonlight* (Pl. 23)

Consider carefully the men busy reviving a woman collapsed by a fire they've built beneath a rock, then pronounce this to be one of the most interesting groups imaginable. And how this touching scene is lit! How the reddish glow of the fire washes over it! What contrast between the pale, weak light of the moon and the strong, red, sad, and sombre light of the flames! It's not every painter who can oppose such discordant phenomena as these and remain harmonious, who can avoid falsifying the point where these two lights meet and blend, generating a special lustre.

71. *A Marine or Sunset*

If you've seen the sea at five o'clock in the evening you know this painting.

72. *Seven Small Landscape Paintings*

I'd like to find a mediocre one, I'll tell you when I do. Even the weakest of these is beautiful, I mean beautiful by conventional

standards, for there are one or two below the artist's own that Chardin has hidden. Think as well of the other works as suits you.

The young Loutherbourg also exhibited a night scene that we might have been able to compare with Vernet's, if only the hanger had wanted; but he placed these two compositions at opposite ends of the Salon: he was afraid the two works might cancel each other out. I've looked hard at them, but I confess to having problems judging between them. There is, it seems to me, greater vigor in the one, greater harmony and resolution in the other. As for their interest, fields and animals seeking to warm themselves beneath rocks cannot be compared with a dying woman being revived. Nor do I think the landscape occupying the balance of Loutherbourg's canvas can be compared with the seascape in Vernet's painting. Vernet's light is infinitely truer and his handling infinitely more refined. To summarize: Loutherbourg would be proud to have produced Vernet's painting; Vernet would not be ashamed to have produced Loutherbourg's.

One of the set of Four Seasons,[86] the one with the mill in the right background, with a running stream around it and women doing their washing on its banks, made a singular impression on me through its color, freshness, variety of objects, the beauty of its site, and the vividness of its depiction of nature.

The rest of the landscapes make one say: "Aliquando bonus dormitat Homerus."[87] These yellowish rocks are wan, pointless, without effect; the same hue prevails throughout; composition with a liver disease. The pilgrim traversing them is wretched, paltry, hard, and dry. A painter concerned for his reputation would not have painted this work; a painter envious of his colleague's glory would have given it great prominence. I like seeing that Chardin is so decent.

Another composition suffering from a liver disease: this work is as dry, as monochromatic, as wan, as cold, as dingy as the preceding one. Chardin stuck it in the same corner. Monsieur Chardin, you are to be congratulated for this.

In this article on Vernet there are, my friend, a few repetitions of things I wrote two years ago, but as the artist showed me the same genius and the same handling, I had no choice but to reiterate the same praise. I hold to my opinion: Vernet challenges Claude Lorrain in the art of raising an atmospheric mist on canvas, and is infinitely his superior in scenic invention, figural drawing, variety of incident, and the rest. The first is purely and simply a great landscapist, the

86 There was no set of Four Seasons in this Salon; Diderot was perhaps thinking of the *Four Times of Day* series (no. 67 above).

87 "Sometimes even Homer nods": Horace, *Ars Poetica*, Book I, v. 359. The original Latin reads: "et idem indignor quandoque bonus dormitat Homerus."

other is a history painter. In my view Claude selected natural phenomena that are rarer and perhaps for this reason more striking; Vernet's atmosphere is more ordinary, and for this reason more easily recognizable.

ROSLIN[88]

77. *A Father Returning to his Estate,*
where he is Greeted by his Family

This painting is a group portrait of the entire La Rouchefoucault family, one of the most illustrious in France, and one of the most respectable by reason of its virtue and the nobility of its sentiments. There was competition between Roslin and Greuze for the commission. Our amateur Monsieur Watelet, whose knowledge of painting can be judged from his poem,[89] and Monsieur de Marigny,[90] head and protector of the arts, decided the matter in favor of Roslin. Let's see what he's come up with, and then we'll say a few words about what the other one had proposed to do.

Roslin's painting represents the Duc de La Rochefoucault, the head of the family, deceased several years ago. He's returning to one of his estates, where his family awaits him. His two daughters, the Duchesse d'Enville and the Duchesse d'Estissac, move towards him; they're followed by their own children. The figures are small-scale. My description will begin at the right and proceed towards the left of the canvas.

The first thing one sees is a country coach, along with the coachman on his seat and some footmen in the livery of the La Rochefoucault family. Towards the forward door, a peasant woman seen from the back, holding out her apron to receive some sort of gift. At this woman's feet a child, also seen from the back, kneeling, bending over a hamper. Then another servant. Further

88 Alexandre Roslin (1718–93). Portraitist of Swedish origin. Granted provisional membership in the Royal Academy on July 25, 1753; received as a full academician on November 24, 1753. As he was a Protestant, a royal waiver of the standing prohibition against non-Catholics was required; this was granted in February of 1754.

89 *L'art de peindre* (1760).

90 Abel-François Poisson, marquis de Marigny (1721–81). The younger brother of Madame de Pompadour; Director of the King's Buildings 1751–73.

forward, a child, in shirt and pants but barefoot and hatless, with a group of peasants to which another valet distributes alms. In the center of the canvas, the head of the family, with one of his granddaughters behind him. In front of him, his two daughters followed by their children move forward very deliberately. Behind this group, at a certain distance, a young man bowing limply: this is the eldest son of the Duchesse d'Estissac. Near him, two other young children. At the extreme left, a young girl. Such are the figures and some of the accessories. Spread a wide green terrace across the background, and you'll have Roslin's sublime composition in its entirety.

And never was a composition stupider, flatter, more dispiriting. The figures are so stiff it's been dubbed the Game of Skittles. At first glance one seems to be at Nicolet's theatre, in the middle of one of his most outrageous burlesques.[91] One recognizes Father Cassandre by his slow, gaunt, sad, distracted air. The imposing creature moving forward in white satin, that's Mademoiselle Zirzabelle, and the lanky fellow bowing, that's Monsieur Liandre. As for the others, they're the family brats. The footmen, peasants, children, and coach as hard and dry as can be imagined; the other figures with blank faces, graceless, without dignity of demeanor. It's a ceremony so cold, so stiff it makes one yawn. What, these girls don't think to run up to their father with open arms, nor this father to open his arms to receive them, nor any of these little ones to break away from the others, crying out as they run, Hello, grandfather, Hello, grandfather? All these people don't seem to have been in any great hurry, but they should have been, for this is the family that, of all those in France, is the closest, the most decent, in which the love of one member for another is the strongest. The La Rochefoucault residence is the very dwelling of Paternal Tenderness, but there's not a hint of this in Roslin's canvas. Here there's neither soul, nor life, nor joy, nor truth: no soul, life, joy, or truth in the masters, no soul, life, joy, or truth in the servants; no soul, life, truth, joy, or animation in the peasants; it's a big, depressing firescreen. The large terrace, green and monochrome, that fills the foreground could very easily pass for the velvet from an old billiard table and manages to muffle, darken, and deaden the scene.

However, it must be admitted that there are fabrics, draperies, details imitated with the greatest verisimilitude; the softness, color, reflected light, and folds of Mlle Zirzabelle's satin, for example, couldn't be bettered. But if a person shouldn't be dressed like a

91 The theatre of Jean-Baptiste Nicolet (1726–96), extremely popular in the 1760s, was situated on the boulevards to the north of the city. It specialized in burlesque entertainments in the tradition of the Italian *commedia dell'arte*. The characters Diderot mentions were stock figures of the productions there.

mannequin, neither should a mannequin be dressed like a person. The truer the drapery, the more the whole will offend if the figures ring false. Likewise for the perfect embroidery here: the more flawless it is, the more it emphasizes the falsity of the objects to which it's applied. When all the figures are rendered with dummy-like stiffness, the drapery must be too. You want to grasp the full truth of my observation? Fix a beautiful swatch of embroidered fabric to a wooden arm, and you'll see how its workmanship and the richness of its stitching and the truth of its folds wither and stiffen this wooden arm even more.

This exceptional work cost fifteen thousand francs, and even if a man of taste were offered anything in the world to accept it, he'd refuse. A single head by Greuze would have been preferable. But, you say to me, Greuze paints portraits, and far better than Roslin, too. —This is true. —Greuze knows how to compose, and Roslin doesn't understand anything about this. —Agreed. —Why then did Watelet and Marigny . . . —Who can claim to understand the motivations of these bigwigs? Greuze proposed to bring the family together in a salon, in the morning, the men busying themselves with experimental physics, the women sewing, with the children disturbing and irritating both in turn; even better, he proposed bringing peasants, fathers, mothers, brothers, sisters, and children into the master's château, all full of gratitude for the aid he'd given them during the bad season of 1757: in that unhappy year Monsieur de La Rochefoucault sacrificed sixty thousand francs to provide work and food for all those living on his property. Six liards and two sous were given to five-year-olds who collected stones in a basket.[92] This was the action that should have been memorialized in paint, and you'll readily agree that this spectacle would have produced an effect very different from that of Father Cassandre's flattery, Monsieur Liandre's bows, Mlle Zirzabelle's satin, and the whole Nicolet burlesque.

Roslin is now as fine an embroiderer as Carle Van Loo used to be a great dyer;[93] he could have been a real painter, but he'd have had to come to Athens very early. It's there that, at the expense of honor, good faith, virtue, and morals, surprising progress was made in the realm of taste, in the feel for grace, in the knowledge and choice of character, expression, and other accessories in an art that presupposes the subtlest, most delicate tact, the most exquisite judgment, untold nobility, a kind of elevation, a multitude of refined qualities, delicious vapors rising from corrupt depths. Your artists, my friend, would have verve, but one that's austere, rustic and wild.

92 "Liard" and "sous" were French currency denominations.

93 In contemporary studio slang, the phrase used here ("un grand teinturier") designated an artist who was a poor colorist, giving everything a similar cast as if it were being seen through a gel.

The Goths, the Vandals could organize a scene, but how many centuries need to pass before they learn, I don't say how to compose like Raphael, but to sense how nobly, simply, and grandly Raphael composed! Do you think that today, in Neuchâtel or Berne, the fine arts can have the same character they once had in Athens or Rome, or even the one they used to have in Paris? No, the state of our morals precludes this. Peoples have been broken down into small groups, each speaking its own harsh, barbarous prattle. There's no competition between one little sovereignty and another, and sometimes the emulation and ferment of twenty million people are necessary if a single great artist is to emerge from the crowd. Take the sixty thousand workers employed in our Lyon manufactory, disperse them throughout the realm, perhaps the quality of workmanship will remain the same, but the taste will be lost. It's a national characteristic that Roslin brought with him to France, and he's retained it. If Mengs produces marvels, it's because he left his country young, because he's in Rome, because he's never left there; take back his trip across the Alps, separate him from the great models, confine him to Dresden or some similar place, and then seen what becomes of him. And why wouldn't I swear to you that he'd have been debased, ruined before reaching the age of ten, I, who every day, here in the capital, see our own teachers and students lose the sense of grandeur they'd acquired by studying the Roman school; I, who know about the effect of residing in the provinces from first-hand experience; I, who lived in the same garret with Preisler[94] and Wille[95] and know what happened when one went to Copenhagen and the other stayed in Paris? Preisler was much more gifted than Wille, but today he's nothing, and Wille has become the finest engraver in Europe. To date I've encountered only one man whose taste remained pure and intact in the midst of barbarians, and that's Voltaire; but what general conclusions can be drawn from a bizarre being who turns generous and gay at an age when others become avaricious and glum?

78. *Head of a Young Girl*

This effort in oilstick [*pastel à l'huile*] doesn't displease me; this medium is solid, it will hold up better than the precious powder applied to the canvas by the pastel painter, which falls off as easily as scales from a butterfly's wings.

94 Johann Martin Preissler (1715–94). Engraver, summoned to Copenhagen to serve the King of Denmark. In 1781 his son, Johann Georg Preissler, moved to Paris and became Wille's student.
95 Jean-George Wille, engraver; see below, pp. 183 ff.

79. More Portraits

His other portraits, including those of Madame Adelaide and Madame Victoire of France,[96] are ordinary, to avoid saying anything worse. No transparency. The imperceptible transitions, the delicate modulations that make for harmony are not to be found here. They're all one color (I don't say local color), they're solid rouge and makeup.

Our two Daughters of France, awkward, stiff, massive, ignoble, tedious, plastered with rouge, very much resemble two hairdresser's mock-ups loaded down with beads, combs, ornaments, little chains, pointed tips, tasselled fringes, flowers, festoons, with the entire stock of a fashionable boutique; or, if you prefer, two fat creatures one can't look at without laughing, so shockingly bad is their taste. The laces, however, are superb.

VALADE[97]

We owe, my friend, a bit of thanks to our bad painters, for they spare both your copyist and my time. Please convey my gratitude to Monsieur Valade, if you ever meet him.

Roslin is a Guido Reni, a Titian, a Paolo Veronese, a Van Dyck in comparison with Valade.

DESPORTES the nephew[98]

Don't forget to thank Monsieur Desportes as well.

Desportes the nephew paints animals and fruit. Here is one of his works, and not the worst of them.

96 Two of the unmarried daughters of Louis XV.
97 Jean Valade (1709–87). Granted provisional membership in the Royal Academy on November 28, 1750; received as a full academician on November 28, 1754.
98 Nicolas Desportes, known as the nephew (1718–87). Nephew of François Desportes. Student of his uncle and Rigaud. Granted provisional membership in the Royal Academy on May 31, 1755; received as a full academician on July 30, 1757.

Imagine to the right a tall tree; hang from its branches a hare grouped with a duck; underneath hang up a leather sack, a game pouch, and a powder box; spread out on the ground a rabbit and a few pheasants. Place in the center of the painting, in the foreground, a reclining dog keeping watch over the game at the tree's foot, and in the background a greyhound who turns his head and stares at the suspended game.

This doesn't lack for color or for truth. Monsieur Desportes, wait until Chardin is no more and we'll pay attention to you. I'm not especially interested in this work, nor in the one in which we see on a marble table to the right some books lying flat with a large folio upended, supporting an open music book with a violin leaning against it; at left, a garland of white muscat grapes, some fruit, some plums, some detached grapes and some roses; but my preference goes to the former. You saw how hard and coarse these works are; well, of the twenty thousand people drawn to the Salon by our painters, I'd wager there aren't fifty capable of distinguishing these paintings from those by Chardin. You work, you take infinite pains, rubbing out, painting, repainting, and for whom? I know your answer by heart. For this small, invisible church of the elect, you tell me, that eventually influences the opinion of the multitude, and that sooner or later makes sure an artist receives his due. Yes, but while waiting he's lost in the crowd, and he dies before your clandestine apostles have converted the blockheads. My friend, one must work for oneself, and the man who doesn't find reward enough in his own work, who doesn't find sufficient recompense closed up in his studio, drunk with enthusiasm for his craft, would do better not to work at all.

MADAME VIEN[99]

83. *A Pigeon Sitting on Her Eggs*

She's on her nest. One sees bits of straw sticking out from beneath the bird at irregular intervals. She feels safe. Without seeing the nest, a pigeon expert like yourself would guess what she's doing. She's in profile, and it's as if we saw all of her; her brown plumage is of the greatest truth; her head and neck are entirely convincing. The

99 Marie-Thérèze Reboul Vien (1728–1805). Student of her husband Joseph-Marie Vien; received as a full royal academician on July 30, 1757.

finesse and precious finish of this work make one pause to savor them. If I didn't fear being accused of harping on trivialities, I'd say the nest's blades of straw are underpainted in the foreground, and that the ones further back are overpainted.

DE MACHY[100]

What wonderful opportunities for study there are at the Salon! What insights can be gained by comparing Van Loo with Vien, Vernet with Leprince, Chardin with Roland, De Machy with Servandoni! One needs to be accompanied by a skilled, candid artist who lets us see and speak as we like but who from time to time pushes our nose up against beautiful things we'd otherwise have missed and against bad ones we'd have praised to the skies. Before long one begins to understand technique; as for the ideal, that can't be taught, but anyone who can judge a poet on this score can also judge a painter; our guide will make us aware that in some cases the artist preferred a less truthful action, a weaker character, a less striking posture to others whose advantages he grasped fully, but whose use would have entailed more loss than gain for the composition as a whole. De Machy elicits approval when viewed in isolation; when compared with Servandoni, he seems wretched. Seeing the one enlarge small things, one feels that the other shrinks large ones. The firm, vigorous color of the first brings out the mealy, grey paleness of the second; however dense one might be, one has to be struck by the staleness, the insipidity of the latter when contrasted with the verve and warmth of the former. Let's get down to specifics.

The Portal of Saint Genevieve on the Day the King Laid its Foundation Stone (Pl. 24). This portal, which is grand and noble, has become a little house of cards under De Machy's brush. The uproar, the crush of people in which several citizens were wounded, suffocated, squashed isn't here, Monsieur De Machy gives us no trace of it, replacing it with little battalions of perfectly erect marionettes, carefully aligned, carefully disposed in parallel rows; the cold symmetry of a procession instead of the movement and disorder of a

100 Pierre-Antoine de Machy (1723–1807). Student of Servandoni. Granted provisional membership in the Royal Academy on November 29, 1755; received as a full academician on September 30, 1758.

grand ceremony. There's neither verve, nor variety, nor character, nor color, nor intelligence; overall effect empty, flat. Cochin's court balls are infinitely preferable.

The *Louvre Colonnade*, De Machy's second painting, conveys no idea of its subject; what's surprising about it is how it reduces one of grandest, most imposing monuments in the world to nothing; inscribe beneath this work: "magnus videri, sentiri parvus": for it's the exact reverse of Servandoni. De Machy knows how to transform what's noble and grand into something small and shabby.

The Passage Underneath the Louvre Peristyle on the Rue Fromenteau Side, third work. Entirely in grey; imposing architecture impoverished once again; this is the man's special talent. There is, however, a ray of sunlight falling from inside the courtyard that's effective.

The Construction of the New Grain Market (Pl. 25), the fourth work, is flat, grey again, lacking in understanding of light; it's a real magic-lantern image. As he shows cranes, scaffolding, bustle, and creates a flickering effect through juxtaposition of shadows that are black, very black, with light that's bright, very bright, I'm convinced that if were projected onto a large sheet children would find it delightful.

As for these other ruins, I don't know what they are; nor do you, nor does anyone.

DROUAIS, portraitist[101]

Extend my warm thanks to Drouais along with your own; you get my meaning.

All this man's faces are no more than the finest rouge artistically deposited on the finest, whitest chalk. Let's pass over these portraits quickly, quickly, to pause a moment in front of this *Young Man in Spanish Dress Playing the Guitar*. To be sure, his character, attire, and face are charming, and if a child of this age and appearance went strolling in the Palais Royal or the Tuileries gardens he'd draw stares from all our women, and in church even the most pious ladies

101 François-Hubert Drouais (1727–75). Student of his father Hubert Drouais, then of Nonotte, Carle Van Loo, Natoire, and Boucher. Granted provisional membership in the Royal Academy in 1755; received as a full academician on November 25, 1758.

would be distracted by him; but he's handsome like all those ladies
we see passing by in their gilded chariots on the boulevards, over-
loaded with rouge and pompons. There's not a single one who
seems ugly in her carriage, and there's not a single one who makes
an unpleasant impression on canvas. This isn't flesh, for where are
life, mellowness, transparency, tonal variety, transitions, nuances? It's
a mask made from the fine leather used in Strasbourg gloves; this
young man whose youth, graceful pose, and luxurious attire render
him so attractive is nonetheless cold, insipid, and dead.

Suppose, my friend, that this *English Boy* you want me to talk
about had truthful coloring, and the work would be precious, for
he's well dressed and has a naive expression and character that are
quite arresting. He seems even more original than the *Little Rascal*
that enjoyed such success at the preceding Salon.

JULIARD[102]

The same polite gesture, if you please, to Monsieur Juliard as to
Monsieur Drouais. If you find a single soul living in Paris, other
than Monsieur de La Ferté of the "Lesser Pleasures,"[103] who knows
that Monsieur Juliard made a *Landscape, Two Landscapes, Three Land-
scape Drawings*, I was mistaken in not seeing and admiring them, in
keeping quiet about them. However, my friend, my motto is not
that of the wise Horace, "nil admirari"; if such is the only way to
obtain and preserve happiness, Denis Diderot is indeed to be
pitied ... You tell me I misunderstand the poet's "nil admirari"? It
means: One should be astonished at nothing ... Grimm, take care;
one can scarcely admire something that doesn't astonish; and rest
assured that if Monsieur de La Ferté, the owner of Monsieur
Juliard's works, admires them, it's because he's more or less aston-
ished by the artist's prodigious talent.

102 Nicolas-Jacques Juliard or Julliard or Juliart or Juliar (1715–90). Student of
 Boucher. Granted provisional membership in the Royal Academy on August 31,
 1754; received as a full academician on July 28, 1759.
103 Juliard was employed by the "Lesser Pleasures" ("Menus Plaisirs"), the agency
 charged with the design and fabrication of a wide range of ephemeral decoration
 for the crown. At this time Papillon de La Ferté was the intendant of the "Menus
 Plaisirs".

CASANOVA[104]

This Casanova is a great painter. He has imagination, he has verve; his brain gives forth horses that whinny, caper, bite, kick, and fight, men who slaughter one another in a hundred different ways, smashed skulls, pierced chests, screams, threats, fire, smoke, blood, the dead, the dying, all the confusion, all the horror of a free-for-all. He also knows how to arrange the most tranquil of compositions, how to depict soldiers marching or resting as well as in battle, and several of the most important technical skills are his to command.

94. *Soldiers Marching*
Large painting

This is one of the most beautiful, most picturesque machines known to me. What a handsome spectacle! What grand, beautiful poetry! How can I transport you to the foot of these rocks that touch the sky? How can I show you this broad-beamed bridge supported by rafters, thrown from the summit of these rocks towards this old château? How can I give you an accurate idea of this château, of the crumbling antique towers that compose it and of the other vaulted bridge that unites and separates them? How will I make the torrent rush down from the mountains, hurl its waters beneath this bridge, and disperse them around the elevated site on which this mass of stone is built? How portray the march of the army advancing along the narrow path contrived at the top of the rocks, leading these men laboriously, tortuously from the summit of these rocks to the bridge giving access to the château? How make you fear for these soldiers, for these heavy, overburdened baggage carts passing from the mountain to the château across this shaky wooden structure? How open up for you the deep dark precipices visible through the rotting wood? How manage to make all these people pass through one of the tower's gates, how lead them through these gates underneath the stone arch that links them together and then scatter them over the plain? Once scattered, you'll make me describe how some bathe

104 Francesco-Giuseppe (or François-Joseph) Casanova (1727–1802). Student of Francesco Guardi (in Venice) and Francesco Simonini (in Florence). Received as a full royal academician in 1763; he exhibited at the Paris Salon from 1763 to 1783. He was the brother of Jacques Casanova, the celebrated erotic adventurer and memoirist.

their horses while others quench their thirst, how some recline
casually on the shore of this vast, serene lake while others gather
beneath a tent they've made from a large sheet attached here to a
tree trunk, there to an edge of rock, drinking, talking, laughing,
eating, sleeping, sitting, standing, lying face up, lying face down,
men, women, children, weapons, horses, baggage. But perhaps
while despairing of summoning up in your imagination so many
animate and inanimate objects, they're there and I did it; if such is
the case, God be praised! But this doesn't exhaust my obligations.
Allowing Casanova's muse and mine to catch their breath, let's
examine his work a bit more objectively.

To the spectator's right, imagine a mass of large rocks of unequal
height; on the lowest of these rocks a wooden bridge extending
from their summit to the foot of a tower; this tower linked and
separated from another tower by a stone arch, the whole of this old
military construction built on a hillock; waters descending from the
mountains pass beneath the wooden bridge, beneath the stone arch,
flowing behind the hillock and forming at its left a broad lake.
Envision a tree at the hill's foot, cover the hill with moss and
greenery; prop a thatched hut against the tower to the right; make
shrubs and parasitic plants emerge from the dilapidated stones of
both towers; prickle the tops of the mountains at left with a few of
them too. Beyond the lake created by the stream at right, imagine
some distant ruins and you'll have an idea of the locale. Now for the
course followed by the army.

It marches from the summit of the mountains to the right along
a precipitous path; it crosses the wooden bridge joining the lowest
of the mountains to the foot of one of the château's towers; it winds
around the hill on which the château is built, arriving at the stone
arch linking the two towers; it passes beneath this arch, and from
there it scatters left and right around the hill, along the shore of the
lake, and arrives, hugging the bottom of the mountains at whose
peak it began. Lifting his eyes, each soldier can measure fearfully the
full height from which he's descended. Now let's move on to
details.

At the summit of the rocks one sees a few soldiers in their
entirety; as they progress along the precipitous path, they disappear;
they appear once more when they embark upon the wooden bridge.
A baggage cart is on this bridge; a large part of the army has already
wound around the hill, has passed beneath the stone arch, and is
resting. Imagine around this hill, on which rises the château, all the
incidents characteristic of military camps, and you'll have Casanova's
picture; it isn't possible to enumerate all these incidents, their
variety is infinite; and what I sketched in the opening lines should
suffice.

Ah! If only the technical components of this composition were equal to the idea! If only Vernet had painted the sky and water, Loutherbourg the château and the rocks, and some other great master the figures! If only all these objects situated on their various levels of depth had been lit and colored in accordance with their spatial placement! This painting demands to be seen at least once in one's life, but unfortunately it completely lacks that perfection these other hands would have given it. It's a beautiful poem, well conceived, well laid out, but badly written.

This picture is sombre, lacklustre, muffled. At first the canvas seems to offer only the accidents having befallen a large piece of scorched bread, an impression that undercuts and destroys the effect created by the huge rocks, the large mass of stone rising in the middle of the canvas, the marvellous wooden bridge, and the precious stone arch, that undercuts and destroys the effect of this infinite variety of groupings and actions. There's no intelligence in the color tones, no aerial perspective, no air between objects, the eyes are hindered and discouraged from wandering. The objects in the foreground have none of the vigor demanded by their placement. If the scene transpires close to the viewer, the figure closest to him should be at least eight times larger than one that's about sixteen meters behind this figure; either the foreground is handled forcefully, or there's no truth, no effect. If on the other hand the scene unfolds deep within the canvas and the viewer is far away from it, the objects will be imperceptibly diminished and will require the softest of tones, because there will be a greater expanse of air between the eye and the scene. Proximity to the eye separates objects, while distance presses them together and blends them. This is the A B C that Casanova seems to have forgotten. But how is it, you ask me, that here he's forgotten what other work shows him to know well? Shall I answer you as I see it? It's because elsewhere his organization is his own, he's its inventor; here I suspect he's only its compiler. He opened his print folder and skillfully mixed together three or four landscapes, compiling an admirable sketch from them, but when he set out to paint this sketch all his skill, craft, talent, and technique abandoned him. If he'd observed the scene in nature or in his head, he'd have seen it replete with its own spatial recession, sky, and water, with its own light and colors, and would have executed it accordingly. Nothing is commoner and more difficult to recognize than plagiarism in painting; perhaps I'll have occasion to talk about this further on. In literature it's betrayed by style, in painting by color. However that may be, how many are the beauties destroyed by the monotony of this work, one which nonetheless, because of its poetry, variety, fecundity, and detail, is Casanova's most beautiful production.

95. A Battle

It's an encounter between Europeans. One sees in the foreground a soldier who's dead or wounded; nearby a cavalryman whose horse is pierced by a bayonet; this cavalryman fires a pistol at another who raises his sabre above him. Towards the left, a felled horse whose rider has been thrown backwards. In the background a scuffle between combatants. To the right, in the foreground, rocks and broken trees. The sky is illuminated by gunfire and darkened by smoke. There's the coldest possible description of a very heated engagement.

95. Another Battle

This is an engagement between Turks and Europeans. In the foreground, a Turkish ensign whose horse has been felled by a blow to its left thigh; the rider seems to pull the flag over his head with one hand, wielding his sabre defensively with the other. But a European has gripped the standard and threatens the enemy's head with his sword. In the right background, soldiers variously attacking and attacked; among these soldiers one stands out, sabre in hand but motionless before the spectacle. In the left background, the dead, the dying, the wounded, and other soldiers all but resting.

This last battle, it's beautiful colors taken from the palette and transferred to the canvas, but no form, no effect, no drawing at all. And why? Because the figures are a bit too large, and our Casanova doesn't know how to execute them. The larger a work, the more difficult it is to retain the qualities of the sketch for it.

The preceding composition in which the figures were smaller is better; but at least both have fire, movement, action; in both the weapon thrusts are in earnest, as are the defensive foils, the attacks, and the mortal blows; they capture my image of the horror of an encounter.

Casanova is not a meticulous draftsman; his figures are short. While his compositions are energetic, I find them monotonous and sterile; a large horse, with or without rider, is always in the middle of his canvases. I know very well that it's difficult to imagine an action more noble, more beautiful than that of a fine horse rearing up on its hind legs, its two others impetuously thrust forward, its head cocked back, its mane flying, its tail agitated, clearing a place for itself in the middle of a cloud of dust; but is the beauty of an object sufficient justification for repeating it indiscriminately? Others tend to structure their compositional pyramids from bottom to top, this fellow orients his pyramids from the surface of the canvas into depth: another source of monotony in his work. There's always a

point in the center of the canvas, very prominent in the foreground, the summit of the pyramid, from which objects are made progressively to recede and cover a wider area until the most distant and most extended of the planes is reached, the base of the pyramid. This organizational principle is so characteristic of him that I'd recognize it from the far end of a gallery.

96. *A Spanish Rider*
Small composition

The Spaniard is on horseback, he occupies most of the canvas. The figure, the horse, and the action couldn't be more natural. To the right is a troop of soldiers marching into the background; at left, hazy mountains.

Fine little picture. quite vigorous, quite vividly colored, and quite true. Handling expert and skillfull, overall effect successful, without harshness. Buy this little painting and you can be sure you'll never tire of it, unless you were born fickle. One sometimes leaves the most attractive woman for no reason other than the length of time one's been with her; one occasionally becomes bored with the sweetest of pleasures without quite knowing the reason. Why should it be otherwise with paintings? What an agreeable thing is life. The same habits that govern human attachments make us tire of possessions once we've obtained them and yet feel our loss of them all the more intensely when they're gone. What a state of affairs! Have you ever been able to fathom it?

BAUDOUIN[105]

A nice young man, attractive, kind, witty, a bit of a libertine. What does this have to do with me? My wife has passed her forty-fifth year, but he won't get near my daughter, neither he nor his compositions.

There were quite a few little pictures by Baudouin in the Salon, hung in a window embrasure, and all the young girls, after having looked distractedly at a few paintings, ended up where they could see *The Peasant Girl Quarreling with her Mother*, and *The Cherry Picker*; it was this window bay that they studied most attentively. At a

105 Pierre-Antoine Baudouin (1723–69). Received as a full royal academician on August 20, 1763. He was a student of Boucher and became his son-in-law.

certain age one would rather read a libertine book than a good book, and one prefers looking at a dirty picture to looking at a good picture. Some old men are even punished for such sterile predilections by having them live on; a few such men, canes in hand, backs hunched over, eyeglasses on their noses, were also seen to gather in front of Baudouin's base little productions.

98. *The Confessional* (Pl. 26)

A confessional is occupied by a priest. He is surrounded by a gaggle of young girls who've come to admit to sins they've committed or would commit all too willingly; so much for the confessor's left ear. His right ear will be filled with the idiocies of the elderly men and women and youngsters that occupy that side. By chance, or due to a rainstorm, two tall brazen fellows have come into the church. They knowingly assess the crowd of young penitents. A scandal ensues; the priest hurls himself from his booth, he dresses down the two impudent intruders. This is the moment depicted in the painting. One of these young men, lorgnette in hand, with an ironic, contemptuous air, his head turned towards the confessor, is tempted to respond in kind. His comrade, insisting that the affair could take a serious turn, tries to constrain him. Most of the young girls have hypocritically lowered their eyes. The elderly men and women are incensed; the youngsters behind their parents smile. This is clever; but our pious archbishop, who won't hear of clever jokes like this, insisted the work be removed.

99. *Hope Unfulfilled*

In a small room, a boudoir appointed for pleasure, one sees a lover casually reclining on a chaise longue, disinclined to renew the efforts that induced his fatigue; standing beside him, a prostitute in a nightgown, irritated, as if saying to him as she freshens her rouge: What, is that all you know how to do?

100. *The Cherry Picker* (Pl. 27)

One sees a tall young gardener in a tree picking cherries; at the foot of the tree a young peasant girl ready to catch them in her apron. Another peasant girl sitting on the ground, looking at the picker; between her and the tree, a donkey fitted with baskets, eating. The gardener has thrown his handful of cherries into the girl's lap, but

two attached to the same stem have remained in his hand, hanging
from his middle finger. A poor joke, a flat, crude idea. But I'll have
my say about these matters at the end.

101. *Little Gallant Idyll*

To the right, a farmhouse with its dovecote. At the farmhouse door,
below the dovecote, a young peasant girl seated, or rather voluptu-
ously reclining on a stone bench; behind her, her younger sister,
standing. They both observe two pigeons on the ground some
distance away, caressing one another. The elder girl dreams and
sighs; the younger one signals with her finger, cautioning her not to
startle the birds. At the top of the house, at a hayloft window, a
peasant boy smiles mischievously at one's voluptuous indiscretion
and the other's guileless concern. I've described it just as it is; much
can be read into it but there's nothing here that makes one blush.
Around the bench a cauldron, some cabbages, some parsnips, a jug,
a tub, and other rustic objects have been scattered at random.

101. *The Awakening*

This is a young woman sitting on the edge of a canopied bed, from
which she's just risen. Standing somewhat further back, a chamber-
maid holds out her dressing gown; at her feet, further forward,
another chambermaid prepares to put on her slippers. I don't see
anything witty in this. Here are feet that will never slip into these
mules; that much is ridiculous and true.[106]

101. *A Young Girl Quarreling with Her Mother*

The scene is a wine cellar. The daughter and her sweetheart were
just on the point . . . just on the point . . . no more need be said, for
the mother has arrived just in time . . . just in time . . . which should
suffice to make the situation clear. The mother is extremely angry,
her fists are clenched on her hips. Her daughter, who is standing, a
freshly trampled bale of hay behind her, weeps; she's had no time to

106 "Voila des mules où ces pieds n'entreront jamais; cela est ridicule et vrai." In both
French and English, *mule* can mean either a slipper without a heel-back or the
offspring of a he-ass and a mare. This animal is the proverbial type of obstinacy.
Thus Diderot's closing remark is a racy joke; he is suggesting it was Baudouin's
subtext for the work.

adjust her corset and shawl, and they're all askew. Beside her, halfway up the cellar stairs, we see the back of a large fellow running off; the position of his arms and hands allows for no doubt about which article of clothing he's adjusting. Our lovers were well prepared; at the foot of the stairs, on a barrel, are a loaf of bread, some fruit, a napkin, and a bottle of wine.

This is quite lascivious, but one can go this far. I look at it, I smile, and I move on.

101. *A Young Girl Recognizing Her Child at Notre-Dame among the Foundlings, or the Strength of Kinship*

The church. Between two pillars, the foundlings' pew. Around the pew, a crowd, joy, commotion, surprise. Within the crowd, behind a nun, a tall girl holding an infant and kissing it.

A beautiful subject botched. I argue that the crowd ruins the effect, reducing a touching, moving event to an incident that's difficult to make out; that there's no silence, no serenity, and that only a few spectators should have been present. Cochin the draftsman–designer [*dessinateur*] responds that the more people there are in the scene, the more forceful the evocation of kinship ties will be. Cochin is arguing like a man of letters, and I'm arguing like a painter. You want to evoke the full force and intensity of these blood ties and yet retain the scene's calm, solitude, and silence? Here's how that might have been done, and how Greuze would have handled it. I imagine a mother and father have gone to Notre Dame with their family, which includes an elder daughter, her sister, and a young son. They come upon the foundlings' pew, the father, mother, and son on one side, the two sisters on the other. The elder girl recognizes her child; at that moment, overcome by maternal affection which makes her forget the presence of her father, a violent man from whom her lapse had been kept secret, she cries out, she rushes forward and picks up the infant; her younger sister pulls at her clothing, but in vain; she pays no heed. She whispers: My sister, what are you doing? Don't you realize the risk . . . Our father . . . The mother's face turns pale and the father takes on a terrible, menacing air: he casts a furious glance at his wife. The little boy, for whom all this remains a closed book, stares vacantly. The nun is amazed; a few spectators, men and women of a certain age, for there shouldn't be any others, react, the women with joy and pity, the men with surprise; and there's my composition, which is much better than Baudouin's. But the right expression for the elder daughter must still be found, and that won't be easy. I've said there should only be spectators of a certain age around the pew because experience suggests that others, young men and women, wouldn't

linger there. So? So Cochin doesn't know what he's talking about. If he wants to defend his colleague against his own better judgment and his own taste, then let him.

Greuze has made himself a painter-preacher of good morals, Baudouin, a painter-preacher of bad; Greuze, a painter of the family and of respectable people; Baudouin, a painter of rakes and houses of ill repute. But fortunately he's not a skilled draftsman, he lacks color and genius, while we have genius, drawing, and color on our side, so we're the stronger. One day Baudouin spoke to me of the subject for a picture: he wanted to show a prostitute who'd come to the rooms of a midwife to give birth in secret, and who was obliged by poverty to abandon her child to the foundling hospital. Why don't you set your scene, I responded, in a garret, and depict a decent woman compelled to do the same thing for the same reason? That would be more beautiful, more moving, and more seemly. A garret is a more appropriate subject for a man of talent than a midwife's wretched quarters. When it doesn't entail any artistic sacrifice, isn't it better to represent virtue rather than vice? Your composition will inspire only a sterile form of pity; mine would inspire the same feelings, but in a fruitful way. —Oh! That's too serious; and then, it's so easy to find prostitutes to model. — Well, do you want an amusing subject? —Yes, one that's even a bit smutty, if you can manage, for I admit it, I like smut, and the public doesn't despise it, either. —If smut you must have, so be it, and you'll even be able to use models from the rue Fromonteau. —Tell me quickly . . . and he rubbed his hands in anticipation. —Imagine, I continued, a hackney-coach moving along the St Denis road between eleven and twelve o'clock. In the middle of the rue St Denis one of the coach's braces gives way, and the compartment is thrown on its side. The window panels slide down, the door opens, and a monk and three prostitutes emerge. The monk begins to run away. The driver's poodle leaves his master's side, follows the monk, and, on catching up with him, grips his long robe between his teeth. While the monk tries desperately to get rid of the dog, the driver, who doesn't want to lose his fare, climbs down from his seat and heads towards the monk. One of the prostitutes applies her hand to a bump on the forehead of one of her companions, while the other, struck by the comedy of this misadventure, completely dishevelled, her hands on her hips, bursts into laughter; the shopkeepers are also laughing on their doorsteps, and some rascally members of the gathering crowd screamed at the monk: "He shit his bed! He shit his bed!" —"That's excellent," said Baudouin. —"And it even has a moral," I added. It's vice punished. And who can say whether the monk of my acquaintance who experienced this mishap eight days ago, visiting the Salon, might not recognize himself and blush? And isn't it something to have made a monk blush?

A Mother Quarreling with her Daughter is the best of Baudouin's
small pictures; it's better drawn than the others and rather agreeably
colored, though still a bit drab. The weariness of the man on the
sofa of the prostitute freshening her rouge, not bad. Everything in
The Confessional should be better drawn, calls for more tempera-
ment, more force. It makes no impression and, into the bargain, has
need of more patience, time, of just about everything, and could use
revisions and corrections by the father-in-law. —There are also
some miniatures and portraits. pretty portraits rather prettily painted;
a *Silenus Carried by Satyrs* that's hard, dry, reddish, satyrs and Silenus
both. All this isn't completely without merit, but it lacks . . . How
to describe what it lacks? This is no less difficult to say than it is
essential to have, and unfortunately it's not popping up as easily as
mushrooms. Why am I having so much difficulty saying this? You
know very well how precious one's two pupils are.[107] Once there
was a university professor who fell in love with the niece of a canon
while teaching her Latin; he got his student pregnant. The canon
exacted a very cruel form of revenge.[108] —Did Baudouin give
painting lessons, fall in love, and impregnate the niece of a canon?
Well, he doesn't seem to have what Abélard lost as a result of that
episode. I bid Monsieur Baudouin a pleasant evening, and I pray
God that He keep watch over you, my friend, and, unless His will
dictates otherwise, that He protect you from canons' nieces, so that
you'll be safe from their uncles.

ROLAND DE LA PORTE[109]

It has been said, my friend, that those who haven't laughed at
Regnard's comedies[110] have no right to laugh at the comedies of
Molière. Well, tell those who pass by Roland de La Porte's work

107 "Vous savez bien ce qu'il faut garder comme ses deux prunelles." In French,
 prunelle means both "pupil" (of the eye) and "wild plum." Diderot here exploits
 this double meaning to make suggestive allusions to the relation between visual
 stimulation, the male sexual organs, and male arousal. As becomes clear in the
 following lines, he feels that, for all its smuttiness, Baudouin's work lacks "balls."
108 Diderot is alluding to the story of the medieval lovers Abélard and Héloise.
 Abelard, a philosopher monk, was castrated for his offense.
109 Henri Horace Roland de La Porte (1724–93). Probably studied with Oudry.
 Received as a full royal academician on November 26, 1763.
110 Jean-François Regnard (1655–1709). French playwright; author of *Le Joueur*
 (1696) and *Les Ménechmes* (1705).

without stopping that they have no right to look at Chardin. It
doesn't have Chardin's touch, nor his vigor, nor his truth, nor his
harmony; it's not that it falls a thousand leagues, a thousand years
short; it's a matter of the little, imperceptible distance that one's
aware of but can't close. You work, study, take pains, strike out,
start over, all wasted effort; nature has made its pronouncement:
You will go so far, just this far, and no further. It's easier to advance
from the Notre-Dame bridge to Roland de La Porte than from
Roland de La Porte to Chardin.

102. *A Medallion Representing an Old Portrait of the King in Imitation Relief*

This is an imitation of an old plaster, replete with all the accidents
worked by age. It has cracks and holes, there's dust, dirt, grime; it's
convincing *ma un poco freddo*.[111] And then this genre is so facile that
only the people continue to admire it.

103. *A Genre Work*

On a wooden table, a fancy handkerchief, a faience pitcher, a
glass of water, a cardboard snuffbox, a pamphlet on top of a
book . . . Poor victim of Chardin! Just compare Chardin's handker-
chief with this one; how hard, dry, and stiff Roland's will seem to
you!

103. *Another Genre Work*

A long sink cuts the canvas horizontally in two; moving from right
to left, one sees mushrooms around a clay pot in which sits a branch
of bay leaves, a bunch of asparagus, and some fresh eggs on a
kitchen table, a portion of which comes in front of the sink, and the
rest of which, in the background and in shadow, passes behind the
bunch of asparagus; a copper cauldron at an angle so the inside is
visible; a tin pepper pot; a wooden mortar with its pestle.
 Another of Chardin's victims; but Monsieur Roland de La Porte,
be comforted: may the devil take me if anyone besides yourself and
Chardin realizes this; and rest assured that anyone in the ancient
world who'd been able to produce such an illusion, however much
this might displease Caylus' remains and the living ears of Webb,

111 "But a little cold."

would have been widely praised, poets would have apotheosized him, his statue would have been set up in Keramea or in a corner of Pritanea.

103. *Another Genre Work*

I could spare you this one; but these works circulate on the market, swindling dealers baptize them to suit themselves and take people in.

Still moving from right to left, it's my customary direction, on a table of bluish, broken marble, some grapes, a few small sugar cubes, a white pottery cup and saucer; in the background a bowl full of peaches, a bottle of ratafia; around them a few plums, a carafe of water, breadcrumbs, some pears, some peaches, finally a tin coffee box. These different objects don't go together, and this is a mistake Chardin doesn't make. He, my friend, who knows how to do flesh excels in all subjects, but he who excels in subjects like these doesn't necessarily know how to do flesh. The colors of garden roses are beautiful, but they don't contain as much life as the rosy cheeks of a young girl. The first might be compared with these works, but this would be to flatter them.

104. *Two Portraits*

I saw them. Monsieur Roland, lend an ear to your two portraits, and you'll hear them tell you in a loud clear voice, despite their apparent weakness and dullness: Go back to inanimate objects . . . They give good advice, almost as if they were alive.

DESCAMPS[112]

To this fellow too, the polite acknowledgement already known to you.

You paint grey, Monsieur Descamps, you paint heavy-handedly and without truth. This child holding a bird is stiff, the bird is neither living nor dead; it's one of those pieces of painted wood with a whistle at the back. And this fat, short, disagreeable woman from Caux, what's she saying? Who's she angry with? She's between

112 Jean-Baptiste Descamps (1706–91). Student of Ulin and Largillière. Granted provisional membership in the Royal Academy on April 7, 1764; never received as a full academician.

two of her children, and it's me she's looking at; the one who's crying, if it's because of the enormous head you've given him, he has good reason.

It's said you dabble in literature; may God grant that your gifts as a writer are superior to your gifts as a painter. If you have a taste for writing, write in prose, in verse, whatever you like, but don't paint; or if, to divert yourself, you move from one muse to the other, keep the latter productions in your rooms; your friends, after dining, napkins on their arms and toothpicks in hand, will say: But that's not bad.

Young Man Drawing, *The Student Modelling*, *Young Girl Feeding Her Bird*, off with all of you to the quarters of Monsieur Descamps your father, and don't come out.

BELLENGÉ[113]

A flower painting, several pictures of fruit, off to the Notre-Dame bridge, to Tremblin's shop, with no possibility of reprieve. And yet the flower painting is his reception piece. It's said to have something, but is its color fresh, seductive? No. Do we see the flowers' velvety surfaces? No. So what is there?

PARROCEL[114]

Two Paintings
Cephalus Reconciled with Procris
and
Procris Killed by Cephalus

Have you ever seen copies of the great masters in taverns? Well, that's what these works are like, only don't give away my secret.

113 Michel-Bruno Bellengé or Bellangé (ca. 1726–93). Born in Rouen, he showed at the Paris Salons between 1763 and 1779.
114 Joseph-François or Joseph-Ignace-François Parrocel (1704–81). Student of his father Pierre Parrocel. Member of the Academy of Saint Luke prior to 1753; granted provisional membership in the Royal Academy in 1753, but he was never received as a full royal academician.

This Parrocel is a family man whose only way of feeding his wife and five or six children is with his palette. Looking at this Cephalus killing Procris in the Salon, I said out loud to him: "You commit even worse crimes than you know." Parrocel is my neighbor; he's a fine fellow, and I'm told he has a gift for decoration. He sees me, he comes up to me, "Here are my paintings," he says; "What do you make of them?" —Well, I like your Procris, she has big beautiful breasts. —Why yes, she's seductive, she's seductive . . . — Think of a better response, if you can.

GREUZE[115]

Perhaps I'm a bit long-winded, but if you only knew how much fun I'm having boring you! I'm no different from the other bores in this world. But then a hundred and ten paintings have been described and thirty-one painters assessed.

Here we have your painter and mine; the first who has set out to give art some morals, and to organize events into series that could easily be turned into novels. He's a bit vain, our painter, but his vanity is that of a child, it's the intoxication of talent. Deprive him of the naiveté that enables him to say of his own work: Look at that, how beautiful it is! . . . and you'll deprive him of verve, you'll extinguish his fire, and his genius will be eclipsed. I suspect that if he were to become modest he'd have no further reason for being. Our best qualities are closely related to our faults. Most respectable women are moody. Great artists are capable of hatchet blows in their heads; almost all female flirts are generous; even good, pious folk sometimes speak ill of others; it's difficult for a master who thinks he's doing good not to be a bit of a despot. I hate all the mean, petty gestures that indicate merely a base soul, but I don't hate great crimes, first because they make for beautiful paintings and

115 Jean-Baptiste Greuze (1725–1805). Student of C. Grandon, an obscure artist in Lyon. Granted provisional membership in the Royal Academy on June 28, 1755; received as a full academician on August 23, 1769. Greuze and Diderot were friends in 1765, but their relations soon became strained. They had a spectacular falling out in 1769, in the weeks surrounding Greuze's abortive attempt to have himself accepted by the Royal Academy as a history painter, not a genre painter, with his *Septimus Severus*. In the wake of this humiliating episode, Greuze refused to exhibit his work at the Salon and kept somewhat aloof from the institution that had rebuffed him.

fine tragedies; and also because grand, sublime actions and great crimes have the same characteristic energy. If a man weren't capable of setting fire to a city, another man wouldn't be able to throw himself into the pit to save it. If Caesar's soul had not been possible, Cato's would not have been either. Every man is born a citizen of either Tenares or the heavens; it's Castor and Pollux, a hero, a villain, Marcus Aurelius, Borgia, "diversis studiis ovo prognatus eodem."[116]

We have three painters who are skillful, prolific, and studious observers of nature, who begin nothing, finish nothing without having consulted the model several times, and they are Lagrenée, Greuze, and Vernet. The second carries his talent everywhere, into popular crowds, into churches, to market, to the fashionable promenades, into private homes, into the street; endlessly he gathers actions, characters, passions, expressions. Chardin and he both speak quite well about their art, Chardin with discretion and objectivity, Greuze with warmth and enthusiasm. La Tour is also worth listening to in intimate conversation.

There are a great many works by Greuze, some mediocre, some good, many excellent. Let's examine them.

110. *Young Girl Crying over her Dead Bird* (Pl. 28)

What a pretty elegy! What a pretty poem! What a fine idyll Gessner[117] would make of it! It could be a vignette drawn from this poet's work. A delicious painting, the most attractive and perhaps the most interesting in the Salon. She faces us, her head rests on her left hand. The dead bird lies on top of the cage, its head hanging down, its wings limp, its feet in the air. How natural her pose! How beautiful her head! How elegantly her hair is arranged! How expressive her face! Her pain is profound, she feels the full brunt of her misfortune, she's consumed by it. What a pretty catafalque the cage makes! How graceful is the garland of greenery that winds around it! Oh, what a beautiful hand! What a beautiful hand! What a beautiful arm! Note the truthful detailing of these fingers, and these dimples, and this softness, and the reddish cast resulting from the pressure of the head against these delicate fingers, and the charm of it all. One would approach this hand to kiss it, if one didn't respect this child and her suffering. Everything about her enchants, including the fall

116 "From the same egg but with different interests": a corrupt citation of Horace, *Satires*, Book II, i, vv. 26–8.

117 Johann Matthias Gessner (1691–1761). German humanist and translator/adaptor of Latin literature.

of her clothing; how beautifully the shawl is draped! How light and supple it is! When one first perceives this painting, one says: Delicious! If one pauses before it or comes back to it, one cries out: Delicious! Delicious! Soon one is surprised to find oneself conversing with this child and consoling her. This is so true, that I'll recount some of the remarks I've made to her on different occasions.

Poor little one, how intense, how thoughtful is your pain! Why this dreamy, melancholy air? What, for a bird? You don't cry, you suffer, and your thoughts are consistent with your pain. Come, little one, open up your heart to me, tell my truly, is it really the death of this bird that's caused you to withdraw so sadly, so completely into yourself? . . . You lower your eyes, you don't answer. Your tears are about to flow. I'm not your father, I'm neither indiscreet nor severe. Well, well, I've figured it out, he loved you, and for such a long time, he swore to it! He suffered so much! How difficult to see an object of our love suffer! . . . Let me go on; why do you put your hand over my mouth? On this morning, unfortunately, your mother was absent; he came, you were alone; he was so handsome, his expressions so truthful! He said things that went right to your soul! And while saying them he was at your knees; that too can easily be surmised; he took one of your hands, from time to time you felt the warmth of the tears falling from his eyes and running the length of your arm. Still your mother didn't return; it's not your fault, it's your mother's fault . . . My goodness, how you're crying! But what I say to you isn't intended to make you cry. And why cry? He promised you, he'll keep all his promises to you. When one has been fortunate enough to meet a charming child like yourself, become attached to her, give her pleasure, it's for life . . . And my bird? . . . My friend, she smiled . . . Ah, how beautiful she was! If only you'd seen her smile and weep! I continued: Your bird? When one forgets oneself, does one remember one's bird? When the hour of your mother's return drew near, the one you love went away. How difficult it was for him to tear himself away from you! . . . How you look at me! Yes, I know all that. How he got up and sat down again countless times! How he said goodbye to you over and over without leaving! How he left and returned repeatedly! I've just seen him at his father's, he's in charmingly good spirits, with that gaiety from which none of them are safe . . . And my mother? . . . Your mother, she returned almost immediately after his departure, she found you in the dreamy state you were in a moment ago; one is always like that. Your mother spoke to you and you didn't hear what she said; she told you to do one thing and you did another. A few tears threatened to appear

beneath your eyelids, you either held them back as best you could or turned away your head to dry them in secret. Your continued distraction made your mother lose her patience, she scolded you, and this provided an occasion for you to cry without restraint and so lighten your heart. Should I go on? I fear what I'm going to say might rekindle your pain. You want me to? Well then, your good mother regretted having upset you, she approached you, she took your hands, she kissed your forehead and cheeks, and this made you cry even harder. You put your head on her breast, and you buried your face there, which was beginning to turn red, like everything else. How many sweet things this good mother said to you, and how these sweet things caused you pain! Your canary warbled, warned you, called to you, flapped its wings, complained of your having forgotten it, but to no avail; you didn't see it, you didn't hear it, your thoughts were elsewhere; it got neither its water nor its seeds, and this morning the bird was no more . . . You're still looking at me; is it because I forgot something? Ah, I understand, little one; this bird, it was he who gave it to you. Well, he'll find another just as beautiful . . . That's still not all; your eyes stare at me and fill up with tears again. What more is there? Speak, I'll never figure it out myself . . . And if the bird's death were an omen . . . what would I do? What would become of me? What if he's dishonorable? . . . What an idea! Have no fear, it's not like that, it couldn't be like that . . . —Why my friend, you're laughing at me; you're making fun of a serious person who amuses himself by consoling a painted child for having lost her bird, for having lost what you will? But also observe how beautiful she is! How interesting! I don't like to trouble anyone; despite that, I wouldn't be too displeased to have been the cause of her pain.

The subject of this little poem is so cunning that many people haven't understood it; they think this young girl is crying only for her canary. Greuze has already painted this subject once. He placed in front of a broken mirror a tall girl in white satin, overcome by deep melancholy. Don't you think it would be just as stupid to attribute the tears of the young girl in this Salon to the loss of her bird, as the melancholy of the other girl to her broken mirror? This child is crying about something else, I tell you. And you've heard for yourself, she agrees, and her distress says the rest. Such pain! At her age! And for a bird! —But how old is she, then? How shall I answer you, and what a question you've posed. Her head is fifteen or sixteen, and her arm and hand eighteen or nineteen. This is a flaw in the composition that becomes all the more apparent because her head is supported by her hand, and the one part is inconsistent with the other. Place the hand somewhere else and no one would

notice it's a bit too robust, too developed. This happened, my friend, because the head was done from one model and the hand from another. Otherwise this hand is quite truthful, very beautiful, perfectly colored and drawn. If you can overlook the small patch that's a bit too purplish in color, it's a very beautiful thing. The head is nicely lit, as agreeably colored as a blonde's could be; perhaps she could have a bit more relief. The striped handkerchief is loose, light, beautifully transparent, everything's handled with vigor, without compromising the details. This painter may have done as well, but he's never done anything better.

This work is oval, it's two feet high, and it belongs to Monsieur de La Live de La Briche.

After the Salon was hung, Monsieur de Marigny did the initial honors. The Fish Maecenas[118] arrived with a cortège of artists in his favor and admitted to his table; the others were already there. He moved about, he looked, he registered approval, disapproval; Greuze's *Young Girl Crying* caught his attention and surprised him. That is beautiful, he said to the artist, who answered him: Monsieur, I know it; I am much praised, but I lack work. —*That,* Vernet interjected, *is because you have a host of enemies, and among these enemies there is someone who seems to love you to distraction but who will bring about your downfall.* —And who is this enemy? Greuze asked him. —*You yourself,* Vernet answered.

111. *The Spoiled Child*

This is a mother beside a table looking complacently at her son, who is giving some of his soup to a dog. The child serves it to the dog in his spoon. That's the subject, but there are a great many accessories; such as, at right, a jug with an earthenware pan in which laundry is soaking; above, a kind of armoire; beside the armoire, a hanging rope of onions; higher up, a cage fixed to one of the armoire's side panels; and two or three poles leaning against the wall. From left to right, up to the armoire, there's a kind of buffet on which the artist has placed an earthenware pot, a glass half full of wine, some material hanging down; and behind the child, a cane chair and an earthenware pan. All of which indicates that this is his little laundress, from the picture exhibited four years ago and very recently engraved, who's gotten married and whose story the painter intends to follow.

118 "*Poisson Mécène*": Marigny's family name was Poisson, which means "fish" in French.

The subject of this picture isn't clear. The idea is not properly characterized; it could be either the child or the dog who's spoiled. There are patches of flickering light effects throughout that trouble the eyes. The mother's head is charmingly colored; but her head-dress doesn't sit right on her head and prevents it from seeming three-dimensional. Her clothing is clumsy, and the piece of laundry she holds even more so. The boy's head is very beautiful, in a painterly way, you understand, it's a painter's version of a pretty child's head, not the way a mother would want it to be. The handling of this head couldn't have greater finesse; the hair even lighter than Greuze usually tends to make it; and what a dog! The mother's bosom is opaque, lacking in transparency, and even a bit red. There are also too many accessories, too many details. As a result the composition is blunted, confused. Just the mother, the child, the dog, and a few household objects would have produced a finer effect. The work would have had the tranquility it now lacks.

112. *A Girl's Head*

Yes, a prostitute's on a street corner, her nose in the air, reading a poster while waiting for a client. This could aptly be described as a work of exemplary coloristic vigor. She's in profile. One would almost say she was in relief, the planes are articulated so well. Here we have a vicious strumpet indeed. Look at how Monsieur the Introducer of Ambassadors, who's beside her, is made to seem pale, cold, flat, and wan; what a blow she strikes from afar against Roslin and his dismal family! I've never seen such havoc.

113. *A Little Girl Holding a Wooden Doll of a Capuchin Friar*

What truth! What tonal variety! And these red blotches, who hasn't seen them on the faces of children who are cold or in pain from teeth coming in? And these tearful eyes, and these swollen, frozen little hands, and these blond tresses on her forehead, all mussed, they're so light and true one wants to push them back under her cap. The crude material of the doll's clothing good, with typical folds. Hood of thick cloth on its neck, arranged in the familiar way. A little Capuchin friar that's quite rigid, quite wooden, quite stiffly draped. Monsieur Drouais, come here, do you see this child? She's made of flesh. And this Capuchin, he's made of plaster. For truth and vitality of color, a little Rubens.

114. *A Head in Pastel*

Another rather beautiful thing. All the flesh is convincing and wonderfully soft, the relief is successful and the strokes thickly applied, though it's a bit grey; the fallen corners of the mouth convey pain mixed with pleasure. It may be, my friend, that I'm mixing two paintings together; I bang my head, paint and repaint the thing in front of me, return to the Salon in my imagination; wasted effort, this has to stay as it is.

115. *Portrait of Madame Greuze* (Pl. 29)

Here, my friend, is a demonstration of how there can be something equivocal about even the best painting. Look closely at this fine, fat fishwife, with her head twisted backwards, and whose pale coloring, showy kerchief, all mussed, and expression of pain mixed with pleasure depict a paroxysm that's sweeter to experience than it is decorous to paint; it's a study, a sketch for *The Well-Loved Mother.* How is it that in one place a given expression is decent, while in another it's not? Must we have accessories and circumstances before we can judge facial expressions? Do they remain ambiguous without these aids? There must be something in this idea. This open mouth, these swimming eyes, this unstable posture, this swollen neck, this voluptuous fusion of pain and pleasure make all respectable women lower their eyes and blush in its vicinity. Not far off, in the sketch of the well-loved mother, we have the same posture, the same eyes, the same neck, the same mixture of passions, and none of them even notice. Furthermore, while women pass by this head quickly, men linger in front of it, I mean those who are connoisseurs, and those who under the pretext of being connoisseurs remain to enjoy a powerful display of voluptuousness, and those, like myself, to whom both descriptions apply. In the forehead, on the cheeks, on the bosom there are incredible passages of tonal mastery; they teach you how to look at nature and recall her to you. The details of this swollen neck must be seen to be believed; they are beautiful, true, perfectly achieved. You've never seen two opposed expressions so clearly evoked together. This *tour de force,* Rubens didn't succeed any better with it in the painting in the Luxembourg gallery, in which the painter showed on the queen's face[119] both her pleasure at having brought a son into the world and the traces of her preceding pain.

119 Marie de Medici, in Rubens' celebrated Marie de Medici cycle, now in the Louvre.

116. *Portrait of Monsieur Watelet*

He is dull; he seems dried out, dim-witted. It's the man himself;
take the painting away.

117. *Another Portrait of Madame Greuze*

This painter certainly is in love with his wife, and he has good
reason; I loved her myself when I was young and she was Mad-
emoiselle Babuti. She ran a little bookshop on the Quai des
Augustins; fresh and doll-like, as white and upright as a lily, ruddy
as a rose. I'd enter with that lively, ardent, slightly crazed air that
was mine at the time, and I'd say to her: Mademoiselle, La
Fontaine's *Tales* and a Petronius, please. —Here they are, Monsieur.
Would you like any other books? —Excuse me, Mademoiselle,
but . . . —Yes, continue. —*The Nun in a Nightgown.* —For shame,
sir! Does anyone keep, does anyone read such vile things? —Ah, ah,
it's vile; Mademoiselle, I had no idea . . . —And another day, when
I passed by, she smiled and so did I.

At the last Salon there was a *Portrait of Madame Greuze with Child*;
at first one was interested by her state, then the beautiful color and
truthful details made one's arms go limp. This work is not as
beautiful, but it is attractive overall, it's well posed, the posture has
a certain sensuality, the two hands are enchanting in the finesse of
their tonal handling, though the left one doesn't fully cohere; one of
its fingers seems broken, which is a shame. The dog being patted by
the beautiful hand is a black spaniel, its muzzle and paws flecked
with spots. Its eyes are full of life; if you look at it a while, you hear
it bark. The lace on her head makes one want to know who made
it; I'd say the same about the rest of her clothing too. The head gave
both painter and model a lot of trouble, you can tell, and that's
already a fault. The patches on the forehead are too yellow; every-
one knows that women who've given birth have such spots, but if
one takes the imitation of nature so far as to depict them, they
should be toned down; this is an instance where the original can be
enhanced a bit without compromising the resemblance. But these
facial irregularities give painters opportunities to display their skill,
and they rarely pass them up. These patches have a reddish gleam
that rings true but that's disagreeable. Her lips are flat; the pinched
quality of her mouth makes her seem a bit prim; the result is
mannered. If this mannerism is to be found in the individual, so
much the worse for the individual, the painter, and the painting. Is
this woman maliciously setting her spaniel against someone? Then
her arch, prim air would be less false, though just as unpleasant.

Otherwise, the mouth, the eyes, all the other details are ravishing; countless coloristic subtleties; the neck supports the head wonderfully, its drawing and coloring are beautiful, and it seems attached to the shoulders as it ought to be. But as for this bosom, I can't bear to look at it, and this, even though at the age of fifty I don't hate bosoms. The painter has his figure bend forward, and with this posture it's as if he were saying to the viewer: Look at my wife's bosom. I see it, Monsieur Greuze; your wife's bosom is slack and yellow; if this is a good resemblance, so much the worse for you, for her, and for the painting. One day Monsieur de La Martelière was leaving his rooms; encountered on the stairs a tall young man going up to Madame's rooms. Madame de La Martelière had the most beautiful head in the world, and Monsieur de La Martelière, watching the young gallant ascend to his wife, mumbled: "Yes, yes, but wait till you see her thighs." Madame Greuze's head is just as beautiful, and there's nothing to prevent Monsieur Greuze from mumbling one day to someone he's met on the stairs: "Yes, yes, but wait till you see her bosom." That won't happen, because his wife is as virtuous as she is amiable. This bosom's yellow cast and slackness are Madame's, but its lack of transparency and deadened quality are Monsieur's.

118. *Portrait of Monsieur Wille, Engraver* (Pl. 30)

Very beautiful portrait. This is Wille's blunt, brusque manner, his stiff neck and shoulders; these are his small, ardent, intense eyes, his blotchy cheeks. How the hair is rendered! How beautiful the drawing! How forceful the handling! What truth and variety in the tones! How superb the velvet of his clothing, and the jabot and ruffles of his shirt! I'd like to see this portrait next to a Rubens, a Rembrandt, or a Van Dyck; I'd like to see how our painter would stand up against them. When one has seen this Wille, one turns one's back on other portraits, even those by Greuze.

123. *The Well-Loved Mother, Sketch*

Sketches frequently have a fire that the finished paintings lack; they're the moment of the artist's zeal, his pure verve, undiluted by any carefully considered preparation, they're the painter's soul freely transferred to canvas. The poet's pen, the skilled draftsman's pencil seem to frolic and amuse themselves. Rapid sketches characterize everything with a few strokes. The more ambiguity there is in artistic expression, the more comfortable the imagination. In vocal music one can't help but hear the words it expresses. I make out a

good piece of orchestral music to be saying whatever I like, and as I know from experience better than anyone else what touches my heart, it rarely happens that the expression I attribute to the sounds, analogous to my current situation, serious, tender, or gay, is less affecting than another one that's less well suited to me. It's rather like this with sketches and paintings: in a painting I see something that's fully articulated, while in a sketch there are so many things I imagine to be there that in fact are scarcely indicated!

The composition of *The Well-Loved Mother* is so natural, so simple, that those who don't give the matter much thought will tend to believe they could have imagined it themselves, and that it didn't require a great deal of mental effort. I answer these people: Yes, I can well believe you'd have distributed all these children around their mother and that you'd have made them caress her; but would you have made one of them cry because he's not singled out from the others, and would you have introduced this man who's so gay, so happy to be this woman's husband and so vain about being the father of so many children; would you have made him say: "I'm the one who did all that." And this grandmother, you'd have thought to place her in the middle of the scene? Are you quite sure?

Let's establish the locale. The scene unfolds in the country. In a low room one sees, moving from right to left, a bed; in front of this bed, a cat on a stool, then the well-loved mother leaning backwards in a large armchair and all her children thronging about her; there are at least six of them. The youngest is in her arms; a second clings to one side, a third clings to the other; a fourth grips the back of the chair and looks down; a fifth is at her cheeks; a sixth stands with his head in her lap, dissatisfied with his role. The mother of all these children has joy and tenderness painted on her face, along with a bit of the strain inevitably following from the overwhelming movement and weight of so many children, whose violent caresses will become too much for her if they continue much longer; this is the sensation bordering on pain, though it's blended with tenderness and joy in this thrown-back posture suggestive of weariness, and the open mouth which gives this head, considered apart from the rest of the composition, its singular character. Around this charming group one sees, in the foreground of the image, a child's garment and a small wagon on the floor. Towards the back of the room, facing the viewer, her back turned to a fireplace with a mirror, the grandmother seated in a chair, her head and clothing very grandmotherly, enjoying the scene before her. Further left and in the foreground, a dog barking joyously, enjoying itself. Much further left, almost as far from the grandmother as she is from the well-loved mother, the husband returning from the hunt; he joins in the scene by extending his arms, tilting backwards a bit, and laughing. He's a big young fellow who carries himself well, and his satisfaction betrays his vanity

at having sired this pretty swarm of brats. Beside the father, his dog; behind him, at the left edge of the canvas, a laundry basket; then, at the door, a glimpse of a servant departing.

This is excellent both for the talent it demonstrates and for its moral content; it preaches population, and paints a sympathetic picture of the happiness and advantages deriving from domesticity; it announces to any man with soul and feelings: Maintain your family comfortably, make children with your wife, as many as you can, but only with her, and you can be sure of a happy home.

124. *The Ungrateful Son* (Pl. 31)
Sketch

I don't know how I'll manage this one, and the next will be even harder. My friend, this Greuze will end up ruining you.

Imagine a room into which scarcely any light enters except through the door when it's open, or through a rectangular opening above the door when it's closed. Let your eyes travel about this sad abode and you'll see evidence of poverty everywhere. There is however at right, in a corner, a bed which doesn't seem too bad; it's carefully made. In the foreground, on the same side, a large leather armchair which looks quite comfortable. The father of the ungrateful son sits here. Place a low armoire near the door, and close to the decrepit old man a small table on which is a bowl of soup that's just been served him.

Notwithstanding the help the eldest son of the household could offer his old father, his mother, and his brothers, he has enrolled in the army; but he's not going away without soliciting money from these unfortunates. He has made his request. The father is indignant, he spares no words in rebuking this unnatural child who no longer acknowledges his father, nor his mother, nor his obligations, and who answers his reproaches with insults. We see him in the center of the image; he seems insolent and impetuous; his right arm is raised on his father's side above the head of one of his sisters; he prepares to leave, he threatens with his hand; his hat is on his head, and his gesture and his face are equally impertinent. The good old man who has loved his children, but who has never been able to bear being separated from any of them, tries to stand up, but one of his daughters on her knees before him holds him down by the tails of his jacket. The young libertine is surrounded by his eldest sister, his mother, and one of his little brothers; the mother tries to hold him back, the brute tries to free himself from her and pushes her away with his foot; this mother seems overwhelmed, heartbroken. The eldest sister has also tried to intervene between her brother and

her father; the mother and sister's postures suggest they're trying
to keep them apart; the latter has grabbed hold of her brother's
clothing, and the way she pulls at it seems to say to him: Wretch!
What are you doing? You push away your mother? You threaten
your father? Get down on your knees and beg forgiveness . . . But
the little brother is crying; he lifts one hand to his eyes and
holds onto his big brother's right arm with the other one, straining
to pull him out of the house. Behind the old man's armchair, the
youngest of all seems frightened, stupefied. At the other end of
the scene, towards the door, the old soldier who recruited and
accompanied the ungrateful son to his parents' home is leaving, his
back turned to everything that's happening, his sword under his arm
and his head lowered. I forgot to mention that in the middle of
this tumult there's a dog in the foreground whose barking makes it
even worse.

Everything in this sketch is thought through, carefully organized,
well described, and clear: the mother's pain and even her partiality
for a child she has spoiled, and the old man's violence, and the
various actions of the sisters and young children, and the ingrate's
insolence, and the indifference of the old soldier who can't help
shrugging his soldiers at what's happening, and the barking dog, an
accessory for which Greuze has a special predilection and knows
how to use well.

This sketch is very beautiful but, in my view, nowhere near as
fine as the next one.

125. *The Bad Son Punished*
Sketch

He's been on campaign, he returns, and at what moment? The
moment immediately following his father's death. Everything in the
house has changed; it was the abode of poverty, now it's that of pain
and misery. The bed is wretched, with no mattress. The deceased
old man reclines on this bed; light from a window falls only on
his face, all else is in shadow. One sees at the foot of the bed on
a stool the sacred taper burning and the holy-water basin. At the
head of the bed the eldest daughter seated in the old leather
armchair, her body thrown back, in a posture of despair, one hand
at her temple, the other holding up the crucifix she'd asked her
father to kiss. One of his frightened little children hides his head in
her breast; the other, on the opposite side of the bed, a bit further
down, arms in the air and fingers spread wide, seems to have grasped
the nature of death for the first time. The younger sister, on the
same side of the bed, at its head, between the window and the bed,

cannot persuade herself that her father is no more; she leans towards him, she seems to be looking for a last glance. She lifts one of his arms, and her open mouth cries out: My father, my father, can't you hear me? . . . The poor mother is standing near the door, her back towards the wall, devastated, and her knees are giving way beneath her.

Such is the spectacle awaiting the ungrateful son. He steps forward, he's at the threshold. He has lost the leg he used to push away his mother, the arm with which he threatened his father is crippled.

He enters. His mother receives him; she remains mute, but her arms indicating the corpse seem to say to him: Look, just look at what you've done! . . . The ungrateful son seems astounded, his head falls forward, he beats his forehead with his fist.

What a lesson for fathers and children!

That's not all. This artist gives just as much consideration to his accessories as to the core of his subjects.

In the book on a table, in front of the eldest daughter, I detect that she, poor thing, had been assigned the painful task of reciting prayers for the dying.

The flask beside the book appears to contain the remains of a cordial.

And the warming-pan on the floor had been brought to warm the dying man's frozen feet.

And here again we have the same dog, not sure whether to acknowledge this cripple as the son of the house or to take him for a beggar.

I can't say what effect this short, simple description of a sketch for a painting will have on others; for myself, I confess that I've not written it without emotion.

This is beautiful, very beautiful, sublime, all of it. But as it's said man can produce nothing that's perfect, I don't think the mother's action rings true for this moment; it seems to me she'd have put one of her hands over her eyes, to block out both her son and her husband's corpse, and directed the ungrateful son's attention to his father's body with the other. The rest of her face could have expressed the intensity of her pain just as clearly, and her figure would have been even simpler and more sympathetic. And then there's a lapse in the accessories, a trivial one in truth, but Greuze forgives himself nothing: the large round basin for the holy water with its aspergillum is the one the church puts at the foot of a coffin; at the foot of a dying man in a cottage it would place a flask of water with a branch of boxwood that had been blessed on Palm Sunday.

Otherwise, these two works are, in my view, masterpieces of composition; none of the postures is awkward or forced; the actions

are true and appropriate for painting; and this last one especially has an intensity that's unified and pervasive. Nonetheless, current tastes are so wretched, so trivialized that these two sketches might never be painted, and if they're painted Boucher will have sold fifty of his flat, indecent marionettes before Greuze manages to sell his two sublime paintings. My friend, I know what I'm talking about. Isn't *The Paralytic*, his painting of the reward earned by having educated one's children properly, still in his studio? And it's a masterpiece of the art. Word of it reached the court, it was sent for, it was much admired, but it wasn't purchased, and it cost the artist twenty écus to obtain the inestimable privilege . . . But I've said enough, I'm becoming ill-humored, in this state I could even get myself into trouble.

About this genre of Greuze's, allow me to ask you a few questions. The first is: What is real poetry? The second: Is there poetry in these last two sketches by Greuze? The third: What would you say was the difference between this poetry and that of the sketch of *Artemisia's Tomb*,[120] and which do you prefer? The fourth: Of two cupolas, one of them obviously painted, and the other, though it appears to be real, is actually painted, which is the more beautiful? The fifth: Of two letters, for example from a mother to her daughter, one of them full of beautiful and impressive demonstrations of eloquence and expressions of affection which one savors at length but which deceive no one, and the other simple and natural, so simple, so natural that everyone is fooled and believes it really was written by a mother to her daughter, which is the good one and which is the more difficult to write? You'll have surmised that I have no intention of pursuing these questions; neither your project nor my own will permit me to insert one book inside another.

126. *The Nursemaids*
Another sketch

Chardin hung this beneath Roslin's family portrait.[121] It's as though he'd written below one of these paintings, "Example of Discord," and below the other, "Example of Harmony."

Moving from right to left, three upended barrels in a row; a table; on this table a bowl, a small saucepan, a cauldron, and other household utensils. In the foreground, a child leading a dog by a leash; to this child is turned the back of a peasant woman in whose lap a little girl is asleep. Further back, an older child holding a

120 By Jean-Baptiste Deshays; see above, no. 37.
121 See above, no. 77.

bird; one sees a tambourine at his feet. The bird's cage is attached to the wall; then another seated woman grouped with three small children; behind her, a cradle. On the foot of the cradle a kitten; on the floor, beneath it, a chest, a pillow, some sticks, and other gear associated with cottages and nursemaids.

Ostade wouldn't have disowned this work. One can't paint any more vigorously; the resulting effect rings true. One doesn't look for the light source. The groups are charming. It's a little example of organization that couldn't be less forced or more successful. You believe yourself to be in a cottage, nothing suggests otherwise, in either its content or its handling. Someone might ask that the cradle be given a little more light; as for myself, it's the picture itself that I'd ask for . . .

Ah! I can breathe freely, Greuze is out of the way. The work he gives me is agreeable, but he certainly gives me plenty of it.

GUÉRIN[122]

An "at your service" to Monsieur Guérin, to his *Women Drawing*, to his *Woman Making her Dog Dance*, to his *Schoolgirl*, to his *Angel Escorting a Child to Heaven*; these are all perfectly miserable scraps. Flee from Monsieur Guérin at the Salon, but tip your hat to him in the street; note how short his entry is; he's not worth discussing at any greater length.

BRIARD[123]

Flee Monsieur Briard in the Salon, too, but in the street bow to the Monsieur Briard who makes life easier for your copyist and your friend.

122 François Guérin (?–1791). Member of the Academy of Saint Luke prior to his affiliation with the Royal Academy; received as a full royal academician on September 28, 1761.

123 Gabriel Briard (1725–77). Student of Natoire. Granted provisional membership in the Royal Academy on July 24, 176; received as a full academician on April 30, 1768.

127. *The Resurrection of Jesus Christ*
Large painting

What a piece of work! Have mercy! This Christ is so thin, so insubstantial, that he'd instill doubts about the Resurrection, if one believed in it, and give credence to the notion of reincarnation, if one didn't. And this tall soldier in the foreground who rises up on the ball of his foot, who shows off his other leg, who displays his fine arms, he's the dancer Dupré executing a pirouette. These other ones, to the tomb's right and left, bring to mind those scoundrels who pretend to be possessed at the church of Saint Suaire in Besançon. The others are asleep; may they remain so, and the painter, too.

128. *The Good Samaritan*

But how can one attempt this subject when one's made of stone? Not the slightest trace of empathy, for either the person giving aid or the one who's being helped. What's the meaning of this fat little man who's kneeling, pressing down on the back and chest of the nude sick man and looking above his head? Judging by the richness and amplitude of his clothing, he's wealthy; so why is he travelling on a nag? Isn't this story a thousand times more interesting in my old Bible than on your canvas? Then why did you paint it? Monsieur Briard, don't make any more Samaritans; if you're going to make anything, make slippers.

129. *A Holy Family*

This little painting is pretty good. This doctor of the law who's reading is nicely characterized; this Joseph listening to him listens very well. The lamp illuminating your scene gives off a yellow glow. Your Virgin is simple; if she were more attentive to the reading in which the good or bad fortune of her Son is in question, this wouldn't be bad at all. As for these young girls entertaining themselves by looking at the child, that's their proper role. You made this work in Rome, that's clear, because it has Natoire's coloring.[124]

124 Charles-Joseph Natoire (1700–77), director of the French Academy in Rome from 1751 to 1774.

130. *Psyche Abandoned*

Briard has placed mountains on the right. At the foot of these
mountains we see Psyche unconscious and reclining on the ground;
then a few trees with Cupid towards their crowns, flying away, and
it was a good idea for him to have left this woman here, not because
she's curious, for what woman isn't? but because she's disagreeable,
at least when she's fainted. Each one of us has his particular graces;
some women are charming when they laugh; others are so beautiful
when they cry that one's tempted to keep them in tears; I've seen
some who looked quite interesting after they'd fainted, but not
Briard's Psyche. In the foreground, towards the left, the artist has
put some water that doesn't make his landscape any fresher; there's
none of the damp vapor that seems to make air palpable, and that
would have rendered the poet's "frigus opacum."[125] This landscape
forms the background. The subject of this work is unclear. One can
make out this is a woman who's being abandoned by Cupid, but
many others are in this situation, too; why is this one Psyche? How
can I tell this Cupid is her lover and not one of those allegorical
figures so common in painting? The reality is that this is a landscape
pure and simple, and that the figures were introduced into it to liven
it up, which they don't do.

130. *The Encounter between Psyche and the Fisherman*

Imagine massive rocks to the right; below these rocks, a women
with a man; behind these two figures, some trees; in the foreground,
another woman seated; near this woman, a dog; further forward, in
the bow of a boat, a boatman with his hook, seen from the back; in
this boat, a woman crouching and bent over who pulls a string from
the water. In the distance, at far right, a ruined château . . . I ask
you, my friend, to stop right there and ask yourself what the subject
of this painting might be . . . But don't exhaust yourself needlessly;
the artist was pleased to designate it as *The Encounter between Psyche
and the Fisherman*. Once again, what is it that indicates Psyche to
me? Where's the fisherman? Where's the meeting? What's the
meaning of this woman on the ground with her dog? And this
boatman? And his boat? And this crouching woman? And her
string? Psyche encountered is no more agreeable than Psyche un-
conscious, and she doesn't seem to interest the supposed fisherman
very much; he's unresponsive. The fisherman seen from the back is

125 "The cool of the shadows": Virgil, *Bucolics*, v. 52.

stiff, dry, wooden. This woman sitting on the ground is there to fill a hole and tie together the composition; this is also the function of her dog. The rocks at right are detestable; the distant view at left is no better. Nothing's bearable except the woman pulling her string from the water.

131. *The Village Soothsayer*

Clearly this man paints without knowing what he's doing; he still doesn't know what a subject is, he hasn't a clue that it must be characterized by essential or contingent circumstances distinguishing it from any other. When he's placed in front of a rather eccentrically dressed peasant a nervous, standing young woman; beside her an attentive elderly woman; when he's dashed off a few trees here and there, and made a young peasant's laughing head emerge from these trees, he imagines I ought to be able to figure out that this is a village soothsayer. The story goes that a well-meaning painter who'd put a bird in his picture and meant it to be a cock, wrote above it: "This is a cock." Despite the evident lack of subtlety, Monsieur Briard would have done very well to write above the figures in his painting: "This one's the soothsayer," "that one's a young girl who's come to consult her," "this other woman is her mother," and "here, the girl's lover." Monsieur Briard, even if one could predict the future a hundred times better than your sooth-sayer, how could one figure out that the laughing figure is in collusion with her? So you still need to write: "This young fellow and the old rascal there are working together." One must be clear, by whatever means necessary.

BRENET[126]

132. *The Baptism of Jesus Christ* (Pl. 32)
Large painting

There are two versions of *The Baptism of Christ by Saint John*, one by Brenet and the other by Lépicié. They've been hung as pendants;

126 Nicolas-Guy Brenet (1728–92). Student of Boucher. Granted provisional membership in the Royal Academy on November 27, 1762; received as a full academician on February 25, 1769.

they're separated only by Challe's *Hector*, and you can judge just
how bad they are by the fact that Challe's *Hector* doesn't manage to
make them look acceptable.

If these painters had had a little sense, a little intelligence, they'd
have asked themselves: What moment should I paint? . . . and they'd
have answered themselves: That in which the eternal Father
acknowledges and designates his Son, makes himself known to the
earth as his Father. Thus it's a day of triumph and glory for the Son;
a day of instruction for men. My scene can be set in the wilderness,
but it shouldn't be deserted, so I'll put a crowd on the banks of the
river. I'll try to achieve some sort of grand lighting effect that
attracts everyone's attention to the heavens. I'll make the full
strength and force of this light fall on the prophet administering the
sacrament and on the head of He who receives it. I want the drops
of water falling from the shell to sparkle like diamonds in the light.
I can only indicate a voice emerging from the clouds by having the
men, women, and children appear to listen to it and register sur-
prise. My two main figures will be grand; that won't be difficult for
St John: an Essene, a fanatic, living in the woods, wandering
through the mountains, covered only by a sheep's skin, nourished
by locusts and crying out in the desert, he can't help but be
impressive. My primary concern should be to preserve in Christ his
gentleness of character, and yet avoid making him into the flat,
traditional figure, from which, however, I can only deviate with
the greatest circumspection. My other concern is to determine
whether or not to depict the paltry dove that's said to be the Holy
Ghost; if I show it, the only way I can avoid making it seem a poor
thing is by enlarging it a bit, by having it agitate its head, feet,
and wings in reaction to the light . . . Are these people crazy, or
what? Do they ever ask themselves questions? Oh, certainly not; and
if their works remain mute, this is because they never talk to
themselves.

In Brenet's *Baptism* you see, at right, a dry, stiff, ignoble Christ
from I don't know where, for He's neither flesh, nor stone, nor
wood. Behind this Christ, a bit further back, some angels. Angels!
Were they the real spectators at the scene? Put a few of them in
your clouds, that's fine; but to have brought them down to earth,
put them on the river bank, involved them in the action, that
goes against common sense. Between the Christ and the St John,
one of these angels pulls some of Christ's drapery away from his
shoulders, for fear they might be dampened by the sacramental
water; has anyone ever imagined anything so impoverished, so
trivial? When an artist has nothing in his head, he should take a
break. And if he still has nothing in his head he should take a

nice *long* break. It's true. I'm sure that Monsieur Brenet, after having thought up this pretty idea, this officious angel who doesn't like wet clothing, rubbed his hands together delightedly, congratulating himself, and that he'd be thunderstruck to hear what I think of it. It's like witty remarks, those making them are put out when no one laughs at them. I admit, however, that I'd have been less severe with the same idea preciously executed in a small work by Lagrenée no larger than my hand. The Christ has the air of a contrite sinner being cleansed of his impurities, and the St John occupying the left side of the canvas has the inappropriate physical aspect of a faun. Furthermore, the scene unfolds in secret, between St John, Christ, and the angels; there's not a soul to hear the Voice cry out: "This is my beloved Son," except those who had no need to hear it. And then bad color, poor organization, figures ill drawn, ignoble heads, and clouds like tufts of wool carried away by the wind.

133. *Cupid Caressing his Mother to Recover his Bow*
 Small painting

The Venus is reclining; we see her from the back. The Cupid, in the air and a bit further back, kisses her; and this because he wants his bow back. And how do I know this? From the catalogue; in the painting there's nothing but a child kissing his mother. If this child simultaneously reached out to seize the bow and arrows from his mother who held on to them, if his mother sought to avoid his kisses, the subject would have begun to gell:

> Cum flagrantia detorquet ad socula
> Cervicem, aut facili saevitia negat,
> Quae poscente magis gaudeat eripi,
> Interdum rapere occupat.[127]

And then the grace and voluptuousness of this Venus, the roguishness and finesse of the child must be seen to be believed. If you take me to mean they're there, you're wrong, they're what's missing. As for color, I'll save that for another time.

127 "As she bends her neck towards your eager kisses, or in teasing playfulness refuses to give them (yes, refuses, since more than he who asks for them, she delights to have them snatched, or at times is first herself to snatch them)": Horace, *Odes*, Book II, xii, vv. 25–8.

LOUTHERBOURG[128]

Here is a young artist who in making his debut puts himself, with
the beauty of his sites and rustic scenes, with the freshness of his
mountains, with the truth of his animals, on a par with old
Berchem, and who dares challenge him with the vigor of his brush,
his understanding of natural and artifical light, and other qualities
this painter shares with the terrible Vernet.

Courage, young man; you've already gone further than is held to
be possible at your age. You're unlikely to become acquainted with
poverty, for you work quickly and your compositions are highly
valued. You have a charming female companion who should settle
you down. Don't leave your studio except to consult nature. Live in
the fields with her; go see the sun rise and set, the colors of the
clouds in the sky. Wander about in the fields amid the flocks; look
at the grass sparkling with dewdrops; observe the mists that rise in
the evening, spread over the plains, and gradually obscure the
mountain peaks. Leave your bed early in the morning, despite the
young, attractive wife resting at your side; precede the sun's return;
observe its veiled disk, the edges of its orb blurred and the bulk of
its rays lost, dissipated, snuffed out in the immense, thick mist which
it tints with a weak, reddish glow; already the nebulous volume
begins to sink beneath its own weight, it condenses near the ground,
dampening it, moistening it, and the softened soil begins to stick to
your feet. Shift your gaze to the summit of these mountains; they're
beginning to pierce through the vaporous ocean. Make haste, hurry
to some elevated spot, and contemplate from there the surface of
this ocean that undulates gently over the earth; discover as it sub-
sides the tips of bell towers, treetops, the upper reaches of buildings,
towns, villages, forests, all of nature's scenery illuminated by the
light of the day star: this star has scarcely begun its course, the eyes
of your charming companion are still closed; soon one of her arms
will reach out for you; hurry back, conjugal tenderness summons
you home. The spectacle of animate nature awaits you. Take up the
brush you've just dipped into light, water, clouds; the various
phenomena filling your head that you have only to fix to the canvas.
While you busy yourself during the brilliant midday hours painting
the freshness of the morning, the sky is preparing a new spectacle

128 Jacques-Philippe de Loutherbourg II (1740–1812). Student of his father J. -P. de
 Loutherbourg I, Tischbein, and Casanova. Granted provisional membership in the
 Royal Academy on June 25, 1763; received as a full academician on August 22,
 1767. In 1771 he went to London, where David Garrick placed him in charge of
 scenery at the Drury Lane Theatre. He never resettled in France.

for you. The light weakens, the clouds circulate, separate, come together, and a storm is brewing; observe the storm take shape, burst, and subside, so that I might rediscover two years hence at the Salon the trees it flattened, the torrents it made swell, the full spectacle of the havoc it wrought, and so that my friend and I, leaning against one another, our eyes fixed on your work, might again be frightened and moved by them!

134. *The Prince de Condé's Hunting Party Assembling in a Part of the Forest of Chantilly Known as the Rendezvous de la Table*

There are quite a few compositions by Loutherbourg, for this artist is prolific; several are excellent, none of them is totally lacking in merit. This one about which I'm going to speak first is the least successful. It's a commissioned work: the site and the subject were assigned and thus the painter's muse was fettered.

If there's anyone who doesn't yet grasp the tedious effect of symmetry, he has only to look at this picture. Trace a vertical line from top to bottom; fold over the canvas along this line, and you'll see half the enclosure exactly coincide with the other half. At the entry to this enclosure one part of the wall exactly coincide with the other part; gradually moving into the background, hunters and dogs coinciding with hunters and dogs; in succession, part of the forest coinciding with a like part of the forest; likewise the walk separating the two luxuriant areas and the table placed in its center: half the table would coincide with its other half, half the walk with its other half. Take a pair of scissors and cut the composition in half along the vertical line, and you'll have two half-paintings each of which is the reverse of the other, as if one of them were a tracing.

But Monsieur Loutherbourg, was violation of this symmetry forbidden you? Was it compulsory that this walk be placed precisely in the center of your canvas? Would the subject have been any less a hunting rendezvous if it had opened up a bit to the side? Aren't there a hundred places in the forest of Chantilly from which this spot can be reached and from which one can see it without its ever seeming the same? Why prefer the central view? Didn't you realize that conformity with the ceremonial prescriptions of du Fouilloux and de Salnove[129] would result in a platitude? That's not all; your hunters and women riders are stiff and mannequin-like. I say take

129 The authors, respectively, of sixteenth- and seventeenth-century treatises on the hunt and its rules of decorum.

this to the Saint-Ovide fair,[130] there'll be a ready market for it
there, for it must be admitted, these dolls are much superior to the
ones sold there, though not all of them, for there are a few that
children will mistake for cutout figures of yellow cardboard. Your
trees are poorly executed and a green you've never ever seen.
As for these dogs, they're all very fine; as is the terrace of the
enclosure extending from the bottom of your canvas into the
background, the only thing over which you had total control; I
recognize you here, in its truth, its irregularities, its intense palette,
and its marvellous atmospheric perspective. It is beautiful and very
beautiful.

My friend, if you think about symmetry for a moment, you'll see
that it's only appropriate for imposing blocks of architecture and of
architecture exclusively, not of nature; this is because buildings are
made according to rules and because symmetry is consistent with
this idea; and because symmetry has a soothing effect and makes
things seem larger. Nature made animals symmetrical, with fore-
heads whose two halves are identical, two eyes, a nose in the
middle, two ears, one mouth, two cheeks, two arms, two breasts,
two thighs, two feet. Cut an animal along the vertical line passing
through the center of the nose, and its two halves will be exactly
alike. This makes possible the movement and contrast resulting from
changing the position of the limbs; this makes a head seen in profile
more agreeable than a head seen frontally, because it has order and
variety without symmetry; this makes a more or less three-quarter
head view preferable to a profile view, because it has order, variety,
and symmetry, but in a somewhat hidden form. In painting, if an
architectural structure is used to decorate a background it should be
placed at an angle to mask a symmetry that would offend, or if it's
shown straight on some clouds should be summoned or a few trees
planted to violate it. We don't want to grasp everything at once;
coquettish women are well aware of this: they encourage and
discourage, expose and obscure. We like it when pleasure lasts; it
should progress in some way. The pyramid is more beautiful than
the cone, which is simple but lacks variety. Equestrian statues give
more pleasure than standing ones; broken straight lines more than
unbroken ones; circular lines more than broken straight ones; ovals
more than circles; serpentine lines more than ovals. After variety,
what has the greatest impact on us is massing. This determines that
groups are more interesting than individual figures; that imposing

130 A fair with merchants' stalls, refreshment stands, temporary theaters etc. held every
 year (August 14–September 15) in the Place Louis-le-Grand (now the Place
 Vendôme) until 1771, when it was moved to the new Place Louis XV (now the
 Place de la Concorde).

lighting effects impress us; that any object represented as large we find to be beautiful. Masses impress us in both nature and art; we're struck by the enormous mass of the Alps and the Pyrenees; by the vast extent of the ocean; by the dark profundities of the forest; by the length of the façade of the Louvre gallery, however ugly; by the imposing structure of the towers of Notre Dame, despite the infinite multitude of little details in their upper reaches that help one's eyes get the measure of them; by the Pyramids of Egypt; by elephants, by whales; by the ample robes of the magistrates and their voluminous folds; by the long, thick, shaggy, and terrible manes of lions. It is this idea of mass secretly imbibed from nature, along with the train of accompanying ideas like duration, grandeur, power, and solidity, that gave birth to ways of handling that are simple, grand, and broad, even in the smallest things, for a shawl can be executed with an elegant simplicity. It's an artist's failure to grasp this idea that determines his taste for trivial forms, for trivial and rumpled draperies, for trivial characterizations, and for trivial compositions. Give me, give artists like this the Cordilleras, the Pyrenees, and the Alps, and we'll manage, they out of imbecility, I through calculated artifice, to destroy their effect of grandeur and magnificence; we have only to cover them with little rounded lawns and little cleared areas, and they'll appear to be newly clothed and covered by a big piece of finely checkered cloth. The smaller the squares and the larger the cloth, the more disagreeable it will appear to the eye and the more the contrast between small and large will seem ridiculous, for the ridiculous is often the result of a juxtaposition of opposed qualities. A serious animal makes us laugh because it's an animal and yet affects a dignified demeanor. The ass and the owl are ridiculous because they are stupid yet seem to be meditating. Do you want to transform the comic monkey wiggling every which way into something ridiculous? Put a long magistrate's wig under his cap. This is why the Président de Brosse, whom I respect in ordinary attire, makes me laugh in his official garb. How can one see, without smilling, a gay, ironic, satyr-like little head lost in the immensity of a forest of hair obscuring it, this forest hanging down both right and left, dominating three-quarters of the little figure? But let's return to Loutherbourg.

135. *A Morning after the Rain*
136. *The Beginning of a Storm at Sunset*
Pendants

In the middle of the canvas, an old château. At the foot of the château, some livestock going to pasture. Behind, a mounted

herdsman guiding them. To the left, some rocks and a pathway through them. How this path is lit! To the right, a distant view with a bit of landscape.

This is beautiful; beautiful light, beautiful effect, but an effect difficult to perceive if one hasn't lived in the country. One needs to have seen, in the morning, this nebulous, greyish sky, this oppressive atmosphere signalling bad weather for the rest of the day; one must be able to recall this pale, melancholy cast thrown over the fields by the previous night's rain, putting the traveller in a bad humor when at daybreak he wakes up and, in his nightgown and nightcap, throws open the window shutter of his inn to see what time it is and what weather the sky holds out for him.

Anyone who hasn't seen the sky darken as a storm approaches, livestock return from pasture, clouds gather, a thin, reddish light illuminate the housetops; anyone who hasn't seen a peasant close himself up in his cottage, who hasn't heard house shutters being noisily secured on all sides; anyone who hasn't felt the horror, silence, and solitude of such a moment suddenly pervade an entire village, will understand nothing of Loutherbourg's *Beginning of a Storm*.

In the first of these pictures I like the freshness and the site; and I like the old château and the darkened portal giving access to it. In the second, the clouds announcing the storm are heavy, thick, too closely resembling dust clouds or smoke. —I agree. The reddish mist . . . —This mist is crude. —I agree once more, so long as you're not talking about the portion covering the mill that's visible at left; this is a sublime imitation of nature; the more I look at it, the less sure I am of art's limitations. When that's been achieved, I can no longer tell what's impossible.

137. *A Caravan* (Pl. 33)
Oval painting

Place at the top and in the center of the canvas, on a mule, a woman holding a small child and giving it suck. Place this woman and this mule so they partially obscure another mule loaded down with clothing, baggage, household utensils, and are partially obscured by another mule likewise loaded down with baggage and merchandise. Place a dog and a drover and the two mules over a flock of sheep, so they form a beautiful pyramid of objects crammed onto one another, between dry rocks on the left and verdant mountains on the right.

Here we have the product of an excessive, ill-judged affection for pyramidal compositions unaccompanied by an understanding of

spatial recession. There is no grasp of such recession, no distinction made between levels of depth; all these objects seem to actually sit on top of one another, the sheep being their foundation; atop this foundation, the two mules, the drover, and his dog; atop this dog, these mules, and this drover, the mule carrying the woman; atop this last, the woman and child marking the peak.

Monsieur Loutherbourg, when it's said a composition must be pyramidal if it is to please the eye, what's meant is not two straight lines gradually moving together to form the tip of an isosceles or scalene triangle; the reference is to a serpentine line that courses over several objects and whose inflections, after having reached the peak constituted by the uppermost object in the composition, continue by descending along another route such that it skims the tips of other objects; and there are as many exceptions to this rule as there are different scenes in nature.

Otherwise, this *Caravan* is vigorous in color; its objects thickly impastoed and its figures picturesquely conceived. A pity it's such a spiky chaos, a chaos that will never disengage itself from the mountains in which the painter has lodged it; there it will remain.

138. *Thieves Attacking Travellers in a Mountain Gorge*
139. *The Same Thieves Captured and Taken Away by Horsemen*
Pendants

There's nothing to add to the titles, they say everything. The small figures peopling these compositions could hardly be more prettily, more ingeniously executed; the mountains rising to either side marvellously handled and of the most vivid color, and the skies charming in color and effect.

You see, my dear Loutherbourg, that I enjoy giving praise, that my feelings naturally incline towards it, and that I myself find it satisfying when my pen has occasion to salute merit. Why not do it all the time? That depends on you. How is it, for example, that in these two works the figures of the thieves captured and taken away by the horsemen are less carefully finished than the same rogues attacking the travellers?

140. *Several Landscape Paintings under the Same Number*

Loutherbourg's landscapes have less tonal refinement than Vernet's but their effects are fully achieved. He lays the paint on thickly; it's true his shadows are sometimes a bit crude and black.

Monsieur Francisque,[131] you who dabble in landscape, come, move closer, observe how true these rocks to the left are! How transparent this running water is! Follow the continuation of this rock; there, moving to the right, have a good look at this tower with its little bridge vaulted from behind, and learn how to place, erect, and light a stone building when a painting calls for one. Don't scorn directing your attention to the wild bushes and plants emerging from the clefts of the rocks upon which the tower is built, because they ring true. This narrow, darkened door cut through the rock isn't bad; what do you make of it? And of these peasants and soldiers you see in the right distance? They're well drawn, they move. And of this sky? It's effective. What? You're not disheartened, Monsieur Francisque? Ah! You think you're just as proficient as Loutherbourg, and thus my lesson is wasted. Well and good, Monsieur Francisque, continue so to value yourself, but you'll be the only one.

Loutherbourg's finest work is his *Night*. I've already compared it with Vernet's, there's no use repeating myself. Those who find the animals poor forget that these are haggard beasts of burden.

But I can't resist discussing the two small landscapes, no larger than my hand, which you'll have seen above the desk at the entrance to the Academy rooms. In the one on the right, some countryside. The other is entitled *Autumn Sunset, between Two Mountains*. On its right there are only darkened mountains; on its left, mountains in the light; between them, a bit of flaming sky; in the foreground, a clear area with a shepherd urging on his animals from below. Both these works are beautiful, but especially the last one, it's the more piquant and vigorous of the two. This man doesn't lack resolution, his touch is broad and decisive. I leave these two *Landscapes* to whatever positive thoughts you're inclined to lavish on them.

If you still have the Salon in mind, you'll be wondering why I've said nothing about the work with livestock that a herdsman has led to drink at a stream in the foreground, its current splashing against yellowish rocks; and about the one in which, between high, forbidding mountains at right and other mountains and a bit of forest at left, the artist distributed sheep and in the foreground depicted a peasant with a cow; the reason, my friend, is that I'd only be forced to repeat the same praises. The rest of the Salon will follow with the next delivery.

131 Joseph-Francisque Millet: see above, nos. 52–4.

LEPRINCE[132]

This is a first-timer who's not without merit. In addition to his reception piece, a very beautiful picture, he exhibited a number of other compositions, several of them worthy of the attention of men of taste. In general, he's mastered the fundamentals of art and design, he draws very well, his figures are ingeniously executed; but his color is not on a par with these two qualities, and this is a pity. By juxtaposing Leprince's work with that of Vernet, it's as if someone were saying to the former: Young man, look closely and you'll learn how to make your distant views recede, how to make your skies less heavy, how to increase the vigor of your handling, above all, in your large works, how to make it less muffled, and how to soften its effect.

I can't address the imitation of things Russian, they should be left to those familiar with that nation and its customs; but overall I find them weak like the artist's health, melancholy and sweet-tempered like his character.

141. *View of a Part of St Petersburg*

It is taken from the palace occupied by our ambassador, Monsieur de l'Hôpital; it shows the island of St Basil, the port, the customs house, the senate, the college of justice, the fortress, and the cathedral. The small figures in the foreground are the ambassador and his suite; they're delectable. The wagon in which we see a recumbent woman taking an outing or travelling, doubtless in a manner that's common in this country, is very good. But I haven't the courage to praise this work while Vernet's *Port of Dieppe* is within view; it is sombre, sad, without sky, without lighting effects, without any effect at all.

142. *A Party of Cossack and Tartar Troops Allocating Their Booty after a Raid.*

The scene is tranquil. Why conform so scrupulously to the dictates of local dress and custom? It seems to me that a quarrel between

132 Jean-Baptiste Leprince (1734–81). Student of Boucher. Granted provisional membership in the Royal Academy on February 24, 1764; received as a full academician on August 23, 1765.

some of these brigands would have introduced some life into this
cold composition, dominated by its picturesque clothing and praise-
worthy only for the handling of the figures, which is broader here
than in any of the artist's other compositions. Technique can be
acquired over time; verve and vision are totally different, one must
have them from birth. I'd gladly say to the Forty who meet three
times a week in the Louvre:[133] What do I care if there isn't a single
solecism in any of your writings, if they don't contain a single
striking idea, a single vital line? You write like Leprince paints and
Pierre draws, very correctly, yes, but coldly. Strictly speaking, there
are only three great and original painters: Raphael, Domenichino,
and Poussin. Among the others making up their schools, so to
speak, some have distinguished themselves by certain specific
qualites; Le Sueur has a corner to himself, as does Rubens. The
latter can be reproached for the occasional crippled hand or botched
head, but when you've seen his figures they stay with you and
inspire distaste for those by others.

143. *Preparations for a Horde's Departure*

To the right, some trees from which a scimitar, a quiver full of
arrows, and other arms are hanging. A Kalmuk is busy taking them
down; he's doing the bidding of his officer, who's standing and has
given him an order. Between the officer and the Kalmuk, beneath
a tent made from a large, taut piece of fabric, we see a Tartar seated
with his wife. The wife is quite attractive, she holds our interest
with her natural demeanor and her grace. To the left, the horde
begins to file off.

Work displaying all the artist's talents and faults. Good, but no
more than that.

144. *Russian Pastoral*

Keep in mind, my friend, that I take customs and dress I know
nothing about just as they're given to me. Artists can say whatever
they like about these matters, but there's a melancholy, a serenity, a
peace, a silence, an innocence here that I find enchanting. It seems
that here the painter's faults worked to his advantage; this simple
subject calls for light, fleet handling, and such is the case here. Very

133 The Académie Française, the French literary academy; not to be confused with the
 Royal Academy of Painting and Sculpture.

little in the way of lighting effects, and there's little here. It's an old man who's stopped playing his guitar to listen to a young shepherd play his panpipe. The old man is seated under a tree; I think he's blind, and if he's not I wish he were. A young girl stands beside him. The young fellow sits on the ground some distance away from the old man and the young girl; his pipes are raised to his mouth. His posture, character, clothing are ravishingly simple, his head is especially charming. The old man and the young girl listen wonderfully. The right side of the scene depicts rocks at whose feet we see a few sheep grazing. This composition goes right to the soul. I can easily imagine myself in it; I'd stay there leaning against the tree, between the old man and young girl, however long the young fellow played. When he'd stopped playing and the old man had once again began to strum his balalaika, I'd sit myself down next to the young man, and when night began to fall, the three of us would conduct the old man back to his cabin. A painting that elicits this kind of response, that makes the viewer imagine himself within it interacting with its figures and that finally gives the soul a delicious sensation, is never a bad painting. You'll say to me: But its color is weak. —Granted. —It is muted and monotonous. —That may be; but it's touching, it's arresting; and what do I care about your skillful tonal transitions, your pure, correct drawing, the vigor of your color, the magic of your lighting effects, if your subject matter leaves me cold? Painting is the art of reaching the soul through the eyes; if effects of technique succeed in arresting the eye, the painter has only gone half the distance.

145. *Fishing near Petersburg*

Dreary, unfortunate victim of Vernet.

146. *Some Peasants Waiting for a Ferry,*
Relaxing while they Wait.

Why do they just relax? Have they no way to introduce variety into their rest? In a moment like this a woman could suckle her infant; peasants could count up their earnings; or if there were a young girl and a young man in love, they'd indicate this with a few furtive caresses. The ferryman wouldn't arrive any less quickly. The mountains to the right strike me as truthful. I'd hazard a remark that the water isn't bad, at the risk of making Vernet laugh, were he to hear me. The bank is good. If the waiting passengers do no more than this, they do it naturally; and I rather like this ferryman.

147. *Bridge in the City of Nerva*

This might be an impressive structure at the site; it might be imposing in its mass, surprising in the oddity of its construction, frightening in the height of its arches; this would be, if you like, the subject of a fine plate in a travel book, but as a painting it's a detestable thing. If you ask me what this might have become under the pencil or brush of Servandoni, I'd answer that I haven't any idea. As for Leprince, he's made a flat composition of it: the bridge is meagre and lacking in effect; these pointed masses supporting it are coarse, without any of the idiosyncrasies that would have livened them up. The entire mountain is ochre. If there's an ironmaster in the area, he ought to think about mining it.

148. *Tartar Halt*

At right we see forests, a horse-drawn wagon passing by, a bit of rock, and then an area where the terrain is uneven, forming a rise, a woman standing and a man sitting. Towards the left, more Tartars. It's on the rise formed by the uneven terrain, in the center of the canvas, a little to its left, near the standing woman and sitting man, that the halt has been called. If the details of local color are accurate, they give this work a certain interest, but otherwise it's not much. The objects are unrelated to one another save by the eye; there's no shared action tying them together. In effect, what do this passing wagon, this standing woman, this seated man, this mounted traveller have in common? What have they to do with a halt or the main subject? Nothing that's apparent. They've been included here like a handkerchief, a teacup, a saucer, a bowl, a basket of fruit would be worked into a genre painting, and at least genre paintings have great verisimilitude and beautiful handling, while in a landscape such as this a beautiful sit coupled with rigorous depiction of local customs is meaningless.

149. *Method of Winter Travel*

To underline the disconnectedness of all these objects, I'm going to describe this painting as if it were a Chardin. Moving from right to left, some low mountains covered with snow. Behind these mountains, the white roofs of a village. In the foreground and at the foot of these low mountains, a large property marker beside a roadway; this marker is placed at the entrance to a forest. A horse-drawn sleigh, advancing to the right, is about to cross a bridge. One must imagine a wide river under the bridge, frozen over and covered

with snow, for we see some pilings and the masts of some large boats pulled in towards the shore. In the left foreground a peasant carting some provisions.

All we learn from this is how Russian sleighs are constructed. I'm not even sure these curved poles wouldn't be appropriate for use in this country, especially in provinces where the roadways are smooth and paved, if one took the precaution of adding large iron wheels.

150. Peasant Halt in Summer

To the right, we see a bit of forest, and near that a wagon loaded with livestock. Lower down, a stream. Advancing towards the left, a large wagon; near this wagon, a cow and a sheep. A man seen from the back leans over a wooden chest in the wagon. In the background, another wagon. Lower down and further left, a group of men and women resting. To the far left and towards the background, another group of men and women.

All these objects, while isolated, are rather harmoniously arranged. A certain skill is required to link them together visually solely by means of the variety of the site and lighting effects; but the sight of them is almost as lifeless as their description, and if they're accurate, and again I imagine they are, they could be of interest only to a man thousands of miles from his country who, glancing at one of these paintings, momentarily returns there, amid his compatriots, close to his father, his mother, his wife, his relatives, and his friends. If I were in Moscow, have you any doubt, my dear Grimm, that a map of Paris would give me great pleasure? I'd say: Here's the rue Neuve de Luxembourg; the one I hold dear lives here;[134] perhaps he's thinking of me at this very moment; he misses me, he wishes me to be as happy as I can so far from him. There's the rue Neuve des Petits Champs. Gaiety, wit, reason, trust, amity, decency, tenderness, and liberty reside there. The amiable hostess[135] had promised the Genevan Aesculapius[136] she'd go to bed at ten o'clock but we were still laughing and talking at midnight. Here's the rue Royale St. Roch;[137] this is where all the finest and sharpest people in the capital gather. Titles and erudition aren't enough to guarantee entry there; one must also be good. There one can count on an exchange of ideas; there history, politics, finance, literature, and

134 Baron Grimm.
135 Louise-Florence-Pétronille Tardieu d'Esclavelles, marquise de Lalive d'Epinay (1726–83), a close friend of Diderot's and Baron Grimm's mistress.
136 Théodore Tronchin (1709–81), a Genevan doctor who settled in France in 1765 and quickly became a member of Diderot's circle.
137 Baron Holbach lived on this street. See note 18 above.

philosophy are discussed; there one is held in sufficiently high regard
to be contradicted; there one finds the true cosmopolitan, the man
who knows how to dispose of his fortune, the good father, the good
friend, the good husband; there all foreigners of any reputation and
any accomplishment are welcome, and can count on the warmest
and politest of receptions. And is the wicked baroness still living?
Does she still tease so many people, none of whom love her any the
less for that? There's the rue des Vieux Augustins.[138] Here, my
friend, words would fail me; I'd put my head between my hands,
tears would fall from my eyes, and I'd say to myself: She is there;
how can it be that I am here?

151. *The Children's Cradle*

This is one of Leprince's best compositions. —You say you find it
better colored than the *Baptism*?—Oh no. —You find it more
interesting than the *Baptism*? —Oh no. But then the *Russian Baptism*
with which you're comparing this painting is a devilishly beautiful
thing.

In *The Children's Cradle* we see, at right, part of a wooden shed;
at the door of this shed, on a crude bench, an old peasant in his
smock, his legs oddly dressed and his feet oddly shod; around this
old man, on the ground, among weeds in the foreground, a bowl,
a small trough, some logs, a cock looking for nourishment; in front
of the old man, a sort of small hammock or cradle occupied by a
chubby, plump, well-fed brat, totally nude, reclining on his swad-
dling clothes. This cradle hangs by a cord from a large tree branch;
the cord has been wrapped around the branch several times. A tall
servant girl, rather young and well enough dressed to preclude her
being the old peasant's wife, pulls on the cord as if she intended to
raise the cradle, or perhaps lower it. Around the cradle, two more
children, one in the background, another in the foreground, one
seen frontally, the other with his back to us, both of them joyfully
observing the little one who's hanging. In the foreground a goat and
a sheep. Further left, an old woman with her distaff and spindle; she
has interrupted her work to address the girl pulling on the cord of
the hammock. At the extreme left, towards the foreground, a
cottage. Around the cottage, rustic tools and accessories.

The peasant is very fine, true to character, true to rustic nature;
his smock, all his clothing full and in good taste. I say the same of
the old woman who was spinning and who appears to be the

138 The family of Louise Henriette Volland, known as Sophie Volland (1716–84),
with whom Diderot had been in love since the mid-1750s, resided here.

children's grandmother; she's excellent: fine head, beautiful drapery, her action simple and truthful. The children, both the one in the cradle and the two others, charming. But there are lots of things here that I find vexing, though this may be the result of my ignorance of the nation's customs. This is a fine cottage for this peasant, but he's too crudely, too poorly dressed for this old woman to be his wife. The girl pulling on the cradle's cord to raise or lower it could be either the daughter of the old woman or her servant, but she has no connection to the peasant. What is the social station of these two women? Where do they live? Either I'm much mistaken or there's some equivocation in this composition. Do Russian women dress better than Russian men? However that may be, here the painter's coloring and touch are much stronger. This is less brick-colored, less reddish than his *Baptism*, but this *Baptism* is much more interesting, it's much richer in human interest. We'll talk about it in a moment.

152. *Interior of a Russian Peasant's Room*

We see in this room a seated Russian peasant girl; this peasant girl is again very well dressed; note this, just as in the preceding painting. Near her, towards the right, a small table on which she leans, one arm reaching towards a basket full of eggs. In front of her, a very demonstrative young peasant, his arms extended, an egg in each hand. A large white curtain hanging from a pole spreads out behind the peasant girl. At her feet is a cat arching its back and rubbing against her. She is elevated on a kind of platform with a single step. On this platform and below it, on the floor, the painter has scattered a basket, another basket, a bowl filled with several vegetables. Further left and in the foreground, there's a table with a water jug. At the extreme left and in shadow, an old woman sleeping, thereby making it possible for the young egg merchant who is her daughter to accept the exchange being proposed to her. This painting is attractive. The basic idea is smutty, or I'm much mistaken. The young peasant is vigorous. Young woman, I'm not quite sure what he's promising you, but in France I'd advise you to discount at least half of it . . . But let's not pursue this point; to really address it, we'd need to know the extent to which Russian men keep their word to Russian women.

153. *View of a Mill in Livonia*

Rather middling, though somewhat less bad than the *Bridge at Nerva*.

154. *Landscape with Figures Dressed in Different Styles*

This landscape shows a mountain to the right. A little beyond the mountain, water with boats near the shore. Advancing towards the left, more mountains filling and making up the background. In the center of the canvas, a sleigh with a litter pulled by a horse; on this sleigh, a hamper in which we see a sheep and a lamb. Still moving to the left, a group of men variously dressed, resting; then a structure raised up on pilework; on this elevated area, a wagon; near the wagon, a young man lying down. At the extreme left, water.

All these isolated actions require a bit more movement and interest; something in the animate beings that would reverberate with the inanimate objects; something in the latter that would provoke a reaction from the former; in other words, invention, an organization conceived for this particular scene, discrimination in the choice of incidents; there's none of that here. Every man who knows how to draw as well as our friend Carmontelle, without having any more verve than he, has only to go outside the city walls around five in the evening or nine in the morning, and he'll find subject matter for a thousand paintings; but these paintings would excite curiosity only in Moscow. If the handling were better, if the imitation of nature in each figure were fully realized; if this were a *Beggar* by Callot, or a *Hurdy-Gurdy Player* by Berchem, or a *Drunk* by Teniers, truthful depiction of the subject would make us forget its wretchedness.

We've just covered quite a lot of ground. I don't know, my friend, whether you're as exhausted as I am, but God be praised, here we are back where we started. Let's sit down, let's unwind; if we were to relax a bit, it wouldn't be a bad thing; then we'd remove our travelling clothes and head off together to this *Russian Baptism* to which we've been invited.

155. *A Russian Baptism* (Pl. 34)

We're there. In faith, it's a beautiful ceremony. This grand silver baptismal font makes a beautiful effect. The office of these three priests standing at right is a dignified one: the first takes the newborn beneath the arms and plunges him into the font feet first; the second oversees the ritual and reads the sacramental prayers; he reads well, like an old man ought to read, holding the book away from his eyes; the third looks attentively at the book; and the fourth, who spreads incense from a burning brazier near the baptismal font, have you noticed how well, richly, nobly dressed he is? How his action is natural and true? You'll agree that here we have four heads that are venerable indeed . . . But you're not listening to me, you're neglect-

ing the venerable priests and the whole sacred ceremony, and your eyes remain fixed on the godfather and godmother. I can't hold this against you; it's a certainty that this godfather has the most virtuous, sincere character one could possibly imagine; if I ever encountered him elsewhere, I couldn't help but seek out his acquaintance and affection: I'd make friends with him, I tell you. As for this god-mother, she's so amiable, so decent, so kind . . . —That I'd make her, you say, my mistress, if I could. —And why not? —And if they're married, so much for your good Russian friend . . . — You've got me there. But in the Russian's place I'd try to keep my friends away from my wife, or I'd have the fairness to say: My wife is so charming, so amiable, so attractive . . . —And you'd forgive your friend? —Oh no. But what an edifying conversation for the most serious of Christian ceremonies, in which we're reborn in Jesus Christ by having the sins committed by our grandfathers seven thousand years ago washed away! Observe how well this godfather and godmother discharge their office! They set the tone: they're pious without bigotry. The figures behind the three priests seem to be relatives, witnesses, friends, assistants. What fine head studies Poussin would make here, for they're completely in character with his own. —What do you mean, talking about studies by Poussin? — I mean to say that I forgot I was talking to you about a painting. And this young acolyte extending his hand to take the vessels of holy oil that another gives him on a tray, concede that he's posed in the simplest yet most elegant way possible; that he extends his arm with ease and grace, and that his figure is charming in every respect. How well he carries his head! How well posed it is! How well his hair is arranged! What distinguished features he has! How erect he holds himself without being either mannered or stiff! How well and simply dressed he is! The man beside him, bending over an open chest, is apparently the father or an assistant looking for something with which to swaddle the infant immediately upon his emergence from the font. Observe this infant carefully, he has everything a beautiful infant ought to have. The child I see behind the godfather is either his page or his squire; and the woman seated in the left background, beside him, is either the midwife or the sick-nurse. As for the woman we glimpse in a bed, beyond this curtain, there can be no mistake, she's the newly-delivered mother, and she'll get a dreadful headache from the burning incense if she doesn't watch out. And that, in faith, is pretty much it, a beautiful ceremony and a beautiful painting. It's the artist's reception piece. How many names do you think we'd read in the catalogue, if one had to produce a painting like this to gain admission to the Academy?

I'm ashamed to tell you that the coloring is coppery and reddish, that the background is too brown, that the handling of light . . . but

human weakness has to manifest itself somehow. Otherwise, this composition is fully achieved; all the figures are interesting; even the coloring vigorous. I'd swear the artist made this work in a period of good health, and that if I were young, single, and were to be offered this Russian for a father-in-law and this young woman so modestly holding her candle next to him for my wife, along with a modest income, no more than would be necessary to allow my little Russian to sleep in on Sunday when she liked, myself keeping her company on the same pillow, and, without hardship, raise little urchins that these venerable fathers would come to baptize every nine or ten months at my home, my faith, I'd be tempted to go to this country to see what the weather is like.

DESHAYS[139]

This is the brother of the one we've lost. These two brothers remind me of an episode from Piron's youth,[140] for today this demented old man beats his chest and confesses before God to all the jokes he's made and all the idiotic things he's done. By God, my friend, this atom that we call Man is vainer than he has any right to be! A wretched little poet who imagines he's offended the Eternal Father, that he gladdens His heart, and that it's in his power to make God laugh or cry at will, as if he were an idiot in the pit of a theatre! Once this Piron got drunk with an actor, a musician, and a dancing master, and was making his way home along with his colleagues, creating a bacchanal in the street. They were arrested and taken to Superintendent of Police La Fosse, who asked the author who he was; he answered: "The father of *The Ungrateful Son*." Likewise to the actor, who answered that he was the tutor of *The Ungrateful Son*. To the dancing master and the musician, the first answering that he was the dancing teacher, the second that he was the singing teacher of *The Ungrateful Son*. The superintendent, on hearing these answers, had no trouble figuring out who he was dealing with. He called Piron aside; he told him he was a member of the family, so to speak, that he had a brother who was a literary man. "By God!" Piron said to him, "I can well believe it, I have one myself who's a fucking

139 François-Bruno Deshays (dates unknown). He was the brother of J.-B. Deshays.
140 Alexis Piron (1689–1773). A fashionable playwright earlier in the century; author, notably, of *Gustave Wasa* (1733) and *La Métromanie* (1738). The story below exploits the title of his successful comedy *The Ungrateful Son*.

idiot." The Deshays who's dead could have said as much, and even to a superintendent of police, for he willingly took the trouble to visit the subordinate magistrates charged with assuring that lanterns aren't broken and prostitutes aren't beaten. I amuse myself telling you stories because I have absolutely nothing to say about the younger Deshays, whose paintings are even worse than his elder brother's were good, and they were very good, who hasn't a flicker of genius, who is totally without talent, and who entered the Academy of Painting just like the Abbé du Resnel entered the Académie Française. One day this last fellow said to me: Do you know of a single mortal who is happier than I? I aspired to three things in my life and I've obtained all three: I wanted to be a poet, and I became one; I wanted to be an academician, and I am one; I wanted to have a carriage, and I have one . . . A story or amusing anecdote, my friend, is worth more than a hundred bad paintings and all the bad things one could say about them.

LÉPICIÉ[141]

My friend, what if we continued to tell stories? . . .

162. *William the Conqueror Disembarking in England*
Very large painting

A general couldn't make it any clearer to his soldiers that they would either conquer or die than by burning the ships that had carried them. This is what William did. What a wonderful deed for the historian! What a fine model for a conquerer! What a beautiful subject for a painter, provided that painter is not Lépicié. What moment do you think the latter selected? Probably the one in which flames are consuming the ships, and in which the general announces the terrible alternative to his army. You think we see the ships burning on the canvas; William on horseback addressing his troops; and on this numberless multitude of faces the full range of impressions of anxiety, surprise, admiration, terror, despondency, and joy; your head fills up with groups, you try to imagine William's true action, the characterizations of his principal officers, the silence or

141 Nicolas-Bernard Lépicié (1735–84). Student of his father Bernard Lépicié. Granted provisional membership in the Royal Academy on September 28, 1764; received as a full academician on July 1, 1769.

grumbling, the stillness or movement of his army. Calm yourself, don't take any trouble the artist hasn't taken himself. When one has genius there aren't any unrewarding moments; genius can impregnate anything.

We see in his picture at right, on the side of the sea and ships, a dim glow and some smoke indicating that the conflagration has begun; some idle, mute soldiers, without movement, without passion, without character; then we see, all alone, a short fat man, his arms extended, screaming his head off; I've asked who he's so angry at a hundred times without being able to find out; then William in the midst of his army, on horseback, advancing from right to left as if he were in his own country and in ordinary circumstances; he's preceded by infantry and cavalry marching on the same side and seen from the back. Neither noise, nor tumult, nor military enthusiasm, nor bugles, nor trumpets; this is a thousand times colder and more tedious than a regiment passing beneath the walls of a provincial town on the way to its garrison. Only three objects stand out, this short, fat, heavy-handed standing figure, placed alone between William and the burning ships, his arms outstretched and screaming without anyone's hearing him; William on his horse, both man and horse as heavy, monstrous, false, and depressing, and even less noble and less meaningful than your Louis XIV in the Place Vendôme; and then the enormous back of another cavalryman and the even more enormous rump of his horse.

But, my friend, do you want a real painting? Leave these figures more or less as they are but rotate them 180 degrees; have them set fire to the ships, have William speak, and show me faces with passionate reactions intensified by the reddish glow from the burning fleet. Use the conflagration to produce some astonishing light effect; the arrangement of the figures would help this, even without changing them. Take note, my friend, of the marvellous effect created by size and mass. Lépicié's composition impresses, attracts attention, but it doesn't hold that attention for very long. If I had the mind of a Le Sueur, a Rubens, a Carracci, or some other such, I'd tell you how one could have brought off the moment chosen by the artist, but lacking such a mind, I haven't any idea. All I can think of is that the interest inherent in the slighted moment would have to be replaced, with just what I can't say, but something sublime that's consistent with its real or apparent tranquility, and that transcends movement; witness the *Universal Flood* by Poussin, which contains only three or four figures. But who is capable of a solution such as this? And when an artist has found one, who responds to it? In the theatre, it's not in the violent scenes that move the crowd to ecstasy that a great actor shows me the extent of his gifts; what could be easier than giving oneself over to fury, to curses, to frenzied outbursts? It's "Sit down, Cinna" and not

A son disgusting from the murder of his father,
His head in hand, demanding his recompense . . . ?[142]

that's difficult to put across. The author, who here serves the same function as the chosen moment in painting, counts for half the effectiveness of the declamation. It's in passion that's controlled, concealed, dissimulated, secretly bubbling in the heart's depths like the fire in the subterranean cauldron of a volcano; it's in the moment preceding the explosion, and sometimes the moment after, that I see what a man is capable of; and what would make me a little vain would be to have created an effect where outward circumstances promised nothing.[143] It's in quiet scenes that an actor shows me his intelligence, his judgment. It's when a painter has disregarded the advantages that go with a dramatic moment that I'm led to expect great character, serenity, silence, and all the wonder of a rare ideal and a technique that's almost as rare. You'll find a hundred painters who can bring off a battle that's joined for a single one who knows how to bring off a battle that's already been lost or won. In Lépicié's painting there's nothing to compensate for the interest he's passed up; there's neither harmony nor nobility; it is dry, harsh, and crude.

163. *Christ Baptized by Saint John*

In a hurry to finish and collect their fee, people like this know not what they do. Woe to the productions of artists who count the hours and who have eyes only for their pay! This one, like the other one, has made his *Baptism* a solitary affair, and judging from the vaporous, greyish tonality in which it's painted, one could say his figures were an arbitrary, bizarre configuration of clouds.

We see at right, in the background, three apostles who are frightened, and of what? There's nothing frightening about a voice that says: "This is my dearly beloved son." This St John, his eyes turned heavenwards, pours water over Christ's head without looking at what he's doing; and this big block of squared stone on which he stands, who brought it there? One would say it was essential to the ceremony, and that a bit of fallen rock would not have done just as well, more naturally and to more picturesque effect. For what does a mason do when he cuts a stone? He removes all its irregularities; this is the symbol of the education that civilizes us, that

142 Corneille, *Cinna*: act V, scene 1, v. 1425; act I, scene 3, vv. 201–2.

143 A rather free rendering of "de valoir quelque chose quand les tableaux ne valent rien": Diderot is here playing with the application of the French word *tableau* to both painting and the theatre.

removes from man the brute the savage imprint of nature, that makes us agreeable for social interaction, insipid in a poem or on canvas. And this soft, pliant, smooth garment, if you tell me it's a lambskin, you're correct; that's what it is, but one that's well combed, well sulphured, well bleached, well tawed, and certainly not one that would belong to a man of the forests and mountains. This Christ towards the left is consumptive, his air ignoble and destitute yet again. Is it absolutely impossible to break away from this miserable traditional characterization? I'm all the more inclined to think otherwise because we have two different Christs: Christ on the cross is very different from Christ in the midst of his apostles. At left, as is customary, in the center of the light, the holy, paltry dove; around it, on one side some cherubim, on the other a group of angels. And you should see the color, the feet, the hands, the drawing, the flesh in all this!

But it seems to me that, as the pictures adorning places of worship are made to impress the acts and gestures of the heroes of religion on the minds of the people and to increase the people's veneration, their being good or bad should be a matter of some concern. As I see it, a church painter is a kind of preacher who is clearer, more striking, more intelligible, more accessible to the common man than his rector and his vicar. The latter speak to ears that are often closed to them. Pictures speak to the eyes just like the spectacle of nature, which has taught us everything we know. I take the argument further, and regard iconoclasts and those contemptuous of processions, images, statues, and all the exterior trappings of worship as executioners in the pay of the philosophers who are the enemies of superstition, with the difference that these hirelings do it much more damage than their masters. Suppress all these tangible symbols, and the rest will soon be reduced to a metaphysical rigamarole assuming as many forms and bizarre twists as there are heads. Imagine for a moment that all men have become blind: I'd wager that within ten years they'd exterminate each other over disputes about the form, effect, and color of the most ordinary beings in the universe. Likewise, in religion suppress all representations and all images, and soon they'll fall out and cut each other's throats over the most fundamental articles of their faith. These absurd religious sticklers don't understand the effect exterior ceremony has on the people; they've never seen our adoration of the cross on Good Friday, the enthusiasm of the crowd at the Corpus Christi procession, an enthusiasm to which even I succumb. I've never seen this long file of priests in religious robes, these young acolytes dressed in their white albs pulled in by their wide blue belts and throwing flowers in front of the Holy Sacrament, this crowd that precedes and follows them in religious silence, many of them

prostrating themselves to touch the ground with their foreheads; I've never heard this grave and affecting chant intoned by the priests and answered affectionately by an infinite number of men's, women's, girls', and children's voices, without my insides being moved, shaken, and tears coming to my eyes. There is something about this, though I don't know what, that is grand, sombre, solemn, melancholy. I knew a Protestant painter who had long resided in Rome and who admitted he'd never seen the sovereign pontiff officiate in Saint Peter's, in the midst of the cardinals and all the clergy, without himself becoming a Catholic. He recovered his own religion at the door. But, they say, these images, these ceremonies foster idolatry. It is droll to see the merchants of deceit afraid that this infatuation might increase their numbers. My friend, if we love truth more than the fine arts, let's pray that God favor the iconoclasts.

164. *Saint Crispin and Saint Crespinian Distributing their Goods to the Poor*

My friend, another little story. You're well acquainted with the Marquis d'Ximenès, to whom our good friend the Count Thiars remarked about a kick the marquis had received from his horse: "How did you reward him?" Well, one day this Marquis d'Ximenès, who makes tragedies like Monsieur Lépicié makes paintings, was reading one of his tragedies to the Abbé Voisenon; it was stuffed with beautiful verses from Corneille, Racine, Voltaire, and Crébillon, and during the reading the Abbé repeatedly stood up and bowed deeply. —"Why are you making all these bows?" the Marquis asked him. —"When we see old friends passing by, shouldn't we greet them?" the Abbé replied. My friend, tip your hat as well; bow deeply to St Crispin and St Crespinian, and so greet Le Sueur.

The two young saints are standing on a kind of platform. To the right, below the platform, old men, women, children, a crowd of poor people, arms outstretched and waiting for the distribution. On the platform, behind the saints to the left, two assistants or companions.

St Crispin's drapery, posture, and characterization are beautiful; he's simplicity itself, and compassion; but he belongs to Le Sueur. As for all these beggars, they are too well dressed, their coloring and flesh are too fresh; the children are fat and chubby; the women beautifully plump; the old men vigorous and well fed, and in a well regulated state these sluggards wouldn't be here, they'd be confined. Carle Van Loo, in his sketches for the chapel in the Invalides, displayed a superior grasp of the limits of poetry and truth.

Somewhere I promised you some remarks about plagiarism in painting, and I'm going to keep my word. Nothing, my friend, is more common or more difficult to recognize. An artist sees a figure, say a woman whose posture he likes; in two pencil strokes her sex is changed and her position recorded. A child's expression can be transferred to the face of an adult, an adult's joy or fear can be given to a child, etc. One opens up one's print portfolio, one isolates a bit of landscape here, another there; one takes a cottage from this sheet, a cow or sheep from that, a mountain from another, and from these assorted bits and pieces one makes a grand composition, just like it's said the late Maréchal de Belle-Isle built up his estate. And there's also the possibility of placing in shadow what had been in the light, and, conversely, of placing what was exposed to the light in shadow. I want painters and poets to learn from, be inspired by, become excited about the work of others, and this kind of borrowed insight and inspiration is not plagiarism. Sedaine[144] heard a decrepit woman dying in her armchair, her face turned towards a window illuminated by the sun, utter the words: "Ah! My child, how beautiful is the sun!" He remembered this, and he made a young woman who'd been confined by a jealous man and had just escaped from a convent declare on seeing the streets for the first time: "Ah! My dear, how beautiful the streets are!" There you have a small example of the kind of imitation that's permissible on a large scale.

AMAND[145]

Greet this fellow too, though not as a plagiarist; what he's got is all his, unfortunately.

165. *Mercury Killing Argus*

His Mercury, of all celestial beings the most svelte, is heavy, with a paralyzed arm, and it's with this one that he threatens Argus. This

144 Michel-Jean Sedaine (1719–97). French playwright, author of *Le Philosophe sans le savoir*.

145 Jacques-François Amand (1730–69). Student of Pierre. Granted provisional membership in the Royal Academy in 1765; received as a full academician on September 26, 1767.

sleeping Argus is very lean, very dry, as a guardian should be, but he's stiff and hideous in a way that no painted figure should be. And this cow lying down between him and Mercury, it's just a cow, no pain, no passion, no boredom, nothing that indicates the metamorphosis. When one has genius, here's a place one can display it. Never did a great master attempt to paint this cow without making a singular image of it. Monsieur Amand, this work is nothing but a wretched daub that's darkened in a dealer's shop. It should be taken back there.

166. *The Family of Darius*

I spent a long time seaching for your *Family of Darius*, but I was unable to locate it or anyone else who'd found it.

167. *Joseph Sold by his Brothers*

As for *Joseph and His Brothers*, that I saw. Choose, my friend: do you want a description of this picture, or would you prefer a story? —But the composition doesn't strike me as being all that bad.—I agree. —This big chunk of rock on which the child's price is being counted out works well in the center of the canvas. — Certainly. —The merchant leaning over this rock and the one behind him are fairly well draped and characterized. I don't deny it. —The Joseph is stiff, short, graceless, lacking in attractive color, expressionless, without interest, and his legs are even a bit dropsical, but that's no reason to rip the whole canvas to shreds. — I've no such intention. —These groups of brothers on one side, of merchants on the other are even arranged with intelligence. —I think so, too. —The color . . . —Ah! Let's not speak of the color and the drawing, I close my eyes to those. What I feel here is a mortal chill overtaking me, and this in front of the most affecting of subjects. What gave you the idea it was permissible to show me a scene like this without breaking my heart in two? Let's speak no more about this picture, I beg you; the mere thought of it pains me.

168. *Hermione Dressing Tancred's Wound*

To the Notre Dame bridge.

169. *Rinaldo and Armida*

Even worse, a hundred times worse than Boucher. Off to Tremblin's shop!

172. *Cambyses, Furious with the Egyptians, Kills their God Apis*

Great subjects treated by I can't say what, for this man isn't an artist, he has none of the necessary parts, unless it be a spark of verve that's extinguished when he proceeds from sketch to canvas. Ah, Monsieur Amand, how right Lemoyne was.[146] This *Cambyses Killing the God Apis*, oil sketch, is summary, but it's energetically executed and certainly is furious.

173. *Psammitichus, One of the Twelve Kings of Egypt, in a Solemn Sacrifice, Lacking a Bowl, Uses his Helmet to Offer Libations to Vulcan*
Sketch

Beautiful subject, very poetic, very picturesque, but all I can find in it is five or six slaughterhouse workers subduing a bull. It's certainly exuberant, but as messy as could be imagined.

175. *Magon Distributing, in the Carthaginian Senate, the Rings of the Roman Soldiers Killed in the Battle of Cannae*
Sketch

Another great subject! This sketch is less impetuous than its predecessors but has more successful lighting effects and is better organized.

Ah! If only I could strip this Amand of his zeal and poetry and give it to Lagrenée! And if I had a child who'd already made some progress in art, by having him look awhile at Lagrenée's *Justice and Clemency*, between Boucher's *Angelica and Medoro* and Amand's *Rinaldo and Armida*, he'd soon understand the difference between the true and the false, the extravagant and the intelligent, the hot and the cold, the noble and the mannered, good and bad color, etc.!

146 The reference is to Lemoyne's observation that it took thirty years to learn how to preserve the merits of a sketch in a finished painting (cited by Diderot on p. 4 above).

FRAGONARD[147]

179. *The High Priest Corésus Sacrificing Himself*
to Save Callirhoé (Pl. 35)
Large painting

It's impossible for me to talk to you about this painting; you know that it was no longer at the Salon when the incredible stir it created summoned me there. It will be up to you to give an account of it; we'll discuss it together; and so much the better, for perhaps we'll discover why, after a first round of tributes paid to the artist, after the first expressions of praise, the public seemed to cool towards it. Every composition whose success is short-lived is lacking in some important respect. But to fill out this entry on Fragonard I'm going to tell you about a very strange vision which tormented me one night, after a day on which I'd spent the morning looking at the paintings and the evening reading some of Plato's dialogues.

PLATO'S CAVE

It seemed to me I was confined in the place known as this philosopher's cave. It was a long dark cavern. I was seated there along with a multitude of men, women, and children. All our hands and feet were chained and our heads so well secured by wooden restraints that it was impossible for us to turn them. But what astonished me was that most of them drank, laughed, and sang without seeming the least bit encumbered by their chains, such that if you were to see them you'd say this was their natural state; I even had the impression that those who made any effort to free their own hands, feet, and heads were regarded with suspicion and called by loathsome names, were avoided as if infected with some contagious disease, and that when anything disastrous happened in the cave they were always held responsible for it. Fitted out as I've just described, all our backs were turned to the entrance of this place and we could see nothing but its inner reaches, across which an immense canvas had been hung.

147 Jean-Honoré Fragonard (1732–1806). Student of Chardin (?) and Boucher. Granted provisional admission to the Royal Academy on March 30, 1765; he never became a full academician.

Behind us were kings, ministers, priests, doctors, apostles, prophets, theologians, politicians, cheats, charlatans, masters of illusion, and the whole band of dealers in hopes and fears. Each of them had a small set of transparent, colored figures corresponding to his station, all so well made, so well painted, so numerous and diverse that they were adequate to represent all the comic, tragic, and burlesque scenes in life.

These charlatans, as I subsequently realized, between us and the entrance to the cave, had a large hanging lamp behind them in front of whose light they placed their little figures such that their shadows were projected over our heads, all the while increasing in size, and came to rest on the canvas at the back of the cave, composing scenes so natural, so true, that we took them to be real, now splitting our sides from laughing at them, now crying over them with ardent tears, which will seem a bit less strange when you know that behind the canvas there were subordinate knaves, hired by the first set, who furnished these shadows with the accents, the discourse, the true voices of their roles.

Despite the illusion created by this arrangement, there were a few in the crowd who were suspicious, who rattled their chains from time to time and who had an intense desire to rid themselves of their restraints and turn their heads; but at that very instant first one then another of the charlatans at our backs would begin screaming in a terrifying voice: Beware of turning your head! Calamity will befall anyone rattling his chains! Show respect for the restraints . . . On another ocassion I'll tell you what happened to anyone disregarding the voice's advice, the danger he ran, the persecution that was his lot; I'll save that for when we talk philosophy. Today, since we're dealing with pictures, I'd prefer to describe to you some of the ones I saw on the large canvas; I swear to you they were easily on a par with the best in the Salon. On this canvas everything seemed rather disconnected at first; figures laughed, cried, played, drank, sang, fought, pulled out one another's hair, caressed one other, whipped one other; when one was drowning, another was being hung, a third lifted up on a pedestal; but gradually everything coalesced, became clear, and was understandable. Here is what I saw pass by at different intervals, which I'll string together for the sake of brevity.

First there was a young man, his long priest's robes in disorder, one hand grasping a thyrsus, his forehead crowned with ivy, who poured a stream of wine from a large antique vase into large, deep goblets which he then held up to the mouths of some women with wild eyes and dishevelled hair. He drank with them, they drank with him, and when they were intoxicated, they rose and ran through the streets uttering cries of fury mixed with joy. The people, struck by these cries, closed themselves into their houses,

fearful of running into them. They were capable of tearing to pieces any foolish person putting himself in their way, and I saw them do it several times. Well, my friend, what do you say to that?

GRIMM: I say here are two rather beautiful pictures, more or less of the same genre.

DIDEROT: Here's a third one in a different genre. The young priest leading these furies was extremely handsome; I took note of him, and it seemed to me, in the course of my dream, that, overcome by an intoxication more dangerous than that induced by wine, he directed his gaze, his gestures, and his most passionate, most tender utterances to a young woman who refused to listen to him and whose knees he embraced, to no avail.

GRIMM: Though this one has only two figures, that wouldn't make it any easier to execute.

DIDEROT: Especially if they were to have the strong expressions and unusual character they possessed on the canvas in the cave.

While this priest was entreating his inflexible young woman, all of a sudden I heard cries, laughter, screams coming from inside the houses and saw fathers, mothers, women, girls, children emerge from them. The fathers threw themselves on their daughters, who'd lost all sense of shame, the mothers on their sons, who refused to acknowledge them, and the children of both sexes, mingling together, rolled about on the ground; it was a spectacle of extravagant joy, of unbridled license, of a fury and intoxication that were inconceivable. Ah! If only I were a painter! All these faces are still vivid in my mind.

GRIMM: I'm pretty familiar with what our artists can do, and I swear to you there isn't a single one who'd be capable of sketching such a picture.

DIDEROT: In the midst of this tumult some old men who'd been spared by the epidemic, their eyes overflowing with tears, prostrated themselves in a temple, beat their heads against the ground, fervently embracing the god's altars, and I heard the god, or perhaps the subordinate knave behind the canvas, say very distinctly: "She must die, or another must die in her place."

GRIMM: But my friend, at this rate don't you realize that only one of your dreams would suffice to fill an entire gallery?

DIDEROT: Wait, wait, I'm not finished. I was extremely impatient to discover the outcome of this ominous oracle, when the temple was newly revealed to my eyes. Its floor was covered with a red carpet bordered by a wide gold fringe; this rich carpet and its fringe fell over the edge of a long step extending the full width of the façade. At right, near this step, was one of those broad sacrifical vessels intended to receive victims' blood. On

either side of that portion of the temple visible to me, two large
columns of white, transparent marble rose towards the roof. At
right, at the foot of the foremost column, had been placed a black
marble urn partly covered by some of the material needed in such
bloody ceremonies. On the other side of the same column was a
large candelabrum of the noblest form; it was so high it almost
reached the top of the column. In the interval before the two
columns on the other side, there was a large altar or triangular
tripod on which the sacrificial fire had been lit. I saw the reddish
glow of the burning braziers, and the smoke of the incense
obscured part of the inner column. There you have the theatre of
one of the most terrible and moving representations unfolding on
the canvas of the cave during my vision.

GRIMM: But tell me, my friend, have you confided your dream to
anyone?

DIDEROT: No. Why do you ask me this question?

GRIMM: Because the temple you've just described is exactly like
the scene in Fragonard's picture.

DIDEROT: That could be. I've heard so much talk about this
painting over the last few days that, obliged to make up a temple
in my dreams, I'd have made up his. However that may be, while
my eyes surveyed this temple and the preparations that portended
I knew not what with a heavy heart, I saw a single young acolyte
dressed in white arrive; he seemed sad. He crouched at the foot
of the candelabrum and leaned against the molding of the inner
column's base. He was followed by a priest. This priest had his
arms crossed over his chest, his head was bent forward, he seemed
absorbed in reflections that caused him great pain; he advanced
with deliberate steps. I waited for him to lift his head; he did so,
turning his eyes towards the heavens and giving voice to the most
mournful of sighs, and I added a cry of my own when I recog-
nized this priest. He was the same one I'd seen entreating the
inflexible young woman so earnestly and so unsuccessfully just a
few moments before; he too was dressed in white; still handsome,
but anguish had deeply marked his face. His forehead was
crowned with ivy and his right hand grasped the sacrificial knife.
He went and stood not far from the young acolyte who'd pre-
ceded him. A second acolyte arrived, also in white, who stopped
behind him.

Next I saw a young woman enter; she was likewise dressed in
white, a crown of roses circled her head. Her face wore a deathly
pallor, her trembling knees gave way beneath her; she barely had
strength enough to reach the feet of he who adored her, for it was
she who had so proudly disdained his tenderness and his pleas.
Though everything transpired in silence, one had only to look at

the two of them and recall the words of the oracle to understand that she was the victim and that he was going to sacrifice her. When she was near the high priest her wretched lover, alas! a hundred times more wretched than she, she lost all her strength and fell backwards onto the bed, the very spot on which she was to receive the mortal blow. Her face was tilted heavenwards, her eyes were closed, her two arms which already seemed lifeless hung at her sides, the back of her head almost touched the robes of the high priest her sacrificer and lover; the rest of her body was limp, but the acolyte who'd stopped behind the high priest gave it some support.

While I was reflecting on the unhappy fate of man and the cruelty of the gods or rather of their priests, for the gods are nothing, and dried a few tears that had fallen from my eyes, a third acolyte entered, dressed in white like the others and crowned with roses. How beautiful this young acolyte was! I can't say whether it was his modesty, his youth, his kindness, or his nobility that interested me, but I found him even more impressive than the high priest. He crouched down some distance from the swooning victim and his pitying eyes were fixed on her. A fourth acolyte, also in a white robe, moved near to the one holding the victim; he bent down on one knee, and on his other knee he placed a wide basin which he held by the edges as if preparing to receive the blood about to flow. The cruel implications of this basin, the place occupied by the acolyte, and his posture were only too clear. By this time many other people had hastened into the temple. Men, born capable of compassion, seek out cruel spectacles so they can exercise this capacity.

Towards the back, near the inner column on the left, I noticed two elderly priests standing, as remarkable for the unusual way their heads were cloaked as for the severity of their character and the gravity of their demeanor.

Almost outside, against the forward column on the same side, was a solitary woman; a bit further on and still more outside, another woman, her back against a stone marker, with a young child naked on her knees. The beauty of this child and, perhaps even more, the singular effect created by the light that fell over them both fixed them in my memory. Beyond these women, inside the temple, two more observers. In front of these two observers, exactly between the two columns, with a view of the altar and its burning brazier, an old man whose character and grey hair made an impression me. I don't doubt the space further back was full of people, but from the spot I occupied in my dream and in the cave I could see nothing more.

GRIMM: This is because there was nothing more to see, because these are all the figures in Fragonard's picture. In your dream they're disposed exactly as they are in his canvas.

DIDEROT: If that's the case, what a beautiful picture Fragonard has made! But hear out the rest. The sky shone forth with crystalline clarity; it seemed the sun had precipitated the entire mass of its light into the temple and took delight in directing it at the victim, when the ceiling darkened, obscured by thick clouds which, spreading about our heads and blending with the light and air, brought forth an unexpected horror. Through these clouds an infernal demon glided forward. I saw him myself: wild eyes bulged from his head; he held a dagger in one hand, the other brandished a burning torch; he screamed. He was Despair, and he carried Love, fearsome Love, on his back. At that very instant the high priest grips the sacrificial knife, he raises his arm; I think he's about to strike the victim, to plunge it into the breast of she who had scorned him and whom the heavens had now delivered to him; not at all, he strikes himself. A generalized shriek pierces and rents the air. I see death's symptoms make their way over the cheeks, the forehead of the loving, generous unfortunate; his knees give way, his head falls back, one of his arms hangs limp, the hand wielding the knife still fixes it in his heart. All eyes are glued to him or fear becoming so; everything signals pain and dread. The acolyte at the foot of the candelabrum stares and gapes in horror; the one supporting the victim turns his head and looks on in horror; the one holding the sinister basin lifts up his frightened eyes; the face and extended arms of the one I found so beautiful reveal all his pain and fright; these two aged priests, whose cruel stares must have feasted so often on steam rising from blood with which they'd soaked the altar, cannot not help but experience pain, empathy, fear; they feel sorry for the unfortunate, they suffer, they are astounded; this solitary woman leaning against one of the columns, overcome by horror and fright, turns away quickly; and the other one with her back against a stone marker falls backwards, one of her hands rises to cover her eyes, and her other arm seems to push this frightening spectacle away; surprise and fear can be read on the faces of the spectators farthest from her; but nothing compares with the astonishment and pain of the grey-haired old man, his hair standing on end, I can still see him, lit by the glow of the burning brazier, his arms extended over the altar: I see his eyes, I see his mouth, I see him lurch forward, I hear his screams, they awaken me, the canvas withdraws and the cave disappears.

GRIMM: That's Fragonard's painting, that's exactly the effect it creates.

DIDEROT: Truly?

GRIMM: It's the same temple, the same arrangement, the same figures, the same action, the same characterizations, the same overall effect, the same virtues, the same faults. In the cave you saw only apparitions, and in his canvas Fragonard, too, has shown us only apparitions. You had a beautiful dream, and a beautiful dream is what he's painted. When one momentarily loses sight of his picture, one fears his canvas might withdraw just as yours did, that these fascinating, sublime phantoms might vanish like those of the night. If you had seen his painting, you'd have been struck by the same magical handling of light and the way the clouds blended with it, and by the ominous effect this mixture created throughout the composition; you'd have experienced the same empathy, the same fright; you'd have seen the mass of this light, strong at first, diminish with surprising speed and skill; you'd have noted the accomplished play of reflected light among the figures. This old man whose piercing screams awakened you, he was just where you saw him, and the two women and the young child, all clothed, lit, frightened just as you've described. Likewise the aged priests, with their loose, full, picturesque cloaked heads, and the acolytes, with their white religious robes, were also distributed on his canvas exactly as on yours. The one you found so beautiful was just as beautiful in the painting, being illuminated from the back such that his forward parts were in half-light or shadow, a painterly effect easier to dream than to achieve, but which deprived him of neither his nobility nor his expressivity.

DIDEROT: What you tell me almost makes me believe, though I don't think this is true during the day, that by night I'm in communication with him.

GRIMM: Surely. But in the painting we observed that the high priest's robes were a bit too much like those of a woman.

DIDEROT: But wait; that's just as in my dream.

GRIMM: That these young acolytes, as noble, as charming as they were, were of indeterminate sex, like hermaphrodites.

DIDEROT: It was just like that in my dream.

GRIMM: That while the victim fell and slumped convincingly, perhaps her lower body was too completely covered by her robes.

DIDEROT: I noticed the same thing in my dream, but I counted such decency a merit, even in such a moment as this.

GRIMM: That her head, weak in color, rather inexpressive, without complexion, without transitions, was more like that of a woman asleep than of one who'd fainted.

DIDEROT: I dreamed her with these same faults.

GRIMM: As for the woman holding her child on her knees, we found her superbly well painted and posed, and the stray ray of light falling on her quite convincing; the reflected light on the

forward column the very limit of truth; the candelabrum, of the most beautiful form and seemingly made of gold. Only figures as vigorously colored as Fragonard's could have held their own against this red carpet with its gold fringe. The old men's heads seemed to us strongly characterized, vividly indicating surprise and horror; the demons quite fierce, quite airy, and the black clouds they brought with them well distributed, giving the scene an air of astonishing terror; the masses of shadow highlighting in the strongest, most piquant way the dazzling splendor of the bright areas. And then a unique feature. Wherever one's eyes settled they encountered fright, it was in every figure: it emanated from the high priest, it spread, it was intensified by the two demons, by the dark clouds accompanying them, but the sombre glow of the braziers. It proved impossible to keep one's soul at a distance from an impression repeated in this way. It was like popular uprisings, in which the passion of the majority takes hold of you even before the cause is known. But in addition to the fear that at the first sign of the cross all these apparitions might disappear, there were judges of demanding taste who discerned something theatrical in the composition that they disliked. Whatever they may say, rest assured that you had a beautiful dream and Fragonard made a beautiful painting. It has all the magic, all the intelligence, all the essentials of pictorial mechanics. This artist has a sublime imagination;[148] all he lacks is a truer sense of color and a technical perfection that he could acquire with time and experience.

177. A Landscape

We see a shepherd standing on a knoll; he plays the flute; his dog is beside him, and a peasant woman who listens to him. On this same side a landscape view. On the other some rocks and trees. The rocks are beautiful; the shepherd is well lit and makes a fine effect; the woman is weak and indistinct; the sky poor.

178. The Parents' Absence Turned to Account

To the right, on some straw, a knapsack with a game bag; beside it a small drum. Further back, a wooden tub with some wet, twisted cloth thrown over it. Still further back, in an alcove, a stoneware urn with a kettle. Then a door into the cottage with a yellow dog

148 *"La partie idéale est sublime dans cet artiste."*

coming in, of whom we see only the head and something of the shoulders, the rest of its body being obscured by a white dog with a clog around its neck; this dog is in the foreground, its muzzle resting on a kind of cask or large tub serving as a table. On this table place a bit of cloth, a green-glazed earthenware plate, and some fruit.

On one side of the table, somewhat back and to the right, a seated little girl, facing us, one of her hands on the fruit, the other on the back of the yellow dog. Behind and beside this little girl, a somewhat older little boy signaling with his hand and speaking to one of his brothers sitting on the floor near the hearth; his other hand rests on his little sister and the yellow dog; his head and torso lean slightly forward.

On the other side of the table, in front of the fireplace at the far left of the painting, signaled only by the glow of its fire, an older brother sitting on the floor, one hand resting on the table and the other holding the handle of a small saucepan. It's to him that his younger brother gestures and speaks.

In the background, very much in shadow, we make out another boy who's already a bit older, clasping and vigorously embracing the elder sister of all these brats. She seems to defend herself as best she can.

All these children resemble one another as well as their elder sister, and I presume that if this cottage doesn't belong to a Parsi, the older fellow is a young neighbor who's seized on the parents' momentary absence to play around with his little neighbor of the opposite sex.

We see to the left, above the fireplace, in an alcove in the wall, some pots, bottles, and other household objects.

The subject is prettily imagined; it makes its effect and is attractively colored. One can't quite make out where the light comes from; but it's enlivening, though less so than in the *Callirhoé*; it seems to originate outside the canvas and falls from left to right. Half the hand of the youngster with the saucepan, the one resting on the table, is especially satisfying, being partly in shadow and partly in the light. From that point, spreading out, the light falls on the two dogs, on the other two children, on all the adjacent objects, and it brings them vividly to life. This white dog placed squarely in the light and in the foreground is a small *tour de force*. One asks oneself why the background shadows are so dark one can barely see the most interesting part of the subject, the older fellow so tightly embracing his little neighbor, but I'd bet my life there's no answer. The dogs are good, but more successful as conceptions than in their handling, they're blurry, blurry, though otherwise respectable. Compare these dogs with those by Loutherbourg and Greuze, and you'll see that

the latter are the true ones. In this fluid idiom one must have a precious finish and include enchanting details. This cloth is heavy-handed and stiff; bad cloth. The child holding the saucepan has greenish, insubstantial legs that never seem to end; his posture is a bit stiff; otherwise, the simple, innocent character of his head is charming. One never tires of looking at the two other children.

Overall, it's a fine little picture in which the artist's style of handling is unmistakable. I like it better than the landscape, which is vigorously colored but lacks a firm touch, two very different things; the site of which lacks variety; in which the small figures, while ingeniously, cleverly executed, are weak, and in which the foreground areas are nowhere near as fine as the mountains.

Fragonard has just returned from Rome. His *Corésus and Callirhoé* is his reception piece; a few months ago he presented it to the Academy, which received the artist by acclamation.[149] It is indeed a beautiful thing, and I don't think there's another painter in Europe capable of imagining its like.

MONNET[150]

179. *Saint Augustine Writing his Confessions*

I only speak of this work to show how many idiocies can be assembled in the space of a few meters.

The saint, visible to the left, turns his head towards the heavens; but is it in heaven or within oneself that one seeks out the faults of one's past life? Apparently this Monnet has never subjected himself to self-examination, nor seen anyone else do so. When one looks towards heaven one can't write; yet this saint is writing. When one writes one doesn't hold the pen upside down, because then the ink runs down the pen rather than onto the paper. An angel in a bad mood serves as his desk; this is a wooden angel, and when one is made of wood one can't be in a bad mood.

149 This is incorrect: Fragonard was granted provisional membership, pending the presentation of a reception piece judged to be acceptable. He never presented such a reception piece and never became a full academician.

150 Charles Monnet (1732–after 1808). Student of J. Restout. Granted provisional membership in the Royal Academy on July 27, 1765; he never became a full academician.

The *Christ Dying on the Cross* by the same artist is no better. He's not dying, he's already dead; when one is dying one's head begins to fall forward; it goes limp as here only after one is already gone. And then it's a wretched, ignoble head, that of an executed criminal, of a martyr of the Place de Grève;[151] no drawing, coloring forced and brackish.

No better results with a mythological subject; his *Cupid*, nude, standing, frontally posed, holding his bow in one hand and grasping a crown in the other, is flat, wan, expressionless, graceless, a mass of inchoate flesh; this thing is no more likely to fly than a goose.

TARAVAL[152]

182. *The Apotheosis of Saint Augustine*

Will he get there? Will he not get there? My faith, I've no idea. I only see that if he falls back and breaks his neck it won't be his own fault, but rather the fault of these two wretched angels who take note of his terrible efforts and make fun of them; perhaps they're two Pelagian angels.[153] But look at how the poor saint struggles, how he thrashes his arms, how agitated he is, how he swims against the current! But what surprises me is that he ought to ascend all by himself like a feather, for there's no body under his vestments; this reassures me about his possibly falling onto this woman and small child underneath him, whom he already obliterates with his color as things are. This woman is Religion, and she's rather well characterized. I'd like to think there's a nude body beneath her drapery, because it's agreeable to imagine this when a woman is young and beautiful; but here the drapery doesn't aid the imagination. The child is a kind of spirit holding the cope, the mitre, and the rest of the saint's worldly slough. He is charming in spirit, color, and

151 The public square in front of the city hall where condemned criminals were executed.

152 Jean-Hughes Taraval (1729–85). Student of Pierre. Granted provisional membership in the Royal Academy on August 3, 1765; received as a full academician on July 29, 1769.

153 The Pelagians denied the efficacity of grace and the existence of original sin. St Augustine was a vociferous opponent of the "Pelagian heresy."

THE SALON OF 1765

handling. Picture, good in a few details but bad overall; from an artist who's well trained and not without force.

183. *Venus and Adonis*

All that's here is a woman's back, but it's beautiful, very beautiful. Beautifully dressed hair, a head that sits well on its shoulders; white flesh that couldn't be truer. When I asked Falconet how someone able to make so beautiful a Venus could also make so flat an Adonis, he answered it was because he'd made the man's face just like the woman's buttocks. The softness of touch that helped him out with one of the figures wasn't suitable for the other figure.

184. *Genoese Girl Asleep over her Work*

This is a small masterpiece of confusion: her head, the cushion, her work, the firescreen all indistinctly bundled together. Some say the head is graciously painted; I didn't see that, but I did see that it is grey.

185. *A Painted Male Nude*

I can no longer recall his *Nude*; but I read a note in my catalogue: Well drawn and broadly painted.

186. *Several Heads Exhibited under the Same Number*

Among several *Heads* by Taraval, there was one of a *Negro* wearing a cap which was a fine imitation of the matte white cast of silver.

And then another of a *Beggar* that I'll remember every time I discuss painting in an artist's presence. A man of letters who'd taken a liking to this head, which is a mediocre thing, remarked to Falconet that he didn't know why it had been hidden away in a dark corner where no one could see it. "That," the sculptor responded, "must be because Chardin, who hung the Salon this year, doesn't know a beautiful head when he sees one." My friend Suard had the intelligence not to respond to the sculptor.

And then another *Head of an Old Man*, making a terrible grimace at the *Negro*, hung beside it; this old man doesn't like negroes.

And then still more heads that don't add up to much.

I could, my friend, stop right here and tell you I'm finished with the painters and the painters with me; but perusing the Academy rooms I discovered four freshly completed canvases, and Monsieur Flipot the caretaker, who's fond of me, told me they were by Restout the son,[154] and that the one in the middle, the young artist's reception piece,[155] was worth a look. Monsieur Flipot, my protector, knows painting as well as some nurses know illnesses; he's seen so many sick people! So I paused, and I saw a Carthusian at the foot of a rock adoring his God nailed to two beams, a Greek poet crowned with roses, convinced that since we live so short a time the best things we can do are laugh, sing, amuse ourselves, intoxicate ourselves with love and wine, and who practised what he preached; a certain philosopher from the same country, walking stick in hand and sack over his shoulder, who in order to accustom himself to denial begged alms from a statue; and then another philosopher, Christian or pagan, who thought that was just fine and went his way without saying a word to anyone and without anyone saying a word to him.

The *Carthusian* (Pl. 36) was kneeling on a rather large rock that almost made him seem to be standing; his crucifix was on the ground, propped up on smaller rocks. The contrite, penitent man had his arms crossed over his chest; he adored, and his adoration was sweet and profound. He's surely a good Molinist[156] who doesn't believe he and all the others will be damned. I'd wager this monk is indulgent and gay, that he's like my former schoolmate Dom Germain, who makes watches, telescopes, and meteorological observations for the Academy of Sciences as well as ballets for the queen, and who makes no distinction between singing Lalande's *Miserere* and scenes by Lully. Anyway, Restout's also has the merit of being well draped. His folds are really those of the material and the nude beneath, and if Chardin wanted to claim this work as his own, he'd be taken at his word.

154 Jean-Bernard Restout, the son (1732–97). Student of his father Jean Restout. He was granted provisional membership in the Royal Academy on September 28, 1765; accepted as a full academician on November 25, 1769. After 1771 and until the first open Salon, in 1791, he boycotted the Louvre exhibitions to register his opposition to rules mandating that all submissions by those not holding office in the Academy be subject to review and potential exclusion by a jury composed of office holders.

155 Diderot is incorrect; Restout the son had just been granted provisional membership in the Royal Academy.

156 A reference to the beliefs of the Spanish theologian Miguel de Molinos (1628–96), who maintained that a soul having attained peace with God was incapable of sin. In 1685 he was imprisoned for espousing these views and recanted them.

The *Diogenes* (Pl. 37) is a poor Diogenes, hard and crudely colored. And these children attracted by his bizarre action, I'd very much like to know why they're the color of a pigeon's throat. Certainly this isn't the pretty, vain, ironic, impertinent, giddy young creature we see twice a week in the rue Royale, who I can't recall what painter, I'm terrible with names, introduced into a scene of this same philosopher's life. She's waiting for him to utter an absurdity; we see she can't wait to laugh.

The *Anacreon* (Pl. 38) occupies the center of the canvas. He's seated, his torso upright and nude, his head crowned with roses, his mouth partly open. Is he singing? I've no idea. If he's singing, it's not French music, because he's not squalling enough. In his left hand he grasps a large silver goblet sitting on a table beside another goblet and some gold vases. His right arm is thrown over the bare shoulders of a young courtesan, her torso facing us, her head in profile, looking passionately at the poet and strumming a lyre. At the foot of the bed we see a large perfuming pan from which scented vapor rises. He listens to the charming music; he savors the delicious wine; his hands and his glances play over the soft skin and beautiful forms, but he'll be damned. The poor man! The lower part of his body is covered by two rich, luxuriant cloths; they begin under the table bearing the goblets, spread over his thighs and legs, and obscure a tiny, tiny part of the courtesan's charms, but imagination supplies what's missing, perhaps improving on it. Of these two cloths the lower one is satin, the upper one a violet silk material with a flowered pattern. Roses and a few bunches of grapes are scattered around the gold vases near the goblets. The front of the courtesan's bed is strewn with flowers. We see at the foot of this bed a thyrsus with a crown. This side of the canvas is finished by a kind of big green curtain. Above the heads of the courtesan and Anacreon we see treetops that suggest the presence of gardens.

This entire composition breathes voluptuousness. The courtesan is a bit paltry; we've all seen more beautiful arms, more beautiful heads, more beautiful throats, more beautiful complexions, more beautiful flesh, more grace and youth, more sensuality, more intoxication. But if she were given over to me as she is, I doubt I'd choose to amuse myself by criticizing her hair for being too dark. Greek courtesans might very well have been like this woman. As for Anacreon, I've seen him, I knew him, and I swear to you that this isn't a good likeness. My friend Anacreon had a large forehead, fire in his eyes, large features, a noble air, a beautiful mouth, fine teeth, a delicate, enchanting smile, a certain animation, fine shoulders, a handsome chest, a bit of a belly, rounded forms, everything about him suggested the easy, voluptuous life, the man of genius, the courtesan, the man of pleasure; and here I see only

a wretched Diogenes, a drunken wagoner, dark, muscled, hard, swarthy, small eyes, small head, flushed and gaunt face, narrow forehead, dirty hair.

Young man, paint out this hideous and ignoble figure. Take up the collection of delicate songs by our poet, acquaint yourself with his life, and perhaps you'll be able to imagine his character properly. And then the work isn't well drawn; this neck is stiff; this deep shadow under the right breast creates a gaping hole where an effect of relief should be, and this ill-considered hole makes the shoulder bone jump out and dislocates it; your Anacreon is disjointed. La Tour was right when he said to me: Don't expect someone who can't draw to be able to produce beautifully characterized heads . . . Why is this so? He added another remark that's easier to explain: And don't ever expect a poor draftsman to become a great architect. I'll tell you why not in another place.[157]

Before closing, I must say a word about a charming picture that will perhaps never be exhibited at the Salon: it was Madame de Grammont's new-year's gift to the Duc de Choiseul.[158] I saw this picture; it's by our friend Greuze. You won't recognize its genre, nor perhaps this artist's style, though his intelligence and finesse are present in it (Pl. 39).

Imagine a window facing onto the street. At this window a green curtain partly open; behind this curtain a charming young girl, just out of bed, who hasn't yet had time to dress. She's just received a note from her lover. This lover is passing beneath the window, and she throws him a kiss. It is impossible to describe the full voluptuousness of this figure; her eyes, her eyelids are laden with it. Such a hand has thrown this kiss! Such a face! Such a mouth! Such lips! Such teeth! Such a bosom! We see this bosom, all of it, despite its being covered by a thin veil. The left arm . . . She's intoxicated, she's beside herself, she doesn't know what she's doing, nor I, almost, what I'm writing . . . This left arm, which she no longer has the strength to hold up, has fallen onto a pot of flowers and crushed them. The note has slipped from her hand; the tips of her fingers have come to rest on the windowsill and are positioned accordingly. You simply must see how they're limply bent; and this curtain, how broad and true; and this pot, how beautiful its form; and these flowers, how well painted they are; and this head, how nonchalantly it tilts backwards! And this chestnut hair, how it emerges from the forehead and flesh! And the subtlety of the curtain's shadow on her

157 Diderot kept his word in the *Salon of 1767*.
158 Étienne François, duc de Choiseul (1719–85). French statesman; minister of foreign affairs 1758–70.

arm, of the shadow of those fingers on her palm, of the shadow of this hand and arm on her breast! The beauty and delicacy of the transitions from the forehead to the cheeks, from the cheeks to the neck, from the neck to the breast! How beautifully her hair is arranged! How beautifully the planes of her head are disposed, how it jumps off the canvas! And the voluptuous limpness reigning from the tips of her fingers through the rest of the figure; and how this limpness overtakes the spectator, coursing through his veins as it courses through this enchanting figure! It's a picture to turn one's head, even yours which is so good.

Goodnight, by friend; come what may, on this note I'm going to put myself to bed. So much for the painters. I'll take up the sculptors tomorrow.

SCULPTURE

I'm fond of fanatics, not the ones who present you with an absurd article of faith and who, holding a knife to your throat, scream at you: "Sign or die," but rather those who, deeply committed to some specific, innocent taste, hold it to be beyond compare, defend it with all their might, who go into street and household, not with a lance but with their syllogistic decree in hand, calling on everyone they meet to either embrace their absurd view or to avow that the charms of their Dulcinea surpass those of every other earthly creature. People like this are droll; they amuse me, sometimes they astonish me. When they've happened upon some truth, they advocate it with an energy that shatters and demolishes all before it. Courting paradox, piling image on image, exploiting all the resources of eloquence, figurative expressions, daring comparisons, turns of phrase, rhythmic devices, appealing to sentiment, imagination, attacking soul and sensibility from every conceivable angle, the spectacle of their efforts is always beautiful. Such a one is Jean-Jacques Rousseau[159] when he lashes out against the literature he's cultivated all his life, the philosophy he himself professes, The

159 Jean-Jacques Rousseau (1712–78). French writer and social theorist. Author of *A Discourse on the Sciences and the Arts* (1750) *Julie or the New Heloise* (1761), *The Social Contract* (1762), and *Émile* (1762). He and Diderot had been close friends in the century's middle years, but by the 1760s their relations had soured.

society of our corrupt cities in the midst of which he burns to reside and whose acknowledgement, approbation, tribute he craves. It's all very well for him to close the window of his country retreat that faces towards Paris, but it's still the only spot in the world for which he has eyes; in the depths of his forest he's elsewhere, he's in Paris. Such a one is Winckelmann[160] when he compares the productions of ancient artists with those of modern artists. What doesn't he see in this stump of a man we call the *Torso*? The swelling muscles of his chest, they're nothing less than the undulations of the sea; his broad bent shoulders, they're a great concave vault that, far from being broken, is strengthened by the burdens it's made to carry; and as for his nerves, the ropes of ancient catapults that hurled large rocks over immense distances are mere spiderwebs in comparison. Inquire of this charming enthusiast by what means Glycon, Phidias, and the others managed to produce such beautiful, perfect works and he'll answer you: by the sentiment of liberty which elevates the soul and inspires great things; by rewards offered by the nation, and public respect; by the constant observation, study, and imitation of the beautiful in nature, respect for posterity, intoxication at the prospect of immortality, assiduous work, propitious social mores and climate, and genius . . . There's not a single point of this response one would dare contradict. But put a second question to him, ask him if it's better to study the antique or nature, without the knowledge and study of which, without a taste for which ancient artists, even with all the specific advantages they enjoyed, would have left us only mediocre works: The antique! he'll reply without skipping a beat; The antique! . . . and in one fell swoop a man whose intelligence, enthusiasm, and taste are without equal betrays all these gifts in the middle of the Toboso.[161] Anyone who scorns nature in favor of the antique risks never producing anything that's not trivial, weak, and paltry in its drawing, character, drapery, and expression. Anyone who's neglected nature in favor of the antique will risk being cold, lifeless, devoid of the hidden, secret truths which can only be perceived in nature itself. It seems to me one must study the antique to learn how to look at nature.

Modern artists have rebelled against study of the antique because amateurs have tried to force it on them; and modern men of letters

160 Johann-Joachim Winckelmann (1717–68). German archeologist and art historian, author of *Reflections on the Imitation of Greek Works in Painting and Sculpture* (1755) and *A History of Ancient Art* (1764).

161 Toboso was a small town outside Toledo in which Cervantes placed the residence of Dulcinea. As E.M. Bukdahl has suggested (*1765*, 1984, note 714, pp. 278–9), Diderot here seems to suggest an image of Toboso as a river in which Winckelmann, having begun to cross, stops in midstream.

have defended study of the antique because it's been attacked by the *philosophes*.

It seems to me, my friend, that sculptors are more attached to the antique than painters. Could this be because the ancients left behind some beautiful statues while their paintings are known to us only through the descriptions and accounts of writers? There's a considerable difference between the most beautiful line by Pliny and the *Gladiator* of Agasias (Pl. 40).

It also seems to me that it's more difficult to judge sculpture than painting, and this opinion of mine, if it's valid, should make me more circumspect. Few people other than practitioners of the art can distinguish a very beautiful work of sculpture from an ordinary one. Certainly the *Dying Athlete* (Pl. 41) will touch you, move you, perhaps even make so violent an impression on you that you can neither look away nor stop looking at it; still, if you had to choose between this statue and the *Gladiator*, whose action, while beautiful and true certainly, is nonetheless incapable of touching your soul, you'd make Pigalle[162] and Falconet laugh if you preferred the former to the latter. A large single figure that's all white is so simple, it has so few of the particulars that would facilitate a comparison of the work of art with that of nature! Paintings remind me a hundred times over of what I see, of what I've seen; this is not true of sculpture. I'd take the chance of buying a picture on the basis of my own taste, my own judgment; if it were a statue, I'd ask an artist's advice.

So you think, you say to me, it's more difficult to sculpt than to paint? —I don't say that. Judging is one thing and making is another. There's the block of marble, the figure is within it, it must be extracted. There's the canvas, it's flat, it's on this surface that one must create. The image must spring forth, advance, take on relief so that I can move around it; if not I myself, then my eye; it must take on life. But if it's modelled, it must live through its modelling, without resorting to the life-bestowing resources of the palette. — But these same resources, is it easy to use them? The sculptor has everything when he has drawing, expression, and facility with the chisel; with these resources he can successfully essay a nude figure. Painting requires still more. As for the difficulties inherent in more complex subjects, it seems to me they increase more for the painter than for the sculptor. The art of composing groups is the same, the art of draping is the same; but lighting, overall composition the sense of place, skies, trees, water, accessories, backgrounds, color, the full array of accidents? "Sed non nostrum inter vos tantas componere

162 Jean-Baptiste Pigalle (1714–85). Student of J.-B. II Lemoyne. Granted provisional membership in the Royal Academy on November 4, 1741; received as a full academician on July 30, 1744.

lites."[163] Sculpture is made for both the blind and those who can see; painting addresses itself only to the eyes. On the other hand, the first certainly has fewer objects and fewer subjects than the second: one can paint whatever one wants; sculpture—severe, grave, chaste— must choose. Sometimes it makes play with an urn or a vase, even in the grandest, most moving compositions: one sees reliefs of frolicking children on bowls about to collect human blood; but this play maintains a certain dignity: it is serious, even when striking a light note. Undoubtedly it exaggerates; exaggeration might even suit it better than it does painting. The painter and the sculptor are both poets, but the latter never makes jokes. Sculpture can't bear the facetious, the burlesque, the droll, and can sustain the comic only rarely. But it delights in fauns and sylphs; without strain it can help satyrs put the aging Silenus back on his mount or bear up the tottering steps of a disciple. It is voluptuous but never lewd. In a voluptuous mode it retains something that's refined, rarefied, exquisite, which alerts me to how protracted, laborious, difficult the work is, and that while it's possible to brush onto the canvas a frivolous idea that can be created in an instant and painted out in the same breath, such is not true of the chisel, which, instilling the artist's idea into material that's hard, resistant, and eternal, should be governed by choices that are original and unusual. The pencil is more licentious than the brush and the brush more licentious than the chisel. Sculpture requires an enthusiasm that's more obstinate and deep-seated, more of a kind of verve that seems strong and tranquil, more of this covered, hidden fire that burns within; its muse is violent, but secretive and silent.

If sculpture cannot tolerate ordinary ideas, it's even less tolerant of middling execution; a slight imperfection in drawing that's scarcely noticeable in a painting is unforgivable in a statue. Michelangelo knew this well; when he despaired of achieving flawless perfection he preferred to leave the marble rough-hewn. —But this is proof that because sculpture can do fewer things than painting, we're more demanding with regard to what we have a right to expect of it. —My thought exactly.

Several questions have ocurred to me concerning sculpture.

The first: Why is it that sculpture, while chaste, is less bashful than painting and displays the sex organs more often and more frankly?

That, I think, is because in the end it provides a less convincing likeness than painting; because the material it uses is so cold, so

163 "It is not our place to compose such great strife": based on Virgil, *Eclogues*, IV, v. 108 ("non nostrum inter vos tantas componere lites").

recalcitrant, so impenetrable; but above all because its principal
difficulty resides in the secret of softening this hard and cold
material, of making it into soft, pliant flesh, of capturing the con-
tours of the human body, of vividly yet accurately rendering its
veins, its muscles, its articulations, its obtrusions, its indentations, its
inflections, its sinuosities, and because a bit of drapery can consume
months of work and study; perhaps because its more primitive,
innocent morals are superior to those of painting, and because it is
less preoccupied by the present than by the future. Men have not
always been clothed; who knows if they always will be?

The second: Why is it that sculpture, both ancient and modern,
strips away from women that veil which nature's own modesty and
the age of puberty throw over the sexual organs, while leaving it in
place for men?[164]

I'm going to try to pile up my answers, so that they'll provide
cover for one another.[165]

Cleanliness, periodic indisposition, a hot climate, the con-
veniences associated with pleasure, libertine curiosity, and the use of
courtesans as models in Athens and Rome, such are the reasons that
first occur to a sensible man, and I think they're good ones. It's a
simple matter not to depict what one doesn't find in one's model.
But it may be that art has more studied motives: it wants you to
note the beauty of this contour, the charm of this meandering line,
of this long, soft, and delicate sinuosity which begins at the end of
one groin and continues with alternating up and down motions
until it has reached the end of the other groin; it wants you to feel
that the course of this infinitely agreeable line would be broken by
an interposed tuft of hair; that this isolated tuft of hair is connected
to nothing and is a stain on a woman, whereas on a man this kind
of natural garment, rather thick on the chest, continues along the
ribs and sides of the belly, thinning but still present, and proceeds,
without interruption, to make itself thicker, higher, bushier around
the natural parts; it wants to demonstrate to you that these natural
parts of a man, shorn of hair, would seem like a bit of small
intestine, like a worm of disagreeable aspect.

The third: Why did the ancients always drape their figures with
damp cloth?

Because however hard one tries to capture the effect of fabric in
marble, one will only succeed imperfectly; because thick, coarse
material obscures the nude figure, which sculpture is even more set

164 Diderot is alluding to pubic hair.
165 "Je vais tacher d'entasser mes responses, afin qu'elles se dérobent les unes par les
 autres": Diderot is making a casual pun here with the verb *dérober* (to conceal), the
 root of which is *robe* (gown, dress).

on articulating than is painting, and because, however truthful its folds, it will always retain something of the heavy quality of stone, coming across as rock.

The fourth: In the *Laocoön* (Pl. 42), why is one of the foreshortened legs longer than the other?

Because without this daring inaccuracy the figure would have been unpleasant to look at. Because there are natural effects that must be mitigated or ignored; I'll cite an example that's very commonplace, very simple, but which I'd defy even the greatest artist to handle without offending either truth or grace. I imagine a nude woman seated on a stone bench; however firm her flesh, the weight of her body solidly pushes her thighs against the stone on which she's sitting, they puff out disagreeably on either side and form, at the back, both of them together, the most impertinent cushion one could possible imagine. What to do? There's no middle course; one must either close one's eyes to these effects and imagine that the woman's buttocks are as hard as the stone and that her pliant flesh doesn't yield to the weight of her body, or throw some drapery all around her figure that simultaneously hides the disagreeable effect and the most beautiful parts of her body from me.

The fifth: What sort of effect would be produced by introducing the most beautiful, the truest painted color onto a statue?

A bad one, I think. First, there would be only one vantage point from which the statue's coloring would be convincing. Second, there's nothing more disagreeable than the immediate juxtapostion of the true and the untrue, and the color's truth would never coincide perfectly with the truth of the object, that object being the statue—solitary, isolated, solid, poised to move. It's like Roslin's beautiful embroidery falling over wooden hands, his beautiful satin, so convincing, placed on mannequins. Hollow out a statue's eyes and fill them with enamel or precious stones, and just see if you find the effect bearable. We see that in most of their busts the ancients preferred to leave the eyes whole and solid rather than trace the iris and outline the pupil, that they preferred to leave one free to imagine a blind person rather than depict pierced eyes; and while this might displease our modern sculptors, in this respect I feel their taste was more austere than ours.

Painting is part technique and part idea, and their relative proportions vary in portrait painting, genre painting, and history painting. The same divisions pretty well apply to sculpture; and seeing that there are women who paint heads, I find nothing strange in seeing the emergence of one who makes busts. Marbles, as is well known, are copies from terra cotta. Some have maintained that the ancients worked directly in marble, but I think these people haven't given the matter sufficient thought.

One day Falconet showed me the submissions of the young students competing for the grand prize in sculpture, and saw how astonished I was by the vigor of expression, the grandeur and nobility of these works produced by the hands of youths between nineteen and twenty years old. Wait ten years, he said to me, and I promise you they'll have forgotten all that . . . That's because sculptors need to use models over even longer periods than painters and, whether due to laziness, avarice, or poverty, the greater number dispense with them after their forty-fifth year. Because sculpture demands a simplicity, a naiveté, a hardy brand of verve that's rarely retained beyond a certain age; and that's why sculptors decline more rapidly than painters, unless this hardy quality is natural, is part of their character. Pigalle is hard-headed, Falconet even more so; they'll both produce good work till the day they die. Lemoyne is polite, good-natured, affected, and respectable; he is and will remain mediocre.

Plagiarism occurs in sculpture, but it's hard to miss. It's neither as easy to bring off nor as easy to hide as it is in painting . . . And now let's move on to our artists.

LEMOYNE[166]

This artist makes fine portraits, that's his only merit. When he attempts a grand machine one feels his head isn't in it. He can knock on his forehead all he wants, no one's there. His compositions are without grandeur, without genius, without verve, without effect; his figures are insipid, cold, heavy, and affected; they're like his character, in which not the slightest trace of the man of nature remains. Look at his monument for Bordeaux; if you deprive it of its imposing mass, what's left? Make portraits, Monsieur Lemoyne, but leave monuments alone, especially funerary monuments. Look, I'm sorry, but you don't even have enough imagination to bring off the hair of a mourning woman. Take a look at Deshays' mausoleum[167] and you'll agree that this particular muse is a stranger to you.

What a beautiful head, my friend, is that of the Marquise de Gléon! How wonderfully beautiful! It lives, it holds the interest, it smiles a melancholy smile; one is tempted to stop and ask her who

166 Jean-Baptiste II Lemoyne (1704–78). Student of his father Jean-Louis Lemoyne and Robert Le Lorrain. Granted provisional membership in the Royal Academy on May 29, 1728; received a full academician on July 26, 1738.

167 The sketch of *Artemis at her Husband's Tomb* by J.-B. Deshays; see above, no. 36.

is meant to be happy, for she is not. I'm unacquainted with this charming woman, I've never heard of her, but I can tell she's in pain, and it's a shame. If this creature's intelligence and character aren't as admirable as her expression and her countenance suggest, renounce all faith in physiognomy forever and write on the back of your hand: "fronti nulla fides."[168]

The bust of *Garrick*[169] is good. This isn't the infantile Garrick who acts foolishly in the street, who plays, jumps, pirouettes, and gambols about his rooms; this is Roscius[170] ordering his eyes, forehead, cheeks, mouth, and all the muscles of his face, or rather his soul, to assume the feelings he wants and who controls the actions of his entire person as you do your feet when you walk, or your hands when you pick something up or put it down. He's acting on stage.

Madame la Comtesse de Brionne, well, my friend, what can I say about her? Mme de Brionne is still only a beautiful preparatory effort; grace and life are about to blossom forth, but they aren't there yet, they're waiting for the work to be finished, and when will it be? The hair is only roughed in; Lemoyne thought black chalk could to the work of the chisel: "Sure, go see if it does." And then this bosom! I've seen knitting that looked like this. Monsieur Lemoyne! Monsieur Lemoyne! One must master the craft of working marble, for this refractory stone does not allow itself to be shaped by unskilled hands. If a fellow practitioner, say Falconet, wanted to be frank, he'd tell you the eyes are cold and dry; that when the nostrils are left solid the mouth must be open, otherwise the bust seems to suffocate; he'd tell you your other portraits are more carefully worked, more detailed, but not fully finished, though they ought to be because nature is, and everything should be finished enough to be seen from close up.

FALCONET[171]

Here's a man who has genius and all kinds of character traits compatible and incompatible with genius, though these last are also

168 "One cannot trust faces."
169 David Garrick (1717–79). Actor, producer, dramatist, poet, and co-manager of the Drury Lane Theatre in London. He was in Paris in 1763–4.
170 Q. R. Gallus Roscius, a celebrated actor of ancient Rome.
171 Étienne-Maurice Falconet (1716–91). Student of his uncle Nicolas Guillaume and Jean-Baptiste II Lemoyne. Granted provisional membership in the Royal Academy on August 29, 1744; received as a full academician on August 31, 1754.

to be found in François de Verulam[172] and Pierre Corneille.[173] This is because he has finesse, taste, intelligence, delicacy, kindness, and grace in full measure; because he's awkward and polite, friendly and brusque, kind and harsh; because he works in clay and marble, and reads and reflects; because he's amiable and caustic, serious and mocking; because he's a *philosophe*, believing in nothing and knowing perfectly well why not. Because he's a good father whose son fled his household; because he was madly in love with his mistress yet made her die of anguish, because this made him sad, sombre, melancholy, because he almost perished from sorrow, and because, though she died some time ago, he still hasn't recovered from the loss of her. Add that no man is more desirous of the praise of his contemporaries and more indifferent to that of posterity. He carries this view to an unbelievable extreme, and has told me a hundred times he wouldn't give a penny to guarantee the eternity of his most beautiful statue.

Pigalle, the decent Pigalle who in Rome was nicknamed "the mule of sculpture," has the hard-headedness to make, knew how to make nature and make it true, vivid, and detailed, but he doesn't have, nor will he ever have, either he or the Abbé Gougenot, as clear a notion of the ideal as Falconet, and Falconet already has Pigalle's technical mastery. Rest assured you'll never get anything like Falconet's *Pygmalion* or *Alexander* or *Friendship* out of Pigalle, and it remains to be seen whether the former will prove capable of equalling Pigalle's *Mercury* and his *Citizen* (Pl. 44). But both are great men, and fifteen or twenty centuries hence, when a few feet or heads from their statues are pulled from the ruins of the great city, they'll prove we weren't children, at least in sculpture. When Pigalle saw Falconet's *Pygmalion* he said: "I'd like to have made that myself." When the monument for Reims was exhibited in the rue du Roule, Falconet, who didn't like Pigalle, said to him after looking and looking hard at his work: "Monsieur Pigalle, I don't like you and I think you feel the same way about me. I've seen your *Citizen*; such beauty is attainable because you've managed it; but I don't think the art can advance one iota further. We will of course remain on the same terms as before." That's my Falconet.

194. *Figure of a Seated Woman*

Intended for an arbor of flowering winter plants, this figure is, in the

172 Francis Bacon (1561–1626), Lord chancellor and author of *Novum Organum* (1620).

173 Pierre Corneille (1606–84). French playwright.

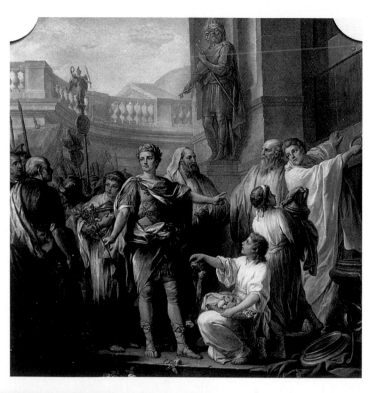

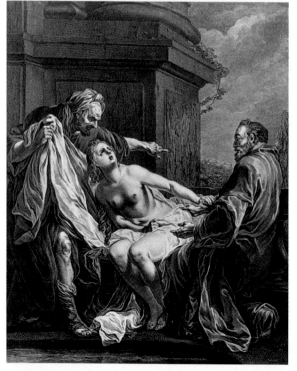

1. Carle van Loo, *Augustus Closing the Doors of the Temple of Janus*. Amiens, Musée de Picardie. See page 8.

2. Carle van Loo, *The Chaste Susanna*, engraving by Gabriel Skorodumov. Vienna, Graphische Sammlung Albertina. See page 12.

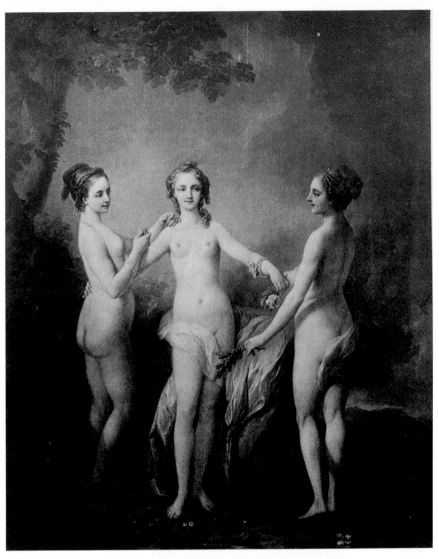

3. Carle van Loo, *The Three Graces*. Château de Chenonceau. See page 10.

6. (opposite) François Boucher, *Dispatch of the Messenger*. New York; The Metropolitan Museum of Art; Gift of Mrs. Joseph Heine in memory of her husband, I. D. Levy, 1944. See page 27.

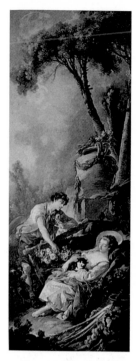

4. Carle van Loo, *The Suppliant Arts Begging Destiny to Spare the Life of Madame de Pompadour.* (c) Collection of The Frick Art Museum, Pittsburgh, Pennsylvania. See page 14.

5. François Boucher, *The Sleeping Gardener.* Private collection. See page 26.

7. Noël Hallé, *Hippomenes and Atalanta*. Paris, Musée du Louvre. See page 32.

8. Charles Lebrun, *The Family of Darius Before Alexander*. Versailles, Musée National du Château. See page 31.

9. (opposite) Joseph-Marie Vien, *Marcus Aurelius Giving Aid to the People*. Amiens, Musée de Picardie. See page 34.

10. (opposite) Louis Lagrenée, the elder, *Goodness and Generosity*. Fontainebleau, Musée du Château. See page 39.

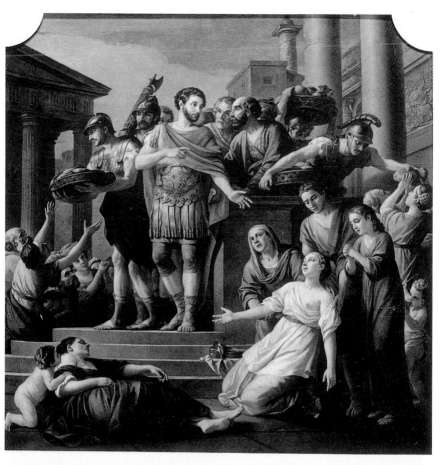

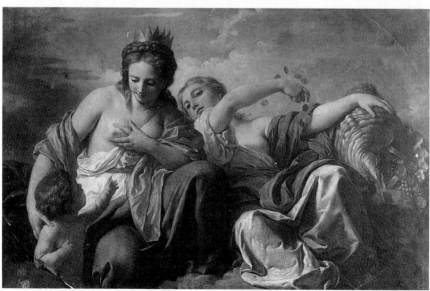

11. Louis Lagrenée, the elder, *The Virgin Playing with the Infant Jesus; the Young Saint John with a Lamb*. Karlsruhe, Staatliche Kunsthalle. See page 41.

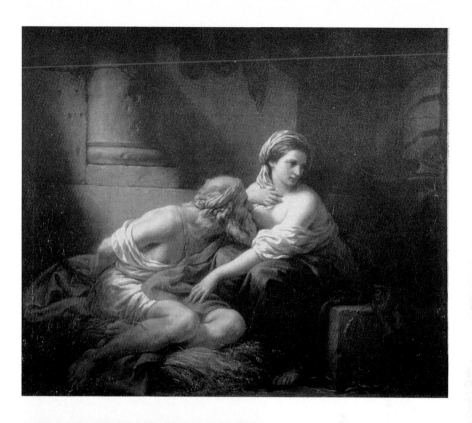

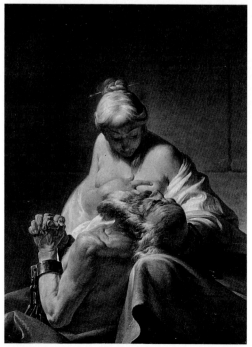

12. Louis Lagrenée, the elder, *Roman Charity*. Toulouse, Musée des Augustins. See page 42.

13. Jean-Jacques Bachelier, *Roman Charity*. Paris, Ecole Nationale Supérieure des Beaux-Arts. See page 52.

14. (following page) Gabriel de Saint Aubin, *View of the Salon of 1765*. Paris, Musée du Louvre, Cabinet des Dessins.

15. Jean-Baptiste Deshays, *The Conversion of Saint Paul.* Montreuil, Eglise Saint-Symphorien. See page 45.

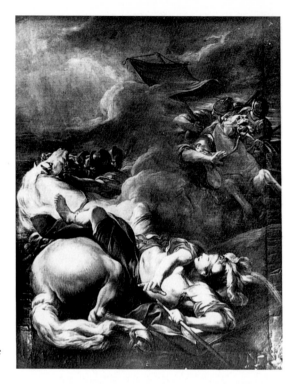

16. Jean-Baptiste Deshays, *Achilles and the Scamander,* engraving by Ph. Parizeau. See pages 46–7.

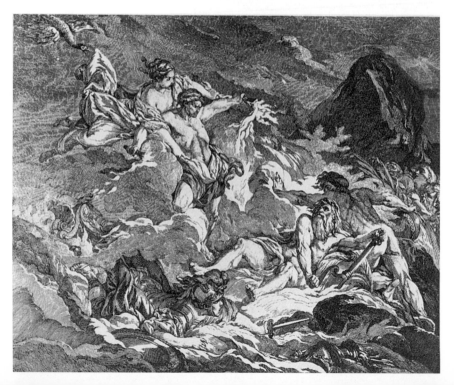

17. Jean-Baptiste Chardin, *The Attributes of Music*. Paris, Musée du Louvre. See page 61.

18. Jean-Baptiste Chardin, *Basket of Plums with Walnuts*. Private Collection. See page 63.

19. Jean-Nicolas Servandoni, *Ruins*.
Paris, Ecole Nationale Supérieure
des Beaux-Arts. See page 67.

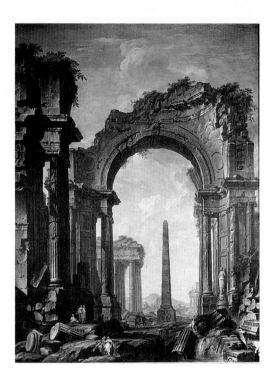

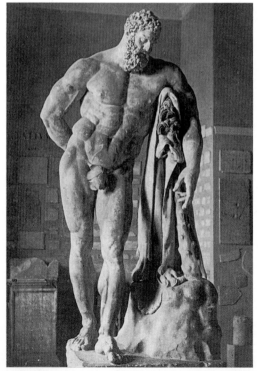

20. *Farnese Hercules*. Naples, Museo
Nazionale. See page 65.

21. (opposite) *Belvedere Antinous*.
Rome, Musei Vaticani. See pages
66, 192, and 211.

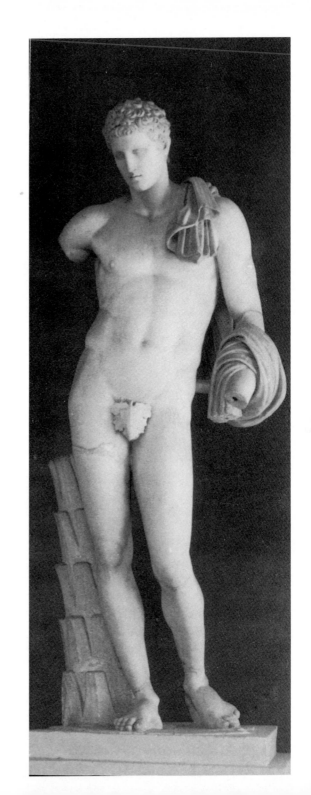

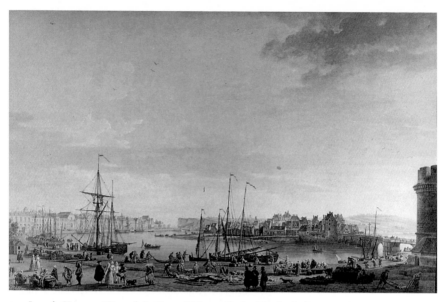

22. Joseph Vernet, *View of the Port of Dieppe*. Paris, Musée du Louvre. See page 71.

23. Joseph Vernet, *Moonlight*. Paris, Musée du Louvre. See page 72.

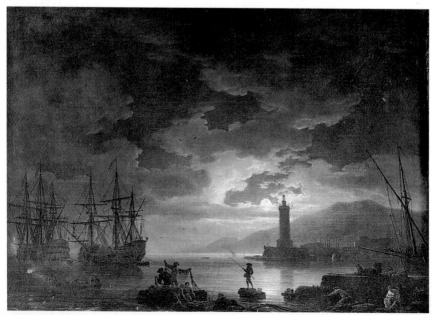

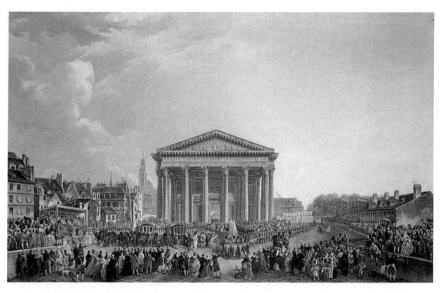

24. Antoine de Machy, *The Setting of the Foundation Stone for the New Church of Saint Geneviève, September 6, 1764.* Paris, Musée Carnavalet. See page 80.

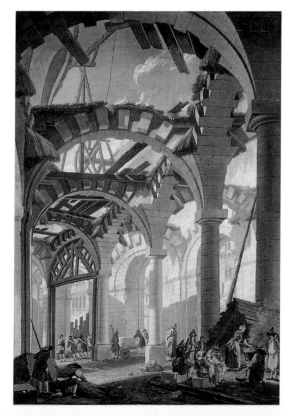

25. Antoine de Machy, *The New Grain Market Under Construction.* Paris, Musée Carnavalet. See page 81.

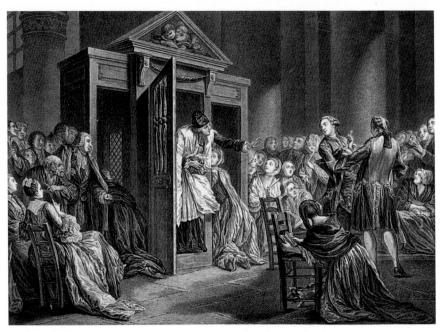

26. Pierre-Antoine Baudouin, *A Confessional*, engraving by Moitte. Paris, Bibliothèque Nationale. See page 88.

27. Pierre-Antoine Baudouin, *The Cherry Picker*, engraving by Ponce. London, Courtauld Institute, Witt Library. See page 88.

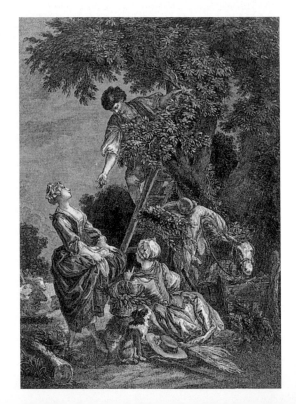

28. (opposite) Jean-Baptiste Greuze, *A Young Girl Crying over her Dead Bird*. Edinburgh, National Galleries of Scotland. See page 97.

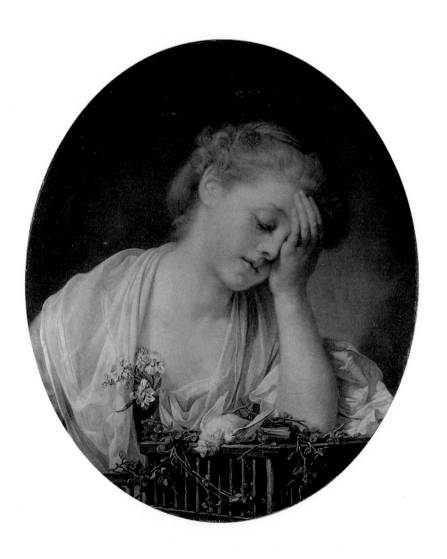

29. Jean-Baptiste Greuze, *Madame Greuze*. Private Collection. See page 102.

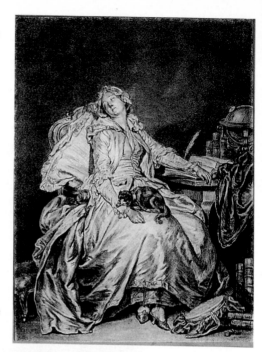

30. Jean-Baptiste Greuze, *Portrait of Johann-Georg Wille*. Paris, Institute de France, Musée Jacquemart-André. See page 104.

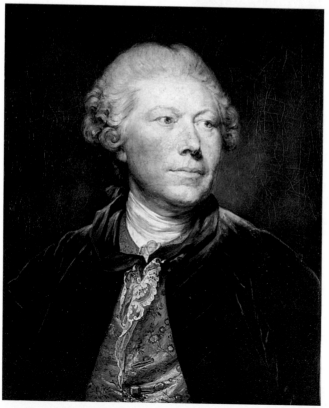

31. Jean-Baptiste Greuze, *The Ungrateful Son*. Lille, Musée des Beaux-Arts. See page 106.

32. Nicolas-Guy Brenet, *The Baptism of Christ*. Notre–Dame–de–Pont–de–Vaux (Ain). See page 113.

33. (following page) Philippe Jacques de Loutherbourg, *A Caravan*. Marseille, Musée des Beaux-Arts. See pages 120–21.

34. Jean-Baptiste Leprince, *A Russian Baptism*. Paris, Musée du Louvre. See page 130.

35. Jean-Honoré Fragonard, *Corésus Sacrificing Himself for Callirhoé*. Paris, Musée du Louvre. See page 141.

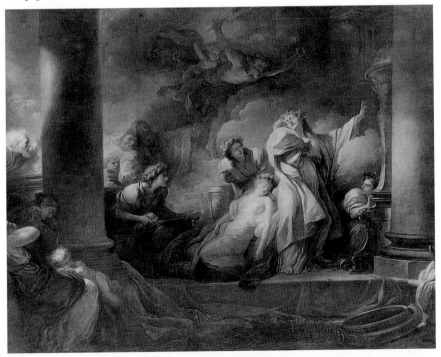

36. Jean-Bernard Restout, *Saint Bruno in Prayer*. Paris, Musée du Louvre. See page 153.

37. Jean-Bernard Restout, *Diogenes Begging Alms from a Statue*. Toulouse, Musée des Augustins. See page 154.

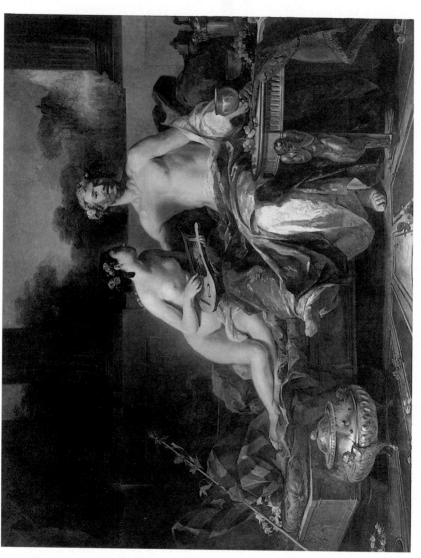

38. Jean-Bernard Restout, *The Pleasures of Anacreon.* New York, collection Didier Aaron, Inc. See page 154.

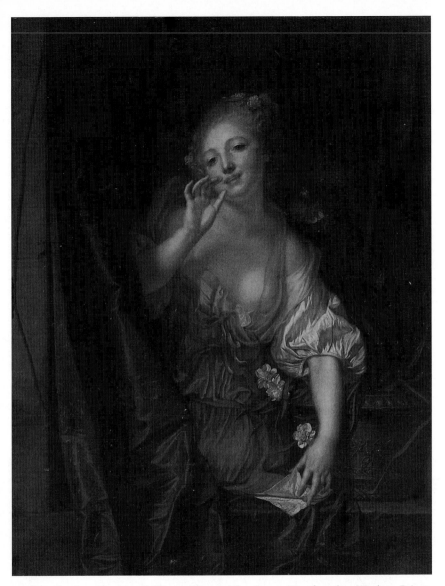

39. Jean-Baptiste Greuze, *A Young Woman Throwing a Kiss from her Window*. Private Collection. See page 155.

40. *Borghese Gladiator*. Paris, Musée du Louvre. See page 158.

41. *Dying Gladiator*. Rome, Musei Capitolini. See page 158.

42. *Laocoön*. Rome, Musei Capitolini. See page 161.

43. Etienne-Maurice Falconet, *Alexander and Campaspe*. Private Collection. See page 166.

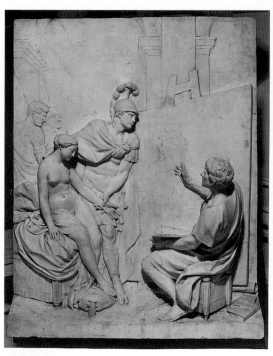

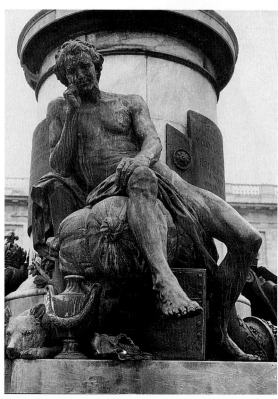

44. Jean-Baptiste Pigalle, *Citizen*, detail of the *Monument to Louis XV*. Reims, Place Royale. See page 164.

45. Jean-Jacques Caffieri, *Bust
of Jean-Philippe Rameau*. Dijon, Musée des
Beaux-Arts. See page 171.

46. Jean-Baptiste-Cyprien d'Huez, *Saint
Augustine*. Paris, Eglise de Saint-Roch.
See page 172.

47. Michel-Ange Slodtz, *Bust
of Iphigenia*. Lyon, Palais Saint-
Jean, Académie des Sciences
et Belles-Lettres de Lyon. See
page 175.

48. Charles Nicolas Cochin, *Frontispiece for the Encylopédie*, engraved by B. L. Prévost. Paris, Bibliothèque Nationale. See page 182.

49. Eustache Le Sueur, *The Death of Saint Bruno*. Paris, Musée du Louvre. See page 194.

50. Peter Paul Rubens, *The Birth of Louis XIII*. Paris, Musée du Louvre. See page 223.

51. Jean-Baptiste Pigalle, *Monument to Louis XV*, engraving by Moitte. Paris, Bibliothèque Nationale. See page 184.

view of everyone, whether great or small, knowledgeable or ignorant, whether connoisseurs or not, a masterpiece of characterization, posture, and drapery. This drapery is a single piece of fabric that falls over the arms, the legs, the torso, the shoulders, the back, the entire figure, articulating it, molding it, revealing it, front, back, and sides, in a way that's as clear and perhaps as delicious as if it were entirely nude. This drapery isn't thick, nor is it a thin veil; it's of an intermediate thickness wonderfully well suited to the lightness and function of the figure. Her face is beautiful; one detects there a tender, mild-mannered interest in the flowers she protects, which she tries to shelter from the menacing cold by covering them with a flap of her garment. She bends slightly forward, and it's impossible to imagine her action represented with greater truth and grace. I've just reread my description and it strikes me as an accurate reflection of the figure. Those intent on finding fault with everything will say the chin projects a bit too much.

195. *Saint Ambrose*
Maquette

This is the passionate bishop who dared close the doors of the church to Theodosius,[174] and whom a certain male sovereign who in the last war claimed to be acting in the world's best interests and had such a strong desire to stroll among priests, as well as a certain female sovereign who's just disencumbered her clergy of all the riches precluding its respectability, would have obliged to have his beard and his ears cut off, saying to him: Learn, Monsieur l'Abbé, that the temple of your God is within my domain, and that if my predecessor graciously conceded the plot of ground it occupies, I can take it back and send you, your altars, and your fanaticism packing.[175] This place is the house of the father common to all men, good or evil, and I intend to enter it whenever I like. I'm not beholden to you, you wouldn't know enough to advise me about my conduct even if I deigned to consult you; what gives you the right to judge me? . . . But the insipid emperor didn't speak like this, and the bishop knew very well with whom he was dealing.

The sculptor has depicted him in the moment of his insolent reprimand; his arm is extended, his aspect severe and censorious;

174 Saint Ambrose (340–97), Archbishop of Milan, who obliged the Emperor Theodosius to undergo the ritual of public penitence after the massacre in Thessalonica.
175 The female sovereign is Catherine II, the Great, of Russia. The male sovereign in question is Frederick II, the Great, of Prussia; Diderot's phrase "faire un tour dans la rue des Prêtres" is probably a reference to Frederick's same-sex proclivities.

he's speaking. His head has temperament, but I think it's a bit small. The drapery grand, ample, well handled, rising picturesquely in front, marvellously indicating the left arm it covers and beneath which I imagine the bishop to be holding his breviary or his homilies; if its volume seems enormous, this is the garment's fault, not the artist's. I'm pretty sure he'd have had an easier time of it showing us a Jewish prophet or some pagan priest whose robes would have been draped over his head after having travelled over and revealed his entire body. But one can turn anything to advantage, as Falconet has demonstrated with his *St Ambrose*, who, unlike most such figures shown to us, doesn't fiddle with his cope over his arm, reminding us of the gesture we associate with Pantaloon.[176]

196. *Alexander Surrendering Campaspe,*
One of his Concubines, to the Painter Apelles (Pl. 43)
Relief

I must describe this relief, because it is beautiful and because without having it clearly in mind it will be difficult to make sense of my observations.

To the right, the painter has left his easel, on which we see the sketch of Campaspe. He bends on one knee, he's surprised and overwhelmed by the honor bestowed on him by the sovereign. This figure in full relief is in front of the easel, which is in low relief.

Alexander is beside Campaspe, in the background, on his feet, somewhat advanced towards Apelles; he seems to offer the painter this beautiful model, he clasps his concubine's wrist with his left hand, his other arm rests on Campaspe's shoulders; it's the action of a man surrendering her to one who's desired her.

Campaspe is seated on a chair covered with some drapery; she lowers her eyes, there's a cushion behind her. This figure is in full relief and is partially in front of the Alexander, which is in low relief, and two soldiers behind her that are also in low relief.

The Apelles in this relief is reminiscent of the *Pygmalion* of two years ago. The outline he's made on his canvas ought to be as delicate as a spider's web, but it's coarse.

The Alexander is extremely beautiful. Goodness and nobility are painted on his face, but goodness dominates, perhaps even a bit too much. Otherwise one could never conceive a truer action, a simpler posture, or nobler drapery. The large mantle thrown over his shoulders is ravishing.

176 Pantaloon was a stock figure of the *commedia dell'arte.*

It was intelligent to have Campaspe lower her eyes. If pleased, her willingness to leave Alexander would have wounded his vanity; if sad, she'd have mortified Apelles. But there's so much innocence and simplicity in the characterization of this head that if you were to place a veil under her chin that fell to her feet, obscuring all the attractions of her nudity such that you could see only her head, you'd take this Campaspe to be a young girl of exemplary education who's totally ignorant of what it means to be a man and who readily submits to the will of her father who's decided the artist here is to be her husband. This characterization of the head is false; it, too, is a paraphrase of the *Pygmalion*, but here it's inappropriate. Falconet, my friend, you've forgotten the social station of this woman, you've neglected the fact that she's a concubine, that she's slept with Alexander, that she's known pleasure with him and perhaps with others before him. If you'd given your Campaspe somewhat larger features, she'd have been a woman and all would have been well. But tell me, please, what are those two legionnaires doing at the back? Did Alexander, who was apparently aware that his concubine was exposing her nude body to the painter's gaze, bring companions with him to her house? Come now, my friend, get rid of these two soldiers so totally out of place; I insist to you they weren't there, and that the scene transpired between three persons, Alexander, Apelles, and Campaspe. —And the laws of low relief? you ask me . . . And the laws of common sense? I answer you . . . —And what will my Campaspe, in full relief, have behind her? . . . —Why, my friend, two women you'll put in the place of these sorry Macedonians; these two women, Campaspe's attendants, will be more decent and more interesting; they were in Campaspe's apartments before the arrival of Alexander, for I'll never convince myself that a woman would expose her nude body to the gaze of an artist all alone. And just think of the delightful character you could give these attendants! They'd withdraw a bit at the appearance of the sovereign; witnessing his generosity, how do you think they'd react? This would make a charming group in relief.

Your Apelles is rather coarsely dressed; a painter isn't a workman like a sculptor. He is thin, and I like that; those in whom the fire of Prometheus burns are consumed by it. But why make his head so woolly? It seems to me genius should be depicted differently. And this Campaspe, who knew since the previous day that she was to be painted, surely she'd have thought to dress her hair differently; its arrangement is far too lackadaisical. As for her flesh, it's certainly beautiful, but it's not as soft as in the statue of *Pygmalion*; when Vien remarked that, this once, you'd demonstrated sculpture's superiority to painting, he wasn't far off the mark.

Falconet has formulated a rule for relief work which strikes me as
reasonable, but which encumbers the artist. He says: The marble
background is the sky, so shadows should never fall onto it. But
how to avoid throwing shadows onto a sky that's contiguous with
the figures? Here's how. If you include in your composition a figure
in full relief, place an object immediately behind it that can receive
its shadow. But what will become of the shadow of this object?
Nothing. It won't case a shadow if you treat it in low relief; then it
will stand out against your marble background like distant objects
against the sky. One doesn't look for the shadow of a body that's
some distance away or that's only half visible. —Does Falconet
follow his rule? —Quite scrupulously. —And what does he think he
gains by it? —Resolution of the low relief passages into a truth
resembling that of painting, to which he can then link the other
parts. This is what made him introduce the two low-relief soldiers
here; he needed objects in the background to receive the shadow of
his Campaspe, who's in full relief, but two female attendants would
have done just as well and would have been more appropriate.

197. *Sweet Melancholy*

This figure is mistitled, it's Melancholy. Imagine a standing young
girl, her elbow leaning on a column and holding a dove in her hand.
She looks at it; how she looks at it! Like a poor recluse peering
through the cracks of her cell at two sweet, passionate lovers. Her
right arm hangs well and nonchalantly, but it's a bit round. The
drapery has also been criticized for being too heavy lower down,
near the legs. Very well! But this is still recognizably the work of a
man who's mastered the physiognomy of even those feelings most
difficult to depict.

198. *Friendship*

Concede, my friend, that if this work had been dug up it would be
the despair of all modern sculptors. It's a standing figure holding a
heart in both hands; it's her own that she tremblingly offers. This is
a work full of soul and feeling; one is touched, moved at the sight
of it. The face solicits acceptance of the gift in the most energetic,
sweet, and modest manner imaginable; she'd be so vexed, this
young child, if it were refused! The characterization of the head is
extremely unusual; I'm not mistaken, in this innocence, timidity,
circumspection all blended together; this open mouth, these out-
stretched arms, this torso bent slightly forward are indescribably
expressive. Her heart races, she's fearful, she's hopeful. I swear

Greuze's *Young Girl Crying over her Canary* is nowhere near as moving. And the terra cotta was bought by a cad of a bookseller! What will be do with it? The arms and hands couldn't be better modelled. The arrangement of the hair is unusual; it's partly from this treatment of the hair, reminiscent of temple priestesses, that the figure derives its sacred character. Some say the idea of the heart is trivial, symbolic, and paltry; myself, I feel it only lacks the antiquity of mythology and the sanction of paganism; if it had these it would have gone unremarked. Some say the legs are a bit heavy; I know what happened: the sculptor, having made the upper part of his figure a bit too long, found it necessary to either disregard the rules of proportion or make the bottom of his figure a bit short; he opted for the latter.

I've just judged Falconet according to the strictest standards of the temple, with the harshest severity. Now I'll add that there isn't a single artist in the Academy who wouldn't take pride in having made the weakest of his works, whatever its faults.

VASSÉ[177]

His *Portrait of Passerat*, rather well modelled. I don't think much of his *Child's Head*. And his *Comedy*? Scraggly drapery, modelled after a little mannequin with pinned-on clothes, graceless; otherwise gay, sprightly, with a forced smile when what's needed is a refined one.

PAJOU[178]

202. *Portrait of the Maréchal de Clermont-Tonnerre*

I remember another portrait of this maréchal. Do you recall it? It was hung over the staircase. There the general was in his leather

177 Louis-Claude Vassé (1716–72). Student of his father Antoine-François Vassé, Puget, and Bouchardon. Granted provisional membership in the Royal Academy on May 31, 1748; received as a full academician on August 28, 1751.

178 Augustin Pajou (1730–1809). Student of Jean-Baptiste II Lemoyne. Granted provisional membership in the Royal Academy in 1759; received as a full academician on January 26, 1760.

vest, standing close to his tent, his demeanor noble and proud. Pajou
has made him innocent and idiotic.

203. *Portrait of Monsieur de La Live de Jully*

Monsieur de La Live, next to it, is cold and flat. Take that to mean
whatever you like, it will still hold true . . .

204. *A Figure of Saint Francis of Sales*

This maquette is heavy-handed and limp. You can tell from the
sketch what the finished version will be like, for I tell you again, my
friend, a marble is never anything more than a copy. The artist puts
his fire into the clay, then when he goes at the stone boredom and
indifference set in, the boredom and indifference adhere to the
chisel and penetrate the marble, unless the sculptor is possessed
of an inextinguishable zeal like that the old poet attributed to
his gods.

205. *Sketch for a Baptismal Font*

Poorly shaped, and the infants supporting it neither effective nor
grouped.

208. *Design for a Tomb*
Drawing

Monsieur Pajou, give it something of a sepulchral, lugubrious air if
you want me to say something good about it.

206. *A Bacchante Holding the Young Bacchus*
Maquette

Miserable. The woman and the child poorly grouped; even so, the
least bad of his works.
 But, you say, doesn't this head of M. de La Live de Jully
strike you as a good likeness? —It lacks finesse. —So much the
better. —Yes, but I mean to say finesse in the carving.

207. *The Anatomy Lesson*
Drawing

This an anatomy lesson? It's a Roman banquet. Take away the corpse, replace it with a large turbot, and this will be a print perfectly suitable for the first edition of Juvenal.

ADAM[179]

212. *Polyphemus Taking his Flock out of the Cave, Touching his Ram, which Usually Leads and which he's Astonished to See is the Last Out; he Prays that his Father Neptune will not Allow the Merchant who's Snookered him to Escape. This Merchant is Ulysses, who Escapes from the Cave by Holding on to the Ram's Belly*

Abominable, execrable Adam! I don't mean the oldest of idiot husbands, but a sculptor of the same name who gives us a desert hermit praying on an outcrop of rock for Polyphemus, I know not what little animal, slight and frizzy, for one of the Cyclops' thick-wooled sheep, and a bag of walnuts for Ulysses.

CAFFIERI[180]

What the devil do you want me to say about Caffieri? That he made busts of *Lully* and *Rameau* (Pl. 45) which attracted attention because of the celebrity of their subjects?

179 Nicolas-Sébastien Adam (1705–78). Student of his father Sigisbert Adam. Granted provisional membership in the Royal Academy in 1735; received as a full academician on June 26, 1762.
180 Jean-Jacques Caffieri (1725–92). Student of his father Jacques Caffieri and Jean-Baptiste II Lemoyne. Granted provisional membership in the Royal Academy on July 30, 1757; received as a full academician on April 28, 1759.

CHALLE[181]

This fellow's just died; God be praised! That's some slight conso-
lation for the loss of Bouchardon.[182]

The bust of *Monsieur Floncel, Royal Censor,* is only a rough sketch;
even so it's not very lively.

218. *Two Reclining Figures Representing Fire and Water*

Can you conceive of a man whose taste is so stunted he poses a
figure with tits on her belly and then covers up her buttocks? You
idiot, what am I supposed to look at? What's more, you can't
imagine how he's covered them. It's with a little strip of drapery
perfectly resembling a chemise that's ridden up, exactly like what a
chambermaid sees on her mistress in the morning. Put a deacon in
front of this *Triton* putting his stole over its head and you'd have a
possessed man ready to give up the devil.

D'HUEZ[183]

221. *Saint Augustine* (Pl. 46)

I overheard an artist passing in front of D'Huez' *St. Augustine* saying:
"My God! What blockheads our sculptors are!" This indiscreet
remark struck me, I stopped, I looked, and instead of a saint I saw
a hideous monkey-head entangled in a bishop's robes.

181 Simon Challe or Challes (1719–65). Sculptor, brother of Charles-Michel-Ange
 Challe. Granted provisional membership in the Royal Academy on November 29,
 1754; received as a full academician on May 29, 1756.
182 Edmé Bouchardon (1698–1762). Student of his father Jean-Baptiste Bouchardon
 and Guillaume Coustou. Received as a full royal academician on February 27,
 1745.
183 Jean-Baptiste-Cyprien d'Huez (1728–93). Student of J.-B. II Lemoyne. Granted
 provisional membership in the Royal Academy on February 28, 1761; received as
 a full academician on July 30, 1763.

MIGNOT[184]

222. *Model of a Naiad Seen from the Back*
Relief

Charming woman's back; fluid, flowing of aspect; pure, simple, unforced drawing.

BRIDAN[185]

223. *Saint Bartholomew in Prayer, about to be Flayed*

He's down on one knee; his arms are raised towards heaven; he prays without fear, without emotion; he offers up his suffering and his life ungrudgingly. The executioner's back is turned. He has grasped the saint's left arm, he has tied a rope around it, and he secures this rope to the top of a wooden frame. His air is very much that of his profession; the knife in his mouth makes one shudder. It's an idea worthy of Carracci. With that exception the group is very beautiful; the forms are ample, the drawing correct, the muscles properly articulated, and all the details carefully observed.

I've told you the knife in the executioner's mouth makes one shudder, and that's true. But I know of one painter who had an even more forceful, more atrocious idea: he had an old priest sharpen his knife against the stone of an alter while waiting for the victim to be delivered to him. I'm not sure the artist isn't Deshays.

184 Pierre-Philippe Mignot (1715–70). Student of A.-F. Vassé and J.-B. II Lemoyne. Granted provisional membership in the Royal Academy on July 30, 1757; never became a full academician.
185 Charles-Antoine Bridan (1730–1805). Student of Vinache. Granted provisional membership in the Royal Academy on June 30, 1764; received as a full academician on January 25, 1772.

BERRUER[186]

224. *Cleobis and Biton*
Relief

Here is a beautiful, a very beautiful work. First off, nothing could be more touching than the action of these two youths who, for want of livestock, harnessed themselves to their mother's wagon and pulled her to the temple. The ancients paid due homage to this action; they rendered it eternal. Ah! If I had the voice that can make itself heard from time present to time immemorial, how I'd celebrate the one that's just transpired before my eyes! I'm going to tell you about it; you won't be any the less touched by the relief.

My publishers paid the Chevalier de Jaucourt's servant a respectable sum.[187] This servant, on his own initiative, unbeknownst to his master, thought that mine had not been so recompensed, that he'd worked even harder than himself, and he came to offer him half this amount. Either I understand nothing, or this act of justice exceeds that of filial piety.

However that may be, let's return to our relief. The mother is seated on her wagon. She has a sacrificial vase on one of her knees; her two hands grasp the top of the vase. Her characterization is straightforward, her posture truthful, and her drapery well conceived. The whole has a scent of antiquity about it that's agreeable. The wagon is solid and beautiful of form. The two youths are nude, in a pious mode appropriate for this relief, and pull convincingly. But I must speak the whole truth; the mother seems a bit young to have such grown-up children. The left leg of the foremost youth is full of nicely observed detail, but the right one seems broken beneath the knee. The head of the other youth is badly drawn; take him by the nose, turn him around to face you, and you'll see that his ear will be situated at the back of his head. And then both their physiognomies resemble those of our angels. Otherwise, this young artist knows how to soften and enliven marble. This is his reception piece. May he be received quickly; Monsieur Flipot,[188] swing wide the doors.

186 Pierre Berruer (1734–97). Granted provisional membership in the Royal Academy on April 7, 1765; received as a full academician on February 23, 1770.

187 For several years' worth of courier trips in connection with Diderot's work on the *Encyclopédie*. The Chevalier de Jaucourt was Diderot's principal collaborator on the project.

188 Flipot was the caretaker of the Royal Academy rooms in the Louvre.

225. *A Marble Vase Decorated with Reliefs of Children Playing with Bunches of Grapes*

A little masterpiece. Children ravishingly grouped, broadly handled, playing convincingly; a marble that seems soft, kneaded; the low relief skillful, and the vase a beautiful shape. The wide band of white marble supporting the relief is most effective.

226. *Design for a Tomb*

Now here's a tomb with a lugubrious character. Figures very moving, one sad and silent, the other active and speaking. The first is Purity decorating a funerary urn with a garland; the other is Friendship giving vent to her pain. Beautiful drapery, quite poetic; finely characterized heads. A beautiful conception. There are other tomb designs by the same artist, but they're not as successful.

Now you're done with the sculptors, and so am I. You can see, my friend, that a hundred works of sculpture can be dispatched with less effort than five or six paintings. It's works of sculpture that convey to posterity the state of the fine arts in a nation; time destroys paintings, the soil preserves debris made of marble and bronze. What's left us of Apelles? Nothing; but since the products of his brush equalled the sublime carvings of his time, the *Farnese Hercules*, the *Apollo Belvedere*, the *Gladiator*, the *Faun*, the *Laocoön*, and the *Dying Athlete* testify today to the extent of his gifts.

This year we lost a skilled sculptor, René-Michel Slodtz.[189] He was born in Paris in 1705. He won the Academy prize at the age of twenty-one; he went to Rome; he learned much; he distinguished himself there. The only things of his I've seen are his *Bust of Iphigenia* (Pl. 47) and his mausoleum for Languet, the vicar of Saint Sulpice, the greatest charlatan of his calling and his century; the head in this last is exceedingly beautiful and the marble is a sublime request to God that he pardon all the man's chicanery. I know of no sinner in whom it wouldn't inspire some faith in divine mercy. But the *Iphigenia* is still finer; it has everything: nobility of character,

189 René-Michel Slodtz, known as Michel-Ange Slodtz (1705–65). Student of his father Sebastien Slodtz. Granted provisional membership in the Royal Academy on December 31, 1749; he never became a full academician.

forms that are well-chosen and pure, fine workmanship, and excellence of taste. Slodtz returned to Paris in 1747. The mediocre Coypel, then First Painter to the King, with whom a certain Monsieur de Tournehem, Madame de Pompadour's uncle and Director of the Academy, was infatuated, received Slodtz coldly, and the artist remained without work.[190] A fine lesson for sovereigns! If they put a mediocrity in charge of the arts, this results in the mortification of gifted men and the protection of mediocrities. The chisel fell from Slodtz' hands, and he found himself working on theatre sets, catafalques, firework displays, and all the puerilities for which the office of "Lesser Pleasures" is responsible.[191] But what befalls a man when he sees his talent disparaged? Chagrin, melancholy, bile pouring into the blood, and death, which came to Slodtz in 1764. His fate recalls that of Puget.[192] Praise is accorded Slodtz' *Tomb of the Marquis of Caponi* in Florence, his *Head of Calchas*, and his reliefs on the portals of Saint Sulpice. He managed to avoid both cold exactitude and affected simplicity, the two faults to which servile imitation of the antique makes one prone. He was so strongly drawn to a supple, gracious idiom that he sometimes sacrificed correctness of drawing. He knew how to work marble, and his peers in the art of representing drapery were few and far between. Moreover, a good man who had the stuff of an expert without being jealous.

In writing this short eulogy of Slodtz, I'm reminded of a story I must incorporate into your chronicle. It used to be that the works of sculpture submitted by the competitors for the grand prize, for a sojourn at the school in Rome, were presented to the king. A student of Bouchardon[193] dared to challenge his master, producing an equestrian statue of Louis XV. This work was brought to Versailles with the others; the monarch, impressed by the beauty of this piece, addressing his courtiers, said to them: "It seems to me I'm

190 Lenorment de Tournehem, who was closely connected to Madame de Pompadour (it was rumored he was her father), served as Director of the King's Buildings from 1745 until his death in 1751. He was largely responsible for the appointment of Charles-Antoine Coypel as First Painter to the King in 1747, a post he occupied until his death in 1752.

191 The "Menus Plaisirs" (literally, Lesser Pleasures): the office responsible for the design and execution of ephemeral decorations needed for court entertainments and festivities, as well as for more momentous ritual occasions such as state funerals and the *sacre*, or coronation, of French monarchs at Reims Cathedral.

192 Pierre Puget (1620–94). French sculptor.

193 Laurent Guiard or Guyard (1723–88). In 1754, while a student, he executed a model for an equestrian statue of Louis XV in archaic dress ("*à la gaulois*") that was admired by the King and by Madame de Pompadour. Bouchardon became jealous, the maquette was ordered destroyed, and Guiard's career suffered.

very graceful on horseback." Nothing more was needed to seal the young man's fate; he was obliged to smash to work himself, and the custom of exhibiting the students' works to the sovereign's gaze was abolished. On which, my friend, feel free to reflect as much as you like while I prepare my remarks about the engravers.

ENGRAVERS

If you think, my friend, that among the countless multitude of men who trace alphabetical characters on paper there isn't a single one without his own way of writing so different from another's that a competent expert could identify it and so determine a judge's verdict, you won't be surprised to learn there isn't an engraver who doesn't have his own burin and way of handling it; nor will you be surprised to learn that Mariette[194] can recognize all these individual burins and styles after I've told you that Le Blanc, Le Bel, or any other jeweler on the quai des Orfèvres[195] has so completely memorized all the important stones he's seen on the market that any attempt to disguise them from his experienced eye by having them recut would prove vain.

There's a way to learn the basics of engraving rather quickly, namely by assembling a portfolio of prints selected for study; and don't think you'd need many, the *Portrait of the maréchal d' Harcourt*, known as the *Gilded Youth*,[196] would be sufficient to teach you about the handling of feathers, flesh, hair, leather, silk, embroidery, fabric, gold cloth, metal, and wood. This is the work of Masson and the engraving is masterful. Add *The Pilgrims at Emmaus*, also known as *The Table-Cloth*, pull together a few excellent works by Edelinck, Visscher, Gérard Audran, not failing to include the latter's *Truth Carried by Time*. Get hold of some small prints by Callot and della Bella; this last is rich and animated; and then exercise your eyes. While we're waiting for you to assemble your portfolio, I'm going to outline the basics of the art for you.

194 Pierre-Jean Mariette (1694–1774). Celebrated Parisian connoisseur, collector, and
 author.
195 "Goldsmiths' embankment": a stretch of the Seine embankment on the southern
 side of the île de la Cité known for its goldsmiths and metalworkers' shops.
196 A free translation of *Cadet à la perle*.

One engraves or makes prints on metal, on wood, on stone, on some animal substances, on glass, in intaglio or in a relief process.

Sculpting is drawing with the mortise and chisel; engraving is drawing with either the burin or the bow-drill; chasing is drawing with the buffer and the small chisel. Drawing is the foundation of a great many arts, and frequently someone can draw fluently with one of these instruments who can produce only mediocre results with the pencil. All these different ways of drawing are what makes one a sculptor, a modeller, a copperplate engraver, a wood engraver, an engraver of precious stones, a medal engraver, a maker of relief stamps, or a chaser. Here I will deal only with the translator of the painter's work, with copperplate engraving.

The copperplate engraver is a writer of prose who undertakes to render the work of a poet from one language into another. Color disappears; truth, drawing, composition, character, expression remain.

It is quite odd and quite vexing that the Greeks, who knew how to engrave precious stones, were completely unacquainted with copperplate engraving. They had seals with which they made wax imprints, but it never occurred to them to expand upon this invention. Just imagine how it would have preserved for us the masterpieces of the great painters of antiquity. Two discoveries that seem closely related are sometimes separated by centuries.

All paintings are destined to perish; cold, heat, air, and worms have already destroyed quite a few. It's up to engraving to save what can be saved. Thus painters concerned about their future glory should keep engravers squarely within their sights. Raphael corrected Marcantonio's prints himself.

An excellent author who falls into the hands of a bad translator, like Homer into the hands of Bitaubé,[197] is lost. A mediocre author lucky enough to meet up with a good translator, like Lucan with Marmontel,[198] has everything to gain. It's just the same with painters and engravers, especially if the former is not a good colorist. Engraving kills the painter whose color is everything, just as translation kills the author who is all style.

In his capacity as translator of a painter's work, an engraver should be able to convey the talent and style of his original. One shouldn't engrave Raphael the same way as Guercino, Guercino the same

197 Paul-Jérémie Bitaubé (1732–1808). French translator who published prose renderings of the *Iliad* (1764) and the *Odyssey* (1785).

198 Jean-François Marmontel (1723–99). French poet, novelist, opera librettist, and critic. His most famous works are *Contes Moraux* (1761), *Bélisaire* (1767; condemned by the Sorbonne), and the posthumously published *Mémoires d'un père* (1804).

way as Domenichino, Domenichino the same way as Rubens, nor Rubens the same way as Michelangelo. If the engraver is skilled, from the first glimpse of his engraving the painter's style will be readily apparent.

Among painters, one will require a clear stroke, a bold touch, an overall treatment that's warm and free; another will insist on something more refined, softer, suaver, asking for more nuanced contours, a less resolute stroke; and don't think such differences are inconsistent with good engraving. Even the style of an oil sketch is distinct from that of preliminary underpainting.

If the engraver doesn't keep to a few enlightened principles, if he doesn't know how to analyze what he copies, he'll treat everything in the same routine way; and for every acceptable print in which his routine agrees with the painter's style there will be a thousand bad ones.

When you examine an engraving and you see the same objects treated differently in it, don't attribute this to arbitrary, bizarre, or capricious taste; this follows from the genre of painting, from the conventions obtaining in the subject. It's becuase a single genre of painting, a single subject, contained distinct treatments, of color, of light, that required different technical approaches.

Don't expect an engraver to be equally skilled at rendering all things. Baléchou[199] knew how to capture the full transparency of Vernet's water, but his mountains resemble velvet.

Don't ascribe merit to work that's merely clean, consistent, and slavishly executed, nor to work that's wildly free and idiosyncratic; the first indicates only patience, the latter only laziness or even inadequacy.

Some artists prefer lozenge-shaped configurations, others squared-off ones. In the former, the dominant strokes that define the forms, the shadows, and the shaded passages cross one another at an oblique angle. In the squared style, they cross one another at right angles. If one juxtaposes lozenge shapes that are exaggerated, that are too long in one direction and too narrow in the other, they will produce an infinite number of little white dots aligned in rows that will prove distracting, especially in areas of shadow where a tranquil, muffled effect is called for.

Some engrave their lines close together, others further apart. Tight engraving produces a softer, more painterly effect. Looser engraving leads to a deadened effect that lacks pliancy and exhausts

199 Jean-Jacques Baléchou (1719–64). Student of Michel and Bernard Lépicié. Granted provisional membership in the Royal Academy on March 29, 1749; he never became a full academician.

the eye. They're like two kinds of fabric, one with a coarse weave and the other with a fine weave. It's the last one that's precious.

It's the intermediate strokes that characterize metal, water, silk, any polished, glossy surface. Strokes can be broken into segments or dots; dots or segments can be inserted between strokes. Stipples give consistency to flesh. Dots and segments can be mixed together according to the effect desired.

If one uses a sharp etching-needle to inscribe lines or hatching without resorting to either the etching process or the burin, this is called "drypoint engraving." The drypoint penetrates the copper without removing any of it. It is used for finishing touches, for the softest, lightest objects, for skies, for distant views; and the contrast between its marks and those that are etched or made with the burin is always lively and agreeable.

If the acid, that capricious slave of the printmaker, has made a furrow that's shallow and has the additional flaw of being wider than it is deep, you can expect to see this area turn out greyer than if it were worked with the burin. Acid is the joy or the despair of the artist, prolonging or shortening his work in proportion to the length of time it's left standing. If it has "bitten" too much and the resulting furrows are as deep as they are wide, such that the furrows print out as black in their centers as at their edges, the poor printer can exercise his arms and use his hands to rub the plate as much as he likes, the tonal range of the etching will still be shrill, black, harsh, especially in the half-tint passages.

If it happens that the furrows are too wide, the contracted white spaces will seem to blend together; then there's nothing that can be done with the burin to prevent acridity and chinks. If the artist manages to keep his white areas wide, he will always have the option of reducing them.

If you closely examine an engraving that's skillfully executed, you'll note that the strokes of the initial work predominate over those added in the final, finishing stage.

It's the second and third set of strokes that give skin its soft-ness. Note how the stipples grow closer near shadows, note how they disperse towards the light. Consider each stipple as a ray of light gone dark. The stipples are not distributed haphazardly; they're always separated from surrounding stipples by empty, white intervals.

Let me talk, my friend. It's with the help of such small technical details that you can tell why you like one print and don't like another, why your eyes take pleasure here and are rebuffed there.

To bring the strokes to their highest degree of vigor is the artist's final task. A principle common to drawing, painting, and engraving

is that even the darkest of darks can only be achieved by means of successive gradation.

The acid has done its job well when only a little touching up with the burin is required, especially in genre images. The burin, grave and serious, can't banter like the etching-needle. In such cases it should only be used with great discretion.

I'd say to the engraver: Have your strokes accurately evoke the forms; be scrupulous in making them thinner in accordance with their level of depth; always make those initially applied determine the disposition of those applied subsequently; make partial shadows that are near fully illuminated areas less densely stroked than patches of reflected light and areas in deep shadow; handle all three kinds of passages in such a way that they reinforce the spatial organization of the whole. Treat each thing in a way appropriate to it, such that figures, landscape, water, drapery, metals are properly characterized. Produce the maximum effect with a minimum of strokes.

A bit more, my friend, about stipple engraving and "charcoal" engraving, and then I'll let you be.

Stipple engraving consists of covering an entire surface with black dots that one softens, weakens, deadens, effaces. They can depict shadows, reflections, tones, half-tones, day and night. When one begins to etch, everything is bright; shadow and darkness increase as one proceeds. In stipple engraving one starts in deep night; the work introduces daylight into this night.

"Charcoal" engraving is the art of imitating charcoal drawings; a wonderful invention that has an advantage over other kinds of engraving, namely of providing examples for students to copy. Those who draw after regular engravings develop styles that are hard, dry, and overly systematic.

The technique of "charcoal" engraving differs very little from that of stipple engraving. It consists of various dots, without order, that one leaves dispersed or applies so thickly they become indistinct, obtaining a result that resembles snow and makes the print appear just like paper on whose tiny obtrusions the charcoal has left its particles. A man named François invented it; it was perfected by someone named Demarteau.

Engraving preserves and multiplies paintings; "charcoal" engraving multiplies and preserves drawings.

I'll say only one thing about medal engraving, namely that sovereigns' concern for their glory has tended to encourage it. Beautiful medallions, handsome coinage add lustre to their reigns. The more great accomplishments they've achieved, the more justified they'll be in thinking that men to come will be curious to see images of those whose lofty deeds are recounted by history.

Now let's move on to the engravings exhibited at the Salon this year.

COCHIN[200]

By Cochin there's a frontispiece for the *Encyclopédie*.

Drawing Intended to Serve as the Frontispiece to the Encyclopédie (Pl. 48)

This is very ingeniously composed. At the top one sees Truth between Reason and Imagination: Reason attempting to remove her veil, Imagination preparing to beautify her. Below this group, a crowd of speculative philosophers; lower still the company of artists. The philosophers fix their eyes on Truth; proud Metaphysics tries not so much to see her as to divine her; Theology turns her back to her and waits to be illuminated from on high. Certainly this composition boasts a considerable variety of character and expression, but the levels of depth don't advance and recede enough; the upper area should fade into the background, the next move forward somewhat, and the third be the most forward of all. If the engraver managed to correct this fault the work would be perfect.

Several Allegorical Drawings on the Reigns of French Kings

Ingenuity, judgment, the picturesque, they're all here, in the heads, the expressions, the grouping of the figures, and the compositions.

200 Charles-Nicolas Cochin (1715–90). Granted provisional membership in the Royal Academy on April 29, 1741; received as a full academician on November 27, 1751. Between 1755 and 1770 he was the principal liaison between the royal arts administration and royal academicians. He also wrote on the arts; Diderot claimed that he first mastered the basic vocabulary of art criticism through close study of Cochin's *Voyage d'Italie* (first ed. 1756).

If this artist, a man of pleasure, a great draftsman, formerly an engraver of the first rank, had made nothing but these drawings, they'd suffice to assure him a solid reputation.

LEBAS[201]

He's the one who delivered the mortal blow to fine engraving among us with a style that's all his own, whose effect is seductive and which all young students have endeavored to imitate, without success.

Four Prints from the Third Set of the Ports of France by Monsieur Vernet, Engraved in Collaboration with Monsieur Cochin

Cochin executed the figures and they're the best things in them. These collaborators cannot have mourned the death of Baléchou with great fervor.

WILLE[202]

He's the only one capable of wielding the burin so that it achieves an effect of strength as well as pliancy; and he's the only one who knows how to execute small heads. His *Itinerant Musicians* good, very good.

201 Jean-Philippe Lebas (1707–83). Student of Nicolas Tardieu. Granted provisional membership in the Royal Academy on November 5, 1735; received as a full academician on February 23, 1743.

202 Jean Georges Wille (1715–1808). Granted provisional membership in the Royal Academy on August 30, 1755; received as a full academician on July 24, 1761.

ROETTIERS[203]

Medals and Tokens for the King;
Six Medallion Portraits of
the Princes and Princesses of
the Galitzine and Trubetskoi Families of Russia

Medals and tokens that don't seem worth looking at if you've seen a large bronze or cameo from antiquity.

FLIPART[204]

Nothing worthwhile. A *Tempest* after Vernet! Oh Baléchou, "ubi, ubi es?"[205]

MOITTE[206]

Couldn't be worse. His *Serenader* and *Lazy Girl* after Greuze almost bearable. As for the *Monument in Reims* (Pl. 51), executed under Cochin's guidance and corrected by him, utterly botched: the figure of the monarch stiff and walking on his heels, faults found in the bronze original; holes and black patches in the lights, background and foreground indistinguishable from one another, the background architecture stuck to the pedestal.

203 Joseph-Charles Roettiers (1692–1779). Student of his father Joseph Roettiers. Granted provisional membership in the Royal Academy in 1716; received as a full academician on December 31, 1717.
204 Jean-Jacques Flipart (1714 or 1719–82). Student of his father Jean-Charles Flipart, J.-B. Peronneau, P. Aveline, and L. Cars. Granted provisional membership in the Royal Academy on June 28, 1755; he never became a full academician.
205 "Where, where art thou?"
206 Pierre-Étienne Moitte (1722–80). Student of Beaumont. Granted provisional membership in the Royal Academy in 1760 or 1761; received as a full academician on June 22, 1771.

BEAUVARLET[207]

Two Young Children Amusing Themselves by Making a Dog Play a Guitar

Broad, fluent engraving.

An Offering to Venus and Another to Ceres
After Vien

Nothing of the finesse of drawing in the paintings.

Two Drawings after Paintings by the Late Carle Van Loo; One, The Spanish Conversation; The Other, Reading

Drawings intended for engraving, limply handled, and the facial expressions completely spoiled. The artist need not have warned us that these weren't originals.

LEMPEREUR[208]
MELLINI[209]
ALIAMET[210]

"De communi martyrum."[211] Nothing to say to them, not even that they should strive to be better; they're what they are, they must stay that way.

207 Jacques-Firmin Beauvarlet (1731–97). Student of N. Dupuis and L. Cars. Granted provisional membership in the Royal Academy on May 29, 1762; received as a full academician on May 25, 1776.

208 Louis-Simon Lempereur (1728–1807). Student of Pierre Aveline. Granted provisional membership in the Royal Academy on August 23, 1759; received as a full academician on March 2, 1776.

209 Carlo-Domenico Mellini (1740–95). Exhibited at the Louvre Salons 1761–77. Granted provisional membership in the Royal Academy on November 28, 1761; never became a full academician.

210 Jacques Aliamet (1726–88). Student of Lebas. Granted provisional membership in the Royal Academy on September 3, 1763; never became a full academician.

211 "From the commmonplace book of martyrs;" this was book of recitations used to celebrate minor saints on their feast days. Here Diderot cites it to emphasize the mediocrity of these three engravers.

DUVIVIER[212]

Lots of medals. Take *The Inauguration of the Equestrian Statue of Louis XV in Paris*, *The Turkish Ambassador Presenting his Credentials to the King*, *The Bust of Princess Trubetskoy* with its reverse, *Her Tomb Surrounded by Cypresses*, and get rid of the rest as scrap iron.

STRANGE[213]

Justice and Forbearance
After Raphael

Why should I reproach him for having altered Raphael's drawing? Others more skillful than he have done likewise.

TAPESTRY

Portrait of Monsieur Pâris de Marmontel
After the original pastel
by Monsieur de La Tour

One would take this to be the original painting.

A Medallion Representing Painting
After the painting by the late Carle Van Loo

My faith, if there's anyone who can distinguish these tapestries from the paintings from a few steps away, I say they should have them

212 Pierre-Simon-Benjamin Duvivier (1730–1819). Student of his father Jean Duvivier. Granted provisional membership in the Royal Academy on November 24, 1764; received as a full academician on December 28, 1776.

213 Robert Strange (1721–92). Student of Cowper (in Edinburgh) and Lebas (in Paris).

both. The Chinese have replaced dyed wool, whose colors are soon faded by the air, with bird feathers, which are more brilliant, more durable, and capable of every nuance.

And "laus Deo, pax vivis, requies defunctis."[214]

After having described and assessed four or five hundred paintings, let's close by justifying our views; we owe as much to the artists we've treated badly, we owe it to the people for whom these pages are intended; it might be that a clear exposition of our standards will offer some compensation for the severe criticisms we've made of several productions. To this end we'll risk appending a little treatise on painting in which we speak in our own way and as best we know how about drawing, color, style, light, expression, and composition.

214 "Praise be to God, peace to the living, tranquility to the dead."

Notes on Painting

NOTES ON PAINTING
To Serve as an Appendix to the Salon of 1765

MY BIZARRE THOUGHTS ABOUT DRAWING

NATURE DOES NOTHING that is not correct. Every form, whether beautiful or ugly, has its cause, and of all extant beings there isn't a single one that's not just as it should be.

Look at this woman who's lost her eyes while still young. The progressive deepening of her sockets hasn't increased the extent of the surrounding pockets. They've sunk into the cavities hollowed out by the organs' absence; they've shrunk. Above, a portion of her brow has been pulled in; below, her cheeks have been slightly lifted. Her upper lip, responding to this movement, has risen somewhat. These alterations have affected all parts of her face, in proportion to their proximity or distance from the principal site of the accident. But do you think that the deformity has been restricted to this oval? Do you think her neck has been completely unaffected? And her shoulders and throat? Yes, to your eyes and mine. But summon nature, show her this neck, these shoulders, this throat, and nature will tell you; this is the neck, these the shoulders, and this the throat of a woman who's lost her eyes while still young.

Direct your glance towards this man whose back and chest are hunched over. As the cartilage in front of his neck grew longer, his vertebrae bent over. His head fell forward, his hands closed into fists, his elbows pushed backwards: all his bodily members conspired to locate a center of gravity consistent with this irregular arrangement. As a result, his face assumed an air of constraint and discomfort. Cover this figure and show nature no more than its feet, and nature will pronounce, without hesitation, these feet belong to a hunchback.

If causes and effects were readily apparent to us, we'd have only

to represent beings just as they are. The more perfect an imitation, the more analogous to its causes, the more it would satisfy us.

Despite our ignorance of cause and effect, and the rules of convention entailed by this ignorance, I suspect that any artist who dared neglect these rules, opting instead for rigorous imitation of nature, would often find justification for oversized feet, short legs, swollen knees, and heavy, cumbersome heads in that refined awareness deriving from continuous observation of phenomena that makes us sensitive to secret relationships, to the natural concatenations between such deformities.

A crooked nose in nature does not offend because everything is of a piece. One arrives at this deformity by way of little adjacent alterations that sustain and redeem it. Twist the nose of the *Antinous*, leaving the rest as it is, and this nose will be unfortunate. Why? Because the *Antinous'* nose wouldn't be twisted at all, but rather broken (Pl. 21).

We say of a man passing by in the street that he's ill made. Yes, according to our poor rules; but according to nature? That's something else again. We say of a statue that it's beautifully proportioned. Yes, according to our poor rules; but according to nature?

Allow me to transfer the veil covering my hunchback to the *Medici Venus*, leaving only the tip of her foot exposed. If nature, summoned once again, set out to complete the figure on the basis of the tip of this foot, perhaps you'd be surprised to see it sketch in a hideous, deformed monster. But as for myself, I'd be surprised if the result were otherwise.

A human figure is a system that's too carefully composed for the consequences of a tiny adjustment, apparently of little effect, not to remove the most perfect artistic production a thousand leagues from the work of nature.

If I were initiated into art's mysteries, perhaps I'd know to what extent the artist should conform to accepted proportions, and I'd tell you; I do know, however, that they don't stand up against the despotism of nature, and that age and social condition dictate that they be sacrificed in a hundred different ways. I've never heard a figure dismissed as badly drawn when its exterior organization revealed its age and its capacity and custom of fulfilling its daily tasks. It is these tasks that determine both a figure's overall stature and the true proportions of its bodily members and their mutual consistency. It's from these that I see emerge the child, and the adult, and the old man; the savage, and the civilized man; the magistrate, and the soldier, and the porter. If ever a figure would be difficult to capture, it would be that of a twenty-five-year-old suddenly formed out of clay, and who'd never done anything; but this man is a chimera.

Childhood is almost a caricature, and I'd say the same of old age.

The child is a shapeless, fluid mass striving to develop; the old man is also a shapeless mass, but dried out, turning inward, tending to reduce itself to nothing. It's only in the interval between these two ages, from the beginning of perfect adolescence to the end of maturity, that the artist submits to a purity and rigorous precision of line, and that the *poco piu* or *poco meno*, the precise placement of a stroke, can make for blemish or beauty.

You'll say to me that age and customary tasks alter the forms but don't abolish the inner organs. Very well ... One must become familiar with them ... I agree. This is why one should study the *écorché*.[1]

Study of the *écorché* doubtless has its advantages; but is it not to be feared that this *écorché* might remain in the imagination forever; that this might encourage the artist to become enamored of his knowledge and show it off; that his vision might be corrupted, precluding attentive scrutiny of surfaces; that despite the presence of skin and fat, he might come to perceive nothing but muscles, their beginnings, attachments, and insertions; that he might over-emphasize them, that he might become hard and dry, and that I might encounter this accursed *écorché* even in his figures of women? Since only the exterior is exposed to view, I'd prefer to be trained to see it fully, and spared treacherous knowledge I'd only have to forget.

It is said the *écorché* is studied only to learn to observe nature, but experience suggests that after such study it's very difficult to see her in any other terms.

No one but yourself, my friend, will read these pages, so I can write exactly what I please. These seven years drawing after the model at the Academy, do you consider them well spent, and would you like to know what I think about them? It's here, during these seven cruel and difficult years, that one's draftsmanship becomes mannered. All these studied, artificial, carefully arranged academic poses, all these movements coldly and ineptly imitated by some poor devil, and always the same poor devil, who's paid to appear, undress, and let himself be manipulated by a professor three times a week, what do they have in common with postures and movements in nature? What does the man drawing water in the well in your courtyard have in common with another who, not pulling the same burden, awkwardly mimics this action, his two arms raised, on the school's posing platform? What does a person pretending to die have in common with another expiring in his bed or beaten to death in the street? What does an artificial wrestler have in common with the one on my street corner? This man who begs, prays, sleeps, reflects,

1 "Flayed figure": a male mannequin with skin and fat removed to facilitate study of the muscles.

and faints upon request, what does he have in common with a peasant stretched out on the ground from fatigue, with a philosopher meditating at his fireside, with a suffocating man who faints in the crowd? Nothing, my friend, nothing. To complete this absurdity, students might just as well be packed off to Vestris or Gardel, or whatever dancing master you like, to learn about graceful movement. The truth of nature is forgotten, while the imagination is filled with gestures, postures, and figures that are false, forced, ridiculous, and cold. There they're stored away, re-emerging for application to the canvas. Whenever the artist takes up his chalks or brushes, these limp phantoms revive and present themselves to him; they're a perpetual distraction, and he who managed to exorcise them from his head would be a prodigy indeed. I once knew a young man of excellent taste who, before making the smallest stroke on his canvas, would get down on his knees and say, dear Lord, deliver me from the model. If today one rarely sees a picture composed of a certain number of figures without observing, here and there, a few of the academic figures, poses, movements, and attitudes so mortally disagreeable to men of taste, and convincing only to those to whom truth is foreign, blame the eternal study of the academic model.

It's not in the school that one learns about the general coordination of movements, a coordination that's sensed, that's seen, that extends, winding its way, from head to foot. If a woman allows her head to fall forward, all her bodily members acknowledge its weighty pull; if she lifts and holds it erect, there's a similar acknowledgement from the rest of the machine.

What an art, and a great one, is the posing of the model; one need only observe how proud of it is Monsieur le Professeur. No need to fear that he might say to the poor salaried devil, my friend, strike a pose on your own, do what you like. Rather than allow him to assume a simple natural posture, he much prefers to assign him some eccentric one. And currently one has no choice but to put up with this.

A hundred times I've been tempted to say to young students I encountered on their way to the Louvre with their portfolios under their arms: My friends, how long is it you've been drawing there? Two years? Why, that's too long. Leave this shop of mannered tics. Go to the Carthusians',[2] and there you'll see real attitudes of piety

2 The Carthusian monastery behind the Luxembourg Palace, now destroyed, which housed one of the most admired works of the French seventeenth century, the *Life of Saint Bruno* cycle by Eustache Le Sueur (now in the Louvre, Paris, see Pl. 49). Diderot is known to have admired these paintings; here, however, he is advising his imaginary auditors/artists to observe both the canvases and the real monks there.

and compunction. Today is the eve of a high holy day; go to a parish church, prowl around the confessionals there, and you'll see real postures of meditation and repentance. Tomorrow go to a tavern, and you'll see the real movement of an angry man. Seek out public gatherings; be observant in the street, in public gardens, at the market, in private homes, and you'll obtain an accurate idea of true movement as it is in the activity of life. Look at your two comrades arguing with one another; note how, without their realizing it, it's the dispute that determines the placement of their limbs. Examine them carefully, and you'll take pity on your insipid professor's lessons and your insipid model's imitations. How I'll pity you, my friends, when one day you find yourselves obliged to replace all the falsehoods you've learned with the simplicity and truth of Le Sueur; and you'll certainly have to do this if you intend to amount to anything.

Posturing is one thing, action another. All posturing is false and trivializing; all action is beautiful and true.

Contrast that's poorly understood is one of the most deadly causes of mannerism. Genuine contrast derives exclusively from an action's essence, or from a diversity of agents or interests. Look at Raphael and Le Sueur; they sometimes place three, four, or five standing figures next to one another, and the effect is sublime. At Mass or Vespers at the Carthusian monastery forty or fifty monks are to be seen in two long parallel lines, with the stalls, actions, and vestments all identical, and yet no two of these monks resemble one another. No contrast should be sought out other than what's needed to individuate them; so much is genuine, any more would be shabby and false.

If these students should be inclined to profit further from my advice, I'd say to them: Hasn't it been long enough for you to see only a portion of the objects you copy? Try, my friends, to imagine that the entire figure is transparent, and that your eyes look out from its center. From there you'll observe the complete exterior disposition of the machine; you'll see how some parts are extended while others are contracted, how the former stretch out while the latter expand; and, consistently preoccupied by the overall effect, by the whole, you'll succeed in showing in that part of the object presented in your drawing everything that would correspond with it but that's not visible, and though displaying only one of its views to me you'll oblige my imagination to envision the opposite view as well; and it's then that I'll write that you're a surprising draftsman.

But it's not enough to evoke the whole successfully; the challenge lies in introducing details without destroying the mass. This is the work of verve, of genius, of feeling, and extremely delicate feeling at that.

Here, then, is how I'd like to see a drawing school run. When the student was able to draw after prints and reliefs with ease, I'd place him before male and female academic models for two years. Then I'd expose him to children, adults, mature men, old men, subjects of all ages, of both sexes, drawn from all walks of life—in a word, to every kind of nature. The prospective models would come in droves to the door of my academy, if I paid them well; if I was in a country with slaves, I'd compel them to come too. The professor would make a point of noting in all these different models how their habitual daily tasks, their way of life, their social station, and their age had introduced accidental features into their forms. Thereafter my student would see the academic model but once every fifteen days, and the professor would allow the model to strike poses on his own. After the drawing sessions a trained anatomist would explain the *écorché* to my student, with constant references to the living, animated nude body; and he'd draw from the *écorché* no more than a dozen times a year. That would be sufficient for him to acquire a sense of how flesh supported by bone and flesh that lacks such support should not be drawn in the same way, that here the outline should be rounded, and there angular; and that if he neglects such details, the whole will seem like an inflated bladder or a ball of cotten.

There would be no mannerism, in either drawing or color, if nature were scrupulously imitated. Mannerism derives from teachers, from the academy, from drawing schools, and even from the antique.

MY FEEBLE IDEAS ABOUT COLOR[3]

Drawing gives a being form; color gives it life. It is the divine breath that animates it.

Only art's masters are good judges of drawing; everybody can judge color.

3 A postulated opposition between *disegno* and *colore* (in French, between *dessin* and *couleur*—the first associated with intellection and the ideal, the second with the experiential and sensual—is a central preoccupation of late Renaissance art theory, and it continued to preoccupy writers embracing academic ideals throughout the Baroque period. In seventeenth-century France this tradition was recast as a debate over the relative merits of Poussin and Rubens, the effects of which would reverberate throughout eighteenth- and nineteenth-century critical writing.

There's no lack of excellent draftsmen; great colorists are few. Likewise in literature. There are a hundred cold logicians for every great orator, ten great orators for every sublime poet. Great engagement can make an eloquent man suddenly burst forth; but whatever Helvétius may say, everybody's not capable of producing ten good verses, even under pain of death.

My friend, go to a studio, watch an artist at work. If you observe him arranging his pure and transitional colors around his palette with perfect symmetry, or if he hasn't confounded this order after fifteen minutes, you can confidently declare that this artist is cold, and that he'll never produce anything worthwhile. He's a counterpart of the dull, ponderous scholar who, when he needs to consult a given passage, climbs up his ladder, takes and opens the volume, goes back to his desk, copies out the line he needs, climbs the ladder once more, and returns the book to its place. Genius behaves very differently.

Someone with a vivid sense of color fixes his eyes on the canvas; his mouth hangs open, he pants; his palette is the very image of chaos. It's into this chaos that he dips his brush, pulling from it the stuff of creation—birds and the coloristic nuances of their plumage; flowers and their velvety surfaces; trees and their varieties of foliage; the blue of the sky and the water vapor that dulls it; animals and their fur, and the varied colorings of their skin, and the fire gleaming in their eyes. He gets up, he moves back, he glances at his work. He sits down again, and you see him give birth to flesh, drapery, velvet, damask, and taffeta; muslin and canvas, coarse material and homespun cloth; you see the yellow, ripe pear falling from the tree, and the green grape attached to its stem.

But why is it that so few artists know how to depict things readily accessible to everyone? Why this variety among colorists, when nature's color is consistent? Surely the disposition of the sense organ counts for something here. Eyes that are tender and sensitive will not find vivid, strong colors congenial. A man who paints will be loath to introduce into his painting effects that cause him discomfort in nature. He won't like brilliant reds, nor piercing whites. Like the material he uses to cover the walls of his living quarters, his canvas will be colored with tints that are tender, gentle, and mild, and frequently he'll compensate in the way of harmony for what he's withheld in the way of vigor. But why wouldn't a man's character and temperament exert an influence over his color preferences? If his thought is habitually mournful, gloomy, and black, if it's always night in his melancholy head and in his lugubrious studio, if he banishes daylight from his quarters, if he seeks out solitude and darkness, wouldn't one be justified in anticipating from him a scene that's vigorous, perhaps, but also dark,

sombre, and gloomy? If he has jaundice and sees everything as
yellow, how could he prevent himself from throwing the same
yellow veil over his composition that his tainted organs throw over
all natural objects, and that vexes him when he compares the green
tree in his imagination with the yellow tree perceived through
his eyes?

Rest assured that the painter reveals himself in his work just as
much, if not more so, as the writer in his. On occasion he manages
to transcend his character, to overcome the disposition and
inclination of his organs. This is like the quiet, taciturn man who
raises his voice. The outburst having finished, he subsides once more
into his natural state, which is silence. An artist who's melancholy or
who was born with sensitive organs will occasionally produce a
painting that's vigorously colored, but he'll soon revert to his natural
color range.

Yet again, if the organs are affected, in whatever way, this will
exert its effect over all bodies, interposing a vapor between them
and us that blights nature and its imitation.

An artist taking color from his palette doesn't always know what
it will produce in his painting. And to what does he compare this
color, this hue on his palette? To other isolated hues, to basic colors.
He does even more than this: he looks at it where he's prepared it
and imagines how it will look in the spot where he's thinking of
applying it. But how often is he deceived in this estimation? In
passing from the palette to the complete scene of the composition
the color is modified, weakened, or keyed up, and its effect com-
pletely changed. Then the artist gropes, reworks, torments his color.
In the course of this effort the hue becomes a composite of different
substances that interact with one another to a greater or lesser
extent, and sooner or later begin to clash.

Generally, a composition's harmony will be as solid as the
painter's brush is sure, his touch resolute and free, his reworking and
torment of his oils discreet, his manipulation of them straightforward
and fresh.

Contemporary paintings are seen to lose their harmonic balance
very quickly, while some older ones have remained fresh, harmoni-
ous, and vigorous despite the passage of time. This advantage strikes
me as owing more to technical mastery than to the quality of the
paints used.

Nothing about a painting can be more alluring than truthful
color. It speaks to the ignorant and the knowledgeable with equal
force. A half-formed connoisseur might well pass over a masterpiece
of drawing, expression, and composition without stopping; a colorist
will always attract the eye.

But what makes a colorist exceptional is the teacher he selects. Over a prolonged period the student copies paintings by this teacher and doesn't look at nature; that is to say, he becomes accustomed to seeing through the eyes of another, and his own fall into disuse. Little by little he develops habits that constrain him and from which he cannot stray or liberate himself. They're shackles he's put on his eyes, just like those the slave wears on his ankles. It's this that causes so much false colorism. He who copies Lagrenée will copy the striking and solid; he who copies Leprince will become reddish and burnished; he who copies Greuze will tend to the grey and violet; he who copies Chardin will be truthful. Thus the variety of judgments about drawing and color, even among artists. One will tell you that Poussin is dry, another that Rubens is exaggerated; as for myself, I'm the Lilliputian who gently taps them on the shoulder, pointing out that they've made an idiotic remark.

It's said the most beautiful color in the world is the attractive reddish tint with which innocence, youth, health, modesty, and decency paint a young girl's cheeks, and this is not only sly, touching, and delicate, but true; for flesh is the most difficult thing to represent. It's a luscious white, uniform without being pale or dull; it's an interaction of red and blue which is all but imperceptible; it's blood, life, the very despair of the colorist. He who's developed a feeling for flesh has taken a great step forward; the rest is as nothing in comparison. Thousands of painters have died without acquiring a feeling for flesh, and there will be thousands more who'll die without acquiring it.

The diversity of our fabrics and materials has encouraged colorists to perfect their art. There's a certain magical effect that's difficult to attain, namely that of the great harmonist. I don't know how to express my thoughts about it clearly. Take a woman dressed in white satin on a canvas. Cover the rest of the painting and look only at her clothing; perhaps this satin will strike you as dingy, dull, untruthful. But place her once more among the objects surrounding her, and the satin and its color will regain their effectiveness. This is because the overall tonal range is too weak; but each object having been adjusted accordingly, their flaws escape your detection: the work is saved by its harmony. It's like nature perceived at twilight.

The overall tonal range of colors can be weak without being false.

The overall tonal range of colors can be weak without destroying the effect of harmony. On the contrary, vigorous, keyed-up colors are difficult to reconcile with such an effect of harmony.

Whiteness and luminosity are two very different things. Everything else in two compositions being equal, the more luminous of

them will give greater pleasure. The difference is like that between night and day.

How then would I characterize the true, the great colorist? He who's captured the tones of objects as they appear well lit in nature, and is still able to create harmony in his painting.

There is such a thing as caricaturish exaggeration of color, as of drawing, and all caricature is in poor taste.

It's said there are friendly colors and enemy colors, and this is correct if it's understood to mean that some are so difficult to combine, clashing so violently with one another, that air and light, the two universal conciliators, are scarcely capable of rendering their immediate juxtaposition bearable. I have no intention of overturning the order of the rainbow for artists. The rainbow is in painting as the ground bass is in music, and I doubt there are any painters who comprehend this component of their art better than a slightly coquettish woman or a flower-girl who knows her craft. But I fear there are pusillanimous painters who use it as an excuse to demarcate the limits of their art in a way that impoverishes it, formulating a neat little technical procedure for themselves that, between us, we might call a protocol. Sure enough, such protocolizers in painting, ever deferential to the rainbow spectrum, are almost always readily identifiable. If they give a certain color to an object, you can be sure of the color they will assign to the object next to it. Once they've settled on the colors in one corner of their canvas, the rest is readily predictable. All their lives they do nothing but move this corner around. It's a portable marker that they skim over the surface and place where it suits them, but always trailing the same retinue. It's like a great lord who always wears the same clothing, accompanied by his valets, who always wear the same uniform. This is not the way Vernet and Chardin proceed; their intrepid brushes delight in the boldest combinations, the greatest variety, and the most sustained harmony, in using all nature's colors and all the nuances of these. And yet they have a technique that's clearly defined and delimited. I have no doubt about this, and I'd discover what it is if I wanted to take the trouble. For man is not God, and the artist's studio is not nature.

You might think that, in view of strengthening one's color skills, some study of birds and flowers wouldn't hurt. Wrong, my friend. Such imitation will never enhance one's feeling for flesh. Consider what Bachelier produced when he looked away from his roses, daffodils, and pinks. Ask Madame Vien to make a portrait, and then carry this portrait to La Tour. No, don't do that; the traitor doesn't sufficiently esteem any of his colleagues to tell them the truth. Instead ask someone else to execute one, too, someone who knows how to paint flesh, to render fabric, skies,

and pinks, and plums with their hazy auras, and peaches with their fuzz, and you'll see how far superior his version is. And what about Chardin, why is it his depictions of inanimate things are mistaken for nature herself? Because he paints flesh when it suits him.

But what drives a great colorist to distraction is flesh's mutability, how it can become more vivacious or moribund in the blink of an eye. This is because while the artist's gaze is focused on the canvas and he's doing his best to trap me with his brush, I move on, and when he looks up again he no longer finds me as I was. Because I think of the Abbé Le Blanc[4] and am overcome by boredom. Because the Abbé Trublet[5] comes to mind, giving me an ironic air. Because I picture Grimm or my Sophie, and my heart beats fast, tenderness and serenity becoming visible on my features; joy is released through my every pore, my heart dilates, my small sanguinary reservoirs are set vibrating and the barely perceptible color of the fluid thus activated augments the bloom and life of my flesh. Even fruits and flowers change under the attentive gaze of La Tour or Bachelier; what torment for them, then, is the human visage, this canvas that becomes excited, animated, flushed, or pale, that expands or contracts in tandem with the infinite multitude of alternatives sustained by this light, fleet expiration we call the soul?

But I was on the verge of forgetting to speak to you about the color of passion, and this despite having all but broached it. Does each passion have its own color? Does this remain unaltered through the various moments of a given passion? The color of anger has its nuances. If it inflames the face, the eyes become fiery; if intense, causing the heart to contract rather than expand, the eyes wander, a pallor spreads over the forehead and cheeks, the lips become whitish and begin to tremble. Does a woman have the same coloring when anticipating pleasure as when in its embrace or taking leave of it? Oh, my friend, what an art is painting! I capture in one line what the painter barely manages to rough in over the course of an entire week. It's his misfortune to know, see, and feel just as I do, yet be incapable of rendering things to his satisfaction; despite these feelings prompting him onwards, to misjudge his capacities and so spoil a masterpiece: he was, without his realizing it, at the very limits of art.

4 Jean-Bernard Le Blanc (1707–81), author, art critic, and dramatist. Diderot makes fun of him in *Rameau's Nephew*.
5 Nicolas Trublet (1697–1770), writer and literary critic. Diderot mocks him, too, in *Rameau's Nephew*.

THE LIFETIME SUM TOTAL OF
MY KNOWLEDGE OF CHIAROSCURO[6]

Chiaroscuro is the appropriate distribution of light and shade. A problem that's easy and straightforward when there's only one regularized object field or one light source, but one whose difficulties increase as the shapes become more varied, as the field is enlarged, as the beings in it multiply; and as there are more light sources, throwing off light in several directions. Ah, my friend, how much false light and shadow there is in a composition that's rather complex! How much license! In how many places is truth sacrificed to effect!

A lighting effect in painting is something like what you saw in the *Corésus*,[7] a mixture of shadow and light, true, strong, and pungent: a poetic moment that transfixes and astonishes you. Doubtless difficult to achieve, but perhaps less so than a graduated distribution that would illuminate the scene in a way that's diffuse and generalized, and in which the intensity of light at each point of the canvas would be determined by its actual placement, by its actual distance from the light source: an intensity which responds to the influence of surrounding objects in a hundred different ways, more or less perceptible in accordance with the dimming or brightening effect they produce.

Nothing is rarer than unity of lighting in a composition, especially among landscapists. Here sunlight, there moonlight; elsewhere a lamp, a torch, or some other burning body. A common error, and one that's difficult to discern.

There is also such a thing as caricaturish exaggeration of light and shade, and all caricature is in poor taste.

If in a given painting the accuracy of its lighting is complemented by a like accuracy of colorism, all is forgiven, at least initially. Errors of draftsmanship, weakness of expression, poverty of characterization, mistakes of organization, all is forgotten; one is enraptured, surprised, captivated, enchanted.

If we find ourselves taking the air in the Tuileries gardens, in the Bois de Boulogne, or in an isolated corner of the Champs Elysées beneath some of the few old trees that weren't sacrificed to the terrace and view from the Hôtel de Pompadour, towards the end of a beautiful day, at the moment when the sun plunges its oblique rays into the leafy mass of these trees, whose intertwining branches stop,

6 "*Clair-obscur.*"
7 *Corésus and Callirhoé* by Fragonard; see above, *Salon of 1765*, no. 176.

reflect, and break them up, fracturing them, deflecting them onto
trunks, ground, and leaves, generating around us an infinite variety
of shadows, some strong, others less strong, some deep, others less
deep, some bright, others brighter, even brilliant; then the tran-
sitions from darkness to shadow, from shadow to light, from light to
full dazzle are so sweet, so touching, so marvellous, that the view of
a branch or a leaf can transfix the eye, suspending conversation at
even the most interesting of moments. Our steps cease involuntarily,
our gaze plays over the magical canvas, and we cry out to one
another: What a picture! How beautiful! It seems we tend to
consider nature as the product of art. And reciprocally, if a painter
manages to achieve a similar enchantment on canvas, we tend to
regard this result of art as natural. It's not in the Salon, it's in the
depths of the forest, among the mountains over which the sun casts
light and shadow that Loutherbourg and Vernet are great.

The sky throws a generalized tint over objects. Atmospheric
humidity is discernible from a distance; close to us its effect is less
perceptible. Near to me, objects retain the full force and variety of
their colors, they're less affected by the shading of the sky and the
atmosphere; from a distance they seem attentuated, diminished, all
their colors blend together; and the spatial interval generating this
confusion, this monotony, makes them all seem grey or greyish,
basically a dull white that's more or less bright, depending on the fall
of the light and the effect of the sun. The effect is the same as that
produced by a many-colored globe made to spin quickly, with
sufficient speed to fuse the different color masses, reducing discrete
sensations of red, white, black, blue, and green to a single, simulta-
neous sense impression.

May those who've not studied and registered the effects of light
and shadow in the countryside, in forest depths, on rustic cottages,
on urban roofs, by both day and night, lay down their brushes, and
above all steer clear of becoming landscape painters. It's not only in
nature, it's in the trees and on the waters of Vernet, it's on the hills
of Loutherbourg that moonlight is beautiful.

Doubtless a site can be delicious. Certainly high mountains,
ancient forests, and immense ruins compel an appropriate response.
The ideas associated with them are lofty. I'd readily have Moses or
Numa[8] descend from them. A view of torrential waters noisily
coursing over precipitous rocks whitened by foam gives me a chill.
If I couldn't see it but heard its din in the distance, I'd say to myself:
Such is the outcome of the famous calamities of history. The world
still exists, and these upheavals have been reduced to pointless

8 Numa Pompilius, the legendary king of early Rome.

distant noise that serves to amuse me. Should I see a real meadow with soft, damp grass, a stream flowing through it, a bit of remote forest holding out a promise of silence, freshness, and solitude, my soul would be moved; I'd think of the one I love. Where is she, I'd cry out; why am I alone here? But it's the varied distribution of light and shadow that makes or breaks the overall charm of such a tableau. Should a mist make the sky gloomy, spreading a greyish monotone cast over the scene, all would fall mute, nothing would inspire or attract me, and I'd wend my way home.

I know a portrait by Le Sueur; you'd swear the right hand comes out of the canvas and rests on the frame. A similarly marvellous effect is widely praised in the leg and foot of Saint John the Baptist by Raphael in the Palais Royal. Such effects have been frequent in all periods, among all peoples. I've seen a Harlequin or Scaramouche by Gillot whose lantern seemed to extend half a foot in front of his body. Are there any of La Tour's heads around in which the eye doesn't seem to move freely? Are there any works by Chardin, or even Roland de La Porte, in which air doesn't seem to circulate around the glasses, fruit, and bottles? The arm of Apelles' thundering Jupiter jumped off the canvas, menacing the impious, the adulterer, moving towards his head. Perhaps only a great master would be capable of piercing the cloud enveloping Aeneas, revealing him to me as he appeared to the credulous, compliant Queen of Carthage:

<div style="text-align:center">

Circumfusa repente
Scindit se nubes, et in aethera purgat apertum.[9]

</div>

But even so, this is not the great, the difficult part of chiaroscuro. That's as follows.

Imagine, as in Cavalieri's geometry of indivisibles,[10] the canvas' depth of field subdivided, in whatever direction, by an infinite number of infinitely tiny spatial planes. The difficult problem is the proper disposition of light and shadow, within each of these planes as well as on each infinitely thin slice of the objects occupying them; these are visual echoes, the intermingled reflections of all this light. When this effect is produced (but where and how is this accomplished?) the eye is transfixed; it remains stationary. Satisfied everywhere, it is everywhere refreshed; it moves forward, it moves backward, it retraces its course. Everything is connected, everything

9 "Suddenly the clouds which had concealed him [Aeneas] parted and dispersed into thin air": Virgil, *Aeneid*, I, vv. 586–7.

10 Bonaventura Cavalieri (1598–1647) gave a new impetus to integral calculus with his principle of indivisibles, which he first advanced in 1635.

coheres. Art and artist are forgotten. It's no longer question of a canvas but of nature, of a portion of the universe.

The first step towards mastery of chiaroscuro is the study of the rules of perspective. Perspective draws parts of physical bodies together or pulls them apart by means of graduated scale, of projection of their parts through spatial planes inserted between the eye and the object, fixed to this same plane or to a plane posited behind the object.

Painters, devote some time to the study of perspective; you'll find yourself rewarded with a certain ease and confidence in the practice of your art. Think about it a moment, and you'll come to understand that the body of a prophet wrapped in voluminous drapery, and his thick beard, and his hair bristling over his forehead, and the picturesque folds that give his head a divine air are governed at every point by the same principles as a polyhedron. After a time none of them will prove more difficult for you than the others. The greater the ideal number of your planes, the more accurate and truthful will be the result; and you need have no fear of becoming cold as the result of one technical consideration more or less.

Just like the overall color scheme of a painting, its overall lighting scheme has its own tonal range. The stronger and brighter it is, the weaker its shadow, the darker and more pronounced it will be. As one moves a light source away from an object, it becomes less brilliant, its shadow feebler. Separate them still more, and you see the object's colors take on a monotone cast, and its shadow becomes so diluted, if you will, that its edges are no longer discernible. Move the light closer again, the object brightens and its shadow becomes more clearly defined. At twilight there are almost no detectable light effects, almost no discernible individual shadows. Compare a natural scene during the day, under brilliant sunlight, with the same scene under a cloudy sky. In one the light and shadow are strong; in the other all is weak and grey. But you've seen these two scenes succeed one another in the blink of an eye a hundred times, when in the midst of open country a thick cloud, propelled by winds prevailing in the upper atmosphere, though the portion surrounding you is still and calm, unexpectedly comes between the day star and the earth. Everything suddenly loses its brilliance. A dark tinge, a sad, dark, monotone veil falls rapidly over the scene. Even the birds are caught by surprise, and they stop singing. The cloud having passed, everything returns to its former brilliance, and the birds warble once more.

It's the moment of the day, the season, the climate, the site, the state of the sky, the placement of the light source that make the overall tonal scheme strong or weak, sad or savory. He who extinguishes the light source must of necessity make the air itself

tangible, and assist my eye in measuring the empty space by means of intermediary, progressively dim objects. What a man, if he's capable of dispensing with the great agent and still, without its aid, achieving a grand effect!

Avoid awkward transitional elements so blatantly, so stupidly placed that it's impossible to misunderstand their function. It's been said that in architecture the principal components should also serve as ornament; in painting the essential objects must double as transitional elements. In a composition the figures must be linked together, move forward or backward without recourse to the intervening supernumeraries that I call plugs or stopgaps. It was by other means than this that Teniers worked his magic.

My friend, shadows also have their colors. Look closely at the edges and even the mass of a shadow cast by a white object, and you'll see an infinite number of alternating black and white points. The shadow of a red object is tinted red; it's as if the light, on striking the scarlet surface, detaches molecules and carries them away with it. The shadow of a body with the flesh and blood of the skin has a slightly yellowish tint. The shadow of a blue object has a blue tone. And shadows and objects cast reflections onto one another. It's these infinite reflections from objects and shadows that generate the harmony on your desk, where work and genius have thrown down a pamphlet next to a book, a book next to an ink-horn, an ink-horn in the center of fifty objects of various kinds, shapes, and colors. Who is it that observes, who is it that knows, who is it that executes, who is it that blends all these effects together, who is it that's cognizant of the necessary result? The laws are simple enough, however, and the first dyer to whom you take a sample of subtly colored fabric will be able to throw a piece of white material into his vat and pull it out colored just as you wanted it. And the painter too observes these laws on his palette when he mixes his colors. There isn't one set of laws for colors, and another for light, and another for shadow; they're all the same.

And cursed be the painter who, in decorating a gallery, neglects these principles! Fortunate are those moments in which they're truly popular! It's the general level of enlightenment in the nation that prevents sovereigns, ministers, and artists from committing foolish acts. "O sacra reverentia plebis."[11] There isn't a single artist who's not tempted to cry out: Rabble, how much trouble I take to secure a sign of approval from you!

There's not a single one who won't tell you he knows this better than I do. By way of response, tell him from me that all his figures make him out to be a liar.

11 "Oh holy respect for the people."

There are objects that shadow makes prominent, and others that become more conspicuous in the light. The head of a brunette is seen to best advantage in shadow, that of a blonde in the light.

There's considerable skill involved in the execution of backgrounds, especially in portraits. One law that applies pretty generally is that there should never be a hue in the background which, in comparison with any hue of the main subject, is strong enough to deaden it or draw the eye away from it.

EVALUATING CHIAROSCURO

If a figure is in shadow, it is excessively or insufficiently darkened if, in comparing it with more brightly lit figures and envisioning it in their places, we don't have a strong, clear impression that it would appear as they do. Take the example of two persons climbing up from a cellar, one carrying a light and the other following him: if the latter is given the appropriate amount of light and shadow, you'll sense that if he were placed on the same step as the former the two of them would be equally bright.

A method for determining whether figures in a painting are lit as they would be in nature: duplicate the picture's ground plan, dispose objects within it in a way identical or similar to their arrangement in the painting, and compare the lighting of the objects in the model with the lighting of the objects in the painting. They should correspond, either precisely or in their general cast.

The scene set by a painter can be as expansive as he wants, but it's not permissible for him to place objects anywhere and everywhere. There are distant prospects in which, the shapes of these objects being no longer discernible, it would be absurd to place them, since objects are depicted on canvas to be seen and read as what they are. When the distance is sufficient to prevent perception of individualizing characteristics, so that, for instance, a wolf could be mistaken for a dog or a dog for a wolf, nothing should be placed there. Here perhaps is a case in which the artist should not stick to nature.

Every conceivable possibility should not be accommodated in fine painting any more than in fine literature; there's a multitude of events whose possibility cannot be precluded, but whose conjuncture strikes one as impossible in the past and unlikely to occur in the future. The possibilities to be considered for use are those possibilities that seem credible, and credible possibilities are those for which it appears likely that they'd move from possibility to actuality

within the time frame of the action in question. Example. A woman could very well be unexpectedly overcome by labor pains in the middle of the countryside, she could very well find a manger there, it's possible for this manger to be leaning against the ruins of an ancient monument; but the possible conjunction of this ancient monument with a manger is to the corresponding reality as the totality of the space within which there are mangers is to the portion of that space that's occupied by ancient monuments. Such a conjunction is quite unlikely and thus should not be given serious consideration; such circumstances are an absurdity, or would be if not indicated by history, along with the other circumstances of the action. It's very different with shepherds, dogs, cottages, flocks, travellers, trees, streams, mountains, and all the other objects spread over the countryside and constituting it. Why is it permissible to put them in a given painting, in the pictorial field? Because they're found in the natural scene one's set out to depict more often than they're not found there. The conjunction or encounter with an ancient monument is as ridiculous as an emperor passing by at the precise moment of the action. Such a passage would be possible, but too improbable for use. That of an ordinary traveller is possible, too, and so likely that its use would be completely natural. But resort to an emperor's retinue or a column must be justified by history.

There are two kinds of paintings. The one, accommodating placement of the eye as close to the surface as possible without depriving it of its ability to see distinctly, renders objects in all the detail visible at this distance, and renders these details as scrupulously as the principal shapes, such that the further the spectator moves away from the painting, the more these details elude him, until finally, at a certain distance, everything disappears; such that in approaching from this distance at which everything is confused, the forms become more and more legible, the details progressively clearer, until the eye, once more in its initial, nearby location, sees the subtlest and most minute variations in the objects on the canvas. This is beautiful painting, this is truthful imitation of nature. My relation to such a picture is like my relation to the nature that was the painter's model. I see it better as my eye moves closer; I see it less well as my eye moves away.

But there's another kind of painting that's no less rooted in nature but that imitates it perfectly only from a certain distance, that's imitative, so to speak, only from a certain point: the kind in which the painter renders vividly and vigorously only those details of the object visible to him from the vantage point he's chosen; from further away one sees nothing, and from closer up it's even worse. His painting isn't a painting; viewed from between his canvas and this point of vantage, one can't say what it is. But this genre of

painting is not to be dismissed completely; it's the one in which the celebrated Rembrandt worked, and its association with his name is high praise.

From which it follows that the law of universal finish has certain limitations. This should be rigorously observed in the first kind of painting discussed above but is not so crucial in the second kind: there the painter can pass over everything in the objects visible only from points closer to the painting than his chosen vantage point.

Take as example a sublime idea of Rembrandt's: Rembrandt painted a *Resurrection of Lazarus*; his Christ has a disconsolate air, he's on his knees at the edge of the grave, he prays, and two arms are seen rising from the bottom of the sepulchre.[12]

An example of another kind. Nothing could be more ridiculous than a man painted leaving his tailor's shop wearing a new outfit, even if this tailor were the finest of his period. The more precisely the outfit conforms to his limbs, the more this figure will resemble a wooden mannequin. Not only is the painter thus deprived of the variety of form and light generated by the folds and rumples of old clothing; there's another factor that influences us without our realizing it, namely the fact that an outfit is only new for a few days but remains old for a considerable time, and things should be captured in their most lasting condition. Furthermore, an old outfit bears the marks of an infinite number of interesting little accidents such as powder stains, missing buttons, etc. resulting from its use; all these accidents stimulate ideas and tend to connect different parts of the attire; powder serves to link the wig with the outfit.

A young man was asked by his family how he'd like to see his father's portrait painted; he was a cutler. Dress him, he said, in his work clothes, his smith's cap, his apron; show him to me in his shop holding a lancet or some other tool he's testing or sharpening, and above all, don't forget to perch his glasses on his nose. This plan was not followed. He was sent a handsome portrait of his father, full length, in a fine wig, a fine suit, and fine stockings, holding a fine snuffbox in his hand. The young man, possessed of taste and probity, said to his family by way of thanking them: What you've done, both you and the painter, is worthless. I asked you for my everyday father, and you've sent me my Sunday-best father . . .

It's for the same reason that Monsieur La Tour, otherwise so truthful, so sublime, made his portrait of Rousseau a conventionally

12 None of the treatments of this subject now attributed to Rembrandt include the most striking feature in Diderot's description, the lifted arms. Diderot may well have had in mind a painting by Jan Lievens (1607–74), now in the Brighton Art Gallery and Museum. If so, his visual memory here played a trick on him: the Christ in this work is standing, not kneeling.

pretty thing instead of the masterpiece he could have produced. I search there for the literary censor, the Cato and Brutus of our age, I expect to see an Epictetus, his clothing rumpled, his wig tousled, with a severity frightening to writers, fashionable people, and the powerful, and I see only the author of the *Village Fortune-Teller*,[13] well dressed, well groomed, well powdered, ridiculously seated on a cane-back chair; and it must be conceded that Marmontel's lines characterize Rousseau very well, the Rousseau one ought to find but seeks in vain in Monsieur La Tour's painting.

A painting of the *Death of Socrates* was shown at the Salon that's as ridiculous a composition of its kind as can be imagined: it depicts the poorest, the most austere of Greek philosophers dying in an elaborately appointed ceremonial bed. The painter didn't realize how virtue and innocence breathing their last in the depths of a dungeon on a bed of straw, on a pallet, would have made for a moving, sublime image.

WHAT EVERYONE KNOWS ABOUT EXPRESSION, AND SOMETHING EVERYONE DOESN'T KNOW

Sunt lacrimae rerum et mentem mortalia tangunt.[14]

Generally speaking, expression is the image of feeling.

The actor who's not conversant with painting is a bad actor; the painter who's not a physiognomist is a bad painter.

Every part of the world has its countries; every country its provinces; every province its villages; every village its families; every family its individual members; and in every individual, each moment has its physiognomy, its expression.

A man experiences anger, he's attentive, he's curious, he loves, he hates, he's condescending, he's disdainful, he's admiring; and each of these shifts in his soul paints itself on his face in terms that are clear, self-evident, about which we're never mistaken.

On his face? What am I saying? On his mouth, on his cheeks, in his eyes, in every part of his face. The eyes light up, fade, languish, wander, stare fixedly; and the imagination of a great painter is an immense repository of all these expressions. Each of us has his own

13 *Le Devin du Village*, an opera by J.-J. Rousseau (he wrote both words and music), produced to great acclaim in 1752.

14 "Tears are shed for misfortunes and mortal sorrows touch the heart": Virgil, *Aeneid*, I, v. 462.

small store of them, and it serves as the basis for our judgments of
beauty or ugliness. Note this well, my friend, consider your response
to the countenance of a man or a woman, and you'll acknowledge
that it's always the image of a positive quality or the trace, more or
less marked, of a negative one that attracts or repels you.

Imagine that the *Antinous* is in front of you (Pl. 21). His features
are beautiful and canonical. His ample, rounded cheeks bespeak
health. We love health, it's the cornerstone of happiness. He's
serene; we love serenity. He seems thoughtful and wise; we love
thoughtfulness and wisdom. I'll pass over the rest of the figure,
directing my attention solely to the head.

Leave all the features of this beautiful face as they are, but give an
upward curl to one of the corners of the mouth; the expression
becomes ironic and the face less pleasing. Put the mouth back as it
was and arch the eyebrows; the personality turns arrogant and less
pleasing. Lift both corners of the mouth simultaneously and open
wide the eyes; you'll have a cynical physiognomy, and you'll fear for
your daughter if you're a father. Allow the corners of the mouth to
relax, lower the eyelids so that they cover half the iris, dividing the
sockets in half, and you'll have a deceitful, secretive, dissembling
man that you'd avoid.

Each of life's stages has its tastes. Sharply outlined vermilion lips,
an open, smiling mouth, beautiful white teeth, a relaxed gait, a
confident gaze, beautiful ample cheeks, a turned-up nose prompted
me to hot pursuit at eighteen. Today, when vice is no longer good
for me and I'm no longer any good at vice, it's the young girl with
an air of modesty and decency, a restrained gait, a hesitant gaze,
walking in silence beside her mother, that attracts my attention and
charms me.

Who has good taste? Myself at eighteen? Myself at fifty? An
answer is easy to come by. If someone had said to me at eighteen:
My child, which is more beautiful, the image of vice or the image
of virtue? An easy question, I'd have answered: It's the latter. To
extract the truth from a man, one must trick passion at every
moment through use of general, abstract terminology. At eighteen,
it wasn't the image of beauty but rather the physiognomy of
pleasure that stirred me to the chase.

An expression is weak or false if it allows for doubt as to the
feeling behind it.

Whatever a man's character, if his habitual physiognomy
conforms to your idea of a virtue you'll be drawn to him; if his
habitual physiognomy conforms to your idea of a vice you'll tend to
keep your distance.

Sometimes we set a physiognomy for ourselves. A face that's
grown accustomed to the expression of a prevailing feeling will
retain it. Sometimes we receive it from nature and have no choice

but to keep it as given. She decided to make us good but grant us wicked faces, or to make us wicked but grant us faces bespeaking goodness.

In the heart of the Saint Marcel quarter, where I lived for a long time, I saw many children with charming faces. By the age of twelve or thirteen their eyes full of sweetness had turned calculating and intense, their pleasing little mouths had become oddly contorted, their rounded necks swollen with muscles, their ample cheeks marred by coarse bumps. They'd taken on the physiognomy of the market and the exchange. Driven to anger, insult, combat, cries, and humiliation in their pursuit of money, they'd acquired an air of sordid calculation, impudence, and wrath that would remain with them for the rest of their lives.

If a man's soul or nature has stamped his face with an expression of benevolence, justice, and liberty, you'll sense this because you carry images of these virtues within yourself, and you'll graciously receive anyone displaying them to you. Such a face is a letter of recommendation written in a language known to all men.

Each mode of living has its own character and expression.

The savage has features that are solid, vigorous, and pronounced, shaggy hair, a full beard, the most fully developed limbs: how could it have been otherwise? He's hunted, run, fought against wild beasts, exerted himself; he's managed to survive, and has engendered his like: the only two natural endeavors. There's nothing about him that's touched with impudence or shame. Rather an air of pride mixed with ferocity. His head is erect, held high. His gaze is penetrating. He's the master of his forest. The longer I consider him, the more he reminds me of the solitude and freedom of his domain. When he speaks, his gestures are imperious, his remarks energetic and brief. He is without law and without prejudice. His soul is quick to anger. He is in a state of perpetual war. He is flexible, he is agile; but he is strong.

His companion's features, like her glance and carriage, are not those of a civilized woman. She's unselfconsciously naked. She has followed her husband over the fields, through the mountains, into the depths of the forest. She's shared in his exertions. She's carried her child in her arms. Her breasts have gone without support. Her long hair is thin. She's well proportioned. Her husband's voice thundered; hers is strong. Her gaze is less penetrating. She's more easily frightened. She's agile.

In society each individual citizen has his own character and expression: the craftsman, the noble, the commoner, the man of letters, the priest, the magistrate, the soldier.

There are physical routines, physiognomic traits associated with shops and workshops that are specific to craftsmen.

Each society has a government, and each government has a dominant quality, real or supposed, that is its soul, its buttress, and its motor.

The republic is a state based on equality. Each subject thinks of himself as a little monarch. The bearing of a republican should be erect, resolute, and proud.

In a monarchy, in which orders are given and obeyed, the prevailing characteristics should be grace, sweetness, honor, and gallantry.

In a despotic state, the prevailing form of beauty will be that associated with slavery. Here show me docile, submissive, timid, circumspect, suppliant, and modest faces. Slaves walk with their heads bowed; it's as though they're always prepared for a sword to strike them off.

And what is sympathy? I understand it to be that rapid, sudden, automatic impulse that draws two beings together at first sight, from the begining, from the first encounter. For sympathy, even in this sense, is not a chimera. It's the immediate, reciprocal attraction exercised by some virtue. Beauty gives way to admiration; admiration to esteem, desire, and love.

So much for character and its various physiognomies; but there's more. To this knowledge must be added extensive experience of scenes of real life. I'll explain what I mean. The goodness and misery of humanity must be studied in all its manifestations; battles, famines, plagues, floods, storms, and tempests; animate nature, inanimate nature, and nature convulsed. One must peruse the historians, devour the poets, and linger over their images. When the poet writes "vera incessu patuit dea,"[15] one should try to understand this conceit by looking within oneself. When he writes "summa placidum caput extulit unda,"[16] one must give form to this head. Sense what would be appropriate and what not; become familiar with with passions both strong and tender, and depict them without resorting to the grimace. *Laocoön* suffers without grimacing. His cruel pain manifests itself from the tips of his toes to the top of his head. It makes a profound effect without inspiring horror. Make sure I can neither fix my gaze nor pull it away from your canvas. Don't confuse smirks, grimaces, twisted mouths, pursed lips and a thousand other puerile affectations with grace or, much less, with expression.

Before all else give your head a beautiful character. The passions reveal themselves more easily on a beautiful face. When they're

15 "Her very gait revealed her to be a goddess": Virgil, *Aeneid*, I, v. 405.
16 "He lifted his serene head above the waves": Virgil, *Aeneid*, I, v. 127.

intense, this only makes them seem the more terrifying. The
Eumenides of the ancients are beautiful, and this only makes them
seem more frightening. It's when we feel attracted and violently
repulsed at the same time that we feel most uncomfortable, and such
would be the impact of a Fury who'd been made imposingly
beautiful.

In men the facial oval is elongated, wide at the top, narrowing
towards the bottom, evincing nobility.

In women and children the facial oval is rounded, evincing youth
and manifesting grace.

Displacing a facial feature even by as much as a hair can make the
difference between beauty and disfigurement.

Acquaint yourself, then, with the nature of grace, or the rigorous
and precise conformity of the limbs with the nature of the action.
Above all, don't mistake it for that of the actor or dancing master.
The grace of an action and that of Marcel are exact opposites. If
Marcel were to encounter a man posed like the *Antinous*, he'd place
one hand under his chin and the other on his shoulder and say to
him, "Come come, you big booby, is that any way to carry
yourself?" Then, pushing his knees back like his own and lifting
him by the arm, he'd add, "Come along, you ninny, brace those
knees, show off that figure; hold your nose up a bit." And after
having turned him into the most insipid of fops, he'd begin to smile
and congratulate himself on his work.

Should you lose all feeling for the difference between a man
presenting himself in company and a man acting from motivation,
between a man who's alone and a man being observed, throw your
brushes into the fire. Your figures will be academicized, denatured,
forced.

Would you like to get a sense of this difference, my friend?
You're alone at home. You're waiting for my copy, which doesn't
arrive. You're reflecting on the determination of sovereigns to have
whatever they want. You're sprawling in your cane chair, your arms
resting on your knees, your nightcap falling over your eyes, where
your sparse, dishevelled hair resembles crooked combs; your dressing
gown is half open, falling in long folds on either side: you're utterly
picturesque and beautiful. The Marquis de Castries is announced;
suddenly the cap is pulled up and the dressing gown drawn closed;
my man straightens up, composes his limbs; he becomes mannered,
"Marcelized," making himself presentable for the arriving visitor,
but quite dull for the artist. Earlier you were just what he needed,
but no longer.

When one considers certain figures, certain facial characterizations
in Raphael, the Carracci, and others, one wonders where they came
from. They derive from a strong imagination, from writers, clouds,

fires, ruins, from the nation in which they gathered the primary features subsequently transformed by their poetry.

These extraordinary men had sensitivity, originality, temperament. They read, the poets above all. A poet is a man with a strong imagination who is moved, even frightened, by the phantoms he himself has made.

I can't resist. It's absolutely necessary, my friend, for me to talk to you here about the action and reaction of the poet to the sculptor or painter, of the sculptor to the poet, and of both to the animate and inanimate objects in nature. I'll imagine myself two thousand years younger, in order to describe for you how in ancient times these artists influenced one another and how they influenced nature herself, stamping her with a divine imprint. Homer said that Jupiter made Olympus shake simply by moving his eyebrows. This is the statement of a theologian, and any marble sculpture on view in a temple was expected to display such a head to the prostrate faithful. The sculptor's brain heated up, and he didn't seize the clay and modelling chisel until after he'd conceived the orthodox image. The poet had hallowed Thetis' beautiful feet, and these feet were articles of faith; likewise Venus' ravishing throat, also an article of faith, along with Apollo's charming shoulders and Ganymede's plump buttocks. The people expected to encounter these gods and goddesses, characterized by their catechismal charms, on their altars. The theologian or poet had brought them to attention and the sculptor was obliged to incorporate them. A Neptune lacking the chest, a Hercules lacking the back described in the pagan Bible would have evoked mockery, and the heretical block of marble would have remained in the studio.

What followed from this (for, after all, the poet had revealed nothing, induced belief in nothing, while the painter and sculptor had only represented qualities borrowed from nature)? On leaving the temple, the people recognized these same qualities in some individuals, and they were strongly affected by this. Womankind endowed Thetis with her feet, Venus with her throat; the goddesses rendered them in turn, but after having sanctified them, rendered them divine. Mankind endowed Apollo with his shoulders, Neptune with his chest, Mars with his sinewy flanks, Jupiter with his sublime head, Ganymede with his buttocks; but Apollo, Neptune, Mars, Jupiter, and Ganymede returned them sanctified, rendered divine.

When some enduring circumstance, or sometimes even a momentary one, had associated certain ideas in people's heads, they can no longer be separated; and if it happened that a libertine recognized his mistress on the altar of Venus, because it was indeed her, if devout he wouldn't be so discouraged from revering the

shoulders of his god in a mortal back. Thus I can't help but think
that when the assembled people took pleasure in contemplating
nude men in the baths, the gymnasia, and the public games, without
realizing it their admiration for this beauty was colored by a blend
of the sacred and the profane, by a bizarre mixture of debauchery
and devotion. A voluptuary holding his mistress in his arms some-
times calls her his queen, his sovereign, his goddess; such remarks,
while mawkish when falling from our own lips, signified quite
differently on theirs. For they were literally true; he was indeed in
the heavens, among the gods; he was really taking his pleasure with
the object of his adoration and that of the nation.

And why should things have transpired any differently in the
mind of a people than in the heads of its poets or theologians? The
works they left behind, the descriptions of the objects of their
passion handed down to us are full of comparisons, of allusions to
the objects of their worship. It's the smile of the Graces, the youth
of Hebe, the fingers of Aurora; it's the throat, arms, and shoulders,
the thighs and eyes of Venus. Go to Delphi and you'll see my
Batylus. Take this girl as model and carry your painting to Paphos.
They only forgot to tell us more often where to go to see this
god or goddess whose original they'd caressed; but the peoples that
read their poetry were not unaware of this. Without these living
simulacra, their gallantry would have been insipid, frigid. I vouch-
safe this to you, my friend, and to you, Suard the refined and
delicate;[17] and to you, Arnaud the ardent and impetuous;[18] and
to you, the original, knowledgeable, profound, and entertaining
Galiani.[19] Tell me, don't you think this is the origin of all those
paeans of mortal men using attributes borrowed from the gods, and
of all those epithets so consistently attached to heroes and gods?
These were so many articles of faith, so many elements of pagan
symbolism consecrated by poetry, painting, and sculpture. When we
see these epithets endlessly reiterated, if they tire and bore us this is
because no statues, temples, or models exist any longer with which
we can associate them. By contrast, each time a pagan encountered
them in a poet he imagined himself in a temple, envisioning the
painting or recalling the statue that had made them familiar.

Wait, my friend, though the following remarks might seem to
resemble ideas that until now have diverted you only as a pleasant

17 Jean-Baptiste Antoine Suard (1732–1817). French writer and journalist.
18 François Arnaud, Abbé (1721–84). French writer; friend of Fontenelle, Mme
 Geoffrin, and Suard.
19 Ferdinando Galiani, Abbé (1728–87). Italian diplomat, economist, and writer
 perhaps best known for his *Dialogues sur le commerce des blés* (1770), which greatly
 influenced Diderot.

dream, as a clever proposition. If our religion wasn't sad, flat meta-
physics; if our painters and sculptors were men comparable to
ancient painters and sculptors (and I refer only to the good ones, for
they probably had bad ones, even more than we do, just as Italy is
the place where the worst music is made along with the best); if our
priests weren't stupid bigots; if this abominable Christianity hadn't
established itself through murder and bloodshed; if the joy of our
paradise wasn't reducible to an impertinent beatific vision of I don't
know what that's both incomprehensible and unfathomable; if our
hell had something to offer besides pits of fire, hideous Gothic
demons, screams, and gritted teeth; if our paintings could picture
something besides scenes of atrocity, of flayings, hangings, roastings,
and grillings, a disgusting carnage; if all our saints weren't clothed to
the tips of their noses; if our ideas of modesty and decency hadn't
precluded exposure of arms, thighs, breasts, shoulders, of the nude
body; if the spirit of mortification hadn't withered these breasts,
softened these thighs, emaciated these arms, lacerated these shoul-
ders; if our artists weren't chained and our poets constrained by the
frightening words sacrilege and blasphemy; if the Virgin Mary had
been the mother of pleasure; or even the Mother of God, if it had
been her beautiful eyes, her beautiful breasts, her beautiful buttocks
that attracted the Holy Spirit to her, and if this had been recorded
in the book narrating her life; if the angel Gabriel had been praised
there for his beautiful shoulders; if the Magdalen had had an erotic
adventure with Christ; if, at the wedding at Cana, a slightly unor-
thodox Christ, a bit drunk, had caressed the throat of one of the
female guests as well as Saint John's buttocks, unsure whether or not
to remain faithful to the apostle of the down-dusted chin: then
you'd see what our painters, poets, and sculptors could do; with
what vigor we'd speak of the charms that would play such an
important, marvellous role in the history of our religion and our
God, and with what attention we'd observe the beauty to which we
owed our birth, the Savior's incarnation, and the grace leading to
our redemption.

We still use expressions such as divine charms, divine beauty; but
without some residue of paganism such as familiarity with the
ancient poets can instill in our own poetic brains they are lifeless and
meaningless. With us, a hundred women with different character-
istics can occasion the same praise; but such was not the case with
the Greeks. There existed, in marble or on canvas, a given model;
and he who, blinded by passion, ventured to compare some com-
monplace figure with the Venuses of Cnidos or Paphos was as
ridiculous as one of us daring to compare the little upturned nose of
some middle-class girl with the Comtesse de Brionne: one would
shrug one's shoulders and laugh in his face.

But in fact, painting and sculpture have provided us with a few traditional types and figures. No one misidentifies Christ, or Saint Peter, or the Virgin, or most of the apostles; and do you think that when one of the faithful recognizes similar heads in the street he doesn't experience a feeling of respect? Wouldn't it be surprising if such figures ever presented themselves to view without awakening a series of sweet, voluptuous, agreeable ideas that set the feelings and passions in motion?

Thanks to Raphael, Reni, Barocci, Titian, and a few other Italian painters, when a woman possesses the qualities of nobility, grandeur, innocence, and simplicity with which they endowed their Virgins, she makes a certain impression on our souls. The feeling we experience is tinged with admiration, tenderness, and respect, even if this respect doesn't long survive our realization that this particular Virgin is professionally dedicated to the public cult of Venus whose rituals are observed every night in the vicinity of the Palais Royal. It's as though we were being propositioned to sleep with the Mother of our God. It must also be admitted that these beautiful and imposing but listless types don't hold out much promise in the way of pleasure, and that having them in painted form above one's headboard is preferable to having their flesh and blood in one's bed.

So many more things, subtler still, could be said about expression! Did you know that sometimes it determines color? Aren't some hues more appropriate to certain professions, to certain passions than others? Pale, wan coloration is not well suited to poets, musicians, sculptors, and painters. These men are usually bilious; if you must use it, blend a yellowish tint into the paleness. Black hair adds brilliance to whites, and vivacity to the eyes. Blond hair is more appropriate for languor, laziness, heedlessness, skin that's thin and transparent, eyes that are moist, sensitive, and blue.

Expression is marvellously strengthened by these accessories that increase harmony. If you paint me a cottage and place a tree at the entrance, I want this tree to be old, broken, cracked, decayed; I want there to be a parallel between the accidents, misfortunes, and misery it's endured and those of the unfortunate resident to whom it lends its shade on holidays.

Such correspondences are not unknown to painters, but if they had a clearer understanding of how they functioned their work would soon benefit. I refer primarily to those with strong instincts, like Greuze; but the others, too, would no longer use those incongruities that inspire pity when they don't incite laughter.

Let me describe for you, by means of one or two examples, the secret, subtle thread that leads through the maze of accessory choice. Almost all painters of ruins depicting solitary buildings, palaces, towns, obelisks, or other toppled structures will show the wind

blowing wildly; a traveller with his baggage on his back, passing by; a woman bent down by the weight of her child dressed in rags, also passing by; men on horseback conversing, their noses under their coats, also passing by. What suggested these accessories? An affinity of ideas. Everything passes away, man himself as well as man's abodes. Change the king of building that's ruined. Imagine, instead of a ruined city, some great tomb. You'll see the affinity of ideas operating on the artist again, but suggesting accessories very different from the first set. The exhausted traveller will have laid down his burden at his feet, and he and his dog will be seated on the tomb's stairs, relaxing. The woman, resting and seated, will be nursing her child. The riders will have dismounted and, leaving their animals free to graze, will be reclining on the ground, continuing their conversation, amusing themselves by reading the inscription on the tomb. This is because ruins are places of danger, while tombs offer a kind of refuge. Because life is a voyage, and the tomb its final resting place. Because man lingers where human remains have been placed. It would make no sense to have the traveller pass by the tomb, only to stop among the ruins. If the tomb has any moving beings around it, these will be either birds soaring far above, or others passing by at full speed, or laboring birds singing in the distance, whose work obscures life's end-point. Here I'm speaking only of ruin painters. History painters and landscapists vary, contrast, and diversify their accessories as their ideas vary, cohere, and intensify, oppose and clash with one another in their understanding.

Occasionally, I've asked myself why it is that the open, isolated temples of the ancients seem so beautiful, so imposing. Because they're decorated on all four sides, but without compromising simplicity. Because they're accessible from any direction: the very image of security. Even kings close their palaces with doors; their majestic character is insufficient protection against human wickedness. Because they're sited in remote spots, and the horror of a surrounding forest, joined with the melancholy of superstitious ideas, stirs up a peculiar sensation within the soul. Because divinity doesn't make itself known in the tumult of the city, preferring silence and solitude. Because in such surroundings the veneration of mankind can be offered up more discreetly, more freely. Because there were no days set aside for assemblies (or if there were, the crowd and the uproar on these festival days diminished their majesty, for they banished silence and solitude).

If I'd been placed in charge of building the Place Louis XV[20] where it stands, I'd have made every effort to avoid cutting down

20 The present Place de la Concorde in Paris.

the adjacent forest. I'd have tried to make sure its dark depths would be visible between the columns of a grand peristyle. Our architects lack genius. They haven't the faintest notion that accessory ideas can be stimulated by geographical location and neighboring elements. In this they resemble our dramatic poets, who've never grasped how to exploit the setting of a scene.

This would be a good moment to broach the matter of selection from natural beauty. But it's sufficient to know that all bodies and all parts of a body are not equally beautiful: so much for form. That all faces are not equally suitable for depictions of any given passion; some pouts are charming, and some laughs disagreeable: so much for character. That all individuals don't manifest their age and social condition to the same extent, and that confusion can be avoided by establishing the strongest correspondence between the natural traits selected and the subject being treated.

But what I touch upon here in passing will perhaps be discussed a bit more thoroughly in the chapter on composition which follows. Who knows where the sequence of ideas will lead me? My goodness, I certainly don't.

SECTION ON COMPOSITION
IN WHICH I HOPE I'LL TALK ABOUT IT

We're only possessed of so much sagacity. We're only capable of so much attention. In making a poem, a painting, a comedy, a history, a novel, a tragedy, a work for the people, one shouldn't imitate the authors of educational treatises. Of two thousand children, there are barely two who could be raised according to their principles. If they'd given the matter any thought, they'd have realized that the exceptionally brilliant are not the best models for universal institutions. A composition intended for display to the eyes of a motley crowd of spectators will be defective if a man can't figure it out through plain good sense.

It should be simple and clear. Consequently, no pointless figures, no superfluous accessories. Treat the subject all of a piece. In a single painting Poussin showed Jupiter seducing Calisto in the foreground and the seduced nymph dragged by Juno in the background. This is a fault unworthy of so accomplished an artist.

The painter has but one instant at his disposal, and it's no more permissible for him to encompass two instants than two actions. There are only a few circumstances in which it's not contrary to

truth or interest to evoke a moment that's already in the past or is yet to come. A sudden catastrophe surprises a man in the midst of his duties; he's within the catastrophe but doesn't yet abandon his tasks.

A singer having difficulty executing a bravura aria, a violinist struggling and straining over his instrument vexes and annoys me. I require ease and freedom of a singer; I want an orchestral musician to move his fingers over the strings with such facility, such lightness of touch, that I've no idea of the difficulties he's negotiating. I expect a pleasure that's pure and painless; and I turn my back on any painter who proposes an emblem, a hieroglyph, for me to decipher.

If the scene is unified, clear, simple, and coherent, I can absorb it in the blink of an eye; but this is not sufficient. It must also be various; and it will be, if the artist is a rigorous observer of nature.

One man reads, not disinterestedly, to another. Without either of them thinking about it, the reader will proceed in the manner that's most comfortable for him; likewise the listener. If it's Robbé[21] who's reading, he'll have the air of a fanatic, he won't look at his text, his eyes will wander erratically. If I'm listening to him, I'll have a serious air. My right hand will seek out my chin and hold up my nodding head; and my left hand will seek out my right elbow to sustain the weight of my head and arm. This is not the way I'd listen to a reading by Voltaire.

Introduce a third person into the scene, and he'll conform to this law just like the first two; and we'll have a system contrived of three individual interests. If a hundred, two hundred, a thousand people arrive, the same law will be observed. Without doubt there will be moments of noise, of movement, of confusion, of undulations, of ebb and flow; these are the moments in which each person thinks only of himself and seeks to throw over the general republic. But the absurdity of such pretension and the uselessness of any such attempt will make itself felt very quickly. Bit by bit, everyone will decide to concede something of his personal interest, and the mass will begin to cohere.

Look at this mass in the moment of tumult; the energy of each individual is at peak intensity; and as no two of them have the same amount, it's like the leaves of a tree, no two of which are the same shade of green, just as no two of these individuals have the same action and posture.

Then look at the mass in a moment of calm, in which each person has sacrificed the minimum amount necessary to safe-guard his interests; and since the same diversity is in force in these

21 Robbé de Beauveset, Pierre-Honoré (1712–92). Satirical and pornographic poet, known for his enthralling readings. Diderot also mentions him in *Rameau's Nephew.*

concessions, there's the same diversity of action and posture. And the moment of tumult and the moment of calm share one thing, namely that everyone is revealed for what he is.

If an artist observes this law of energy and interest his composition will be truthful throughout, no matter how large his canvas. The only kind of contrast that taste can endorse, one resulting from a variety of energies and interests, will be present, and no other kind is necessary.

The contrasts encouraged by study, by the Academy, by the school, by technical facility are false. These are no longer actions unfolding in nature, they're actions that are carefully prepared and considered, acted out on the canvas. The painting is no longer a street, a public square, a temple; it's a theatre.

No one has ever produced a painting of a theatrical scene that's tolerable, and no one ever will; the results make a cruel mockery of our actors, our set designs, and perhaps even our poets.

Something else that's no less shocking: the minor customs of civilized people. The rituals of courtesy, so attractive, pleasant, and admirable in the world, are disagreeable in the arts of imitation. It's only on firescreens that women can bend their knees and men gesture gracefully with their arms, tip their hats, and step delicately backwards. I know very well that Watteau's paintings will be cited as counter-examples, but I scoff at them and will persist in doing so. Strip Watteau of his sites, his color, the grace of his figures, that of their clothing; then look at the scene depicted, and judge for yourself. The arts of imitation require something that's savage, crude, striking, enormous. I'm willing to allow a Persian to place his hand against his forehead and bow; but note the character of this bowing man; note his deference, his adoration; note the grandeur of his drapery and his movement. Who is it that deserves such profound homage? His God? His father?

To the platitude of our curtsies and bows add that of our clothing; our ruffled sleeves, our tightly fitting breeches, our squared, pleated coat-tails, our garters, our monogrammed buckles, our pointed shoes. I defy painters and sculptors of even the greatest genius to turn this paltry system to advantage. What a thing would be a marble or bronze version of a Frenchman in his buttoned jerkin, his sword, and his hat!

Let's return to organization, to the arrangement of the figures. A little can, and should, be sacrificed to such technical considerations. How much? I have no idea. But I know I don't want it to compromise expression or the impact of the subject. First touch me, astonish me, tear me to pieces, make me shudder, weep, and tremble, make me angry; then soothe my eyes, if you can.

Every action is composed of several moments; but, to repeat what I've said before, the artist has only one that lasts no longer than the blink of an eye. However, just as, on a pained face over which joy is beginning to dawn, I find present feeling blended with the residue of past feeling, so, within the moment selected by the painter, postures, expressions, actions, and traces can persist from the preceding moment. A group of associated individuals doesn't register change in a single instant. This is well known to those familiar with nature, those with a feeling for truth: but they also understand that these wavering figures in transition only augment the principal effect to a certain extent, taking away in interest what they add in the way of variety. What sustains my attention? The crush of a crowd. I can't resist the attraction exercised by so many people. Despite myself, my eyes, arms, and soul reach out to their eyes, their arms, their souls. So I'd prefer, if this were possible, to push back the moment of the action, to focus its energy and get rid of the sluggish. For I can well do without those with sluggish responses, unless they produce a sublime effect by contrast, a rare occurrence. Even when such contrast leads to a sublime effect, they transform the scene: their slow reaction becomes its main subject.

Unless in an apotheosis or some other subject of pure phantasy, I can't bear the mixture of allegorical and real beings. I can see all Rubens' admirers beginning to get upset; but I don't care, so long as good taste and truth look favorably on me.

The mixture of allegorical and real beings makes history seem like a fairy tale, and, to make myself clear, this flaw disfigures most of Rubens' compositions for me. I can't make any sense of them. What is this figure holding a bird's nest, this Mercury, this rainbow, this zodiac, this Sagittarius doing in a bedroom, around the bed of a woman in labor?[22] Texts should be made to emerge from the mouths of each of these figures, stating their purpose, as in the old tapestries in our châteaux.

I've already told you what I think about the monument in Reims executed by Pigalle, and my argument brings me back to it. What is the meaning of this woman pulling a lion by its mane beside a dock-hand stretched out on a few sacks? The woman and the animal are heading towards the sleeping dock-hand, and I'm sure an infant would cry out: Mama, this woman is going to make her wild animal eat the poor sleeping man. I don't know if such is her intention; but that's what will happen if the man doesn't wake up, and if the woman advances another step. Pigalle, my friend, take up

22 The reference is to Rubens' *Birth of Louis XIII* in his Marie de Medici cycle, now
 in the Louvre; see Pl. 50.

your hammer and smash this bizarre combination of beings. You want to depict a king that's a protector of agriculture, commerce, and the population. Your dock-hand sleeping on his sacks is clearly Commerce. Put a felled bull on the other side of your pedestal with a vigorous inhabitant of the fields leaning on the animal's head, between his horns, and you'll have your Agriculture. Put a stout peasant woman nursing a child between them, and I'll recognize Population. Isn't a felled bull a beautiful thing? Isn't a nude peasant at rest a beautiful thing? Isn't a peasant woman with large features and large breasts a beautiful thing? Wouldn't this composition offer a wide variety of natures for your chisel? Wouldn't it move me, interest me more than your symbolic figures? You'd have shown me a monarch who protects the less fortunate, which is as it should be; for they constitute his flock, and the nation.

One must think long and hard about one's subject. It really is a question of fitting out one's canvas with figures. These figures must seem to belong where they are, as in nature. They must all contribute to a common effect, with strength, simplicity, and clarity. Otherwise I'd say, like Fontenelle to the sonata: "Figure, what do you want from me?"[23]

Painting has something in common with poetry, though this is not widely acknowledged: both should be "bene moratae," morally grounded. Boucher is completely unaware of this, he's always morally defective and never endearing. Greuze is always honest,[24] and crowds gather in front of his paintings. I'd go so far as to say to Boucher: If it's your intention always to pitch your work for smutty eighteen-year-olds, you're right, my friend, keep on making buttocks and breasts; but as far as upright folk including myself are concerned, it won't do you much good to show your work in the bright light of the Salon, we'll forsake you to seek out, even in a dark corner, the charming Russian and the young, upright, decent, innocent godmother at his side by Leprince. Make no mistake, this last figure does more to inspire me to sinful activity in the morning than all your unchaste creatures. I don't know where you find them; but lingering over them too long isn't healthy.

I'm not a prude. I sometimes read Petronius. Horace's satire *Ambubaiarum* affords me at least as much pleasure as any of his others. I know three-quarters of Catullus' infamous little madrigals by heart. When on a picnic with my friends and loosened up a bit

23 It is reported that Fontenelle, exasperated by the music at a concert he was attending, cried out "Sonata, what do you want from me?"

24 Diderot's word here is *"honnête"*. In eighteenth-century French this term has multiple connotations, all of which Diderot means to evoke here: upright, straightforward, dependable, trustworthy, responsible, without pretension.

by white wine, I recite some of Ferrand's suggestive epigrams[25] without shame. I can forgive the poet, the painter, the sculptor, and even the philosopher for a moment of verve and extravagance; but I don't want him always to dip his brush there, perverting the function of the arts. One of Virgil's most beautiful verses, and one of the most beautiful principles of the arts of imitation, is as follows:

Sunt lacrimae rerum et mentem mortalia tangunt.[26]

One should inscribe over the door of one's studio: Here the unfortunate will find eyes that weep for them. To make virtue attractive, vice odious, and ridicule effective: such is the project every upstanding man who takes up the pen, the brush, or the chisel should make his own. Let a wicked person circulate in society, aware of some secret infamy he's committed; here he finds apt punishment. Without realizing it, upstanding people cross-examine him. They judge him, challenge him. He becomes embarrassed, grows pale, stammers, he has no choice but to accept his sentence. Should his steps lead him to the Salon, let him fear prolonged study of your austere canvases! It's your charge as well to celebrate, to perpetuate great and beautiful actions, to honor virtue persisting even in affliction, to stigmatize vice that's unduly recompensed, to frighten tyrants. Show me Commodus abandoned to wild beasts. Let me see him ripped to pieces on your canvas. Make me hear the cries of fury mixed with joy around his dead body. Wreak vengeance on the wicked in the name of the good, of the gods, and of destiny. Anticipate, if you dare, the judgment of posterity; or should you lack the requisite courage, at least paint me the judgments it has already meted out. Turn against fanatical peoples that same dishonor they directed against those trying to instruct them, to inform them of the truth. Spread out before me bloody scenes of fanaticism. Teach both sovereigns and peoples what is to be expected of such "sacred" preachers of lies. Why don't you also sit down among humanity's teachers, those comforting the afflicted, those avenging crime, those rewarding virtue? Don't you know that

Segnius irritant animos demissa per aurem,
Quam quae sunt oculis subjecta fidelibus, et quae
Ipse sibi tradit spectator?[27]

25 David Ferrand (ca. 1590–1660). French writer and poet.
26 "Tears are shed for misfortune and mortal sorrows touch the heart": Virgil, *Aeneid*, I, v. 462.
27 "Less vividly is the mind stirred by what finds entrance through the ears than by what is brought before the trusty eyes, and what the spectator can see for himself ": Horace, *Ars Poetica*, vv. 180–2.

Your figures are mute, true enough; but they make me speak to
myself, engage in a dialogue with myself.

Compositions are sometimes assessed in terms of how picturesque
or expressive they are. I note whether the artist has placed his figures
so as to maximize the effectiveness of his lighting scheme, whether
the whole speaks to my soul, whether the people are like individuals
ignoring one another in a public park, or the animals like those
placed by landscapists at the feet of the mountains.

Every expressive composition can also be picturesque, and when
it has been imbued with all the expression to which it's susceptible,
then it is sufficiently picturesque, and I congratulate the artist for not
having sacrificed common sense to visual pleasure. If he'd done
otherwise, I'd have cried out just as if I were listening to a smooth
talker mouthing nonsense: You speak very well, but you don't
know what you're talking about.

There are ungrateful subjects, without a doubt; but it's only the
ordinary artist who encounters them frequently. Everything strikes a
sterile head as being ungrateful. In your opinion, is a priest dictating
homilies to his secretary an interesting subject? Yet look at what
Carle Van Loo made of it. Incontestably, this subject resulted in the
simplest and most beautiful of his oil sketches.

It's been claimed that organization is inseparable from expression.
It seems to me there can be organization without expression, and
even that nothing is more commonplace. As for expression without
organization, this strikes me as much rarer, especially when I con-
sider that the slightest superfluous accessory hinders expression, be it
a dog, a horse, a broken column, or an urn. Expression requires a
strong imagination, a burning ardor, the art of stirring up phantoms,
of bringing them to life, to full realization; organization, in poetry as
in painting, presupposes a certain temperamental blend of judgment
and verve, of enthusiasm and wisdom, of drunkerness and cold
calculation such as rarely occurs in nature. Without this meticulous
balance, a prevalence of enthusiasm or reason will make the artist
either extravagant or cold.

A properly conceived principal idea should exercise despotic
control over all other considerations. It's the activating force of the
machine that, like the one holding celestial bodies in their orbits,
exercises its power in inverse proportion to distance.

Does the artist want to discover whether there's anything equivo-
cal or indecisive in his canvas? Let him summon two educated men
and ask them, separately, to explain his composition in detail. I
know very few modern compositions that would pass this test. Of
five or six figures, there'd be barely two or three that wouldn't need
to be painted over. It's not sufficient to intend that this be one
thing, and that another; it's also necessary that your idea be precise

and coherent, and that it be rendered so clearly that it can't be misinterpreted, by either myself or others, by either your contemporaries or those who'll follow after.

Almost all our paintings are characterized by a weakness of concept, a poverty of ideas that makes it impossible for them to rattle us, to evoke deep feelings. One looks, turns away, and remembers nothing of what one's seen. There's no phantom that haunts and pursues us. I dare propose to the most intrepid of our artists that they frighten us with their brushes as much as the writers for the news sheets do with their simple narratives, like the one about the crowd of Englishmen dying, suffocating in a dungeon too small for them on orders from a nabob.[28] What use is it for you to grind your colors, take up your brushes, and exploit all the resources of your art if you move me less than a news sheet? These men are without imagination, without verve. Strong, grand ideas are beyond their reach.

The larger a composition, the more studies after nature it will require. Who'll have the patience to finish it? Who'll fix its price after it's completed? Examine the works of the great masters and in a hundred different places you'll observe the artist's parsimony juxtaposed with his talent; among many truthful passages drawn from nature, an infinite number of things routinely executed. These are all the more annoying for being next to the others, like deception rendered more shocking by the presence of truth. Ah, if only a sacrifice, a battle, a triumph, a public gathering could be depicted with as much truth in its details as a domestic scene by Greuze or Chardin!

It's regarding this point above all that the history painter's work is infinitely more difficult than that of the genre painter. The number of genre paintings defying this criticism is infinite, but where is the battle painting that could withstand the scrutiny of the king of Prussia? The genre painter has his subject incessantly before his eyes; the history painter has either never seen his or has seen it only for an instant. And then the one is an imitator pure and simple, a copyist of ordinary nature, while the other is, so to speak, the creator of an idealized, poetic nature. He follows a narrow course from which it's difficult not to stray. Favoring one side he courts paltriness; the other, extravagance. It could be said of the latter option, "multa ex industria, pauca ex animo"; of the former, "pauca ex industria, plurima ex animo."[29]

28 A reference to the so-called Black Hole of Calcutta incident of 1756, which resulted in the death of 120 British soldiers.
29 "Many things invented, few that are honest;" "Few things invented, most of them honest."

The immensity of his work makes the history painter neglect details. Which of the painters now among us takes care to finish his hands and feet? He aims for an overall effect, he says, to which such trifles are irrelevant. Such was not the view of Paolo Veronese, but it's his. Almost all large-scale contemporary compositions are sketchy. But the hands and feet of the soldier playing cards in his guard-house are the spitting image of those with which he marches into battle and defends himself in the fray.

What would you have me say about costume?[30] It would be shocking to defy it beyond a certain point, but pedantry and bad taste frequently result when it's rigorously observed. We're not offended by nude figures in a century, among a people, in a context where clothing is customary. Because flesh is more beautiful than the most beautiful of draperies. Because the body of a man, his chest, arms and shoulders, and the feet, hands, and throat of a woman are more beautiful than the richest of the materials with which they might be covered. Because their execution is more difficult, requiring greater skill. Because "maior e loginquo reverentia,"[31] and by using nudes the scene is rendered more remote, bringing to mind a simpler, more innocent age, more primitive moral values that are better adapted to the imitative arts. Because we're dissatisfied with the present and this return to ancient times doesn't displease us. Because, while primitive nations become progressively, imperceptibly more civilized, such is not the case with individuals; men are sometimes seen to strip and become savages, but it's rare for savages to clothe themselves and adopt civilized ways. Because half-nude figures in a composition are like the tracts of forest and countryside we retain around our country houses.

"Graeca res est nihil velare."[32] Such was the custom of the Greeks, our masters in the fine arts. But if we've permitted the artist to denude his figures, let's not be so barbarous as to impose ridiculous Gothic dress on him. The eyes of taste are not those of a pensioner at the Academy of Inscriptions.[33] Bouchardon dressed Louis XV in Roman attire, and he was right to do this. But let's not

30 In contemporary French usage, *costume* designated not only dress but all details pertaining to the accuracy of historical reconstitution (architecture, geography, climate, custom, etc.).

31 "Remoteness augments prestige": Tacitus, *Annals*, I, xlvii.

32 "The Greek custom is to leave the figure entirely nude": Pliny, *Natural History*, XXXIV, 10.

33 Founded by Louis XIV and Colbert in 1663, primarily to draft commemorative Latin inscriptions of various kinds; during Diderot's lifetime this academy had become a center of historical erudition.

exalt a license into a precept. "Licentia sumpta pudenter."[34] As these people are ignorant, not knowing when to restrain themselves, I don't doubt that, even if you throw a bridle over their heads, they'll still manage to put a plumed cap on the head of a Roman soldier.

I know of no laws concerning the draping of figures. It's entirely a matter of poetry in the realm of invention, and of rigor in that of execution. No little folds jumbled one on top of the other. Anyone who's thrown a bit of cloth over a man's extended arm and who's seen, when he bends it, some of his muscles jump up and sink down again while others do the reverse, all these movements being visible beneath the cloth, will take his mannequin and throw it into the fire.

I can't bear it when I'm shown the *écorché* beneath the skin, but I can never get too much of nude forms rendered visible beneath drapery.

The ancients' way of depicting drapery has provoked much comment, both positive and negative. My own view, which in this matter is of no consequence, is that it heightens the play of light over broad areas by establishing contrast with the light and shadow in its long, narrow portions. Another way of handling drapery, especially in sculpture, sets broad areas of illumination against each other, the result being that they destroy each other's effects.

It seems to me there are as many genres of painting as of poetry, but such categories are superfluous. Portrait-painting and bust-making should be honored by a republican people accustomed to having citizens' attention focused on the defenders of their laws and their liberty. In a monarchical state things are different; there's only God and king.

And yet, if it's true that a skill is sustained only by the first principle that gave it birth—medicine by empiricism, painting by the portrait, sculpture by the bust—contempt for portraits and busts bespeaks a decadence in these two arts. No great painters who couldn't make portraits: witness Raphael, Rubens, Le Sueur, Van Dyck. No great sculptors who couldn't make busts. Every student begins as his art itself began. Pierre said one day: Do you know why we history painters don't do portraits? Because it's too difficult.

Genre painters and history painters don't openly avow the contempt they feel for each other, but one senses it. The latter regard the former as minds of limited scope, lacking ideas, poetry, grandeur, elevation, and genius, who slavishly pursue a nature they dare not lose from view a single moment. Poor copyists whom they'd readily compare to a craftsman at the Gobelins[35] carefully selecting

34 "That license [will be granted,] which is used with restraint": Horace, *Ars Poetica*, v. 51.
35 Royal tapestry factory, opened in 1663.

the woolen threads best suited to render the nuances of the painting by the sublime individual that's behind him. As they'd have it, these are specialists in trivial subjects, in little domestic scenes lifted from street corners who deserve credit only for the mechanical skills of their craft, and who are as nothing when these skills have not been developed to the very highest degree. The genre painter, on his side, regards history painting as a genre of phantasy, devoid of verisimilitude or truth, in which extravagance is the norm; which has nothing in common with nature; in which duplicity betrays itself in exaggerated expressions that never existed anywhere; in incidents that are completely imaginary, entire subjects never seen by the artist outside his airy head; in details taken from God knows where; in the style dubbed grand and sublime that has no model in nature, in figural action and movement that's very different from the real thing. You can see very clearly, my friend, that it's the quarrel between prose and poetry, between history and epic poetry, between heroic tragedy and middle-class tragedy, between middle-class tragedy and unbridled comedy.

It seems to me that the distinction between genre painting and history painting is intelligent, but I'd like to see a little more attention paid to nature in the way it's formulated. The appellation "genre painter" is indiscriminately applied to painters of flowers, fruit, animals, woods, forests, and mountains, as well as to those borrowing their scenes from everyday domestic life; Teniers, Wouwermans, Greuze, Chardin, Loutherbourg, and even Vernet are all considered genre painters. But I submit that Greuze's treatments of a father reading to his family, an ungrateful son, and a marriage contract, that Vernet's seascapes, which offer all kinds of scenes and incidents, are for me no less history paintings than are Poussin's *Seven Sacraments*, Le Brun's *Family of Darius*, or Van Loo's *Susanna*.

Here's the reason. Nature has created a wide variety of entities, some being cold, motionless, non-living, non-sentient, non-reflective, and others living, sentient, and reflective. A line was drawn for all eternity: imitators of dead, brute nature must be called genre painters; imitators of sentient, living nature must be called history painters; and so the quarrel is resolved. But if we allow these terms to retain their generally accepted connotations, I see that genre painting has almost all the difficulties of history painting; that it calls for just as much intelligence, imagination, and even poetry; a like competence in drawing, perspective, coloring, chiaroscuro, character, feeling, expression, drapery, and composition; a stricter adherence to nature, with details that are more carefully finished; and that, because it depicts the things that are most familiar and best known to us, there are more judges of it, and better ones. Is Homer any less great a poet when he marshals frogs into battle on the banks

of a marsh than when he bloodies the currents of the Simois and the Xanthus, engorging the beds of these two rivers with human bodies? It's just that here the subject is grander, the scene more terrible. Who doesn't recognize himself in Molière? And if we were to bring the heroes of our tragedies back to life they'd have a difficult time recognizing themselves on our stages; if brought before our history paintings, Brutus, Catiline, Caesar, Augustus, and Cato would all ask who these people were. What does this mean, if not that history painting requires greater elevation and perhaps imagination, a stranger, different kind of poetry; genre painting, greater truth; and that all art's resources, even a spark of genius, would commonly be on display in paintings of the latter kind, even when reduced to a vase or a basket of flowers, if the owners of the rooms in which they hung had as much taste as they have money. Why put our tiresome cleaning utensils on this buffet? Are these flowers any more brilliant in a Nevers vase than in one of—more attractive shape? And why don't I see, around this vase, a group of dancing children, the joys of harvest, a bacchanal? If this vase has handles, why not cast them in the form of two intertwining snakes? Why not have the tails of these snakes descend onto its lower portion, making a few serpentine curves there? And why not have their heads poised over its lip, looking for water within to slake their thirst? There's great skill involved in knowing how to animate dead things; and the number of those able to make things touched with the breath of life seem to retain it is small indeed.

A word more, before closing, on portrait painters and sculptors. A portrait can have a sad, sombre, melancholy, or serene air, because such states have a certain permanence; but a portrait that's laughing is without nobility, lacking in character, sometimes even devoid of truth and consequently quite silly. Laughter is fleeting. One laughs at something specific, but susceptibility to laughter isn't an essential character trait.

I can never prevent myself from thinking that a sculptural figure executing some action properly, to the extent it executes it properly, can't be beautiful from every side. Aiming for equal beauty from every angle is pure folly. Pursuit of correspondences between the limbs for purely technical reasons, sacrificing a rigorously truthful depiction of one's action to such considerations, is the origin of a trivializing style based on false oppositions. Every scene has a point of view or vantage from which it's more interesting than from another one; it's from there that it should be seen. Sacrifice all subordinate vantages or viewpoints to this one, that's the best way to proceed. What group is simpler or more beautiful than that of *Laocoön* and his children? What group is more disagreeable when viewed from the left, from where the father's head is barely visible and one of the children is blocked out by the other? And

yet the Laocoön is the most beautiful work of sculpture yet known
to us.

MY REMARKS ON ARCHITECTURE

Here, my friend, it's not my intention to examine the character of
the various architectural orders; still less to assess the advantages of
Greek and Roman architecture as opposed to the claims of Gothic
architecture, showing you how the latter can expand space vertically
through the height of its vaults and the lightness of its columns,
masking the imposing character of the resulting mass with a multi-
tude of ornamental elements in poor taste; nor to emphasize the
analogy between the darkness of stained glass and the incomprehen-
sible nature of the adored being, not to mention the dark nature of
the ideas in the adorer's head; but rather to convince you that
without architecture there's no painting and no sculpture, and that
it's to this art for which there's no model extant under the heavens
that the two arts imitating nature owe their origin and their
advance.
 Imagine yourself in Greece in the period when an enormous
wooden beam supported by two squared tree trunks formed a
magnificent, superb entrance to Agamemnon's tent; or, without
going so far back in time, place yourself amid the seven hills when
they boasted only huts, those huts inhabited by the brigands who
were the forebears of the pompous masters of the world.
 Do you think there was even a single bit of painting, good or
bad, in any of these huts? Surely not.
 And the most revered gods, as later given shape by the chisel
of the greatest masters, how would they strike you from such a
vantage? As markedly inferior, as much more crudely hewn than
these misshapen logs, on which a carpenter has approximated a nose,
some eyes, a mouth, and hands and feet, and before which the
inhabitants of your villages pray.
 Well, my friend, you can be sure these temples and huts and gods
will remain in this miserable state until there's some great public
disaster, a war, a famine, a plague, a public vow, in consequence of
which you'll see a triumphant arch raised to the victor, a great stone
structure consecrated to the gods.
 Initially the triumphant arch and the temple would be remarked
only for their bulk, and I doubt the statue placed on it would surpass
the old one save in being larger. And larger it would certainly be,

for of necessity the guest would be given proportions adapted to its new dwelling place.

Rulers of all periods have been rivals of the gods. If a god has a vast dwelling, the ruler will expand his own. The powerful, rivals of their rulers, will expand theirs in turn. The leading citizens, rivals of the powerful, will do likewise; and in less than a century one will have to look outside the walls encompassing the seven hills to find any huts.

But the walls of the temples, of the ruler's palace, of statesmen's residences, of wealthy citizens' homes will be full of extensive, bare surfaces crying out for decoration.

The pitiful domestic gods will no longer be suitable for the spaces assigned them; others will have to be devised.

And devised they'll be, as best as can be managed; the walls will be covered with canvases more or less badly daubed.

But paralleling a refinement of taste, and an increase of wealth and luxury, very soon the architecture of temples, palaces, residences, and modest houses will improve; and sculpture and painting will make like progress.

I now put these ideas to the test of experience. Cite a people that's had statues and paintings, painters and sculptors, but no palaces or temples, or whose religious customs banished colored canvas and sculpted stone from their temples.

But if architecture gave birth to painting and sculpture, conversely it's to these two arts that architecture owes its great perfection, and I advise you to be suspicious of any architect who's not also a fine draftsman.[36] Where would such a man have educated his eye? Where would he have acquired a refined feeling for beautiful proportions? Where would he have developed his ideas of grandeur, simplicity, nobility, heaviness, lightness, stylishness, solemnity, elegance, and seriousness? Michelangelo showed himself to be a great draftsman when he conceived his plan for the façade and dome of Saint Peter's in Rome, and our own Perrault drew with superior skill when he imagined the Louvre colonnade.

36 "*Un grand dessinateur.*" In addition to the meanings associated with "drawing" in English, the French term *dessin* and its derivatives often designated the process of intellection fostered in the humanist academies that sprang up in post-Renaissance European art centers. Diderot's usage here is typical: in this paragraph he plays on the multiple overtones of these words, blurring the distinction between draftsmanship per se and the skills of design and invention developed by academic training. Compare this passage with the first section of the *Notes on Painting* ("My Eccentric Thoughts About Drawing"), where his focus is on the concrete particulars of drawing instruction, and so on the more literal meaning of *dessin.*

And so I'll bring my little chapter on architecture to a close. The whole of the art is contained in these three words: solidity or security, decorum, and symmetry.

From which one ought to conclude that the rigorous Vitruvian system for measuring the orders must have been formulated only to foster monotony and suffocate genius.

But I won't conclude this section without bringing a little problem to your attention.

It is said of Saint Peter's in Rome that its proportions are so perfectly controlled that even at first glance the impact of the building's grandeur and extent is compromised, such that one could say of it, "magnus esse, sentiri parvus."[37]

One might raise some objections to this. What's the point of all these admirable proportions? To make a great thing seem small and commonplace? Surely it would have been better to ignore them, and greater skill manifested in producing the opposite effect, making an ordinary, commonplace thing seem grandiose.

The response is that the building would have indeed appeared larger at first glance if the canons of proportion had been violated; but which is to be preferred: stimulation of an admiration that's grand and immediate, or the fostering of one that's weak at first but increases bit by bit, finally becoming grand and definitive upon close examination and reflection? It can be agreed that, everything else being equal, a slender, lank man will seem larger than a man who's well proportioned; but one might ask which of these two men one admires more, and whether the first might not gladly consent to have himself reduced to more rigorous, antique proportions, even at the risk of losing something of his imposing aspect. It might be added that in the end a narrow building made to seem larger comes to be understood as what it is, while a large building made to seem ordinary and commonplace finishes by being comprehended as large, the disadvantageous effect of its proportions disappearing during the spectator's inevitable process of revision in experiencing the building.

And one might point out that it wouldn't be surprising if the man consented to a reduction of his apparent grandeur, exchanging it for more rigorous proportions, because he'd be aware that such rigorous proportional relationships among his limbs would make him maximally adapted to life's various functions, that they're the basis of strength, dignity, grace, and, in a word, beauty, which is always founded on utility; but that none of this holds true for a building that has only one aim, one goal.

37 "Grand in reality, small in appearance."

Some deny that the spectator's more considered examination of the building's component elements leads to a revised assessment, upgrading the unfavorable impression garnered at first glance. Approaching a piece of statuary that suddenly becomes colossal, without doubt we're astonished, grasping that the building it adorns is much larger than we'd originally thought; but once we've turned our back to the statue, the general impression created by the rest of the structure reasserts its claims, and the building, in fact quite large, once more seems rather ordinary and commonplace: so that from one vantage point all the details seem grand and the rest somewhat humble and ordinary. In an opposed, less regular design approach, all the details would seem small, while the whole would impress as extraordinary, imposing, and grand.

The ability to make objects seem larger through the magic of art and to conceal great size through proportional manipulation are assuredly two great skills; but which of them is the greater? Which of them should the architect value more highly? How should Saint Peter's in Rome have been constructed? Was it preferable to reduce the building's impact to something ordinary and commonplace through a rigorous observation of proportional canons, as opposed to giving it an astonishing aspect through use of a less austere, less regular design? A decision should not be reached too quickly: after all, it is only very gradually, or never, that Saint Peter's in Rome, thanks to its acclaimed proportions, produces the response that would have been elicited immediately and unequivocally with a different design approach. What kind of harmony is it that compromises the overall effect? What kind of a flaw is it that only enhances the whole?

Here we have the basic elements in the quarrel between Gothic architecture and Greek architecture clearly laid out for us.

But doesn't the same problem arise in painting? Who is the greater painter: Raphael, whose works we seek out in Italy but would fail to notice as we passed by if someone didn't tug at our sleeve and say, here it is; or Rembrandt, Titian, Rubens, Van Dyck, and any number of other great colorists who summon us from afar, fixing our attention through an imitation of nature that's so forceful, so striking, that we can't tear our eyes away?

If we encountered any one of Raphael's female figures in the street she'd stop us dead in our tracks; we'd drop to our knees, overcome by the most profound admiration, and hold on to her feet, following her until she undressed for us. Now, on the painter's canvases there are two, three, four such figures; they're surrounded by crowds of additional male figures that are just as beautiful, all of an exemplary grandeur, simplicity, and truth, and engaged in extraordinary, interesting actions; yet none of this calls out to me,

none of it speaks to me, none of it draws my attention! I must be encouraged to look carefully, I must be tapped on the shoulder, while both the knowledgeable and the ignorant, both the powerful and the powerless rush towards Teniers' tavern scenes without prompting. I'd be so bold as to say to Raphael: "Oportuit haec facere et alia non omittere."[38] I'd also be so bold as to assert that there's no greater poet than Raphael: as to whether there's a greater painter, I pose the question; but any answer will have to begin with a clear definition of painting.

Another question. If architecture has been impoverished by being subjected to measuring standards and modules, she who should acknowledge no law other than that of an infinite variety in design, then haven't painting, sculpture, and all the other arts based on drawing been similarly impoverished by requiring figures to be so many heads high, and heads so many nose-lengths long? Hasn't the science of social circumstances, emotions, and passions, of the various considerations germane to design been reduced to a mere matter of ruler and compass? I defy anyone to show me, anywhere on the earth's surface, not a single figure in its entirety, but the smallest portion of such a figure—a fingernail, for example—that an artist can manage to imitate rigorously. Leaving natural deformities to one side, focusing only on those necessarily resulting from repeated tasks, it seems to me that only depictions of the gods and of savage man ought to be subjected to proportional rigor; also heroes, priests, and magistrates, but less systematically. In depicting those of lower social station, the artist should work from an exceptional individual, or one that's highly representative of those in his circumstances, and effect the modifications necessary to characterize him effectively. The resulting figure will be sublime not when my attention is drawn to his exemplary proportions, but when I see in him a set of deformities that's consistent with and contingent upon his circumstances.

In effect, if we understood how everything in nature was interconnected, what would become of all these symmetry-dictating conventions? A hunchback is a hunchback from head to foot. The tiniest specific flaw has an incontrovertible effect on the whole mass. This influence might be imperceptible, but it is none the less real. How many of our rules, of our productions win praise only because of our laziness and inexperience, our ignorance and poor eyesight!

And then, to return to painting, which is where we started, we should never forget Horace's dictum:

38 "One must do these things without neglecting the rest."

Pictoribus atque poetis
Quidlibet audendi semper fuit aequa potestas;
Sed non ut placidis coeant immitia, non ut
Serpentes avibus geminentur.[39]

In other words: Rubens the celebrated, imagine and paint anything
you please, but on condition that I never see, in the bedroom of a
woman in labor, a zodiac, a Sagittarius, etc. Do you know what that
is? Serpents coupled with birds.

If you attempt an apotheosis of the great Henry,[40] elevate your
mind; be venturesome; fling down, sketch out, pile up as many
allegorical figures as your active, prolific genius can generate; well
and good. But if you've painted the portrait of the corner seamstress,
along with a counter, some pieces of fabric strewn about, a measur-
ing rod, a few young apprentices, you'll end up with nothing more
than a canary in its cage. It ocurred to you transform your seamstress
into a Hebe? Fine, I've no objection, and I'll no longer be shocked
to see Jupiter with his eagle, Pallas, Venus, Hercules, and all the
gods of Homer and Virgil arrayed about her. It will no longer be the
shop of a middle-class woman, it will be the assembly of the gods,
it will be Olympus; and what do I care, so long as it's all of a piece?

Denique sit quod vis simplex duntaxat et unum.[41]

A LITTLE COROLLARY TO THE PRECEDING

But what's the point of all these principles if taste is capricious, and
if beauty is not subject to eternal, immutable rules?

If taste is capricious, if there are no rules determining beauty, then
what is it that prompts these delicious feelings that arise so suddenly,
so involuntarily, so tumultuously in the depths of our souls, dilating
or constricting them, forcing our eyes to shed tears of joy, pain,
and admiration, whether in response to some grand physical

39 "Painters and poets have always had equal license to dare all ... But this [on
condition that they] not [abuse this right,] merging the savage with the tame,
coupling serpents with birds": Horace, *Ars Poetica*, vv. 9–10, 12–13.

40 Henry IV. Diderot is again referring to Rubens' Marie de Medici cycle, now in the
Louvre.

41 "In short, whatever you undertake to do, make it simple and of a piece": Horace,
Ars Poetica, v. 23.

phenomenon or to an account of some great moral action? *Apage, Sophista*:[42] You'll never convince my heart that it's mistaken in skipping a beat, nor my entrails that they're wrong to contract from profound emotion.

The true, the good, and the beautiful are very closely allied. Add some unusual, striking circumstance to one of the first two qualities and truth becomes beauty, or beauty truth. If the solution to the problem posed by three bodies is as simple as the movement of three points inscribed on a scrap of paper, this is nothing; it's a purely speculative truth. But if one of these three bodies is the star that lights up our days, another the orb that shines through our nights, and the third the globe we inhabit, suddenly the truth becomes grand and beautiful.

One poet said of another poet: He won't go far, he doesn't know the secret. What secret? That of focusing on things of inherent interest, on fathers, mothers, women, and children.

I see a high mountain covered by a deep, dark, ancient forest. I see and hear descending from it, very noisily, a stream whose rushing waters crash against steep outcrops of rock. The sun is setting; it transforms the droplets of water clinging to the rough surface of the stone into so many diamonds. But after having cleared these obstacles, the water is collected into a large, broad canal that leads to a machine. It's there that, under enormous blocks of stone, the basic material of human subsistence is ground and prepared. I glimpse the machine. I glimpse its wheels whitened by foam. I glimpse the top of the owner's cottage through the branches of a willow. I look into myself, and I dream.

Without doubt the forest that makes me reflect on the origin of the world is a beautiful thing. Without doubt the rock that's an image of constancy and perseverance is a beautiful thing. Without doubt the droplets of water transformed by the sun's rays, broken and refracted into so many brilliant, liquid diamonds are beautiful. Without doubt the noise, the roar of the rushing stream that breaks the vast silence and solitude of the mountain, giving my soul a violent shock, instilling in it a secret terror, is also beautiful.

But these willows, this cottage, these animals grazing nearby, this spectacular display of utility, does it add nothing to my pleasure? And what of the different feelings it evokes in an ordinary man and a philosopher? It's the latter who reflects, seeing in each forest tree a mast that will one day lift high its head against wind and storm; in the mountain's bowels the raw metal that one day will boil in blast furnaces, prior to transformation into machines for cultivating the

42 "Back, sophist!"

earth or destroying its inhabitants; in the rock, blocks of stone that will be used to construct the palaces of kings, the temples of the gods; in the rushing water, at one moment the source of life, at another the ravage of the countryside; then thinking on its fusion with larger streams and rivers; on commerce, the inhabitants of the universe connected to one another, their treasures transported from bank to bank, from where they're dispersed into the continental depths; and his volatile soul will pass rapidly from a tender, voluptuous feeling of pleasure to a sensation of terror, if his imagination proceeds to summon up the waves of the ocean.

It's in this way that pleasure increases proportionally with imagination, sensitivity, and knowledge. Nature and the art that copies it have nothing to say to a man who's stupid or cold, and very little to a man who's ignorant.

So what, then, is taste? A capacity, acquired through reiterated experience, to sense the true or the good, along with the circumstances rendering it beautiful, and to be promptly, vividly moved by it.

If the experiences that shape judgment remain clear in the memory, one's taste will be enlightened. If there are no such distinct memories, only vague impressions, one's taste will be instinctive.

Michelangelo gave the dome of Saint Peter's in Rome the most beautiful form possible. The geometer La Hyre, impressed by this form, plotted its arc and found that this curve was the one that offered the greatest resistance. What is it that inspired Michelangelo to use this curve, among the infinite number from which he could choose? The experience of everyday life. It's this that suggests to a master carpenter, just as surely as to the sublime Euler,[43] the angle of support best suited to prop up a wall threatening collapse. It's this that teaches him how to give the sails on a windmill the pitch most favorable to rotation. It's this that sometimes prompts us to introduce subtle elements into our calculations that find no justification in the academy's rules of geometry.

Experience and study: these are the fundamentals of those who execute as well as those who judge. I'd be inclined to add sensitivity to the list. But as we see men acting with justice, benevolence, and virtue solely through a proper understanding of their own best interests, through intelligence and a taste for order, without deriving any pleasure or gratification from it, it follows that there can be taste without sensitivity, just as there can be sensitivity without taste. In its extreme form sensibility is not discerning; it's moved by everything. The first will tell you coldly, That is beautiful; the other will

43 Leonard Euler (1707–83). Swiss physicist and mathematician.

be moved, transported, inebriated. "Saliet tundet pede terram, ex oculis stillabit amicis rorem."[44] He'll stammer; he'll be unable to find words to describe the state of his soul.

The happier of the two is undoubtedly the latter. The better judge? That's another matter. Cold, austere men who are tranquil observers of nature are often better able to articulate their views. They simultaneously are and are not enthusiasts; they're both man and animal.

Reason sometimes rectifies a rapid judgment made by sensibility; it appeals against it. Thus the large number of works quickly applauded but as quickly forgotten, and the many others that, while initially either unnoticed or disdained, with passing time, advancing intelligence and sensitivity, and closer attention, come to be valued at their true worth.

Such is the uncertain prospect for any work of genius. It stands alone. It can be appreciated only by immediate comprehension of its relation to nature. And who is the only one capable of grasping this relation? Another man of genius.

44 "He'll bounce about, he'll stamp his feet, he'll weep fervently": Horace, *Ars Poetica*, vv. 429–30 (Diderot's citation is approximate).

SELECT BIBLIOGRAPHY

For reasons of space, articles and monographs on individual artists have not been included. For such sources published before 1984, the reader is advised to consult the bibliography in the *Diderot et l'art* exhibition catalogue, cited below.

Becq, Annie, *Genèse de l'Esthétique Française Moderne: de la Raison Classique à l'Imagination Créatrice, 1680–1814*, 2 volumes, Pisa, 1984.

Bukdahl, Else Marie, *Diderot critique d'art*, 2 volumes, Copenhagen, 1980–2.

Chouillet, Jacques, *La Formation des idees esthétiques de Diderot, 1745–63*, Paris, 1973.

Courajod, Louis, *Histoire de l'école des beaux-arts au XVIIIᵉ siècle: l'école royale des élèves protégés*, Paris, n.d. [1874].

Crow, Thomas, *Painters and Public Life in Eighteenth-Century Paris*, New Haven and London, 1985.

Curtius, Ernst Robert, *European Literature and the Latin Middle Ages*, trans. by Willard R. Trask, Princeton, 1953, excursus no. XXV, "Diderot and Horace," pp. 573–83.

Diderot, Denis, *Correspondance*, edited by G. Roth and J. Varloot, 16 volumes, Paris, 1955–70.

Diderot, Denis, *Oeuvres complètes*. Volume XVI. *Salon de 1767. Salon de 1769*, critical edition with notes, text established by Annette Lorenceau, notes by Else Marie Bukdahl and Michel Delon, Paris, 1990.

Diderot, Denis, *Oeuvres de Denis Diderot publiées sur les manuscrits de l'auteur par Jacques-André Naigeon*, Paris, 15 volumes, 1798. The *Salon de 1765* and *Essais sur la peinture* are in vol. XIII; the *Salon de 1767* is in vols. XIV and XV.

Diderot, Denis, *Salons*, edited by Jean Seznec and Jean Adhémar, 4 volumes, Oxford, 1957–67 (vol. II, *Salon de 1765*, 1960; vol. III, *Salon de 1767*, 1963). 2nd edition, Oxford, 3 volumes published, 1975–83 (vol. II, *Salon de 1765*, 1979; vol. III, *Salon de 1767*, 1983).

Diderot et l'art de Boucher à David, exhibition catalogue, Paris, 1984.

Diderot et Falconet. Le Pour et le Contre. Correspondance polemique sur le respect de la postérité, Pline et les anciens auteurs qui out parlé de peinture et de sculpture, edited by Y. Benot, Paris, 1958.

Fort, Bernadette, "Voice of the Public: The Carnivalization of Salon Art Criticism in Prerevolutionary France," *Eighteenth-Century Studies*, vol. 22, no. 3 (spring 1989), pp. 368–94.

Fried, Michael, *Absorption and Theatricality: Painting and Beholder in the Age of Diderot*, Berkeley, Los Angeles, London, 1980.

Furbank, Philip Nicholas, *Diderot: A Critical Biography*, London, 1992.

Hobson, Marian, *The Object of Art: The Theory of Illusion in Eighteenth-Century France*, London and New York, 1982.

Hobson, Marian, "What is Wrong with Saint Peter's? Or, Diderot, Analogy and Illusion in Architecture," *Reflecting Senses: Perception and Appearance in Literature, Culture, and the Arts*, ed. Walter Pape and Frederick Burwick, Berlin and New York, 1995, pp. 53–74.

Locquin, Jean, *La peinture d'histoire en France de 1747 à 1785*, Paris, 1912 (new edition Paris, 1978).

Michel, Christian, *Charles-Nicolas Cochin et l'art des lumières*, Rome, 1993 (Bibliothèque des écoles françaises d'Athènes et de Rome, publication no. 180).

Seznec, Jean, "Diderot et l'affaire Greuze," *Gazette des Beaux-Arts*, 6th series, LXVII (May–June 1966), pp. 339–56.

Seznec, Jean, *Essais sur Diderot et l'antiquité*, Oxford, 1957.

Wilson, Arthur M., *Diderot*, New York and Oxford, 1972.

Wilson, Arthur M., *Diderot*, New York and Oxford, 1972.

Wrigley, Richard, *The Origins of French Art Criticism: From the Ancien Régime to the Restoration*, Oxford and New York, Oxford University Press, 1993.

INDEX

The page numbers of Diderot's principal discussion of referenced artists are in italics. An asterisk following a title indicates that the work in question was exhibited at the Salon of 1765.